EARTHWORKS RISING

INDIGENOUS AMERICAS
Robert Warrior, Series Editor

EARTHWORKS RISING

Mound Building

in Native Literature

and Arts

CHADWICK ALLEN

University of Minnesota Press
Minneapolis / London

**INDIGENOUS
AMERICAS**

The University of Minnesota Press gratefully acknowledges the financial assistance provided for the publication of this book by the Russel F. Stark Endowed Professorship at the University of Washington.

Portions of chapter 1 are adapted from "Serpentine Figures, Sinuous Relations: Thematic Geometry in Allison Hedge Coke's *Blood Run*," *American Literature* 82, no. 4: 807–34; copyright 2010 Duke University Press; reprinted by permission. www.dukeupress.edu. Portions of chapter 1 are adapted from "Performing Serpent Mound: A Trans-Indigenous Meditation," *Theatre Journal* 67, no. 3 (October 2015): 391–411; copyright 2015 Johns Hopkins University Press; reprinted with permission by Johns Hopkins University Press. Portions of chapter 3 and the Introduction are adapted from "Vital Earth / Vibrant Earthworks / Living Earthworks Vocabularies," *Routledge Handbook of Critical Indigenous Studies*, edited by Brendan Hokowhitu, Aileen Moreton-Robinson, Linda Tuhiwai Smith, Chris Andersen, and Steve Larkin, 215–28 (London: Routledge, 2020). Portions of chapter 4, chapter 5, and the Introduction are adapted from "Re-scripting Indigenous America: Earthworks in Native Art, Literature, Community," *Twenty-First Century Perspectives on Indigenous Studies: Native North America in (Trans)Motion*, edited by Birgit Daewes, Karsten Fitz, and Sabine N. Meyer, 127–47 (London: Routledge, 2015). Portions of this book are adapted from "Earthworks as Indigenous Performance," in *In the Balance: Indigeneity, Performance, Globalization*, edited by Helen Gilbert, J. D. Phillipson, and Michelle Raheja, 291–308 (Liverpool: University of Liverpool Press, 2017); reprinted with permission of The Licensor through PLSclear.

Excerpts from Phillip Carroll Morgan, "Postcards from Moundville" were originally published in *Famine Pots: The Choctaw-Irish Gift Exchange, 1847–Present* (Michigan State University Press, 2020). Excerpts from Allison Hedge Coke, *Blood Run: Free Verse Play* (Salt, 2006) are reprinted with permission of the author. Excerpts from Monique Mojica's unpublished script "Inside-Outside," *Sideshow Freaks and Circus Injuns* are reprinted with permission of the author. Excerpts from Dave Oliphant, *Lines & Mounds* (Thorp Springs Press, 1976) are reprinted with permission of the author. Excerpts from Joe Napora, "The Adena Serpent Mound: Adams County, Ohio" (broadside, 1983) are reprinted with permission of the author. Excerpts from Aku Wuwu, "Serpent Mound" were originally published in *Coyote Traces: Aku Wuwu's Poetic Sojourn in America*, translated by Peihong Wen and Mark Bender (Columbus: National East Asian Languages Resource Center, Ohio State University, 2015), 37, 39; reprinted with permission of The Ohio State University. Excerpts from Alice Azure, *Games of Transformation* (Albatross Press, 2011) are reprinted with permission of the author. Excerpts from Margaret Noodin's unpublished poem "Aazhawa'zhiwebag / Paths into the Past" are reprinted with permission of the author. Excerpts from Phillip Carroll Morgan's unpublished essay "The Origins of Anompolichi the Wordmaster (first draft)" are reprinted with permission of the author. Excerpts from Linda Hogan, "The Maps," *A History of Kindness: Poems* (Torrey House Press, 2020) are reprinted with permission from Torrey House Press. Excerpts from Joy Harjo, "The Southeast was covered" were originally published in *An American Sunrise: Poems*; copyright 2019 by Joy Harjo; reprinted by permission of W. W. Norton & Company, Inc.

Images by Alyssa Hinton copyright Alyssa Hinton; reproduced by permission.

Every effort was made to obtain permission to reproduce material in this book. If any proper acknowledgment has not been included here, we encourage copyright holders to notify the publisher.

Published by the University of Minnesota Press
111 Third Avenue South, Suite 290
Minneapolis, MN 55401–2520
http://www.upress.umn.edu

ISBN 978-1-5179-1232-1 (hc)
ISBN 978-1-5179-1233-8 (pb)

A Cataloging-in-Publication record for this book is available from the Library of Congress.

Printed in the United States of America on acid-free paper

The University of Minnesota is an equal-opportunity educator and employer.

31 30 29 28 27 26 25 24 23 22 10 9 8 7 6 5 4 3 2 1

For W. D. Holder

CONTENTS

ACKNOWLEDGMENTS

This project began with a question: How could I bring Indigenous earthworks into the literary studies classroom? I am grateful to those who encouraged, assisted, and—with some regularity—challenged my endeavor to answer that question in increasingly complex ways. *Earthworks Rising* is immeasurably better because of you.

The most important parts of my earthworks education occurred in community, and my most creative thinking about the mounds developed through conversations, debates, and collective performances. I call out central mentors and inspirations LeAnne Howe, Monique Mojica, Allison Hedge Coke, Phil Morgan, Alyssa Hinton, Marti Chaatsmith, and others across the chapters and codas, but I would be remiss not to express my gratitude more formally here or to name the many individuals and organizations that helped make this book and its ideas possible.

I am pleased to acknowledge research and other material support from the College of Arts and Sciences and the Newark Earthworks Center at The Ohio State University, both of which helped stage the 2011 Society of American Indians Centennial Symposium and its inspiring visit to the Octagon and Great Circle Earthworks. The Wexner Center for the Arts, located on the OSU campus, was vital to my research, as was the Centre for Aboriginal Theatre in Toronto, which hosted rehearsals and a staged reading of the earthworks-grounded performance *Sideshow Freaks and Circus Injuns*. At the University of Washington, I am pleased to acknowledge generous assistance from the Russel F. Stark Endowed Professorship, the Simpson Center for the Humanities, and the UW Libraries. Key supports at UW also include colleagues and students involved in the Summer Institute on Global Indigeneities (SIGI) and the Center for American Indian and Indigenous Studies (CAIIS).

I benefited greatly from conversations with colleagues and collaborators Hokulani Aikau, Chris Andersen, Jose Aranda, Sonya Atalay, Nadine

Attewell, Alice Azure, Christine Ballengee-Morris, Mark Bender, Susan Bernardin, Kim Blaeser, Lisa Brooks, Kirby Brown, Katie Bunn-Marcuse, Jodi Byrd, Jill Carter, Amanda Cobb-Greetham, Krista Comer, Andy Couch, Birgit Daewes, Phil Deloria, Jean Dennison, Vince Diaz, Wai Chee Dimock, Michael Dowdy, Anne Ellegood, Brenda Farnell, Laura Furlan, Edgar Garcia, Helen Gilbert, Mishuana Goeman, Melody Graulich, Jane Hafen, John Hancock, Joy Harjo, Joanna Hearne, James Pepper Henry, Linda Hogan, Brendan Hokuwhitu, Craig Howe, Hsinya Huang, Michael Johnson, Daniel Justice, Merrill Kaplan, Ric Knowles, Linda Lomahaftewa, Tsianina Lomawaima, Melissa Lucashenko, Tony Lucero, Emily Lutenski, Dustin Mater, Janet McAdams, America Meredith, Shannon Gonzalez Miller, Dian Million, Nicole Moore, Aileen Moreton-Robinson, Meg Noodin, Margaret Wickens Pearce, Beth Piatote, Mary Louise Pratt, Michelle Raheja, Carter Revard, Linda Tuhiwai Smith, Lindsey Claire Smith, Paul Chaat Smith, Alice Te Punga Somerville, Shannon Speed, Laura Stevens, Tereza Szeghi, Lisa Tatonetti, Jesse Oak Taylor, Chris Teuton, Priscilla Wald, Glenna Wallace, Robert Warrior, Spy Denome Welsh, Jim Wilson, Michael Wilson, Rob Wilson, Cedric Woods, Kathy Woodward, Aku Wuwu, and Mike Zimmerman.

I am grateful for the expert attention of Jason Weidemann and the team at the University of Minnesota Press.

Finally, I am grateful for the inspiration of my family in Oklahoma and of my ancestors in Oklahoma and the Southeast, and for the support of Joel Tobin, who always makes sure I am cared for wherever I happen to land. *Chokma'ski.*

Indigenous Earthworks within (and without) the White Imaginary

> Mound-Builders! What magic in the very word; what an epitome of all that is romantic and mysterious in human experience! Mere mention of the name suffices to conjure visions of a shadowy race dimly viewed across the ages— come from no one knows whence, gone no one knows whither, or when.
>
> — Henry Clyde Shetrone, *The Mound-Builders:
> A Reconstruction of the Life of a Prehistoric American Race,
> through Exploration and Interpretation of Their Earth
> Mounds, Their Burials, and Their Cultural Remains* (1930)

> I am Choctaw, returned to the ancient city
> and capital of my ancestors, the Imoklasha,
> on the Black Warrior River.
> I am every man and every woman
> who has been expelled or exiled
> from their home
> and returned.
>
> — Phillip Carroll Morgan, "Postcards from Moundville" (2018)

The title listed on the event website and printed on the promotional flyer suggested life-giving breath, a promise of resuscitation: *AIR: American Indian Returnings.* It was late September 2018, the turn of the autumnal equinox. I was delivering the annual AIR lecture at the University of Georgia, scheduled to coincide with this season of balance—this time of making things "even," of beginning cycles anew—organized by Choctaw writer and intellectual LeAnne Howe, author of the novels *Shell Shaker* and *Miko Kings*, the poetry collection *Evidence of Red*, the essay collection *Choctalking on Other Realities*, and the verse play *Savage Conversations*. Although the U.S.

settler nation-state forcibly removed the majority of Southeastern peoples to the Indian Territory west of the Mississippi in the 1830s—including, infamously, most of Howe's Choctaw Nation along with their relatives the Chickasaw, as well as the Muscogee Creek, the Seminole, and the Cherokee, the so-called Five Civilized Tribes, each of which walked a remarkably brutal Trail of Tears—since joining the University of Georgia, Howe has been determined to demonstrate the multiple ways descendants of these nations violently relocated to what became the U.S. state of Oklahoma have returned and, importantly, continue to return to the Southeastern homelands—not only physically, in the sense of moving material bodies back to the lands that constitute what is now the U.S. South, but also intellectually and imaginatively, in the sense of returning through story, song, and performance, through visual and tactile arts, through research and scholarship.

Mine was the fourth lecture in the series, an auspicious position, completing and balancing the initial sequence. I had been invited, in part, because I am a scholar who identifies with south-central Oklahoma, the lands to which the Chickasaw were removed, and who traces Chickasaw ancestry through my maternal line (although my family is not enrolled and I am not a Chickasaw citizen). I followed the writers and intellectuals Joy Harjo (Muscogee), Jody Byrd (Chickasaw), and Daniel Heath Justice (Cherokee), who had presented their compelling work on the three previous autumnal equinoxes. Titled "Across and through These Lands: Earthworks, Indigenous Identity, and Return," my lecture juxtaposed the vibrant photo-collages and 3D installations of Alyssa Hinton, a mixed media artist of Tuscarora and Osage descent who has placed Southeastern burial mounds at the productive center of much of her work, with the brilliant, mathematically encoded poetry of Allison Hedge Coke, a writer, activist, and intellectual of Creek, Huron, and Cherokee descent who has advocated on behalf of the Upper Mississippian mounds at Blood Run, on what is now the border between Iowa and South Dakota, and other sites.[1] The purposeful juxtapositions in that lecture became the basis for chapter 4 of this book, but the broader idea of Native Americans returning to ancient mounds and to principles of mound construction, use, and stewardship through contemporary artistic and literary productions drives the book as a whole.

Earthworks Rising examines the ways in which twentieth- and twenty-first-century Native artists, writers, and performers engage ancient Indigenous earthworks and earthworks principles—including the principle of carefully layering selected materials and the principle of carefully aligning specific works and sets of works within and across abstract space, embodied place, and multiple material, social, and spiritual worlds—in their contemporary productions developed in multiple genres and across multiple media. Major touchstones for this project include the scholarly and creative work not only of LeAnne Howe, Alyssa Hinton, and Allison Hedge Coke but also of Kuna and Rappahannock actress and playwright Monique Mojica and Choctaw and Chickasaw poet, novelist, and intellectual Phillip Carroll Morgan. But as my first epigraph suggests, even a Native-anchored and Native-focused study must contend with the fact that Indigenous earthworks have fascinated—and continue to fascinate—across North American generations and their increasingly diverse cultures, including multiple generations of non-Native settlers and their descendants. In other words, we must contend with historical and ongoing attempts to capture Indigenous earthworks within the white imaginary.

Indeed, almost since their arrival on the continent, non–Native Americans have sought to control the physical phenomena of mounds and other earthworks, not only their bodies of packed soil but also the material, human, and other-than-human remains these earthen bodies often protect and carry. Moreover, settlers and their descendants have sought to control the narratives that frame evolving approaches to earthworks stewardship, research, and understanding. Both the mere presence and the actual complexity of so-called mounds—an imprecise term I nevertheless use throughout the book because of its ubiquity across scholarly, popular, and Indigenous discourses—contradict foundational non-Native beliefs about the European settlement of North America and, often, confound supposedly established non-Native truths about the North American continent, its peoples, and its histories. To state up front what is perhaps the most obvious example: How could a New World "discovered" by Columbus or de Soto or the Pilgrims or other Europeans have been a "virgin land" and a "howling wilderness" and also have been a densely populated, elaborately planned,

and highly engineered landscape? A landscape of constructed urban, sub-urban, village, ceremonial, and rural spaces connected by systems of well-marked trails and well-maintained roads and, especially, by navigable rivers, streams, and creeks? A vast interconnected network of established centers for agriculture and politics, for trade and art and spiritual practice, for the production and dissemination of knowledge?[2]

Beginning at least in the eighteenth century, popular non-Native dis-courses on ancient American mounds and on the imagined builders of these diverse and sophisticated monumental structures have fixated on the spectacular and the fantastical. In one widely disseminated specula-tion, a race of "white" giants build thousands of well-engineered and aes-thetically elegant burial mounds, walled enclosures, terraced platforms, and animal effigies across nearly half of the North American continent. Once their extraordinary work is completed, however, these intelligent, fair-skinned giants are easily overrun by hordes of late-arriving "copper Huns," the ruthless, dim-witted ancestors of the "savage" Indians who will eventually be discovered by Columbus, de Soto, the Pilgrims, and the first white settlers who reach the wilds of the Ohio Valley and the Great Lakes and the Mississippi River and the seemingly endless woodlands, prairies, and bottomlands in between. In other speculation the mounds were built by bands of traveling explorer-architect-engineers originally from China or Egypt or even more exotic-sounding Phoenicia. Or the mounds were built by adventurous Vikings who came from Norway via Iceland and Greenland, or by hearty fishermen blown off course across the Atlantic from the coasts of Ireland or Wales. There were popular theories motivated by Western philosophy and religion involving either citizens of the fabled city of Atlantis or one of the Lost Tribes of Israel. And in the case of the especially "enigmatic" and "mysterious" effigy known as the Great Serpent, there was speculation that this mounded figure of a snake uncoiling for a quarter mile atop a prominent bluff and juxtaposed with the outline of a disk-shaped object had been created by none other than the Hebrew God himself. This theory, to which I briefly return in chapter 1, proclaimed that the biblical Garden of Eden, with its sly tempter to knowledge and forbid-den fruit, was located not in the established Holy Land set between the

River Jordan and the Mediterranean Sea but in an obscure rural county of what is now the U.S. state of Ohio.

According to these and other popular theories, any real or imagined "race" of people might be suspected of building tumuli and barrows (that is, burial mounds) of various sizes and shapes, embankment walls running in straight lines or graceful curves, hilltop enclosures simple and elaborate, geometric enclosures precise and small or precise and enormous, truncated pyramids and huge platforms rising toward the sky in multiple terraces, or evocative effigies of animals, birds, and humans. Any race, that is, but that of the Indigenous peoples actually living in North America prior to and at the time of Columbus's or other Europeans' first arrivals. Even Henry Clyde Shetrone (1876–1954), the accomplished director of the Ohio State Archaeological and Historical Society quoted in the first epigraph, who in his massive, 508-page study *The Mound-Builders* sought to dispel any lingering ideas that non–Native Americans had built the mounds, hesitated to connect the ancient builders to actually living American Indians.[3] Shetrone believed all evidence pointed to the fact that the mounds had been built by the ancestors of Native American peoples. But he also believed the builders of the mounds were long gone—and that no one knew for sure what had become of them. Somehow, these sophisticated architects and industrious engineers, these accomplished artists and astronomers, these skilled organizers of food, labor, and materials, had simply vanished.

Collecting his research and writing his study in the early decades of the twentieth century, Shetrone was already a latecomer to the field and its speculations. European Americans had been asking questions about who built and first used the thousands of earthen mounds they found spread across the eastern half of the North American continent since the beginnings of the early colonies—not only ordinary settlers but such luminaries among colonial intellectuals as Thomas Jefferson, Noah Webster, Benjamin Franklin, and William Henry Harrison—developing a wide range of theories about the so-called mound builders across the eighteenth and nineteenth centuries. As my brief synopses suggest, most of these speculations appear fanciful by twentieth- and now twenty-first-century standards. To counter the popular theories, Shetrone offers a comprehensive survey of

the best scholarship available, divided into twenty well-organized chapters and supported by 299 well-chosen illustrations. Only in his "Summary and Conclusions," however, does Shetrone reveal what he considered the true and verifiable story.

Shetrone begins his final chapter by restating his study's central questions:

> Who were the Mound-builders? Whence came they, and when? Why did they build mounds? What became of them? These important queries, the five "W's" of mound archaeology, were proposed in the Introduction, but for reasons to be stated presently the answers to them have been withheld.[4]

To solve the mystery of these five W's, Shetrone affirms the Bering Strait land-bridge theory, which has the "Mongoloid" ancestors of Native American peoples arriving from Asia between twelve thousand and eight thousand years before the present, and asserts that these "primitive migrants" were hunter-gatherers who "simply partook of nature's bounty in so far as they were able" (482, 483). In Shetrone's account these "wandering nomads" eventually find their way through what is now Alaska, down the length of what is now the continental United States, and on south into what is now Mexico and Middle America, where they (rather suddenly) become "sedentary agricultural peoples"; the "magic key that unlocked the door to progress," Shetrone states, "was nothing more nor less than maize or Indian corn" (485). These "rudiments of agriculture"—the domestication and increasingly sophisticated cultivation of corn and her sister plants—engender "confidence" for the people Shetrone now calls "American aborigines" to once again succumb to their "instinctive urge to seek new homes" and to leave "the parental area in Mexico" to continue their wandering and exploring (485). Some of these confident nomads head back north. In Shetrone's imagined route, this northern migration occurs in several stages. The first is a landing in what is now the U.S. desert Southwest, where the agriculturally savvy nomads build with stone, followed by a second stage in which these horticulturalist-adventurers head eastward into what is now the U.S. Southeast, finally bringing the original "Asiatic migrants at Bering Strait"

into "the country of the mound-builders" (486). A third stage has the migrants again moving northward into "the northern half of the mound area," that is, the Ohio Valley (486). Wandering up from what is now Mexico, how did these "primitive" peoples develop technologies that allowed them to build earthen mounds, Shetrone asks, rather than the stone pyramids and other structures of the Mayans and Aztecs? The archaeologist reasons thus:

> Clearly, the building of mounds as a developed trait was not carried by the migrants from Mexico; rather, the germ of that trait, originating before the assumed dispersal from the nuclear area, was destined to find expression in Mexico in the characteristic pyramids and temples, and in the mound area in the form of earthen mounds. As noted in an early chapter, the erection of mounds as monuments to the dead, as bases for domiciliary and ceremonial structures, and in the form of defensive and ceremonial earthworks, is a primary and natural human trait. (487–88)

Mound building is a widely dispersed, "primary and natural" human trait, Shetrone confirms—occurring, for instance, across Europe and Asia—and thus the building of mounds demonstrates the basic humanity of the ancestors of Native Americans. Building mounds was nothing less than their (organic) destiny.

Although he was certain these ancient Americans had been fully human, in 1930 Shetrone was not prepared to draw a direct link between the builders of the mounds and either historical or contemporary American Indians. Once again evoking the discourse of an inevitable destiny, Shetrone writes: "These native American peoples, who, *although their culture was not destined to be perpetuated,* nevertheless had a part in that greatest of all human experiments, the blazing of the trail from savagery *toward* civilization" (488–89, emphasis added). For Shetrone and many of his contemporaries, all the old binaries were set firmly in place (that is, "savagery" versus "civilization" as well as its many cognates and derivatives) and the case seemed relatively settled. (Notice in Shetrone's account that the builders of the mounds blazed a trail *toward* civilization but did not actually reach their destination.) But despite the warehouses of physical "evidence" archaeologists,

anthropologists, and historians amassed and cataloged, and despite the reams of scholarship they published prior to and after 1930, speculations about the possibility—even the likelihood—of non-Native builders of the mounds were not put to rest in the early twentieth century. Scholars following Shetrone, working across multiple disciplines, continued to engage—and combat—theories about who built the mounds, no matter how banal or bizarre. Robert Silverberg's 1968 *Moundbuilders of Ancient America: The Archeology of a Myth*, for example, remains a compelling standard text for any study.[5] The October 1991 special issue of the popular scientific journal *National Geographic, 1491: America before Columbus,* which anticipated the coming 1992 Columbus Quincentenary observances, makes clear that, in the late twentieth century, the discourses of "mystery" and "enigma" remained pervasive in earthworks research and reporting, and the severing of the builders of the mounds from historical and contemporary American Indians remained ongoing within both scientific and popular genres. In the article "A Southeast Village in 1491: Etowah," archaeologist George Stuart writes: "There was much to learn. The site—like similar ones from Georgia to Oklahoma to Illinois—was marked by great mounds. Yet no Native American tribe could remember who built them or why."[6] It is perhaps no surprise, then, that speculations have continued into the twenty-first century—including pseudoscientific, pseudoreligious, extraterrestrial, and faux Native theories of the earthworks and their origins—especially on the internet.

Those of us with personal, intellectual, and ethical commitments to Indigenous nations, however, are bound to repeat neither the spurious speculations nor the specious theories of the past. We are also not bound to settle for the cautious conclusions of contemporary non-Native archaeologists, anthropologists, and historians, whose "scientific" disciplines, although often extremely helpful, insist on particular versions of positivism that have tended to limit consultation with Indigenous individuals and communities and to restrict viable avenues for analysis and interpretation based in Indigenous knowledges. There are other ways to research and think about—and, importantly, other ways to research and think *with, through,* and *among*—the mounds. Rather than follow (exclusively) the in-

stincts or practices of Shetrone and other non-Native scholars, we might follow the instincts and practices of Native American leaders such as Chief Glenna Wallace of the Eastern Shawnee Tribe of Oklahoma, one of the nations forcibly removed from the densely mounded area of what is now the U.S. state of Ohio after passage of the Indian Removal Act in 1830, a mere century prior to the publication of Shetrone's Ohio-based work of scholarship. In the foreword she provided for *The Newark Earthworks: Enduring Monuments, Contested Meanings* (2016), Chief Wallace writes: "My people, my ancestors treasured these mounds. Perhaps they did not build them, but they loved them, protected them, revered them. They knew their importance, and these earthworks were sacred to them."[7] Following Chief Wallace, we might begin our account with positive statements about earthworks, their builders, and both their original users and subsequent caretakers rather than with enigmatic questions about origins and endings. Without the constraints of the white imaginary, we might pose questions other than those that happen to begin (in English) with the letter *W*.

We might begin by stating that, contrary to centuries-old stereotypes and to the ongoing wishful thinking of settler cultures, prior to the arrival of Europeans the so-called New World was no "virgin land" expectantly awaiting the builders of civilization, no "howling wilderness" in need of taming by the righteous movers and shakers of the earth. South, Central, and North America lacked neither intelligent individuals nor highly organized communities, and they did not want for sophisticated technologies. By the common era's fifteenth century, when verifiable "history" supposedly begins, these continents had already witnessed long series of events involving moved earth and built environments: cycles and systems of intricately managed land- and waterscapes; expansive cities, suburbs, and towns; intersecting trade routes for objects and ideas; and flexible networks of human mobility and of intellectual, artistic, agricultural, and spiritual exchange. Depending on their specific locations and needs, Indigenous peoples from what is now southern Peru to northern Canada had already quarried, carved, and positioned stone; fashioned, stacked, and plastered bricks; or piled, packed, and re-formed the soil of the earth itself, basket by fifty-pound basket.[8]

In the North American context, thousands of earthen mounds, embankments, and enclosures remain extant, although often obscured, eroded, or desecrated, sometimes partially or wholly destroyed, and occasionally reconstructed. The compound noun *earthworks* evokes the collective presence of these remarkable structures, their remnants, the traces of their memory, and the possibilities for their renewal. Moreover, the word's internal juxtaposition—grounded *earth*, dynamic *works*—indicates these structures' synthesis of artistry and engineering: projects in applied Indigenous science staged as ceremonial complex, social forum, sports or civic arena, busy marketplace, artistic workshop, open-air theater in the round, square, or octagon.[9] Constructed across a large expanse of the continent over thousands of years, these sites of "worked" earth suggest the multiplicity of their original functions, and they suggest the extent, purposefulness, and complexity of Indigenous interactions with land and engagements with technology, sometimes singularly and within remarkably short intervals of time, but also cooperatively among diverse nations and over multiple generations. The ongoing presence of these works—massive, well-engineered, aesthetically exquisite structures, intricately planned, mathematically and geometrically encoded, and multiply aligned with waterways, with ridges and other natural features of the landscape, and with the visible patterns of the moving cosmos above—reveals the false premises that undergird settler fantasies of a primeval "new" world untouched by human hands or human minds.

In what are now the central and southern regions of Ohio, from which Chief Wallace's Eastern Shawnee people were removed in the early nineteenth century—and to which I happened to relocate to work as a professor of English and as a cofounder of the interdisciplinary program in American Indian Studies at The Ohio State University in the late twentieth and early twenty-first centuries—these structures include hundreds of large burial mounds and hundreds of large embankment walls formed into roadways, enclosures, and geometric figures, built between approximately two thousand and five hundred years before the present. Many of the burial mounds were looted in the nineteenth and early twentieth centuries or were destroyed in the development of settler agriculture and the building of set-

tler towns, highways, railways, or canals. Several, however, were excavated by archaeologists. Once these mounds had been surveyed and mapped, measured into grids, dissected into layers, and sifted, they were evacuated of their human remains and funerary objects and, in some cases, subsequently reconstructed with the aid of heavy machinery and other modern technologies. Such is the case with the impressive Seip-Pricer Mound sited along Paint Creek near what is now Paxton Township, whose emptied, restored, and manicured form measures 240 feet long, 130 feet wide, and 30 feet high and which serves as a regular destination on one of the primary routes for mounds tourism in southern Ohio. Other burial mounds remain relatively intact, although typically these are obscured by decades if not centuries of neglect and overgrowth and by an encroachment of non-Native civilization. A telling representative is Jeffers Mound. Sited along the Olentangy River in what was once a complex of mounds and embankments but is now a near-suburb of Ohio's capital city, Columbus—all ironies of the name apparently intended—the twenty-foot-high conical mound is covered by weeds and trees and literally surrounded by a circular residential street ringed with middle-class houses, several of which regularly display U.S. flags. An isolated survivor, Jeffers Mound remains a political and ideological captive. (I have more to say about the Seip Earthworks and Jeffers Mound sites in chapter 4.)

The remarkable geometric earthworks in central and southern Ohio consist of thick embankment walls positioned into outlines of large-scale circles, squares, and octagons. Some of the most awe-inspiring are located in what is now the town of Newark, less than an hour east of Columbus (Figure 1). Foremost among these are the monumental Octagon Earthworks—the outline of a mathematically perfect octagon enclosing fifty acres of land connected by a walled corridor to the outline of a perfect circle enclosing an additional twenty acres—and the Great Circle Earthworks—a massive walled and moated enclosure with a diameter spanning nearly twelve hundred feet (Plates 1 and 2). Similar to the Jeffers burial mound, the Octagon enclosure, despite its long recognition as one of the most archaeologically significant ancient sites in North America, is a contemporary captive: the Moundbuilders Country Club has leased the Octagon from the Ohio

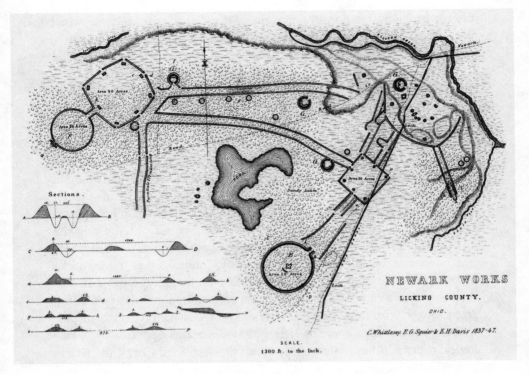

FIGURE 1. Ephraim G. Squier and Edwin H. Davis's 1837–1847 map of the "Newark Works" showing the relationships among the Octagon Earthworks, Great Circle Earthworks, Wright Square, parallel embankments, and other structures. Source: *Ancient Monuments of the Mississippi Valley* (1848).

Historical Society since 1910 and has run a members-only golf course on the grounds since 1911.[10] Asserting its right as lessee to conduct uninterrupted economic activity, and citing its need to protect its property interests in the greens, roughs, sand traps, and other "improvements" it has made to the grounds, including the construction of a clubhouse and miles of paved pathways for golf carts, the country club allows the public full access to the site—including that public composed of Native American individuals, communities, and federally recognized bands, tribes, and nations—only

four days each year, which are determined by the country club's leadership. The enactment of this kind of "protection" through settler physical and economic occupation, symbolic and discursive appropriation, and material and spiritual desecration is a common feature of extant sites of Indigenous historical and ongoing significance across the United States and other settler nation-states; the golf course manifests a species of outrageous irony that will surprise no one who is familiar with Native American and Indigenous histories.

In addition, Ohio hosts two large earthen structures that are indisputably effigies, that is, earth mounded into discernible mimetic shapes, such as animal figures.[11] Best known is the Serpent Mound located in Adams County in southern Ohio, mentioned earlier, whose uncoiling form undulates for a quarter mile along an arced ridge above the Brush Creek Valley, its restored and manicured body aligned to true astronomical north, its head to the summer solstice sunset point on the horizon (Plate 3). Less well known but of no less importance is the large effigy located in what is now Granville, Ohio, just west of Newark, known as the Alligator Mound—but in no way resembling an actual alligator (Plate 4). (I offer detailed analyses of the Serpent in chapters 1 and 2, and a briefer analysis of the so-called Alligator in the coda to Part I.)

Thus we might state that, across thousands of years, within broader practices of sacred science and civic art, Indigenous North Americans layered rock and packed soil into durable, multiply functional, highly graphic constructions of large-scale earthworks. These remarkable structures, which express Indigenous understandings of natural, human, and cosmic relationships through a concretized geometry of raised figures, include thousands of individual mounds and mound complexes spread across nearly half of the North American continent. What remain of these mostly devastated earthworks are largely unknown to contemporary citizens of the United States and Canada outside the kinds of speculations and wild theories briefly described in earlier paragraphs. As this book elucidates, however, earthworks have reentered artistic and literary consciousness with the creation, presentation, and performance of works of multimedia art and works of multigenre literature by twentieth- and twenty-first-century

Native artists, writers, and performers. These contemporary Indigenous productions—including photo-collages, prints, paintings, installations, narrative fiction, poetic sequences, individual poems, drama and performance pieces, and both scholarly and personal essays—actively confront settler-colonial ideologies in which mounds are marked as "mysterious" and are viewed as offering a treasured silence: a silence valued precisely for the ways in which it allows non-Native commentators to impose ideologically driven theories onto a supposedly blank canvas. And these Indigenous productions actively confront a dominant aesthetics in which "lyrical" Natives are allowed to offer ecological and spiritual sensitivities but no recognizable science, thus making it possible for dominant settler cultures—including dominant scholarly and professional cultures—to celebrate specific aspects of Native sentiment they find useful while denigrating or simply ignoring Native sovereignty, technological sophistication, and practical sense. Diverse contemporary Indigenous productions evoke and assert the expressive presence of obscure earthworks, the complexity of their still-unresolved histories, the multiplicity of their still-relevant contexts. They render visible both the seemingly imperceptible pasts and the willfully unimagined futures of Native North America.

SIGHTING INDIGENOUS SITINGS

The raised forms of Indigenous earthworks marked territorial boundaries and significant roadways; they created focal points within urban settlements and within centers for economic trade, technological and artistic exchange, intellectual and spiritual practice. Platform, conical, pyramid, ridgetop, geometric, and effigy "mounds" thus represent achievements in science and aesthetics on a monumental scale. They integrate the precise observation of natural phenomena with geometry and other abstract forms of knowledge, as well as with practical skills in mathematics, architectural design, engineering, and construction. Many earthworks were sculpted to mark and to mirror perceived patterns in the sky—the regular movements of the sun and moon and the stars in transit—both in the bodies of individual works and in the arrangements of multiple works into complex sites and cities; more-

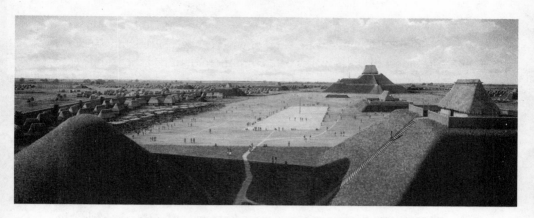

FIGURE 2. Mural depicting aerial view of central Cahokia at its height, including the massive Monks Mound and the central plaza. Painting by Lloyd K. Townsend. Courtesy of Cahokia Mounds State Historic Site.

over, particular works were often aligned to specific celestial events, such as an equinox or solstice sunrise or sunset point on the horizon.

Some of the best-known examples of Indigenous earthworks include the well-preserved and, in some cases, reconstructed ceremonial, burial, and boundary-marking works extant at the large mound city known as Cahokia—located in what is now southern Illinois along the eastern bank of the Mississippi River, near its confluences with the Missouri and Illinois Rivers, outside of Saint Louis, Missouri, which was once Cahokia's mounded suburb.[12] The more than one hundred mounds built within the five-square-mile, thirty-two-hundred-acre central zone of the Cahokia site date from about a thousand years before the present, and they include the massive Monks Mound, a platform with a mile-square base that rises in multiple terraces to a height of nearly one hundred feet, sited to correspond to the sunrise points of the vernal and autumnal equinoxes and the summer and winter solstices (Figure 2). Recent research reveals, as well, Cahokia's simultaneous alignments to major lunar cycles.[13]

Other well-known examples, as already noted, include the large-scale geometric earthworks (outlines of circles, squares, and octagons) and

the large-scale effigy earthworks (including Serpent Mound and Alligator Mound) situated along the waterways of what is now central and southern Ohio. The oldest of these works date from more than two thousand years ago and, depending on their specific locations, are sited to correspond to prominent solar, lunar, or other celestial events. Contemporary researchers have determined, for instance, that the Octagon Earthworks is not only a mathematically perfect octagon enclosing fifty acres of land, but also a lunar calendar that encodes in its precise structure the 18.6-year cycle of the moon's northernmost and southernmost rise and set points on the horizon.[14] Moreover, researchers have determined that the elaborate complex of earthworks at Newark, which includes the lunar-aligned Octagon along with its companion geometrical figures known as the Great Circle, the Wright Square, the Salisbury Square, and the Cherry Valley Ellipse, is sited as a whole within an even larger schematic template that encompasses the entire Cherry Valley and is based on the rise and set points for the summer and winter solstices. In other words, similar to the thousand-year-old Mississippian city of Cahokia, the two-thousand-year-old complex of geometrical earthworks at Newark, associated with a culture that archaeologists typically designate as Hopewell, is aligned to both significant solar and significant lunar phenomena at the same time.[15] Researchers have also determined that the complex at Newark was connected to a related complex sixty miles to the south, known as the High Banks Works, located near what is now the town of Chillicothe. The two sites, each of which included the mounded outline of a large octagon linked to the mounded outline of a large circle, appear to have been connected by a straight and bounded roadway. At certain times of the year, this embanked roadway became aligned beneath the visible stars of the Milky Way, creating a "star path" between the lunar observation site at Newark and the mixed solar-and-lunar interment site at Chillicothe.[16]

In response to these and other types of archaeologically based evidence, including the presence in some of the excavated mounds of large caches of natural materials originating great distances from central and southern Ohio (including copper and silver mined from the northern Great Lakes region, Knife River chert from what is now the Dakotas, obsidian from

what is now Montana, bear teeth from the Rocky Mountains, mica from the Appalachian Mountains, galena from what is now Missouri and Kansas, meteoric iron from what is now Kansas or possibly other locations, quartz and mica from what is now the Southeast, large marine shells from the Gulf Coast, shark teeth from the Gulf or southern Atlantic Coasts), contemporary researchers speculate that, beginning roughly two thousand years before the present, the region was a center for Indigenous North American social, spiritual, and, importantly, technological and artistic activity and exchange. Archaeologists have located over six hundred earthworks complexes within the contemporary borders of Ohio.

But there are literally *thousands* of individual earthworks and earthworks complexes sited across the eastern half of the North American continent, from what is now the Deep South in the United States to southern Ontario in Canada, with some, like the massive Poverty Point site located in what is now northeastern Louisiana, having origins dating to at least three or four thousand years before the present, and others having origins dating to more than five thousand years before the present. These are historical facts—not merely archaeological facts, but historical facts—that many if not most contemporary North Americans find difficult to fathom. And yet the evidence has been all around us for centuries, as Comanche art critic and intellectual Paul Chaat Smith reminds readers in his essay "The Ground beneath Our Feet" from his 2009 collection *Everything You Know about Indians Is Wrong*. Writing about the 2004 opening of the National Museum of the American Indian in Washington, D.C., Smith refocuses attention on the fact that even the National Mall, "a fabulously weird theme park of the country's idea of itself over the past few centuries," is an "ancient place" with a history much older than the city of Washington, the District of Columbia, or the settler nation-state of the United States of America.[17] "Washington," Smith writes,

> was built on Indian debris; everyone in the field [of anthropology] knew that. William Henry Holmes, a celebrated artist, geologist, [and] archaeologist . . . wrote a century earlier that artifacts were so numerous in this town, "in certain localities . . . they are brought in with every load

of gravel from the creek beds, and the laborer [constructing] our streets passes them by the thousands beneath his hammer; and it is literally true that in this city, the capital of a civilized nation is paved with the art remains of a race who occupied its site in the shadowy past."[18]

Smith's point is that the whole of the United States—the whole of every settler nation-state occupying the Americas—is built on similar "Indian debris." The extant remains of mounds, enclosures, effigies, and other earthworks constitute but one of the most striking examples. And yet even these massive structures have been difficult for contemporary viewers to perceive.

As detailed by Shetrone in 1930 and by the many archaeologists, anthropologists, and historians who have produced comprehensive studies in the decades since, earthworks have been sketched, mapped, surveyed, sometimes excavated, and too often looted by non-Indigenous settlers and their descendants since at least the eighteenth century. However, it is the twentieth-century technology of aerial photography, a form of remote sensing, that has enabled contemporary viewers to see a wide range of earthworks and earthworks complexes from a great height, the only perspective from which these structures can be viewed as complete wholes. It is interesting to note that the first known aerial photographs made of a North American archaeological site, produced in 1922, were taken not by trained archaeologists but by pilots in the U.S. Army Air Service who happened to fly over Cahokia with a camera.[19] Since the 1920s, increasingly sophisticated and purposeful aerial photography has made it possible for archaeologists and other researchers to consider how large-scale constructions of packed earth function as and within sign systems in what are increasingly revealed to be regularized—that is, *planned*—patterns. Drawing on knowledge gained from conventional surveying, mapping, and excavation, as well as from aerial photography, the legibility of earthworks and their systematic patterning has been further enhanced by the late-twentieth-century development of computer-generated models for particular sites.[20] In addition, as I describe in greater detail in chapter 1, since 2008 researchers in Ohio have been surveying earthworks through

the aircraft-based optical remote sensing technology known as light detection and ranging (LiDAR), which deploys laser pulses to measure ground elevation. Combined with Global Positioning System (GPS) data, LiDAR creates highly detailed, three-dimensional, color-coded imaging of topographic data. These vivid pictures make it possible to see evidence of earthworks no longer visible to the naked eye, as well as to conceptualize more precisely the specific siting, geometric patterning, and celestial alignments of individual earthworks and earthworks complexes.

In short, the more legible earthworks become through aerial-based technologies—that is, the better contemporary viewers are able to see these works both as individual constructions and as multigenerational components within larger sign systems and patterns—the better we are able to understand earthworks not as the legacy of fantastical giants, Vikings, or citizens of Atlantis but as Indigenous technologies related to Indigenous science and to Indigenous social structures and systems, and the better we are able to conceptualize earthworks not as "mysteries" and "enigmas" but as forms of Indigenous sign making and encoding that employ "geometric regularity" and "geometrical harmony" in order to record natural, human, and cosmic relationships within remarkably durable structures.[21]

SITING / SIGHTING / CITING

In the contemplation of Indigenous earthworks from multiple ground-based and aerial perspectives, the word *siting* evokes, foremost, the concept of position: where these precise and well-engineered structures stand within North American landscapes, why they occupy particular locations, how they relate to other physical phenomena, and how they both reflect and intersect social, economic, political, and spiritual systems. Earthworks parallel natural ridges and embankments, follow the waterways of rivers and creeks, mirror the regular seasons of the sun and moon, the patterned coordinates of stars in transit. They occupy symbolic positions, too, aligning within Indigenous North American systems of representation, within complexes of ceremony and ritual, within economies of power and exchange.

The word *siting*, however, invites an obvious pun, the substitution of its

familiar homophone *sighting*, evoking the equally relevant concept of per-
ception. In our contemporary era it is difficult to actually see Indigenous
earthworks, because they have been obscured in North American land-
scapes by centuries of erosion, reforestation, and human neglect, on the
one hand, and, on the other, by centuries of violent attack, agricultural
cropping, and partial or full removal by European American settlers and
their descendants. The very presence of earthworks in North American
material and symbolic landscapes has been largely erased within U.S. and
Canadian institutions, evacuated from formal systems of education, from
civil and environmental engineering, from rural and urban planning, from
art, commerce, and politics. For too many North Americans living in the
twenty-first century, Indigenous earthworks are either completely invisible
or, if seen, an illegible presence, a ghostly sign or a sign of forgotten ghosts.
The mounds, their remnants, and their traces appear to bear no inscribed
meaning. *Sighting* thus evokes the great difficulty for most contemporary
viewers to perceive earthworks in terms of the complexity of their inter-
related structures, the conceptual power of their designs, the aesthetic
beauty of their architectural forms. It has become hard to imagine how the
peoples who built these structures applied their detailed observations of
natural phenomena to sophisticated planning and design, to techniques
for construction, to the organization of necessary labor. All these achieve-
ments have been consistently devalued—or simply ignored—within the
Western intellectual traditions that have come to dominate North America.

 Siting can, of course, provoke an additional substitution. Scholarly read-
ers, especially, may consider *siting*'s less obvious homophone, *citing*, which
evokes related concepts of the contemporary quotation of earthworks for
the forms of Indigenous knowledge they continue to embody in the de-
signs and patterns of their structures, and the contemporary praise of
earthworks for the remarkable achievements they represent in Indigenous
mathematics, engineering, architecture, art, and astronomy. But perhaps
more profoundly, *citing* can also evoke the way the builders, first users, and
later caretakers of mounds themselves understood earthworks as forms of
citation. Hundreds or thousands of years ago, mounds were purposely lo-
cated and specifically designed to cite connections to already ancient an-

cestors, to past locations of dwelling, ceremony, or events of communal significance, to entities within or emanating from the moving cosmos above, to established or evolving understandings of the origins of the community (such as stories of emergence and migration) or of the land itself (such as stories of the Earth Diver).[22] All three versions of *siting* apply to the contemplation of Indigenous earthworks and earthworks principles that endure in North American landscapes. And all three versions invite viewers to open their eyes, their intellects, and—importantly—their imaginations to messages coded in and among structures that are multiply layered and multiply aligned within and across space and within and across time.

THROUGH THE MEDIUM OF THE LAND

For the past two hundred years, most of the scholarly energy focused on earthworks has been organized by non-Native archaeologists, anthropologists, and historians, both amateur and professional, and within predominantly non-Native languages, epistemologies, and systems of ethics. In this way, similar to research on other aspects of Indigenous lives and cultures, research on earthworks has been disconnected from the foundations of Indigenous inquiry. The majority of this non-Native research has restricted its investigations to questions about the physical construction of earthworks within specific chronologies (these researchers repeatedly ask not only *who* built the mounds but also *how* they were built, *when*, and whether they were built over relatively brief periods of time or over periods that were more lengthy, even multigenerational) and to questions about the siting of mounds within specific geographies (*where* they were built, but also *why* they were built in certain ways at certain times and in certain locations). More recently, these fields have begun to expand the scope of their interests and the range of their interlocutors, including an increased attention to consulting not only with environmental scientists, urban planners, and landscape architects but also with a range of Indigenous individuals and communities. Little scholarship, however, has been devoted to trying to understand—or even imagine—the full effects of earthworks on people: those who came together to plan and build individual mounds

or embankments or to construct multi-structure complexes and expan-
sive cities; those who lived among earthworks permanently or seasonally;
those who visited sites, centers, and cities for trade or special events; those
who embarked on sacred pilgrimage to important burials or to potent ef-
figies perhaps once in a lifetime. Few scholars have asked what it might
have meant to live, work, and play, to celebrate and mourn, in the presence
of—and in relation to—earthworks. And few have asked what it might have
meant to gather at these sites for ceremony or debate, for astronomical ob-
servations, for sporting events and games, for the securing of marriages
and other forms of social and political alliance, for artistic and intellectual
exchange, for regular upkeep, maintenance, and repair. In fact, most re-
search that engages the potential "experiential" meaning of earthworks, as
opposed to their potential "referential" or symbolic meaning, focuses on
the embodied experience of building the mounds, basket by fifty-pound
basket, rather than on the embodied experience of living among, visiting,
or contemplating one's relationship to these structures.[23] Even less re-
search has considered what those experiences might mean for Indigenous
peoples living in the present or in the future.

Our understanding of earthworks and both their original and ongo-
ing significance has been limited, in other words, by the methodologies,
discourses, and colonial assumptions of standard archaeological, anthro-
pological, and historical practice. Part of that limitation has been the dis-
cursive severing of the planners, builders, and first users of ancient earth-
works, who lived hundreds or thousands of years ago, from historical and,
especially, contemporary Indigenous peoples of North America.[24] The idea
of continuous genealogies and clear links from the distant past of earth-
works planning, construction, and original use to the contemporary pe-
riod of Indigenous appreciation, reclamation, repatriation, and potential
reactivation of earthworks has proven too problematic for dominant ar-
chaeological, anthropological, and historical communities, as well as for a
host of other non-Native communities that wish to claim kinship with or
assert ownership over the mounds, such as Indian hobbyists, certain re-
ligious groups, and versions of the New Age movement.[25] Only rarely are
Indigenous North American individuals, communities, or nations invited

to contribute to either scholarly or popular conversations about earthworks, their histories, their ongoing significance, or their possible futures.

Unlike Shetrone and his scholarly descendants, I am not trained as an archaeologist, anthropologist, or historian, and the concern of the present book is not to answer the supposed five W's of mound archaeology. As a scholar of contemporary Native American and Indigenous literary and artistic self-representation, I engage the useful work of archaeologists, anthropologists, and historians—always with a critical eye—but my objective is to move beyond typical analyses of earthworks as sources of ethnographic data about so-called prehistoric peoples cut off from living Indigenous communities and nations. Instead, in line with Indigenous studies frameworks and in collaboration with Indigenous researchers, I investigate contemporary Native American artistic, literary, and performative engagements with earthworks and earthworks principles. As already noted, earthworks principles include the careful layering of diverse building materials to create durable structures, as well as the mathematical encoding of Indigenous knowledges into the physical structures of mounds, complexes, and cities. These principles also include the creation of multiple structural patterns and often simultaneous structural alignments. Based on analyses of these contemporary engagements, I speculate about how earthworks themselves might be understood as forms of Indigenous knowledge still relevant in the present and central to Indigenous futures.

In developing such speculations, I employ the provocative idea that earthworks might be understood as forms of Indigenous *writing*. Following the lead of Indigenous artists and intellectuals, I employ a definition of writing expansive enough to include any form of encoding knowledge in any medium, rather than a narrow definition that would apply exclusively to alphabetic, syllabic, logographic, and other sound- or speech-based scripts.[26] Not everyone will agree with this usage. But my hope is that even those who wish to restrict the term *writing* only to alphabetic, syllabic, and logographic scripts will be willing to join me and other researchers in posing a set of central questions: How might earthworks be understood not only as built environments, but also as forms of information storage, transmission, and exchange? How might they be understood as systems of signs

arranged into systematic patterns, as systematic encodings of knowledge produced through Indigenous technologies and practices?

My first contribution to understanding how the work of contemporary Native American artists, writers, and performers reengages earthworks and earthworks principles was prompted by my early attempts to analyze how these contemporary productions—novels, poems, essays, performance pieces, and works of visual and installation art—make meaning at the level of their underlying *structures* as well as at the level of their explicit commentaries, symbols, and themes. Re-viewing and interpreting earthworks through the lens of these contemporary productions, I observed that earthworks do not present a form of writing knowledge *on* or *into* the land, a form of *en*graving or *in*scribing similar to the Nazca Lines famously etched into the arid surfaces of southern Peru. Rather, earthworks present a form of layering carefully selected rocks, clays, and soils into scripts that rise *above* the earth's surface, scripts that not only create readable "marks" but also re-form, alter, and significantly add to the landscape in ways that affect human and other-than-human movements and interactions. Earthworks create raised scripts of platform, conical, linear, ridgetop, and, perhaps especially, geometric and effigy "mounds." This is encoded knowledge presented as scripts built up from "borrowed" rock and soil, and thus a form of writing knowledge literally *through the medium* of the land itself. At the time, the observation felt like a revelation; I realize now it was but the beginning of understanding. Likening earthworks to writing, even within the broadest of definitions, takes us only so far toward understanding diverse earthworks in themselves and in their relationships to builders, original users, and later users and caretakers, let alone toward understanding how Native artists, writers, performers, and communities engage earthworks and earthworks principles in contemporary productions.

Individual earthworks are but individual components within complex built environments that indicate multiple forms of planning and physical manipulation. This includes the "borrowing" and transportation of particular rocks, clays, and soils from one location to another to facilitate the piling, heaping, and sculpting of particular mounds and embankments. But it also includes the infilling and leveling of adjacent plazas or the interi-

ors of walled enclosures and the construction of raised causeways through marshes, wetlands, or other low-lying areas. All of these activities took place on a monumental scale, and often within expansive networks of inter-related and connected sites, complexes, centers, and cities.[27] The material forms of these Indigenous built environments encode knowledge, but their "reading" requires more than—or something different from—alphabetic, syllabic, logographic, or other semiotic deciphering. Earthworks and earth-works complexes are not simply visually apprehended; they are understood neither in the way we make sense of glyphs and alphabetic characters nor in the way we make sense of various kinds of models or diagrams. They are neither idealized abstractions of coordinates drawn on maps or schemat-ics nor geometric figures plotted on graph paper. Their reading, as I dem-onstrate across the chapters and codas that follow, requires methodologies that are embodied and performative: walking specific sites in order to "see" them in their fullness, making physical contact with mounds and embank-ments, placing our human bodies in relation to their bodies of earth.[28] Moreover, earthworks and earthworks complexes are not simply inert matter—dead physical material appropriate for standard archaeological methods of stratigraphy (analyzing the order of layers) and taxonomy (clas-sifying various elements into standard categories). From many Indigenous perspectives, earthworks are embodied material, and earthworks are ani-mate. Assembled from vital earth, during their planning, construction, and use earthworks are imbued with social, psychic, and spiritual power that humans encounter physically, socially, and spiritually, and through which humans encounter each other as well as other-than-human beings and forces.

I will have more to say about the embodied and animate materiality of earthworks as the book progresses. Before leaving this section of the intro-duction, though, I should briefly outline why I do not engage the currently fashionable academic discourse of the so-called new materialisms, which similarly describe physical matter as "lively" and "agentive." Usually contex-tualized as part of a broader "ontological turn" within Continental philoso-phy and within Anglo-American critical theory, the new materialisms are seen as responding to the earlier "linguistic turn" of poststructuralism and

to the predominant focus on human subjectivity within recent research in the social sciences. The new materialisms stress, instead, the ways in which concrete physical matter remains a key component of events, lives, and worlds, not only for humans but also for other-than-humans. In this way, the new materialisms intersect ecocriticism and philosophical posthumanism, the environmental humanities, and animal studies. In their 2015 guide *Place in Research: Theory, Methodology, and Methods*, social science researchers Eve Tuck (Unangax) and Marcia McKenzie characterize the "new materialist turn" as being primarily concerned with "how matter comes to matter" across a range of inquiries and analyses.[29] And in their useful 2013 essay "Beyond the Mirror: Indigenous Ecologies and 'New Materialism' in Contemporary Art," art historians Jessica Horton and Janet Berlo describe how new materialisms "share a basic conviction that matter—whether in the forest or in the lab—has agency, can move, act, assume volition, and even enjoy degrees of intelligence often assumed to be the unique domain of human subjectivity."[30] But, as Tuck and McKenzie acknowledge and as Horton and Berlo explain in detail—and as readers of this introduction will likely be aware—sustaining the fiction of the "newness" of the so-called new materialisms depends on the foregrounding of European and Anglo-American epistemologies and perspectives and on the continued erasure of relevant Indigenous epistemologies and perspectives. "Indigenous scholars and scholars of the indigenous," note Horton and Berlo, "will attest to the survival of alternative intellectual traditions in which the liveliness of matter is grasped as quite ordinary, both inside, and at the fringes of, European modernity. Once we take indigenous worldviews into account, the 'new materialisms' are no longer new."[31] A range of Indigenous and Indigenous studies scholars, working across multiple disciplines, offer related critiques and corrections. In an essay published in 2015, for instance, Dakota social scientist Kim Tallbear states: "But the field [of new materialisms] has starting points that only partially contain indigenous standpoints. First of all, indigenous peoples have never forgotten that nonhumans are agential beings engaged in social relations that profoundly shape human lives. In addition, for many indigenous peoples, their nonhuman others may not be understood in even critical Western frameworks as *living*. 'Objects'

and 'forces' such as stones, thunder, or stars are known within our ontologies to be sentient and knowing persons."[32] Earthworks are among the categories construed as inanimate "objects" within non-Native discourses that often function as living beings and agentive forces within Indigenous understandings.

REMEMBERED VITAL EARTH

If we acknowledge earthworks as modes of land-writing, as raised earthen scripts of encoded knowledge that create complex patterns for human thinking *and* for human movement around, into, between, and among their vital material forms, how might we understand their functions and use, not only referential *but also* experiential, not only conceptual *but also* physical—in the past, in the present, in possible futures? In other words, how might we better perceive and how might we better understand *from Indigenous perspectives* the remarkable accomplishments of North America's extensive and diverse mound-building cultures over a period of thousands of years? Both Native and non-Native scholars offer useful ways to begin.

Although he does not address earthworks directly, we might turn first to the well-known insights of N. Scott Momaday, the Pulitzer Prize–winning Kiowa and Cherokee novelist, poet, essayist, and visual artist who has inspired two generations of Native writers and intellectuals toward more expansive approaches to understanding the complexities of Indigenous relationships to the environment. In "The Man Made of Words," the address he delivered to the First Convocation of American Indian Scholars in 1970, Momaday challenges his audience to perceive the land that defines their existence as Indigenous peoples in the fullness of that land's own history and intrinsic sense of being. He challenges them—and all of us—both to *perceive* the material details of a specific area of land within a particular moment or across a particular stretch of time, and to *perceive with* that material detail, also within and across time. To *see* but also to *see with* the land's potential for physical interaction and psychological engagement, to *see* and to *see with* the land's capacity to provide emotional solace, to provoke spiritual contemplation. At least once in our lives, Momaday challenges, all

humans should attempt a type of seeing that is also a *seeing with*, a type of
seeing that is located within the body but also actively engages the imagi-
nation. A type of seeing and seeing with that focuses our vision but also
our other senses; a type of seeing and seeing with that assumes multiple
points of view across multiple incarnations of a specific land-, water-, or
skyscape, its manifold life and multiple lives, its extraordinary events and
regular seasons. He writes:

> Once in his life a man ought to concentrate his mind upon the remem-
> bered earth, I believe. He ought to give himself up to a particular land-
> scape in his experience, to look at it from as many angles as he can, to
> wonder about it, to dwell upon it. He ought to imagine that he touches
> it with his hands at every season and listens to the sounds that are made
> upon it. He ought to imagine the creatures that are there and all the
> faintest motions in the wind. He ought to recollect the glare of noon
> and all the colors of the dawn and dusk.[33]

Notably, Momaday's challenge is to perceive land understood not as
"wilderness"—empty of human participation—but rather as space with
and within which the human community participates and co-produces
meaning.

In 1974, another speaker featured at the First Convocation of American
Indian Scholars, the Tewa anthropologist Alfonso Ortiz, made a related
assertion relevant to the contemporary perception of earthworks in his
response to a symposium on writing American Indian history. "As we
would learn from any good traditionalist," Ortiz states, "Indian traditions
usually exist more in space, in a specific place, than in time. It is no ac-
cident that some of us who happen to be Indians as well as scholars place
the word *space* before time when we write. . . . Any historians who over-
look this fact run the risk of proceeding into the writing of Indian history
without taking the most sublime of Indian values into consideration."[34]
Ortiz's invocation of the "sublime" in this articulation of the centrality of
space in Native American values helps to focus Momaday's fusion of em-

bodied and imaginative perception, embodied and imaginative seeing, anchored in specific landscape.

Three decades later, in an essay originally published in 2001—the same year she published her novel *Shell Shaker*, which is anchored in a specific Southeastern earthworks landscape and organized according to principles of seasonal time, and which I make a central focus of chapter 5—LeAnne Howe reframes Momaday's challenge to perceive and to perceive with the land as an integral component of her theory of "tribalography." In this early statement of what has become an influential articulation of how tribal histories are written across multiple genres, Howe states:

> Native stories, no matter what form they take (novel, poem, drama, memoir, film, history) seem to pull all the elements together of the storyteller's tribe, meaning the people, the land, multiple characters and all their manifestations and revelations, and connect these in past, present, and future milieu. I have tried to show that tribalography comes from the Native propensity for bringing things together, for making consensus, and for symbiotically connecting one thing to another. It is a cultural bias, if you will.[35]

Earthworks represent other versions of tribalography—additional forms of "Native stories"—that connect humans and other-than-humans across designations of past, present, and future. In an essay published in 2013 titled "Embodied Tribalography—First Installment," Howe advances Momaday's and Ortiz's ideas from the 1970s to fully articulate a perception and a value of the "reciprocal embodiment between people and land," a perception and a value that earthworks would appear not simply to validate but epitomize.[36]

Theories of reciprocal embodiment are suggestive of the possibilities of *multiperspectivism* and *reciprocal seeing* for perceiving the built environments of individual earthworks and of earthworks complexes and networked systems. In attempting to perceive the land in its fullness, we become aware of how the land "and all the creatures that are there" perceive us as well. Similar ideas of "relational ontology" have been described in South

American contexts in the theory of "Amerindian perspectivism" developed by Brazilian anthropologist Eduardo Viveiros de Castro, based primarily on his work with Indigenous peoples in the Amazon.[37] Mary Weismantel, a U.S.-based relational archaeologist and a specialist on pre-Incan Indigenous cultures in Peru, has begun to translate Viveiros de Castro's theories into focused methodologies for conducting (more) Indigenous-centered forms of archaeology. In a series of productive essays, Weismantel has developed theories for better understanding human encounters with monumental Indigenous structures and built environments in Peru. Although she does not specifically address North American earthworks, Weismantel articulates a methodology for more fully understanding how Indigenous spaces are "culturally produced" in specific ways and toward specific ends. She articulates effective methods, that is, for understanding a particular Indigenous site as a "highly fabricated visual and sensory environment that [itself] shapes the phenomenon of perception, just as the viewer's preexisting expectations do."[38] In contrast to the white imaginary and to orthodox theories that assume Indigenous built environments are "mysteries," "enigmas," or "accidents," and in contrast to the so-called new materialisms that subsume Indigenous perspectives on materiality within universalist conceptions of the human, these relational theories begin from the assumption that Indigenous built environments reflect the culturally and historically specific contingencies and aspirations of their makers.

This is the basic premise from which the twentieth- and twenty-first-century Native artists, writers, and performers engaged in *Earthworks Rising* begin their own inquiries and assertions. For unlike the majority of non-Native archaeologists, anthropologists, and historians, these contemporary Native artists, writers, and performers acknowledge the realities of *ongoing* Indigenous relationships to ancient earthworks and to enduring earthworks principles.

VITAL EARTHWORKS RE-MEMBERED

Archaeologists, anthropologists, and historians typically organize accounts of earthworks as chronologies divided into multiple periods, and these re-

searchers typically describe the builders of earthworks as emanating from multiple cultures associated with specific periods and specific geographies. The peoples in the Americas prior to the period of earthworks production, described by Shetrone as "nomadic migrants" from Asia, are often categorized, along with their early descendants, as Paleo-Indians. Most archaeological accounts of mound building in what is now the southeastern and midwestern United States begin with an Archaic period (roughly between 8000 and 1500 B.C.E.), followed by a Woodland period (roughly between 1000 B.C.E. and 1000 C.E.), followed by a Mississippian period (roughly between 800 and 1600 C.E). Some archaeologists add additional periods or subperiods based either in chronology, such as Early, Middle, and Late Woodland, Emergent Mississippian, and so forth, or in geography, such as Upper Mississippian. In accounts for the Ohio Valley and upper Midwest, the Archaic Indians are usually followed by the so-called Adena (roughly between 1500 B.C.E. and 500 C.E.), Hopewell (roughly between 100 B.C.E. and 400 C.E.), and Fort Ancient cultures (roughly between 1000 and 1650 C.E.). None of these designations, of course, bear any relation to the actual peoples or cultures they attempt to describe.

Rather than follow a strict archaeological, anthropological, historical, or even literary chronology, *Earthworks Rising* is organized into three parts that evoke the three-worlds theory of mound-building cultures—an above world, a surface world, and a below world—and that correspond with three major descriptive categories for Indigenous earthworks: effigy mounds, platform mounds, and burial mounds. Each aligns with a central earthworks concept and with one or more primary positions in space. In Part I, effigy mounds align with the concept "crossing worlds" and with the spatial positions "above and below." In Part II, platform mounds align with the concept "networking systems" and with the spatial positions of the four "cardinal directions." And in Part III, burial mounds align with the concept "gathering generations" and with the spatial position "center." Two chapters organized around analyses of multiple literary, performative, and artistic engagements with the effigy Serpent Mound, located in southern Ohio, comprise Part I, followed by a brief coda organized around an embodied engagement with the so-called Alligator Mound in central

Ohio. A single chapter organized around analyses of literary and performative engagements with major sites of Mississippian platform mounds in the Southeast and Midwest, including the mounds at Cahokia in Illinois, comprises Part II, followed by a more substantial coda organized around literary and embodied engagements with what is believed to be one of the northernmost Mississippian sites, located in Wisconsin, known as Aztalan. And two chapters organized around analyses of literary and artistic engagements with burial mounds located across the Ohio Valley and the expansive Mississippian world comprise Part III, followed by a brief coda organized around an embodied engagement with a relatively obscure burial site in central Ohio known as the Holder-Wright earthworks. (Here I should note that the chapters in Part III discuss several images of disturbed burials and violated human remains; although I have tried to ensure my analyses are respectful of human dignity, some readers may find these images unsettling.) The book closes with a brief, meditative conclusion that focuses on contemporary planning and building on the ground—that is, on Indigenous earthworks literally rising in the twenty-first century.

A number of touchstones recur across the book, such as Hedge Coke's sequence of interrelated and mathematically encoded earthworks poems, *Blood Run: Free Verse Play;* and several through lines will become apparent, such as my process of developing analyses through an explicit layering of diverse materials. As in this introduction, I engage relevant non-Native archaeological, anthropological, historical, and popular discourses where appropriate, as well as relevant non-Native literary, artistic, and performance discourses (the latter often for context or as counterexample). In addition to the elements of the three-part macrostructure just outlined, the chapters and codas are organized around my personal history of embodied encounters with mounds, enclosures, and other earthworks, sometimes on my own but often guided by and in generative conversation with fellow researchers. My 2018 AIR lecture in Georgia, with which I open this introduction, marked one episode in a series of collaborations with LeAnne Howe. Although I admired and taught Howe's work for years after first hearing her read at the Native American Literature Symposium in 2002, we became colleagues through our service to the Native American and

Indigenous Studies Association and then friends through a series of extended conversations about mounds that developed into a research partnership that remains ongoing. In 2011, I learned about the innovative performance piece Howe had begun to develop with Monique Mojica. *Sideshow Freaks and Circus Injuns* draws on family histories in which relatives of Howe and Mojica "played Indian" at various public venues but is set in the specific sideshow and circus of the 1904 Saint Louis World's Fair, in the shadow of the great mound city Cahokia, and grounds its organizing principles and dramatic structures in Indigenous understandings of and relationships to earthworks. Since 2011, I have collaborated with Howe and Mojica and their artistic team to bring the evolving performance to various states of completion.[39] As I recount across several chapters and codas, this active, often site-specific collaboration has been a central driver for my evolving understanding of Indigenous engagements with earthworks.

Moreover, Howe and Mojica have been important conduits to additional Indigenous and non-Indigenous researchers, writers, artists, and performers engaged with mounds and mound principles. It was Mojica who first alerted all of us to the evocative photo-collages and installations depicting burial mounds created by Alyssa Hinton. And it was Howe who first put me in conversation with Phillip Carroll Morgan, a skilled researcher of Southeastern mound cultures and author of the 2014 historical novel *Anompolichi: The Wordmaster* published by the Chickasaw Press—set in the year 1399, during a period of active mound construction and use across the Southeast and Midwest—which I center in chapter 3. Morgan, too, has become a valued mentor and friend. Other long-term collaborations include my work with former Ohio State colleagues affiliated with the Newark Earthworks Center, especially Marti Chaatsmith (Comanche citizen, Choctaw descendant) and Christine Ballengee-Morris (Eastern Band Cherokee), who helped host Howe and Mojica in Ohio and who arranged for artists America Meredith (Cherokee) and Linda Lomahaftewa (Choctaw and Hopi) to visit as well, and who have guided the center's efforts to build relationships with tribes removed from Ohio, which is how I came to know the remarkable Chief Glenna Wallace. More recently, I have been fortunate to collaborate with colleagues such as Margaret Noodin (Anishinaabe), who

hosted my visit to earthworks in Wisconsin and then gifted me with a dual-language earthworks poem, which I center in the coda to part II.

Beyond a handful of major works—entire novels and sequences of poems, significant art exhibitions or performance pieces—earthworks often appear in contemporary Native American productions much as they appear in contemporary North American landscapes, that is, as glimpses and traces. These briefer mentions, references, and allusions manifest in multiple forms: as sections of works of nonfiction, such as the substantial study first published in 1949, *They Came Here First: The Epic of the American Indian* by D'arcy McNickle (Cree and Salish); as the basis for particular scenes in novels, such as *The Last of the Ofos* by Geary Hobson (Quapaw and Cherokee) published in 2000; as key episodes in contemporary storytelling, such as in the 2012 composite text *Cherokee Stories of the Turtle Island Liars' Club* orchestrated by Christopher Teuton (Cherokee); as key references in evocative works of scholarship, such as the essay "A Return to the South" by Jodi Byrd (Chickasaw) published in 2014; as key icons in evocative works of multimedia art, such as *Dreaming Perched upon the Mounds* by Dustin Mater (Chickasaw) completed in 2013; as key anchors in memoir and personal essays, such as "The Mound Builders" by Diane Glancy (Cherokee descent) published in 2011, "Turning Earth, Circling Sky" by Linda Hogan (Chickasaw) published in 2018, or "Halbina' Chikashsha, A Summer Journey" by Rebecca Travis (Chickasaw) also published in 2018; as potent lines or stanzas in individual poems, such as "The Mound" by Louis Littlecoon Oliver (Muscogee Creek) published in 1990 or "The Southeast was covered" by Joy Harjo (Muscogee Creek) published in 2019 as part of her debut collection while serving as U.S. poet laureate. But as in the ever-changing North American landscape, in the ever-growing body of Native art and literature these glimpses and traces of earthworks remain notable and productive across space and time. Their evocative presence startles us toward older understandings of embodied awe. Their evocative presence startles us toward new conceptions of embodied power.

PART I

Effigies

Crossing Worlds

Above and Below

Serpent Sublime, Serpent Subliminal

> Among all the monuments, curious, vast and inexplicable left by the Mound
> Builders the Serpent Mound is the most mysterious and awe-inspiring.
>
> – E. O. Randall, *The Serpent Mound, Adams County, Ohio:*
> *Mystery of the Mound and History of the Serpent; Various*
> *Theories of the Effigy Mounds and the Mound Builders*, Ohio
> Archaeological and Historical Society (1907)

> Serpent Mound is an internationally known National Historic Landmark
> built by the ancient American Indian cultures of Ohio.
>
> – *Serpent Mound*, Ohio History Central online (2018)

ONE

The majestic Serpent Mound first entered my consciousness as an un-
likely juxtaposition. It was not 1907, when the Ohio State Archaeological
and Historical Society—chartered in 1885, holding the deed to the large
effigy and operating its reconstructed site as a state memorial since
1900—released a second edition of its 1905 "pamphlet" of 125 pages, *The
Serpent Mound*, written by the society's secretary, E. O. Randall, in "an at-
tempt to present in popular form all that is worthy of publication concern-
ing Ohio's most unique prehistoric relic, the origin and purpose of which is
still a mystery."[1] Randall's early description of the effigy would set the tone
for the next century:

The serpent, beginning with his tip end, starts in a triple coil of the tail
on the most marked elevation of the ridge and extends along down the
lowering crest in beautiful folds, curving gracefully to right and left and

swerving deftly over a depression in the center of his path and winding in easy and natural convolutions down the narrowing ledge with head and neck stretched out serpent-like and pointed to the west; the head is apparently turned on its right side with the great mouth wide open . . . immediately in front of which is a large oval or egg-shaped hollow. (10)

It was also not 1964, when that same institution, its name shortened to the Ohio Historical Society, released a revised third edition of its more popular and more concise 1930s tourist booklet, *Guide to Serpent Mound*, written by the society's curator of archaeology, Emerson Greenman. Like the 1957 second edition, the third reflected changing theories about the effigy's construction, meaning, and purpose (and cut the booklet down from its original twenty-three illustrated pages to a more tourist-friendly eighteen). Greenman's description was less poetic and more economical than Randall's but continued its basic themes:

Serpent Mound is an embankment of earth nearly a quarter mile long, representing a gigantic serpent in the act of uncoiling, with the greater portion of the body extended in seven deep curves nearly to the tip of the tongue of land upon the elevated surface on which it lies. Partly within the open jaws of the serpent is an oval wall of earth representing the open mouth.[2]

It was, however, before the mid-1990s, when the society produced a glossy tourist memento of twenty pages, *Serpent Mound*, in a larger format and with higher production values—generously sized black-and-white illustrations and archival images on the interior pages, high-resolution color photographs on the front and back covers—co-written by the society's curator of natural history, Robert Glotzhober, and curator of archaeology, Bradley Lepper. Although its language and style remain suitable for tourists, Glotzhober and Lepper's description aspires to a higher level of "scientific" precision:

The effigy, as we know it today, consists of two portions: the serpent proper and an oval enclosure. The oval, located at the front of the ser-

pent's head, has been variously explained as an egg being swallowed by the snake; as an egg being ejected by a frog as it leaps away from the serpent; as a symbolic representation of a solar eclipse as the sun is being swallowed by the horned serpent that figures in various Native American legends; or simply as the open mouth of a striking serpent.[3]

And it was certainly before the mid-2010s, when the society, now renamed Ohio History Central, produced a range of digital materials for the *Serpent Mound* pages of its website. Its description maintains Glotzhober and Lepper's more "scientific" tone in its attempt to acknowledge the Serpent's Indigenous origins: "It is an effigy mound (a mound in the shape of an animal) representing a snake with a curled tail. Nearby are three burial mounds—two created by the Adena culture (800 B.C.–A.D. 100), and one by the Fort Ancient culture (A.D. 1000–1650)."[4]

It was, instead, the mid-1980s. I was an undergraduate, and, hungry for classes on any aspect of American Indian cultures (there were few choices at my esteemed institution), I enrolled in a large lecture course on North American archaeology. My memory is that, in addition to several textbooks, we were assigned a course packet of photocopied articles and chapters written by prominent non-Native archaeologists, anthropologists, and historians. Dense sections of these spiral-bound pages described nineteenth- and twentieth-century mappings, surveys, and excavations of Indigenous mounds and other earthworks, beginning with excerpts from the first major survey, published in 1848, *Ancient Monuments of the Mississippi Valley* by Ephraim Squier and Edwin Davis, which includes what is still the most iconic "map" of the Great Serpent (Figure 3). The level of technical detail in the articles and chapters was often numbing for an undergraduate student, and I admit to skimming as much as I read; the detailed descriptions of human violation that occurred during the opening of mounds were occasionally horrific. Many of the excavated burials, including those sited in proximity to the mysterious Serpent, were located in Ohio, a state in which I would later live and work for nearly seventeen years but which was then a (constructed and, often, I would later learn, reconstructed) landscape completely unknown to me.

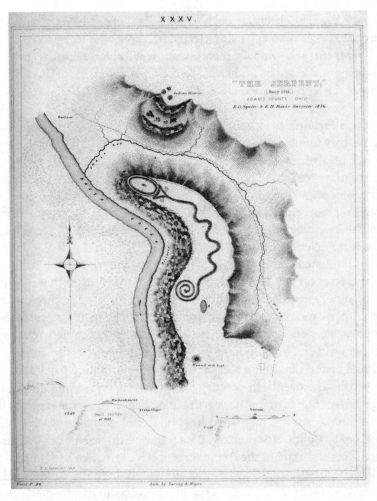

FIGURE 3. Ephraim G. Squier and Edwin H. Davis's 1846 map of "The Serpent." Source: *Ancient Monuments of the Mississippi Valley* (1848).

About the same time, outside my assigned coursework I read the African American novel *Meridian*, Alice Walker's semi-autobiographical coming-of-age story published in the U.S. bicentennial year of 1976 and set mostly in Georgia—another landscape I had yet to visit—before, during, and immediately after the 1960s movement for civil rights. Walker's better-known epistolary novel *The Color Purple* had appeared in 1982 and won both a National Book Award and the Pulitzer Prize for Fiction in 1983, and it seemed everyone I knew had either just finished it or was reading it then. Walker and her work occupied a crucial center of discussions about literature, race, gender, and power; the extraordinary success of *The Color Purple* brought renewed attention to *Meridian* and its compelling protagonist, Meridian Hill. In an early chapter, it is the memory of a young Meridian's "ecstatic" encounter with a "sacred" Indian burial mound that sets her destiny as an activist and as something of a prophet and possibly a saint. Like the Serpent effigy in Ohio, this burial mound on Meridian's father's Georgia farm curves and twists its presence on the land in the sinuous shape of a snake. But where amateur and professional anthropologists since the days of Squier and Davis have tended to emphasize the Ohio Serpent's dynamic head, speculating, in particular, about the meaning of its mouth apparently hinged wide-open—how, as an emissary of the underworld, the Serpent appears to perform a symbolically charged act of swallowing a life-giving egg or possibly the life-giving disk of that counterbalancing avatar of the sky-world, the sun—Walker emphasizes, instead, the tail.[5] Moreover, in contrast to typical descriptions of the Ohio effigy's tail as a "tight spiral," Walker describes the tail of her Sacred Serpent as a coil fantastically large and deep, its curving walls imagined not only as graphic symbol, knowledge encoded into the medium of the land itself, but also as ossuary, as twisting repository for the remains of the Indigenous dead.[6]

I can no longer put my hands on my copy of the archaeology course packet, but what I remember most of its sometimes faded, sometimes off-kilter pages is a sharply defined emphasis on death: black-and-white diagrams of conical burial mounds, rendered in the cutaway style, the cross sections revealing distinct layers of rock and soil and, often, multiple levels

of elaborate human interment, what anthropologists call "stacked cemeteries," a kind of micro-hotel for those enigmatic ancients passed on.[7] The diagrams were accompanied by series of black-and-white photographs. In some, we witness faceless men performing acts of excavation from the late-nineteenth-century era of road-, rail-, and city-building, or the 1930s era of WPA civic improvement projects, or the 1960s era of highway and interstate expansion; their shovel-wielding bodies indicate the height and scale of the large mounds they systematically dismantle and destroy. In other photographs, we witness the now disinterred dead, ancestors the anonymous laborers have exposed and the named anthropologists have labeled, recorded, and displayed, old bones removed from the earth-womb but sometimes still crouched in fetal positions, sometimes still surrounded by prized personal items, funerary objects, or other-world companions, set beside a yardstick or other official unit of measure.

I still have my well-thumbed paperback of *Meridian* and reread it in the course of drafting this chapter, but there are two details I remember most from my first reading. One is very much of the mid-1970s era of U.S. bicentennial celebration and critique: Walker begins her novel about the African American civil rights movement, set mostly in Georgia, with an epigraph from the deeply tragic final paragraphs of John Neihardt's "as-told-to" autobiography of a Lakota holy man, *Black Elk Speaks*, originally published in 1932—about the time the Ohio Historical Society produced its first *Guide to Serpent Mound* for tourists—but popularized in the 1960s and 1970s as a quintessentially American "spiritual classic." The late passage evokes the 1890 massacre of Lakota men, women, children, and elders along Wounded Knee Creek, South Dakota, near the Pine Ridge Reservation, when Black Elk was still a relatively young man. Now aged and diminished, in the moment of speaking to Neihardt Black Elk asserts with devastating certainty: "I did not know then how much was ended." The other detail runs counter to the findings of anthropologists both amateur and professional: Walker depicts her Southeastern burial mound not in the expected conical or ridgetop style but rather in the sly shape of a biblical Serpent twisting in the Father's garden. For the right kind of gifted daughter—for the right kind of activist Eve—the deep coils of this burial-serpent, Walker asserts,

perform a transformative magic. These spiraling walls holding the stacked (Indigenous) dead defy Black Elk's purported sense that a "people's dream" died alongside the multigenerational victims of brutal colonial massacre and, instead, propel new generations of ([African] American) life.

I would like to say I noticed, in my first reading of *Meridian,* how Walker conflates the ideas and possible functions of effigies and burials for the purpose of building particular symbols and themes, although I know such awareness is unlikely. My semester-long course in archaeology notwithstanding, back then I understood little about the diverse types of mounds, embankments, enclosures, and other earthworks constructed by Indigenous peoples for thousands of years across a broad expanse of the eastern half of the North American continent. Indeed, I continue to learn and expand my capacity for understanding. I would also like to say I noticed how Walker conflates the traditions of the Georgia Cherokee and other mound-building peoples of the Southeast—including the Chickasaw, the Choctaw, and the Muscogee Creek—with those of the Lakota and other Plains Indians. Peoples of the northern, central, and southern plains, but perhaps especially the Lakota "Sioux," experienced a renewed visibility in the 1960s and 1970s, during the height of contemporary American Indian activism and the beginning of the so-called American Indian literary renaissance. This was particularly true among non-Native artists and intellectuals, who not only rediscovered older literary works sympathetic to the "plight" of Indians like *Black Elk Speaks* but celebrated new works in American Indian history told from new perspectives, such as Dee Brown's *Bury My Heart at Wounded Knee.* Brown's best-selling, popular account of the so-called Indian Wars at the end of the nineteenth century, published in 1970, ends with the same tragic quotation attributed to Black Elk that Walker deploys as her epigraph to *Meridian.* I realize that that awareness also is unlikely. It was not until 1984, precisely when I first encountered this juxtaposition of non-Native archaeology and African American literature, that the original stenographic notes from the interviews conducted for *Black Elk Speaks* were finally analyzed and made available to the public, published as *The Sixth Grandfather: Black Elk's Teachings Given to John G. Neihardt,* edited and introduced by anthropologist Raymond DeMallie. Although we

now had conclusive evidence that the tragic words attributed to Black Elk were actually invented by the non-Native poet Neihardt, it would take years for that information to circulate.[8] And it would take decades for the power of Neihardt's enticing vision of Native American death and erasure—the end of "a people's dream"—to begin to dissipate. It is a process many of us understand to be ongoing.

TWO

Like Neihardt's tragic inventions, Walker's conflations of the Indigenous Southeast with the Indigenous Plains and of effigies with burials provoke fascinating questions about their seductive power. It did not occur to me to consider them in any depth, however, until after 1997, when I began my first academic job at The Ohio State University and was able to make a first visit to the Serpent Mound (Plate 3). Even then, although I experienced the graphic presence of the effigy in the rural landscape of southwestern Ohio as aesthetically beautiful and spiritually potent, and although I found the old-fashioned dioramic displays housed in the state memorial's small interpretive center to be equal parts fascinating and offensive—cutaway models created in the late 1960s reveal the intricate layering of rock and soil that forms the body of the Serpent but also expose the multiple levels of human bodies interred in the nearby burial mounds—it would be another several years before I began to contemplate the differential representations of the Serpent, including my memory of Walker's *Meridian*, and how they produce distinctive registers of meaning. These issues came into sharper focus for me in 2006 with the publication of *Blood Run: Free Verse Play*—a book-length sequence of interrelated earthworks poems that is simultaneously a script for staged or imagined performance—written by Allison Hedge Coke, a writer, intellectual, and activist whose ancestry includes Cherokee, Huron, and Creek and who is thus a descendant of mound-building peoples. In her poem titled "Snake Mound," which can also be understood as a monologue, Hedge Coke defies typical archaeological and tourist representations of the effigy as mysterious object or enigmatic sign in need of non-Native interpretation. Instead, she imag-

ines the effigy as an animate force in possession of her own voice—the Serpent in and as Indigenous performance:

Snake Mound

Present invisibility
need not concern.

My weight remains
heavy upon this land.

Winding,
weaving, incurve,

mouth undone,
for egg swallow.

Though my body
suffered sacrifice
to railway fill,

my vision bears
all even still.

Be not fooled.
Be not fooled.

I will appear again.
Sinuous, I am.[9]

At the same time, Hedge Coke defies typical representations of the effigy as an isolated figure by imagining her as but one component within an interconnected complex of animate and articulate forces—the Serpent in and as Indigenous networked system.

I was fortunate to first encounter selections from *Blood Run* in 2005, before its publication, and on the voice rather than on the page, when Hedge Coke performed parts of the manuscript as an invited speaker for the inaugural Newark Earthworks Day held on Ohio State University's regional

campus at Newark. Although the event was staged in close proximity to the massive complex of two-thousand-year-old mounds, embankments, and geometric enclosures in and near the town of Newark, including the remarkable Octagon and Great Circle, the site designated for Hedge Coke's performance was less than auspicious. The event's planners had scheduled the reading of earthworks-inspired poetry against a scholarly presentation by a renowned archaeologist. Attendees were forced to choose: "science" or "literature"? The celebrated (white male) scholar was assigned to speak in the campus's high-tech auditorium, where there were comfortable chairs, a large screen for PowerPoint slides, and excellent acoustics; the (Native and female) poets were assigned to a cavernous cafeteria space in a more mundane building, where they read to a small group of listeners, arranged in a circle of folding chairs, over the banging sounds of staff cleaning the campus's industrial-sized kitchen. Nonetheless, despite my annoyance at the planners' unthinking disrespect and despite the immediate distractions of the noise, I was drawn into Hedge Coke's performed juxtapositions of intimacy and scale, her method of creating multiple voices to animate an earthworks site from multiple perspectives across time. Once the book was published, I repeatedly taught *Blood Run* in my courses on Native American and Indigenous literatures. Class discussions focused on the arrangement of the sixty-six poems that the sequence comprises; how the opening and closing narrative poems frame a series of sixty-four persona poems, through which a cast of thirty-seven distinct earthly, cosmic, and abstracted voices "speak" the site into existence on the written page and in the spoken voice—and potentially through the performing body. Some voices, including that of the Snake Mound, speak only once; others speak multiple times.[10] We noted the absence of a central human protagonist, from either the past or the present, how Hedge Coke refuses to "speak for" or "speak as" those who built and first used Blood Run, but how several of the site's voices refer to the presence of descendants, the builders' "heritage seed" and "children's children" still close by (58, 68). The voices of the site's human and nonhuman "intruders," however, speak for themselves, exposing their motives and assumptions. We examined the period-crossing diction and sophisticated wordplay of Hedge Coke's poetic lines, the braided

development of *Blood Run*'s multiple themes, its indictments of the intruding looters, squatters, and anthropologists, its calls for the repatriation of human remains, and its predictions for the renewal of earthworks systems.[11] But I had to admit to my students that I sensed more was going on below these intricate surfaces than I could articulate. It would take two years of reading and rereading the poems, silently but especially aloud, in and out of published order, in and as embodied performance; two years of intuiting how the sequence produces meaning through its layered poetic structures as well as through its singular and collective voices, its specific language and explicit themes; two years of research into archaeological, historical, arts, and Indigenous methods of scholarship on mounds and mound principles, before I gained a fuller sense of the complexity of the book's Indigenous aesthetics and activist poetics: what I came to understand as its thematic geometry and systems of multiple alignments.

During these protracted efforts I was fortunate, as well, to attend a chance lecture by the Ohio-based non-Native archaeologist William Romain, whom I knew as the author of *Mysteries of the Hopewell: Astronomers, Geometers, and Magicians of the Eastern Woodlands*—a work I had lightly skimmed but, at that point, neither read nor understood. I remember the specific date and time of the lecture in autumn 2008, because it was late in the afternoon on my birthday. (I include this detail only to emphasize the fortuitous nature of my attendance; I wanted to be elsewhere but felt compelled to support my colleague who hosted Romain in her class.) Romain's lecture was titled "LiDAR Imaging of Ohio Hopewell Earthworks: New Images of Ancient Sites." I sat near the door and planned to escape as soon as the lights went down for the inevitable PowerPoint. But once Romain began speaking, I quickly became interested and then mesmerized by the vibrant images on his slides and by his graphs of mathematical alignments and tables of computer-generated earthworks data the images had enabled.

Romain and his colleagues had begun to survey major Ohio earthworks through the aircraft-based optical remote sensing technology known as light detection and ranging (LiDAR), which, as briefly described in the introduction, deploys laser pulses to measure ground elevation. Combined with Global Positioning System (GPS) data, LiDAR creates highly detailed,

three-dimensional, color-coded imaging of topographic data. These vivid pictures make it possible to see evidence of earthworks no longer visible to the naked eye, as well as to conceptualize more precisely the siting, geometric patterning, and celestial alignments of individual earthworks and earthworks complexes. In 2008, early work was already demonstrating how LiDAR imaging strengthens hypotheses about Ohio earthworks that are based on ground-level observations and measurements, such as the finding that these structures are consistently located near water and that they typically align with solar and/or lunar events. LiDAR was validating additional speculations as well, confirming that Ohio earthworks are consistently oriented to the lay of the land, often running parallel to natural ridges or embankments, and that geometric earthworks (outlines of circles, squares, and octagons) are typically "nested," that is, calibrated to fit within each other, even when located some distance apart. Perhaps most intriguing, LiDAR was confirming speculation that the sizes of the major Ohio earthworks appear to be based on a consistent unit of measurement, that unit's multiples, and that unit's key geometric complements.[12] In his lecture Romain suggested that any one of these aspects constitutes a striking achievement in the construction of earthworks. That Indigenous mound-building cultures spanning roughly fifteen hundred years of earthwork activity in Ohio were able to incorporate all of these aspects into the construction of specific sites at the same time is truly astounding.[13] Inspired, I not only stayed to the end of the lecture but took copious notes; as the slides of mathematical equations and geometric figures accumulated, I began to form an idea about *Blood Run*.

Rereading Hedge Coke's sequence through the lens of aerial-based LiDAR imaging reoriented my thinking. I reread Romain's *Mysteries of the Hopewell* more carefully. And I spent weeks "mapping" the structures undergirding the interrelated poems of *Blood Run*: counting stanzas, lines, words, and syllables, diagramming mathematical relationships and complex alignments within and across the book's multiple sequences. I began to realize that when viewed from the surface—that is, moving among the animate voices, intricate language, and specific content of individual poems—the formal structures of Hedge Coke's sequence appear rather flat or two-

dimensional. The monologues, dialogues, and choruses of unexpected voices overwhelm in their detail, with the effect that the underlying poetic structures do not stand out as especially developed or regularized. Viewed from an "aerial" perspective, however—from "overhead" and at a relatively great height, as though flying over earthworks in a small plane—the book's macrostructure becomes more clearly visible and increasingly legible. The patterning of Hedge Coke's sequence of diverse but intimately related free-verse poetic forms is revealed to be highly complex, even, we might argue, three-dimensional. From an aerial perspective, we can better see the mathematics and geometry at the foundation of Hedge Coke's carefully constructed "earth"-works and better determine the specific units of measurement on which the poet has based individual constructions, complexes, their multiple alignments and, indeed, multiple nestings.[14]

Over time I came to better understand how the poetic structure Hedge Coke builds across *Blood Run* is based on a principle of layering diverse forms and materials, the construction technique for building actual Indigenous earthworks. This textual world of sections, poems, stanzas, lines, words, and syllables is also based on the repetition, recombination, and reconfiguration of a limited set of natural numbers—*four, three*, their sum, *seven*, and multiples of all three—as well as on the repetition, recombination, and reconfiguration of the sequence of *primes*, those natural numbers that can be divided only by themselves and the number one, which is itself unique in the sense that the number one is neither a prime nor a composite number. Hedge Coke's embedded manipulations of four, three, seven, and the sequence of the first twenty-four primes illustrate what Tewa scholar Gregory Cajete describes in *Native Science: Natural Laws of Interdependence* as the "proper role of mathematics" within Indigenous scientific systems. As in contemporary physics, a field often engaged with phenomena "that cannot be explained in words," Cajete argues that within Indigenous fields of science mathematics helps render "transparent" certain "basic relationships, patterns, and cycles in the world" through their quantification and symbolic "coding."[15]

By this point I was completely obsessed with the structures of *Blood Run*. Although Hedge Coke had not had access to aerial-based LiDAR imaging

technology when she composed her poetic sequence and "free verse play," she had nonetheless encoded her work in ways similar to the builders of the mounds. Like Romain's images, Hedge Coke's multiply coded, three-dimensionally imagined, and highly patterned sequence of poems—dense with data—reveals new ways of seeing and new ways of conceptualizing an important earthworks site. In contrast to the 3D images produced by LiDAR, however, Hedge Coke's sequence provides a rare fourth dimension: perspectives that are explicitly and distinctly Indigenous.[16]

Hedge Coke imagines the extensive Blood Run earthworks site (located on both sides of the Big Sioux River on what is now the South Dakota–Iowa border) not only as alive but as highly patterned and articulate. Moreover, the poet simulates the mathematical and geometric encoding of earthworks and their multiple alignments with one another, with natural features in the landscape, and with the sun, moon, stars, and other elements of the greater cosmos in her precise positioning of poems within numbered sections and within the sequence as a whole, as well as in her precise numbering of lines, in her precise patterning of stanzas per poem, lines per stanza, words per line, even syllables per word, and, crucially, in how these multiple numerical configurations align, further, with specific content, with wordplay, allusion, and imagery, with building themes. Hedge Coke's highly patterned poetic script written for multiple voices endeavors to move audiences and performers in the present, I realized, so that they might act on behalf of the future. In particular, her evocation of mounds as systematically patterned and highly articulate is meant to spur action toward their contemporary protection, toward their renewal and future reactivation. Remarkably, in the years since the 2006 publication of *Blood Run*, that positive action has begun.[17]

In 2010, I published a first article on *Blood Run* focused on an analysis of Hedge Coke's evocative "Snake Mound," quoted above, which gives voice to the destroyed serpent effigy that was once central to the site.[18] The poet acknowledges this physical violation and spiritual sacrifice, I noted, from the very beginning of the poem: although it is modeled on the extant Serpent Mound in Ohio, "Snake Mound" speaks from a position of "present invisibility" and apparent absence. In her formal acknowledgments, positioned

at the end of the sequence rather than at the beginning, Hedge Coke confirms that "Once, a snake mound effigy of a mile and a quarter length, much like the worldwide lauded Snake Mound in Ohio State, existed in this very place—Blood Run. The railroad used it for fill dirt" (93). Simultaneously, "Snake Mound" aligns with the Serpent Mound in Ohio in its subtle but elaborate poetic structures and in its precise positioning within *Blood Run*.

Hedge Coke sites "Snake Mound" on the individual page, within section II ("Origin"), and within the broader sequence, I argued, so that it cites both the physical characteristics and known celestial alignments of the Serpent Mound effigy in Ohio. The body of the extant Serpent runs roughly a quarter mile in length and is mounded to a height of three to four feet. It begins at its southern end with its tail in a triple-coiled spiral, undulates along the plateau above the Brush Creek Valley in seven distinct body convolutions, then straightens out toward its broad and horned head. As already noted, the Serpent's mouth appears to hinge wide open, poised to swallow a large, oval-shaped disk. Since the nineteenth century, some viewers have interpreted the effigy as a snake attempting to swallow an egg and have assumed the site was used primarily in rituals for fertility. Others have interpreted the effigy as the great horned serpent, a symbol of the lower world, attempting to swallow the disk of the sun, a symbol of the upper world, which can suggest an iconic representation of a solar eclipse. Still other viewers, including Romain, have speculated that the effigy embodies the philosophical concept of a cosmic balance, in which the forces of the lower world, represented by the horned serpent, are in productive tension with the forces of the upper world, represented by the sun. In this interpretation, the serpent symbolizes "dark" forces that include "the moon, night, winter, darkness, and death." The oval disk, in a contrasting symmetry, signifies "the sun, daytime, summer, light, and life."[19]

Building on the work of earlier surveyors, Romain confirms eight astronomical alignments in the body of the Serpent: true astronomical north, the summer solstice sunset point, and six lunar rise and set points on the horizon (247).[20] He hypothesizes that "perhaps the Mound Builders celebrated world renewal ceremonies at the site, in order to help strengthen the powers of the upperworld in the continuing struggle against the forces of the

underworld. In this way," he concludes, "the Serpent Mound builders would have been able to exercise some control over the forces that ruled their universe and affected their lives" (253). Romain's speculation is strengthened by Cajete's characterization of the motivations behind Indigenous astronomy and, more broadly, attempts by Indigenous peoples "to align themselves and their societies with what they perceived was the cosmic order" (217). Cajete argues: "Native astronomers were driven not only by their own awe and curiosity, but were also serving the innermost needs of their societies—to *resonate* with the cosmos and to be the *power brokers* of their worlds" (217–18, emphasis added).

In *Blood Run*, "Snake Mound" is situated as the nineteenth poem within section II ("Origin"), which consists of the first twenty-eight of the larger sequence's sixty-four persona poems. In an aerially based analysis, we note immediately several numerical alignments: two is the first prime, nineteen is the eighth prime, twenty-eight is the result of multiplying four and seven (two of the sequence's basic units of measurement) and sixty-four is the cube of four (4 x 4 x 4, or four made three-dimensional).[21] Four and seven are related, further, by the fact that seven is the fourth prime. In many Indigenous North American cultures, these numbers are associated both with natural phenomena and with ritual activity and the sacred. Moreover, the number four can describe a two-dimensional schematic of the world divided into the cardinal directions; the number seven can describe a three-dimensional schematic that adds to the four cardinal directions the three complementary spatial positions above, below, and center. If we divide the twenty-eight poems of section II into four sets of seven—into balanced quadrants, each composed of a three-dimensional world—"Snake Mound" is positioned as the fifth poem within the third set, revealing further significant alignments. Five is the third prime, and three is the second.

Within the third set of seven in section II, the first three poems that precede "Snake Mound" manifest cosmic forces that align with the specific siting of the Serpent Mound in Ohio: the personae "Moon," "Blue Star," and "North Star." The Moon is one of the "dark" forces associated with death and the lower world. Her poem/monologue begins by emphasizing practices of burial and mourning: "My children were buried 'neath altitude, /

within masses of earth as their sisters mourned them / with painted faces resembling my spirit full" (27). The Blue Star, another name for the bright star Sirius, is associated with the western direction and with the winter season ("In cold, I dangle in west"), other "dark" forces associated with death and the lower world. Her poem/monologue concludes by emphasizing constancy in the face of change: "Look to me when change requires courage. / My face bears all will, stability" (28). The North Star indicates the Serpent Mound's primary alignment with true astronomical north. Her poem/monologue begins by emphasizing her centrality to processes of Indigenous orientation and navigation: "By me multitudes thread earthly blanket, / set their paths to come, go, / weave their ways nightly" (29).

The fourth poem in the set, immediately preceding "Snake Mound," manifests the collective persona of "The Mounds," which appears in a total of seven poems across the sequence. This second appearance of "The Mounds" (two is the first prime) is placed in dialogue with "Snake Mound" across the central spine of the open book, suggesting their intimate relationship. Indeed, both poems are composed of the same number of lines, seventeen, which is the seventh prime. In this instance, the collective persona articulates the imminent danger of violation and erasure of the earthworks at Blood Run: "Somewhere along the way, the world went inside out, / yielding, unfolding, to tools crafted to scrape unbearably ransomed. / In this turning, all we have come to hold, now exists in jeopardy" (30). This danger is especially acute for the site's effigy Snake Mound, which was destroyed during the construction of the railroad in the name of U.S. "progress."

Seventeen brief lines compose the "Snake Mound" persona poem, creating a narrow column of words visually suggestive of a snake. These seventeen lines are divided into eight stanzas: seven stanzas of two lines each and one stanza of three lines. As already noted, seventeen is the seventh prime, two is the first (and only even) prime, and three is the second prime. The eight stanzas can be aligned with the eight known astronomical alignments of the extant Serpent Mound in Ohio: true astronomical north, the summer solstice sunset point, and six lunar rise and set points. The poem's seventeen lines are also arranged into eight distinct statements of varying lengths: two statements of two lines each, one statement of four lines,

Snake Mound

1	Present invisibility	
2	need not concern.	*statement 1*
	[1]	
3	My weight remains	
4	heavy upon this land.	*statement 2*
	[2]	
5	Winding,	
6	weaving, incurve,	
	[3]	
7	mouth undone,	
8	for egg swallow.	*statement 3*
	[4]	
9	Though my body	
10	suffered sacrifice	
11	to railway fill,	
	[5]	
12	my vision bears	
13	all even still.	*statement 4*
	[6]	
14	Be not fooled.	*statement 5*
15	Be not fooled.	*statement 6*
	[7]	
16	I will appear again.	*statement 7*
17	Sinuous, I am.	*statement 8* (31)

FIGURE 4. Allison Hedge Coke's "Snake Mound" marked to highlight the poem's 17 lines, 7 gaps of white space between its 8 stanzas, and 8 statements.

one statement of five lines, and four statements of one line each. All of these numbers are either prime (two, five, seven), sacred (four, seven), or, in the case of the number one, unique in the sense that it is neither prime nor composite. Moreover, the particular sequencing of statement lengths (2–2–4–5–1–1–1–1) simulates the Serpent's structure of complex head, long body, and tightly coiled tail. Finally, the poem's division into eight stanzas means that, on the page, there are seven "convolutions" or turns

in the seven gaps of white space between stanzas, further mirroring the Serpent Mound in Ohio.

What I came to call the poem's thematic geometry, that is, its multiple numerical structural alignments and the relationships of those alignments to the poem's significant ideas, including the idea that the imagined persona is linked to the extant Serpent in Ohio, asserts both the sacredness of the Snake Mound effigy and its *primality*—its condition of originality, primacy, indivisibility. The specific content of the poem's seventeen lines, divided into eight stanzas and arranged into eight statements, positioned at the juncture of multiple prime and sacred numbers, reinforces these alignments and supports the hypothesis that the Serpent Mound may have been devoted to ceremonies designed for nothing less than world renewal.

Despite her apparent invisibility, and despite her history of violation and assault, Snake Mound asserts her ongoing physical and spiritual presence. In her penultimate, seventh statement (the fourth prime) at line 16 (4 x 4, or four squared, that is, four made two-dimensional), Snake Mound asserts (in four words), "I will appear again." In her final, eighth statement (4 x 2, or 2 x 2 x 2, the cube of two, the first and only balanced prime made three-dimensional) at line 17 (the seventh prime), Snake Mound then asserts (in three words) both the primacy of her curving physical form, "Sinuous," and the primacy of her spiritual being, "I am." For many readers, this final phrase, separated from the serpentine adjective *sinuous* by the singular curve of a comma, will evoke one of the self-reflexive self-representations of the invading settlers' Hebrew God as expressed in Exodus 3:14: "I am who I am."

It is worth drawing attention to Hedge Coke's provocative use of the adjective *sinuous*, with which Snake Mound directly responds to the dominant ideologies that authorized the razing of her physical body by asserting her own self-reflexive self-representation. Formed from the noun *sinus*, indicating a curve or bend, or a curving part or recess within a larger structure (not unlike the punctuation of a comma), *sinuous* indicates a serpentine or wavy physical form but also carries primary meanings of strong, lithe movements, intricacy or complexity, and indirectness. The related verb

sinuate means to curve or wind in and out, whereas the verb *insinuate* means to suggest or hint slyly, to introduce by indirect or artful means. The derivation is most evocative in the connotations it draws from the field of anatomy. Here *sinus* indicates a recess or passage: the hollow in a bird bone, cavities in a skull. In human bodies, the *sinuses* evoke connection to the nasal passages and thus to life-giving breath. The sinuses are also receptacles and channels for fluids, especially for venous blood, that is, blood that has been deoxygenated and charged with carbon dioxide, ready to pass through the respiratory organs to release carbon dioxide and renew its supply of life-giving oxygen. "Sinuous, I am" thus does more than simply indicate the (apparently absent) effigy's serpentine physical form. Within the line's overt biblical syntax and tone and its subtle numerical alignments, *sinuous* slyly suggests Snake Mound's assertion of her central role as a technology for activating the physical and spiritual life of Blood Run. It is through the vehicle of this presently invisible, narrow, and curving passageway that life-giving breath will return.[22]

That the celestially aligned Snake Mound evokes a renewing breath links Hedge Coke's representation of the effigy to Cajete's assertion that "the historic efforts of Native cultures to resonate with the heavens also represent their attempts to live up to an ideal ecological relationship with the Earth" (256). Resonance and renewing breath link this representation of the effigy, as well, back to Hedge Coke's opening narrative poem in section I ("Dawning"). Titled "Before Next Dawning," the narrative poem offers an expansive overview of Indigenous history, moving from the ancient North American past to world events of the early twenty-first century in a total of 176 lines. This number indexes the 176 earthworks still extant when Blood Run was mapped at the end of the nineteenth century, a fact to which Hedge Coke draws attention in her author note (xiv). The number can be factored as 4 x 44, emphasizing the book's sacred basic unit of measurement, four, and in effect evoking its cube; this factoring of 176 thus evokes the number sixty-four (4 x 4 x 4), the precise number of persona poems that animate *Blood Run*. "Before Next Dawning" ends in ritualized prayer organized into a four-part, nearly palindromic structure. Through the meta-

phor of "breath" and "breathing," the speaker prays for the renewal of the endangered land, the violated earthworks, the desecrated human remains at Blood Run, ultimately, for the renewal of the entire planet:

> Yet,
> testament in danger still, monstrous machines,
> bulldozing scars upon soil,
> lifting the earth's very skin up,
> baring her bones, bones
> of her People for raking, then smothering her
> breath with concrete, brick, mortar—
> Never more allowing her to freely breathe.
>
> May she breathe again.
> May she breathe.
>
> May she breathe.
> May she breathe again. (9–10)

"Sinuous, I am" asserts Snake Mound's crucial role in this prayed-for physical and spiritual renewal.

In Snake Mound's invocation of a breathing, life-giving passageway, we can discern, too, Hedge Coke's thematic alignment of the effigy's persona with that of the central, life-giving River. River appears twice in the sequence: first in the privileged (and unique) position of the first persona to speak in *Blood Run*, the first poem in section II ("Origin"), and then in the similarly privileged position of the sixteenth poem (4 x 4, or the square of the sacred basic unit of measurement, four) in section III ("Intrusions"). This second appearance is simultaneously the forty-fourth persona poem within the larger sequence of sixty-four, again emphasizing River's connection to the sacred number four and aligning her, as well, with the significant factoring of the opening narrative poem's 176 lines (4 x 44). (I have more to say about River's role in *Blood Run* in chapter 2.)

Following "Snake Mound," the final two persona poems in the third set

of seven in section II reinforce the role of the effigy in the spiritual life at Blood Run. The sixth poem/monologue, which immediately follows "Snake Mound," animates the secretive persona "Esoterica," which represents Indigenous sacred and medicinal knowledge: "spark between Creator, Creation. / I am sacrament for some nearby" (32). Composed of fifty-three lines, "Esoterica" is the longest persona poem in the sequence, and it is the only poem divided into numbered sections. At this point in the analysis, it will come as no surprise that fifty-three is the sixteenth prime; sixteen, as already noted, is the square of four, the sacred basic unit of measurement for *Blood Run*. Moreover, the number of sections in the poem, seven, is the fourth prime and another number associated with the sacred. Finally, the set ends with the seventh persona poem, the shape-shifting spiritual guide "Clan Sister," who, like the collective persona The Mounds, speaks seven times across the sequence. This is Clan Sister's second appearance (two is the first prime); her poem/monologue consists of sixteen lines divided into four stanzas of four lines each, accentuating her relationships to natural phenomena, ritual activity, and the sacred. Mid-poem, anticipating the realization of a prophecy about River's power to cleanse and remake the world, Clan Sister states: "Wondrous revelations / occur rarely. / Once a lifetime" (35).

THREE

By placing the singular voice of Snake Mound, which speaks only once in *Blood Run,* in direct dialogue with the second appearance of the collective voice of The Mounds, which speak a total of seven times across the sequence, Hedge Coke creates a specific context of juxtaposition and a specific set of productive tensions. Situated on the left page and composed of seventeen lines of varying lengths divided into six tiered stanzas—visually suggesting the physical shapes of sloped earthworks—The Mounds speak first. In a tone of great reverence, in the opening five stanzas The Mounds describe the deliberate, prayerful process of their original construction and how their aligned bodies "made model" the movements of the sun and moon for "millennia." In the final, sixth stanza, reverence shifts to ominous

foreboding. The Mounds now describe a world turned "inside out," a world that places "all that [they] have come to hold" in "jeopardy" (30). Facing The Mounds on the right page, Snake Mound is composed of seventeen brief lines of more uniform length divided into eight stanzas, suggesting an articulated, serpentine shape. Although The Mounds' final word, "jeopardy," directly foreshadows the fate of the destroyed Snake Mound, in her opening lines the effigy calmly responds to this sense of apprehension: "Present invisibility / need not concern." Here and elsewhere in the poem, the wordplay is productive: although her sinuous body of mounded earth is no longer visible, the effigy remains "present." In the following lines, she states, "My weight remains / heavy upon this land," with the pun on "weight" (wait) suggesting a period of dormancy and anticipation rather than loss and absence. At lines 12 and 13 the effigy even claims the endurance of her power to see despite her apparent lack of vitality: "my vision bears / all even still." The three-word admonition repeated verbatim at lines 14 and 15—which I read as shifting stress from "Be not *fooled*," emphasizing the passive imperative's action (followed by the heavy pause of a period), to "Be *not* fooled," emphasizing the adverbial negation (followed by the heavy pause of a second period)—slows the pace of this penultimate, seventh stanza in order to imbue the final, eighth stanza with a heightened sense of anticipation and drama. At line 16, structurally charged by squaring of the sacred number four, in four words Snake Mound eschews The Mounds' nostalgia for the distant past and anxiety about the present to assert a defiantly positive future: "I will appear again" (31).

In performance, specific casting heightens the tensions of the dialogue—in terms of the genders and ages of the actors, for example, or their affiliations with Indigenous communities.[23] Modulations of the performers' voices, expressions, and gestures add further dimension and nuance, as do the physical orientations of the performers' bodies in relation to the audience and to each other as they speak, listen, react. When a group rather than an individual performs The Mounds, multiple possibilities arise for speaking the collective persona's lines: in unison as a communal multivoice, sequentially as individual voices that alternate by line or stanza, in an overlapping round, or in some combination of these. Multiple possibilities

also arise for configuring the bodies of the actors in simple or complex alignments with each other, with other features of the real or imagined landscape and cosmos of the performance space, or with the body of the actor voicing Snake Mound, as well as for choreographing how the performers move their bodies, individually or in unison, and thus how they shift and re-shift their alignments. In performance, Hedge Coke's vision of the enduring vitality of the mounds becomes fully instantiated, as does her understanding of the significance of alignments that are multiple and simultaneous. The message is not simply that Snake Mound continues to articulate knowledge and meaning, to possess voice, despite destruction of her physical body. The seemingly lost Serpent "speaks" because she is aware of interlocutors; her voice remains vital not in isolation but within a multidimensional dialogue structured by, with, and through additional earthworks and other aspects of the site. Snake Mound's message resides not in her singular voice but in the complex interactions her voice performs between particular poems and across the larger script of *Blood Run*.

Other Native artists and intellectuals have engaged the physical characteristics, terrestrial and cosmic alignments, and powerful "voice" of the Serpent effigy, including Choctaw writer and intellectual LeAnne Howe and Kuna and Rappahannock actress and playwright Monique Mojica, who have been co-developing a performance piece, *Sideshow Freaks and Circus Injuns*, that grounds its dramaturgy in the materiality, abstract patterning, multiple alignments, and multiple discursive and practical functions of Indigenous earthworks. Central to their process for gathering material for the structure and content of the new play has been an extensive "mound crawl," similar to a "pub crawl," of mound sites from Louisiana to Ontario. At each, the playwrights engaged in what Mojica describes in a 2012 essay, "In Plain Sight: Inscripted Earth and Invisible Realities," as an "Indigenous artistic research methodology . . . that speaks to the embodiment of place."[24]

Similar to Hedge Coke's methodology for producing *Blood Run*, in which she "composed at the site," Mojica and Howe's methodology is based in the idea of an "embodied research": approaching earthworks in an appropriately respectful manner, spending significant time with their forms, walking their contours, making physical contact, engaging the full range of

the human body's senses to listen and feel for song, story, and movement contained within these earthen bodies, remnants, and remains (Mojica, "In Plain Sight," 220).[25] Their methodology also involves an "embodied improvisation": actively connecting one's human body to earthworks as sign systems and as systems of encoded knowledge by imagining one's way *into* the lives that have been lived at and through the mounds—that is, the lives of both "the ancestors who built them" and "the peoples who still inhabit the region" (220). Mojica explains: "The land *is* our archive and our embodied relationship to the land defines Indigenous identities, history, science, cosmology, literature—and our performance" (219). As an Indigenous artist, it is her responsibility "to make visible that which has been made invisible. It is a responsibility that compels me to remember things I never knew and restore them to consciousness" (221). And rather than rely exclusively on a journal or camera, Mojica states, "I record and document with my body" (221). This is what Mojica means by "embodied relationship" in the context of Indigenous earthworks research: her human body aligns with the encoded body of an earthwork; in the process, her own body, too, becomes encoded with knowledge. Mojica's descriptions of her research methodology align with Hedge Coke's descriptions of her attempts in *Blood Run* "to speak through the vessel despite the self, to image the land, the animal and plant life able to vicariously bear witness, for the essence of particular ghostings and remaining skeletons to be freed through lingual and geometric presence in some way."[26]

In an unpublished abstract for the new performance, Howe and Mojica emphasize processes of layering and, as a result, transforming the materials they gather from various sites: "We are mound building with our theatre." In this way their practice aligns with that of other Indigenous intellectuals, such as Shawn Wilson (Cree), who advocate approaching research as an operation of ceremony, and with that of a growing cadre of Indigenous archaeologists.[27] Some in this latter group, following the lead of Linda Tuhiwai Smith (Maori) in her groundbreaking *Decolonizing Methodologies: Research and Indigenous Peoples* (1999) and Joe Watkins (Choctaw) in his influential *Indigenous Archaeology: American Indian Values and Scientific Practice* (2000), emphasize the need for archaeologically based research projects

to be designed and implemented in collaboration with the Indigenous communities affiliated with specific sites.[28] Others explore how archaeological methodologies based in Indigenous epistemologies can transform the field's orthodox approaches to sites and artifacts. In the process, they argue, differently informed archaeologists can build better relationships with Indigenous communities that, understandably, are often suspicious of the field's motivations for conducting research and often concerned about the handling of ancestral human remains and the treatment of objects of historical and spiritual significance. Cree archaeologist Tara Million, for example, argues:

> Practicing archaeology within an Aboriginal philosophy transforms the person of the archaeologist. The archaeological site becomes a ceremonial area and the archaeologist a ceremonial practitioner. In addition to being the holder of a sacred site, the archaeologist is the holder of artifacts and ecofacts—all sacred objects, given by an aware archaeological record. . . . An Aboriginal archaeologist is the locus for a relational web that incorporates past, present, and future, living and non-living, academic and community, Aboriginal and non-Aboriginal. As an embodiment of the *axis mundi* [central, connecting pole and hollow tube] she receives powerful gifts from the animate archaeological record that carry the obligation of redistribution and reciprocity throughout all of these relationship networks.[29]

The challenge is to relearn how to access and align with Indigenous knowledge encoded in the land all around us, in Ohio and in other parts of the Americas, written through Indigenous technologies and practices, waiting not to be "discovered" by outside explorers but to be recorded and documented through living Indigenous bodies in order to be reactivated in Indigenous presents for Indigenous futures.

In October 2011, a year after the publication of my article about Hedge Coke's "Snake Mound," I had the opportunity, along with local Native colleagues, to assist Mojica in visiting research sites in central and southern Ohio, including the geometric enclosures at Newark, the burial mounds

known as Seip and Jeffers, and the effigy Serpent Mound, and to partici-
pate in her methodologies of embodied research. It is difficult to describe
these collective and multidimensional experiences in exclusively Western
scholarly terms. And I have found it necessary, in my attempts to align with
the work of Mojica and other Indigenous researchers, to openly defy the
Western academy's standard of so-called objectivity and its logic of so-
called scholarly distance. Over time, these attempts have developed into an
active refusal to impose the Western scholarly voice—the typical voice of
archaeologists, anthropologists, and historians—once again on Indigenous
mounds.

After a pleasant drive south and west from Columbus, sipping take-away cof-
fees and sharing stories, we arrive at Serpent Mound State Memorial on a bright
autumn morning. Approaching the park entrance, we immediately notice a large
number of butterflies, those living symbols of transformation. They seem to fol-
low us, and Mojica comments that butterflies have been a common experience
at other sites. Sometimes, she says, it has been damselflies.

To prepare for our anticipated encounter, Mojica has us smudge ourselves
with sage and asks us to take a moment while still standing in the parking lot to
quietly introduce ourselves to the ancestors, to let them know we're here and to
let them know we're aware that they're here, too. Mojica then suggests we es-
tablish our bearings by first viewing the effigy from the observation tower. Built
by the Ohio Archaeological and Historical Society over a hundred years ago, in
1908, and rising twenty-five feet above the ground, the metal tower assists staff
archaeologists, no doubt, but primarily enables the gaze of tourists. For four,
maybe five generations, the tower has focused that gaze toward the effigy and
away from the three burial mounds nearby.

We climb. Hands gripping rails, eyes watching the open risers, in a slow
single-file procession we ascend the sky-world to behold our relative from the
underworld below. Many have speculated about the intended audience for
earthworks, especially for large geometric figures like the fifty-acre Octagon
at Newark or large animal figures like the Serpent. Why go to so much trouble,
some researchers ask, when the spectacular results of planning and labor could
be appreciated only by hawks and eagles, or by the stars? A few sites might be
viewed from adjacent hills, but not all, and no hill affords a completely over-
head perspective. There are odd theories, of course, involving aliens from outer

space. And there are archaeologists who argue that powerful shamans must have directed construction, that a shamanic point of view, an altered state of consciousness, a spiritual experience of elevation or flight—not spaceships—explains the scale, the symbolic significance of these mounds.[30]

Although I have climbed the tower's steps on previous visits, when we reach the raised platform I am startled anew. From this height, situated behind the body's second and third convolutions, it is possible to perceive the Great Serpent more-or-less as a whole and thus to contemplate not only its scale as graphic symbol but also its remarkable performance of energy. *It begins in the tail, in the tight fist of the triple-coiled spiral. The spiral opens then expands through seven convolutions of the extending body, the body as a whole turning to follow the distinctive curve of the ridge. Energy culminates in the broad triangular head, mouth seeming to arch wide open, preparing to swallow an oval-shaped disk.* We take it all in, silent, then quietly remark on the beauty of the Serpent's green form moving through the multi-green landscape, the land itself beginning to turn to autumnal golds and browns. But mostly it is this focused performance of energy, this vector and syntax of signs conjoined atop the arc of the ridge—*coil, waves, triangle, oval*—that we attempt to describe. And we remark on our mixed feelings of awe at the Serpent's survival, understanding that its near destruction might have been made complete, that there easily could have been no period of careful reconstruction, no funds raised for a protective park, and yet grief at the Serpent's colonial capture in the state memorial. Such a telling designation, memorial: historical marker of time made frozen in the past, tribute to the fallen dead, gravestone for those lost but especially for those forgotten. Static and suspended. I find myself reciting these lines from Hedge Coke's "Snake Mound": "my vision bears / all even *still.*"

After a time, we collect ourselves and descend the observation tower to walk beside the contours of the undulating body. We note how differences in elevation and perspective affect our perception of each part of the Serpent, and how we now struggle to perceive the effigy as a mimetic figure. Does it matter, we ask, that we cannot see the Serpent in its entirety while standing on the ground? That we must walk to enable perception and, walking, must imagine parts into the whole, connect distinct signs—*coil, waves, triangle, oval*—into the serpentine sentence? Finally, having walked along the full length of the effigy up and back and having discussed how closely the raised body follows the curve of the ridge that extends above the waters of Brush Creek, we wait patiently

until the few other tourists present that day finish their tour and leave. Alone with the Serpent, we ignore the posted signs and complete what we have begun to realize is our own performance. In violation of the colonizer's edict (grateful as we are that it may keep others off the mound), we lay our small human bodies against the grass surface of the effigy's massive body, warmed by the sun, to listen and feel.

Each perspective—bird's eye view from above, human's eye view standing on the earth's surface, and up close, mound's eye view lying surreptitiously on the body of the effigy itself—is informative and emotionally powerful in its own way. But it is when we make physical contact, body resting upon body, that we experience the most intense feelings that the Serpent is more than a remarkable feat of engineering, more than a mimetic or abstract symbol linking us to the past, more than a system of encoded knowledge and astronomical alignments, although it is all of these. Despite its near destruction, first by human neglect and then by human violence; despite its multiple excavations, the careful incursions of shovel and trowel, the fine siftings of its layered soils, the searches for charcoal and ash; despite its reconstruction by curious, well-meaning outsiders; despite its colonial capture and sensationalist display in the state memorial—the Serpent remains a living entity.

With our hearts pressed against the fluid, curving form of its body, we are again cognizant of the Serpent's unmistakable performance of energy. Now, however, instead of perceiving wave-like movement from above, as we had standing on the raised platform of the observation tower, we feel waves of subtle motion from below. Mojica recounts in her essay "In Plain Sight": "The serpent writhes and undulates beneath us" (240). And suddenly, from our prone positions lying against the effigy's warmed body, we again perceive movement visually as well: threading the grass atop the Serpent's back are the orange and white forms of woolly caterpillars. Like the butterflies encountered at the memorial's entrance, the caterpillars are living symbols of transformation: movement within a designation of stasis. We begin to imagine the myriad forms through which such movement might manifest—in the past, in the present, in possible futures.

Later, when we gather at the safety rail close to the edge of the ridge, behind the spiraling tail, to quietly discuss our experiences and to watch the late sun dapple the waters of Brush Creek below, we are joined by an unexpected avian visitor. We have been aware of birds off and on all day, mostly at a distance,

but this one alights in the tree nearest the coil, only a few feet from us, extends then folds large dark wings, shakes a bald and speckled head. The vulture takes command of a low branch and sets about the business of preening; this is no fleeting visit. Seemingly lost in thought and feathers, she turns a red-rimmed eye our direction only occasionally, though we have the distinct impression she listens carefully to what we say. She stays with us a full hour. We find her close presence reassuring, a calm and provocative force, a reminder of the sky-world that slowly turns our conversation. Mojica is prompted to recall the iconography of twin vultures found among the funerary objects removed from some of the Mississippian mounds, which prompts all of us to recall the three burial mounds nearby. And thus we remember how the Serpent's performance of energy is but one component within a larger system—within multiple systems. We think about the role played by scavenging birds of prey not only in Southeastern iconography but in bone-picking ceremonies for assisting the dead in their journey to the next world. It is another form of movement and transformation. Another form of connection across worlds, cooperation across species. When we arrive at our realization, our avian companion again extends dark wings; she cocks her bald head and takes her leave.

It will be later still—several years later—when I am studying a detailed map of how Brush Creek runs its course through Adams County, that I will notice a notation for a relevant landmark located to the south of the Serpent. Designated Buzzard's Roost Rock because of the large number of turkey and black vultures that regularly circle the air currents there and that often congregate on the exposed rock, the distinctive dolomitic outcropping rises five hundred feet above Brush Creek, closer to where its waters join the Ohio, which eventually join the Mississippi. Today, though, through fading light we follow the vulture's deliberate journey without this conscious knowledge, watching until we can no longer distinguish sky and valley, messenger and scaffolding trees.

As Hedge Coke so powerfully anticipates in *Blood Run*, in our embodied research we experience the effigy as vital and multiply interconnected. Situated within three- and four-dimensional worlds and within highly patterned systems of encoded knowledge, we experience the effigy as continuing to speak, as continuing to perform in, as, and through the land and its transformations—*coil, waves, triangle, oval.*

FOUR

In developing *Sideshow Freaks and Circus Injuns*, Mojica and Howe have written about earthworks and earthworks research both separately and together. In an essay titled "Embodied Tribalography: Mound Building, Ball Games, and Native Endurance in the Southeast," for instance, Howe states: "Mounds were built by layering different kinds of soils one upon the other. As Indigenous playwrights, Monique and I hope to employ the deep structure of earthworks as dramaturgical models. Our soil layering will be represented in the stories we layer in the play."[31] Moreover, Howe draws upon her research with Mojica to argue that mounds themselves "embody stories" (80). As her primary example, she analyzes the large effigy known as Bird Mound, or Mound A, thought to be around thirty-six hundred years old, part of the massive earthworks complex at Poverty Point in what is now northeastern Louisiana. Howe makes a compelling case for rethinking our understanding of the large bird effigy, which archaeologists believe was built over a relatively brief period of only three months. The effigy may not be simply a static symbol or icon—what an older archaeology might have named a "totem"—but rather the embodied *story* of a key animal figure for Southeastern peoples, the red-tailed hawk. As Howe explains:

> The total time needed to create a red-tailed hawk, from mating to a fledgling leaving the nest, is approximately ninety days. Three months. Therefore, it would seem that Bird Mound at Poverty Point is possibly a performance mound that embodies the story of the red-tailed hawk from conception to first flight—the story of its creation. (82)

Howe's argument for rethinking the Bird Mound as story, as embodied and encoded performance, opens multiple possibilities for expanding our understandings of the effigy Serpent.

Howe and Mojica have created a series of improvisations and scripted scenes that draw directly from their embodied research and speculative theories. One scene, based on an improvisation by Mojica, bears the working title "Inside-Outside" and builds from Mojica's research experience with me and other colleagues at the Serpent Mound in Ohio and with Howe and

others at another serpent effigy located at Rice Lake, near Peterborough, Ontario, Canada.[32] The brief scene contrasts the perspective "from OUTSIDE an effigy mound" with the perspective "from INSIDE a burial mound." Effigy juxtaposed with burial: I immediately think of Hedge Coke's Snake Mound in direct conversation with The Mounds in *Blood Run;* but I also recall the detail of the deep pit, the spiraling well, the grassy curving wall of the tail of the Sacred Serpent filled with the remains of the Indian dead depicted in Walker's *Meridian.* I try to remember: Does Walker's conflation of burial and effigy possess its own voice or voices? Does it contribute dialogue or embody story? Does it participate in a networked system? Can it be understood as Indigenous performance?

However seductive the pull toward conflating effigy and burial, similar to Hedge Coke, Mojica resists, while still acknowledging the proximity of Indigenous interments to the Serpents; effigies juxtaposed, aligned, and in dialogue with burials, but not conflated. As embodied researcher understood also as performer—as embodied performer understood also as researcher—Mojica begins the improvisation with movement, the vectored "approach" *from* "outside" *toward* the Serpent, and then contact:

> We weep, belly down. Sobs. Sobs, heart on the serpent, belly on the snake, we feel it, undulate, beneath our bellies, bringing us its song. Thank you. Thank you, for leaving this for us to see, when all is almost gone, your bones pulverized to dust. Add tears and stir. Add tears and stir. Add tears and stir. We reconstitute our broken bodies from your bones. . . . Buzzard watches. Shadow bird. Song begins. Serpent writhes, long ago meteor charged, long ago meteor radiating through our spines: three coils of its tail, seven undulations and release. Then circle. The Great Serpent reaching towards water.[33]

Mojica's embodied improvisation centers attention on a contemporary Indigenous response to encounter with the ancient effigy. Movement toward the Serpent culminates in physical contact. The response is emotional but also spiritual; physical encounter with the effigy evokes the presence of Indigenous ancestors and draws the presence of the natural world, includ-

ing highly symbolic animals, such as Buzzard (Vulture), often associated with the movements of life and death as a cycle of renewal. This cycle is evoked as well in the imagery of mixing the "pulverized" bones of ancestors with tears of the living in order to "reconstitute" Indigenous bodies in the present. It is at this point the speaker notes "Song begins." *Song* is one of the gifts given by the ancestors through the vehicle of the multiply encoded mound.

At the same time, physical encounter with the effigy enables encounter with a previous cosmic contact, the power of an ancient meteor strike, which, like the evocation of ancestors and the presence of Vulture, represents connections among upper, surface, and lower worlds. This element is especially intriguing. The Serpent in Ohio lies not only on a distinctively shaped ridge above the Brush Creek Valley but also on the outer edge of a fifteen-square-mile area of "geological disturbance" bearing a "crypto-explosion structure" created more than two hundred million years ago by the impact of a meteor.[34] The speaker/performer suggests the effigy draws upon and expresses this ancient cosmic energy in its "writhing" form; in turn, the writhing body of the Serpent transfers the meteor's ancient cosmic energy into the receptive body of the speaker/performer. Finally, the first part of the improvisation ends with acknowledgment of the effigy's energy represented in the "three coils of its tail, seven undulations and release" and with acknowledgment of its proximity to water, another link to the lower world. As the improvisation continues, these elements repeat and build. The "Outside" section concludes: "The song begins, and we who think these thoughts as if they were our very own, answer the call."

The scene proceeds from the embodied movement of the "Approach from OUTSIDE an effigy mound" that ends in the embodied response to "song" to a "Voiced" section "from INSIDE a burial mound." The improvisation thus acknowledges the close proximity of burial mounds to both the Serpent Mound in Ohio and the serpent effigy at Rice Lake in Ontario. More precisely, the improvisation juxtaposes embodied encounter with the effigy with a disembodied voice emanating from a burial mound. The latter, however, relies on an embodied Indigenous presence as audience, as necessary recipient for these words "voiced" from within the mound. As in Hedge

Coke's *Blood Run*, in Mojica's improvisation "song" and "voice" are linked to the embodied presence of Indigenous descendants able to hear:

> It's time. It's time, come home and rest yourself in the folds of mother's skirts. There's something I must tell you, there's something you need to know. Once there was conversation, come closer, come closer, I almost have you. Here. Here, here, my most prized possession, needles made from bird bone tucked under my arm, come, come, come, reaching towards water, looking out over power, my most prized possession, my bundle of needles made from bird bone.
>
> Come. There's something you need to know. We're here, we're here, still here. Nothing is lost. We're here, we are here, still here, nothing lost, you, are not lost. My most prized possession. This bundle of needles, made from bird bone, my most treasured possession, my bundle of needles made from bird bone tucked under my arm. There's something you must know.[35]

The tone of the voice emanating from the burial mound is urgent, its message vital. The ancestors remain; nothing is lost. The repeated detail of the female ancestor naming her most prized possession, her bundle of needles made from bird bone buried alongside her within the mound, links back to the presence of Vulture at the Serpent effigy and focuses attention on gendered labor and creativity. But the repeated detail also links to the listening presence, the Indigenous descendant—she who is also the ancestor's "most prized possession." The improvisation ends with the female, maternal voice from within the burial mound emphasizing life in the movement of breath and linking this life to creative labor: "Mounds of light and shadow. Breathing, breathing, breathing. Built basket by fifty pound basket. Breathing."

As already noted, Hedge Coke similarly focuses attention on the significance of breath and breathing. The final lines of the opening narrative poem, "Before Next Dawning," voice a gendered prayer for renewal of endangered land, for renewal of violated earthworks, for renewal of desecrated human remains: "May she breathe. / May she breathe again" (10).

Ultimately, the lines voice prayer for renewal of the living planet as mother, for renewal of the elements of the dynamic cosmos understood as all our relations.

FIVE

These and other experiences with the Serpent effigy, its representation and its performance, prompted me to revisit Walker's imagined burial mound in *Meridian*, to reconsider the novel's seductive conflations, to review the scholarship it has launched, the arguments made about the mound's and the novel's obvious power and potential meaning. Scholars of African American literature, the primary authors of criticism on *Meridian*, both before and after the 1984 publication of *The Sixth Grandfather*, appear uninterested in—or largely unaware of—Walker's conflations, including those who have analyzed Walker's engagements with *Black Elk Speaks* or with Native American symbolism and motifs more generally.[36] More recently, researchers interested in "Red-Black" or "Afro-Native" literatures and histories have engaged the novel in terms of its intersections of African American and Native American blood, land, and memory in the South, and these scholars have worked to recover Walker as a writer of both African American and Cherokee ancestry.[37] I wondered: has any researcher approached Walker's compelling novel about the ideological, racial, and gender complexities of the movement for African American civil rights from the Indigenous perspectives of the mounds?

Walker titles the early chapter in which her protagonist encounters the Sacred Serpent on her father's Georgia farm "Indians and Ecstasy." In her seductive descriptions, Walker not only conflates general details about the Serpent effigy in Ohio with general details about burial mounds but also refigures the triple coil of the Serpent's tail as a large "well," a deep "pit." This well does not resemble the tail of the Serpent in Ohio, but it does bear resemblance to a Plains Indian "vision pit." As explained below, the technology of the vision pit is used in some versions of Plains Indian traditions of the vision quest, what in Lakota is called *hanble ceyapi*, "crying for a vision."[38] No known serpent effigy is located within the borders of what is now the

state of Georgia or in other parts of the Southeast. Nonetheless, in Walker's imagination the Sacred Serpent on the Hill family's farm is "thousands of years old," "full of dead Indians," and constructed as a five-hundred-yard-long "curving, twisting hill" with a "springing head."[39] Similar to the tail of the Serpent Mound in Ohio, the tail of the Sacred Serpent is "coiled." In marked contrast, at the center of this coil Walker imagines "a pit forty feet deep, with smooth green sides" (57). The pit's extraordinary depth bears no resemblance to any known effigy on the continent, serpent or otherwise, and its dimensions bear little resemblance to those of actual vision pits constructed by Plains Indians.[40]

Walker describes three generations of the African American Hill family as able to access the visionary potential of the coiled pit at the center of the Sacred Serpent's tail. When Meridian's great-grandmother, Feather Mae, enters the deep pit as a young woman and stands at its center:

> something extraordinary happened to her. She felt as if she had stepped into another world, into a different kind of air. The green walls began to spin, and her feeling rose to such a high pitch the next thing she knew she was getting up off the ground. She knew she had fainted but she felt neither weakened nor ill. She felt renewed, as from some strange spiritual intoxication. Her blood made warm explosions through her body, and her eyelids stung and tingled. (57)

Following this experience, according to family stories, Feather Mae renounces "all religion" that is not "based on the experience of physical ecstasy" (57). Skipping a generation, the next Hill to experience this power is Meridian's father, a schoolteacher and amateur historian as well as a farmer. When a young Meridian witnesses Mr. Hill returning from "the deep well of the Serpent's coiled tail," she senses "his whole frame [radiating] brightness like the space around a flame" (58). Finally, Meridian herself enters the coiled pit. At first she experiences "a sense of vast isolation" at being "surrounded by the dead," at being "so utterly small, encircled by ancient silent walls filled with bones, alone in a place not meant for her" (58). But then, willing away her fear, similar to her great-grandmother and

father, she experiences the "ecstasy" of transcending her normal consciousness and expanding her vision:

> It was as if the walls of earth that enclosed her rushed outward, leveling themselves at a dizzying rate, and then spinning wildly, lifting her out of her body and giving her the feeling of flying. And in this movement she saw the faces of her family, the branches of trees, the wings of birds, the corners of houses, blades of grass and petals of flowers rush toward a central point high above her and she [is] drawn with them, as whirling, as bright, as free, as they. (58)

When Meridian "comes back to her body," Walker's description invokes not only the Plains Indian ritual of the vision quest but also of the Sun Dance: "When she came back to her body—and she felt sure she had left it—her eyes were stretched wide open, and they were dry, because she found herself staring directly into the sun" (58).

The vision pit used by some Plains Indians as part of the vision quest does not play a significant role in *Black Elk Speaks*, but it is described in some detail in *Lame Deer Seeker of Visions: The Life of a Sioux Medicine Man*, a 1972 "as-told-to" autobiography written with Richard Erdoes. Walker draws on *Lame Deer* as inspiration for her 1984 poetry collection *Horses Make a Landscape Look More Beautiful;* the title is taken verbatim from the caption for a photograph of a northern plains landscape positioned at the center of *Lame Deer.* In the opening chapter, Lame Deer recounts his vision quest at age sixteen: "I was all alone on the hilltop. I sat there in the vision pit, a hole dug into the hill, my arms hugging my knees as I watched old man Chest, the medicine man who had brought me there, disappear far down the valley."[41] As described by Lame Deer, a vision pit is relatively modest; the vision seeker must "crouch" in its shallow, cramped space. The book's series of illustrations includes a photograph of a younger Lakota medicine person, Leonard Crow Dog, "about to go down into the vision pit." Standing within the pit, Crow Dog's shoulders remain above ground. Dakota novelist Susan Power describes a vision pit of similar dimensions in her 1994 novel *The Grass Dancer.* When a character stands "upright" in the vision pit

constructed atop Angry Butte, his head remains above ground.[42] In the next generation, the character's son stands in the "same deep pit his father had occupied thirty years before" (326). His head, too, remains at least partially above ground, and he is aware that in seeking his vision he stands "simultaneously buried in the earth and thrust into the air" (327).

In *Meridian*, in contrast to Hedge Coke's *Blood Run* or Mojica's "Inside-Outside," the Serpent effigy exists in a singular state, isolated in the landscape, with no complex of other earthworks for juxtaposition, alignment, or dialogue. The one detail of context and potential alignment that Walker includes is the proximity of "a slow-moving creek that was brown and sluggish and thick, like a stream of liquid snuff" (56).[43] Moreover, the chapter focuses on selected individuals who have personal access to the effigy's power through their eccentricity and unusual sensitivity. The "ecstatic" experience of that power then confirms each individual's status as exceptional within the African American and white social worlds at the novel's center.

Meridian and her father speculate about the purpose of the ancient burial mound and, in particular, its extraordinary, forty-foot-deep pit at the tail. In their intergenerational exchange, we witness Walker's attempt to convert Neihardt's tragic discourse on tribal death into the potential for an expanded understanding of enduring life:

> Her father said the Indians had constructed the coil in the Serpent's tail in order to give the living a sensation similar to that of dying: The body seemed to drop away, and only the spirit lived, set free in the world. But [Meridian] was not convinced. It seemed to her that it was a way the living sought to expand the consciousness of being alive, there where the ground about them was filled with the dead. (58–59)

The scene resonates with ideological and empathetic power. But neither (African American) generation can imagine the mound, the Indigenous peoples who built it, or their descendants as part of a "living" social world. The mound sits in the landscape not only isolated but also without voice or embodied story. It evokes neither energy nor performance. Its singular mimetic design, its sinuous shape, is imagined not in relation to Indigenous

worldviews that connect upper and lower worlds or that honor relationships between humans and key aspects of the natural world, but rather in terms of Western ideas of psychological "consciousness" and somewhat modified but still recognizably Christian understandings of religious "ecstasy."

Most significantly, neither generation of the Hill family, nor their author, appears ready to imagine living Indigenous peoples in the contemporary South. Scholars have drawn considerable attention to the passage in which Mr. Hill surrenders his deed to the sixty acres upon which the Sacred Serpent lies to "the Indian," the Oklahoma Cherokee named Walter Longknife, who arrives at the Georgia farm unannounced, unaccompanied, and on foot, the last detail an obvious signal to the 1830s Trail of Tears. Longknife, whom Walker strongly associates with Mr. Hill, is figured not as an official emissary from the Cherokee Nation of Oklahoma—whose federally recognized sovereignty could conceivably entitle it to make a claim to the mound on Mr. Hill's farm—but rather as an individual "wanderer" and "mourner" (54). Moreover, Longknife is a remnant of Cherokee identity who exhibits symptoms of post-traumatic stress not as a result of the intergenerational effects of forced Removal, the ongoing legacy of that violence and loss, but rather because he "had killed a lot of people . . . in the Second World War" (55).[44] He suffers from what was once described as shell shock. After spending "most of the summer camping out on the land," Longknife abruptly returns the deed to Mr. Hill and moves on (55). Although the scene is poignant and critics are correct to note the complexity of Mr. Hill's awareness that his land bears an Indigenous history, it is striking that Walker is unable to imagine Longknife as interacting with the Sacred Serpent itself, with Cherokee kin who tenaciously remain in Georgia, or with other individuals and communities (still) Indigenous to the South. Similar to the imagined burial-effigy, Longknife is figured as bereft, as surprisingly alone in the "land of his ancestors" (55). And, perhaps most telling, he possesses no voice of his own; he utters not a single word of recorded dialogue.

Not long after Longknife returns the deed to Mr. Hill, "white men in government-issued trucks" arrive to seize the "Indian burial mounds of the Sacred Serpent"—now suddenly made plural—in order to create a "public

park" and "tourist attraction" (56). In a racially segregated Georgia, African Americans are denied entry to the park, including the Hill family, who have given up their farm. The scene is framed as tragic loss for Mr. Hill and as a tragedy unique to the mid-twentieth-century South. In many of its key movements, however, the scene follows the history of the creation of the Serpent Mound State Memorial in Ohio more than a half-century earlier. As Robert Silverberg recounts in his 1970 popular overview *The Mound Builders*:

> In the summer of 1883, F. W. Putnam of the Peabody Museum [at Harvard] came to the Great Serpent. Describing his visit, he wrote of the awe he felt at seeing "the mysterious work of an unknown people whose seemingly most sacred place we had invaded There seemed to come to me a picture as of a distant time, and with it came a demand for an interpretation of this mystery. The unknown must become known."
>
> The mound then belonged to a farmer who was aware of its scientific importance and who had refrained from planting crops on the site. But Putnam was worried about the Great Serpent's future; already there was talk of leveling the giant Cahokia Mound to get ballast for a railroad track, and who knew what might happen to the Serpent if the farmer sold his land?
>
> In 1886, Putnam visited the Serpent again. . . . He found the mound partly obliterated by amateur excavators, the trampling of cattle and visitors, and the effects of rain. And the farmer said he was about to sell. . . .
>
> A group of Bostonians raised $5,880, and in June 1887, Putnam bought the mound for the Peabody Museum. That summer he spent eight weeks restoring it to the condition it had been in when Squier and Davis had made their chart 40 years before. He also built a fence with a turnstile, and installed a hitching post and horse trough for the convenience of visitors. In 1900, the Peabody Museum gave the Serpent to the Ohio Archaeological and Historical Society to be maintained as a state park.[45]

Moreover, Walker frames the ecstatic experiences of the Hill family, their bold interpretations of sojourning with "dead Indians" within the deep green coils of the Sacred Serpent, the exchange of the deed, and the

seizure of the site to create a state park within familiar dominant tradi-
tions for the display of "dead Indians," their representations, and their
artifacts within archives and museums. "Indians and Ecstasy" opens with
Meridian's memory of the "small white room" her father "had built for him-
self . . . like a tool shed in the back yard." The room has "two small windows,
like the eyes of an owl, high up under the roof." The owl imagery associates
the room with Western traditions of learning and wisdom (think of the owl
of Athena), but at the same time, given the context, it evokes dread, since
in some Native American traditions owls are seen as harbingers of death.
When a young Meridian peeks into this isolated room, she sees her father,
a student and teacher of history, seated "at a tiny brown table poring over a
map . . . that showed the ancient settlements of Indians in North America."
It is a scene of the solitary Western researcher at work in a library or ar-
chive, discovering another people's past through books and maps. The walls
of the small square room are covered in "photographs of Indians," including
Curtis-style photographs "of Indian women and children looking starved
and glassy-eyed and doomed into the camera" and the tragic photographs
of the frozen dead after the 1890 massacre at Wounded Knee. There are also
shelves with "books on Indians, on their land rights, reservations, and their
wars" (53).[46] The chapter's ending closes the frame with Meridian's mem-
ory of visiting the state capital's "museum of Indians," where she "peered
through plate glass at the bones of a warrior, shamelessly displayed," and
her memory of visiting Sacred Serpent Park years after its creation, when
African Americans are finally allowed admittance: "she returned one af-
ternoon and tried in vain to relive her earlier ecstasy and exaltation. But
there were people shouting and laughing as they slid down the sides of the
great Serpent's coil. Others stood glumly by, attempting to study the mean-
ing of what had already and forever been lost" (59). Although most scholars
have characterized Walker's chapter in exclusively positive and ecumeni-
cal terms, as (only) affirming connections among African Americans and
Native Americans in the South, it is difficult to read these lines as other
than a reified version of Neihardt's tragic discourse at the end of *Black Elk
Speaks*. It is difficult to read these lines as other than a version of the dis-
course of inevitable, irrevocable (Indigenous) loss.

SIX

Whether archaeological or poetical, "fact" or "fiction," works by non-Native writers, artists, and intellectuals tend to promote the idea that the Serpent Mound constitutes a transhistorical "mystery" (generations ask, What *is* it?) and a place-based "enigma" (Why, they wonder, is it located *here*, in the middle of a seeming nowhere?), and that whatever the effigy's meaning might have been in the past (always in the *past*), it has been "lost" or "forgotten," and thus the effigy presents an opportunity for contemporary speculation (How can *I* unlock its secrets?). Many late-nineteenth- and early-twentieth-century works, like E. O. Randall's 1907 *The Serpent Mound* (quoted at the beginning of the chapter), proceed in a tandem fashion—the subtitle yokes *Mystery of the Mound* with *History of the Serpent*—positioning the study of the effigy somewhere between a biblically inspired typology (the Serpent as icon of temptation and human corruption) and a more comparative symbology (serpent worship as "primitive" religion found around the world).

In this vein, Randall begins his secular work with an epigraph from Longfellow's often-quoted 1855 epic *The Song of Hiawatha*, which transposes Judeo-Christian iconography into Indigenous traditions: "Mitche Manito the Mighty, / He the dreadful Spirit of Evil, / As a serpent was depicted, / As Kenabeek, the great serpent. / Very crafty, very cunning, / Is the creeping Spirit of Evil, / Was the meaning of this symbol" (5).[47] Later, under a section titled "Curious Theories," Randall entertains speculation that the effigy is, in fact, a manifestation of the biblical serpent. Perpetrated at the turn of the twentieth century by the Reverend Landon West of Pleasant Hill, Ohio, "a prominent and widely known minister of the Baptist church," this interpretation contends "the mound itself was created by the hand of the Creator of the World" and that its location "marks" the very "site of the Garden of Eden" (95). In Reverend West's understanding, the oval disk before the mouth of the serpent is neither an egg nor the disk of the sun but "represents the fruit with which Satan beguiled and tempted Eve" (96). Severed from any connection to Native Americans, past or present, the site serves as an eternal reminder of the Fall.[48] Although he humors rather than endorses the theory of divine creation, Randall includes it among his

several examples of "Serpent Worship" from across Europe and around the globe (66–93).

As a bookend to his epigraph from Longfellow, Randall concludes his work on this comparative note. He quotes in full a poem about a (supposed) serpent mound located at Loch Nell in Scotland. An intriguing "report" of the Scottish serpent, including a suggestive illustration, had appeared in 1872. Randall quotes various experts, who ask:

> Is there not something more than mere coincidence in the resemblance between the Loch Nell and the Ohio serpent, to say nothing of the topographies of their respective situations? Each has the head pointing west, and each terminates with a circular enclosure, containing an altar, from which looking along the most prominent portion of the serpent, the rising sun may be seen. If the serpent of Scotland is the symbol of an ancient faith, surely that of Ohio is the same. (122)[49]

While Ohio may not be the location of the Garden of Eden, it may represent a direct connection to Europe. The poem Randall quotes—"impromptu lines, inspired by the presence of the Great Dragon [i.e., the serpent mound]"—was composed by the Scottish scholar and prolific poet John Stuart Blackie (1809–95). It begins with the mystery of the effigy's siting: "Why lies this mighty serpent *here*, / Let him who knoweth tell— / With its head to the land and its huge tail near / The shore of the fair Loch Nell?" (emphasis added). The poem then links the serpent in Scotland to serpent symbols around the world, because "not here alone, / But far to East and West / The wonder-working snake is known" (123). Blackie evokes snake symbols from India, Africa, and Greece as well as from other parts of Britain, eventually arriving at a New World connection in Mexico (not Ohio), appearing to draw from one of the many studies of worldwide serpent worship in circulation during the nineteenth century.[50] Similar to the Reverend Landon's biblical certainty, Randall's poetic bookends leave little (or no) room for local Indigenous possibilities.

Non-Native poets writing in the late twentieth century continue the trend of leaving little or no room for Indigenous understandings of the

Serpent, especially for understandings generated by living Indigenous peoples. Some of these poets emphasize global comparisons, linking the effigy in Ohio to well-known examples of so-called prehistoric art, such as the Nazca Lines in Peru or the Paleolithic cave paintings in Altamira, Spain. Most evoke the effigy as prompt for poetic explorations more personal in nature. Examples include Sam Bradley's "Serpent Mound *(Serpent Mound State Park, southern Ohio)*," published in *Poetry* magazine in 1969. In twenty-one lines arranged into three stanzas, Bradley's concise poem moves from (potential) acknowledgment of the relationship between Indigenous snake imagery and rivers ("Mid-continent is restless with rivers. / This is birth-land") to familiar theories that (all) earthworks must have served as military fortifications and are thus signs of Indigenous violence ("I think of a buried fortress, once great / with warriors") to even more familiar theories of inevitable Indigenous death and erasure ("Among themselves / they shared annihilation") and a resultant sense of the site's physical and emotional isolation ("Loneliness, the leveller, has left these walls / where an earth serpent swallows an egg") that leads to revelation of the speaker's personal sense of isolation brought on by the loss of his birthright to farmland through his father's failures ("My father's broad fields that I looked on / were mortgaged, and lost to me") as well as the loss of his own son ("They take my son, too. . . . I am lonely here").[51]

Another example is Dave Oliphant's collection *Lines & Mounds,* published with a small press in 1976, the same year Walker published *Meridian.* The title poem meditates on the expressive art and physical act of writing, linking the Nazca Lines in Peru to earthworks located in the U.S. Midwest ("Writing them here / the letters form / like the Nazca lines / or the Hopewell mounds"), and ending, perhaps predictably, with "the Indian dead."[52] The collection also includes a poem titled "Serpent Mound (Louden, Ohio)." Oliphant's speaker links the snake effigy not to likely Southeastern or Woodland descendants of its builders but to the Snake Clan of the Hopi in what is now Arizona. Next, similar to Randall in 1907, the speaker contrasts this potential for comparative symbology with the potential for biblical typology: "yet instead of sin you mean / one in touch with palpitant earth" (26). Finally, having evoked the potential to understand the

earth as a living presence—the contemporary meaning of *palpitant* is "rare," but the word is suggestive of a *palpitating* heart—the poem ends, similar to Bradley's, with a more personal revelation. For Oliphant's speaker, the revelation is the effigy's potential to spur psychological and spiritual redemption: "finding your strength in [the earth's] decay / coiling about with a love-death squeeze / will make us spit out the oil of deceit / & save us from burning in night" (26).

Of the non-Native poems I have located, the most interesting are those by the Ohio-born writer Joe Napora. Published as a broadside and formatted on the page as two columns, Napora's 1983 "The Adena Serpent Mound: Adams County, Ohio" demonstrates something of the effigy's symbolic complexity in the poem's potential for multiple reading strategies and multiple interpretations.[53] Napora's instructions indicate: "The three readings are down each margin, the left one first, and then across line by line." Similar to Oliphant, Napora makes comparisons to global traditions, evoking the famous cave paintings of animals "in various natural attitudes / sitting, crouching, walking, standing" at Altamira, and suggests the Serpent's potential to provoke "healing." More so than either Oliphant or Bradley, however, Napora emphasizes the materiality of the effigy itself, describing its form in great detail ("The serpent starts / in a triple coil of the tail") and listing the measurement of its length, "thirteen hundred and thirty-five feet," not once but twice.

This emphasis on materiality continues in Napora's 1987 long poem *Scighte*, published as a limited-edition art book in collaboration with artist and bookbinder Timothy Ely and artist and paper maker Ruth Lingen.[54] Napora's title, which gives the impression of having been lifted from Middle English, is a conflation of the modern English homophones *site*, *sight*, and *cite*—which link, as I note in the introduction, issues related to place, vision, and quotation.[55] Indeed, the poem begins by suggesting the Great Serpent is itself a citation of the star constellation Draco, the dragon of European traditions—not the horned serpent of Indigenous traditions. Following this (not so) subtle shift away from the Indigenous, Napora develops a theme of the serpent's link to "motion" across the multi-page poem, but he evokes numerous other, unnamed "mounds" as well; and although Lingen's

pulp paper evokes snake-like forms in its green and brown colors and serpentine shapes, Ely's illustrations more obviously depict topographic maps, at least one burial mound, and the hilltop enclosure located in central Ohio known as Fort Ancient. Although Napora's emphasis on the idea of *site* is potentially productive of more Indigenous-focused understandings, the poem's elliptical movements and juxtapositions offer catalogs of destruction, including a page of tabular lists of "existing" and "destroyed" "earthmounds" followed on the facing page with the devastating lines "now: // all destroyed." The suggestion that the Serpent "starts / constant motion" is quickly followed by the declaration that this motion is "stopped," "locked / in time," "a knot tied." The poem ends with a melancholic meditation on the (purportedly) lost abundance of the past, when a balanced and generative earth provided all that was needed by those ecologically savvy natives who knew how to ask of the earth all the right questions: "This / union / provided a topography / which answered all *their* needs. // . . . When *we* asked" (emphasis added). Napora's shift in these final lines, from "their" needs to when "we" asked, is subtle but significant, a version of colonial appropriation through assertion of a universalizing discourse. Despite its emphasis on the specificity of place, *Scighte*'s vision is more limited than it asserts. Ultimately, the poem and the art book work not as citation of Indigenous accomplishment but as yet another diversion from actually engaging Indigenous individuals, communities, or traditions.

SEVEN

In autumn 2014, I had the unexpected opportunity to break from the Indigenous–settler binary and consider a view of the Serpent Mound from outside a North American context when I met Aku Wuwu, a prominent literary critic and scholar at Southwest University for Nationalities in Sichuan Province, People's Republic of China. Wuwu is also a well-published poet of the Yi ethnic minority who writes in the Yi language and Chinese. He was visiting my Ohio State colleague Mark Bender, a scholar of East Asian languages and literatures who has translated Wuwu's work into English. This was not the Yi poet's first visit to the United States or Ohio, and he had

asked to meet me because of my work on Indigenous literatures. During a trip to the States in 2005, Wuwu had met several Native Americans in different parts of the country and had visited earthworks in Ohio. Thinking about connections to his own traditions in southwestern China, he had composed a number of pieces about his experiences, including a poem titled "Indian Serpent Mound" in Chinese (in its English translation titled "Serpent Mound").[56] The poem is now part of a 2015 collection presented in Chinese with English translations, *Coyote Traces: Aku Wuwu's Poetic Sojourn in America.*

Wuwu's "Serpent Mound" is composed of four stanzas. The speaker situates the "mound of serpentine earth," "a great snake / ancient totem of Native peoples," within the Ohio landscape, speculates about its potential meanings, and attempts to relate the effigy and its meanings to the "wisdom of the East." On its own, the poem draws attention, foremost, for the seeming novelty of its Asian perspective on an Indigenous North American phenomenon, but also for the surprising level of perceptiveness in its descriptions and the subtlety of its expression in English translation. Read in conversation with and through the lens of the work of non-Native amateur and professional anthropologists, Native American writers and intellectuals Hedge Coke, Howe, and Mojica, the African American (or Afro-Native) writer and intellectual Walker, and non-Native poets like Bradley, Oliphant, and Napora, the poem draws additional attention, especially to the first line of its second stanza, which begins the speaker's series of speculations about the effigy's possible purpose and meaning. In this first line, the speaker situates the Serpent "Beside the ancestors' tombs"—that is, in proximity to, but distinct from, burial mounds. As in the work of Hedge Coke and Mojica, the mound is understood as part of a larger complex of earthworks, and there is significant relationship to burials but no conflation.

Having established this key distinction, the speaker suggests the builders of the effigy may have used "the power of the snake / to prevent invaders from disturbing / their forefathers' sacred space," from disturbing the burial mounds, but immediately notes the effigy's proximity, as well, to water. "As snakes are also symbols of rivers," the speaker states, "Native

civilizations / were inseparable from / the ancient rivers of North America." The speaker intuits the importance of rivers for sustenance but also their importance for travel and movement, their function as Indigenous super-highways. In the third stanza, the speaker speculates further that Serpent Mound may have been "a cipher" of Native "migration routes," that it may have "mark[ed] recognition of / the directions," that it may have been "—perhaps— / a shrine to worship heaven and earth." In other words, the speaker imagines multiple purposes and multiple alignments.

The poem ends, in the fourth stanza, with the provocative idea that "ancient Natives / took the land of North America as a canvas" upon which they created "cryptic portraits" "with their feet." As in the recognition of the importance of rivers, in this final image the speaker emphasizes movement and links this intentional, purposeful movement on and across the land—the "ancient Natives" do not *find* but rather *take* the land "as a canvas"—to Indigenous expression, self-representation, and wisdom. Although his speaker does not hear voice or song emanating from the mound, none-theless, similar to Hedge Coke, Howe, and Mojica, the Yi poet perceives the effigy's "snake shape" as embodied story. He imagines the Serpent Mound not as emblem of death or loss but as enduring evidence of embod-ied Indigenous performance.

These themes of the Serpent's relationship to rivers and to the perfor-mance of power, and of the land serving as a canvas for encoding layers of knowledge, help frame the analysis of an additional complex engagement with the effigy I pursue separately in chapter 2, "River Revere."

River Revere

The Banks of the Ohio brings to form a serpent, an image common to many
Native American traditions, including those of the Moundbuilders of the
Ohio River valley and [Jimmie] Durham's own Cherokee culture.
– Sarah Rogers, "Introduction: Poetry and Politics,"
from the *Will/Power* exhibition catalog (1993)

I remember the living
building earthworks all along my banks
– Allison Hedge Coke, "River," from *Blood Run* (2006)

The Banks of the Ohio first caught my attention as a provocative mnemonic.
Constructed from found and repurposed materials by the controversial
artist, poet, essayist, and activist Jimmie Durham, who claims a Cherokee
ancestry and heritage, and part of the *Will/Power* exhibit on view at the
Wexner Center for the Arts in Columbus, Ohio, in the autumn of 1992, this
multimedia installation of a massive horned serpent—trailing mud as it
undulates through the white space of the gallery—explicitly responded to
the colonial amnesias and settler erasures that were ongoing in the offi-
cial observances of the Columbus Quincentenary. Seeming to erupt from
within the austere aesthetics and rigid geometries of the Wexner Center's
renowned architecture, *The Banks of the Ohio* sinuously articulated the per-
sistent mobility of Indigenous discourses and the persistent messiness of
Indigenous memory. But as I gathered my own found and repurposed ma-
terials for the current project on contemporary engagements with earth-
works and earthworks principles, I became interested in the possibilities of
the sculpture's alignment with the Serpent Mound located ninety miles to
the southwest of Columbus in rural Adams County. Initially, my plan was
to incorporate a brief, focused reading of Durham's installation within the

range of analyses developed across chapter 1. The approach seemed straight-
forward: since Durham constructed *The Banks of the Ohio* during the thirty-
year period between the appearance of Alice Walker's figure of the Sacred
Serpent in her 1976 novel *Meridian* and the appearance of Allison Hedge
Coke's figure of the Snake Mound in her 2006 sequence of interrelated
poems *Blood Run*, I would consider how Durham imagines his figure of the
Serpent within the historical provocation of the Columbus Quincentenary
and within the situational irony of a gallery space marked as avant-garde—
the self-consciously postmodern architecture of the Wexner—but located in
the landlocked, midsize midwestern city improbably named for the fifteenth-
century Admiral of the Ocean Sea. In 1992, I would ask, did Durham follow
Walker to create a mysterious icon of Indigenous loss and death (the Sacred
Serpent imagined as isolated ossuary for the silent bones of the Indian
dead), or did he anticipate Hedge Coke to create an animate force able to
voice its Indigenous story for the living (Snake Mound imagined as invis-
ible but networked and articulate presence)?

Admittedly, my initial questions skewed toward predetermined an-
swers. Given what I had read of Durham's writing, and given what I knew
of his reputation for artistic innovation and political activism, I assumed
his sculptural work—which I had not examined in detail—must be antici-
patory of Hedge Coke's radical assertions of active Indigenous presence.
My questions quickly proved inadequate, however, as I began to appreciate
the complexity of Durham's installation: it does more than "imagine" the
Serpent effigy on a continuum between the seeming poles of Walker's static
representation and Hedge Coke's active performance. As suggested by the
syntactic sleight of hand in its title, *The Banks of the Ohio* imagines *through*
and *beyond* the Serpent to incorporate both the gross materiality and the
subtle symbolic power of the constant but ever-changing Ohio River lo-
cated to the effigy's south.

In 2016, as I began to research the installation and its relevant contexts
in earnest, publicity began to circulate for *Jimmie Durham: At the Center of
the World*, the first North American retrospective of Durham's artworks pro-
duced across multiple media since the 1980s. The retrospective would be
on view at the Hammer Museum in Los Angeles between late January and

early May 2017, then travel to additional locations; it would not, however, include *The Banks of the Ohio*, which, as I explain below, is no longer extant.[1] Once opened, the retrospective brought renewed attention to the breadth and eclecticism of Durham's work, but also to perennial suspicions that Durham might not be what he and others have claimed, namely, a person of Native American descent and, more specifically, a person of Cherokee descent. Across 2017 and 2018, retrospective-inspired suspicions and open accusations appeared in diverse outlets, including the Native press, but especially in the pages of art magazines, on art websites and blogs, and across social media; the accusations, in particular, took a variety of tones, from mournful and disappointed to analytic and sober to angry and cynical. Often, they were linked to similar accusations against other artists, writers, and scholars: of wannabe-ism, of "playing Indian" for self-aggrandizement or profit, of ethnic fraud.

Anticipating and then visiting the retrospective in early 2017 provided an opportunity to place my evolving understanding of Durham's installation within the context of his larger body of work. But the question of who can and cannot—or who should and should not—claim an Indigenous identity in the United States (or Canada or elsewhere) was not the impetus for my interest in *The Banks of the Ohio*, and these issues are not central concerns of the present chapter. In the wake of the controversy, however, readers may expect scholarship on any aspect of Durham's work to take a firm stand on the artist's identity.

I read a broad range of the accusations as they appeared in print and online. Although some of these seemed less than fully cognizant of the multigenerational traumas inflicted by U.S. settler colonialism and others seemed unable to grasp the sly complexities of Durham's critiques of Native American identity politics (such as the implied irony of his repeated statement that he is "not a Cherokee artist"), many were nuanced, well researched, and well argued. As I draft this chapter, I remain supportive of the perspectives of Cherokee nationalists, such as the artist and curator America Meredith, who highlight the long history of Native stereotypes perpetrated by non-Native outsiders and pretenders and who insist on the critical necessity of promoting Native self-representation.[2] At the same

time, I am also persuaded by the perspective articulated by the Comanche intellectual, art critic, and National Museum of the American Indian curator Paul Chaat Smith, who has been a friend and colleague to Durham since 1974, when both were involved with the American Indian Movement and its activism on behalf of Native Americans. Smith provided a brief framing essay for the retrospective's handsome catalog; there, he takes his cue from the fact of his sustained friendship with Durham over more than forty years as well as from the fact that Durham has lived outside the United States since 1987 (he was living in Mexico when he created *The Banks of the Ohio*) and in Europe since 1994. Titled "Radio Free Europe," Smith's essay does not raise questions about Durham's asserted Cherokee ancestry and heritage. On the contrary, Smith concludes the essay by extending his personal confidence in the legitimacy of Durham's Cherokee identity to the entirety of Indigenous America. He writes:

> Another Durham quote applies here, the one that says, "Europe is an Indian project." How cool is that?
>
> But what it suggests to me is that Jimmie Durham, stone-cold Cherokee Indian, even named for the famous country singer Jimmie Rodgers, like so many other Cherokee sons of the 1940s, is a lot of things, and one of them is this: Jimmie Durham is an Indian project.
>
> Perhaps all I'm really saying is that even more than needing him, we really miss him [now that he lives in Europe]. The Red Nation wants him back.[3]

The writing of Smith's essay for the exhibition, of course, predates the public accusations that began to circulate after the retrospective opened in Los Angeles. The exhibit's move to the Walker Art Center in Minneapolis in June 2017 generated a second round of critique, including from a group of enrolled Cherokee tribal members, artists, and academics and from a group of Minneapolis-based Native artists and curators.[4] Smith was invited to the Walker to deliver a public address. Presented to a live audience on August 31, the talk was published on the Walker's website as an essay titled "The Most American Thing Ever Is in Fact American Indians: On Jimmie

Durham, Native Identity, and *Americans*, the Forthcoming Smithsonian Exhibition."

For his audience at the Walker, Smith frames the central issues in these terms:

> So the most incendiary, and also the most interesting, charge leveled at Durham is that he is a white man who for decades has perpetuated ethnic fraud. I believe this to be untrue, and I'll explain why. While I know positions have hardened, and I'm not likely to convince those who've argued the other side, I do want to start with some areas of agreement. I agree Indian nations in the United States must be the arbiters of who is a citizen and who is not. I agree many tribes have been harmed by people who falsely claim tribal citizenship or cultural affiliation. I agree tribal sovereignty is always, to greater and lesser degrees, under attack, and there's no guarantee it will exist in 20 or 50 years.[5]

In his typically wry style, Smith explores possible scenarios for understanding Durham's identity but states that what he believes is "Jimmie Durham was born into a Cherokee family, has never considered himself anything but Cherokee, and neither did anyone else in his family" (8). Smith then describes Durham's well-documented antipathy toward the colonial construct of tribal enrollment, and he comments on the irony of contemporary artists and scholars celebrating Indigenous activism but unquestioningly bowing to the "state authority" of tribal governments on issues like identity (10, 12).[6] He moves toward conclusion to this part of his address by noting that the heaviest criticisms have been directed at the non-Native curators, scholars, and critics who supported Durham and his career over the decades, rather than at their Native counterparts:

> On the other hand, the campaign is much too lenient with scores of well-known Indian artists and curators who have supported Durham since the 1970s. These are people who should be held to account for enabling the alleged fraud to continue. People like myself. Why are you giving us a pass? We all knew Jimmie was not enrolled, and we also

knew he fundamentally disagreed with that very concept. We all knew
his Cherokee identity was controversial. I can assure you if myself or any
of these colleagues believed Jimmie was a white man, they would not
have exhibited with him or written about him. What most of us thought
was that his not being enrolled was not determinative of whether some-
one was Cherokee or not. [It] is fine to disagree with that position, but
it feels cheap to denounce the Lucy Lippards and barely mention the
many leading Native writers, artists, and scholars who never saw what
was so blindingly obvious to those critics. (12)

Smith ends the section with this reflection on self and community: "So it
brings me back to an even bigger question than who is Jimmie Durham?
And that is, who are we?" (16).

Resolution to the controversy seems unlikely in the near future—
perhaps ever. In light of the position taken by the Cherokee Nation and
by respected Cherokee artists and intellectuals, I considered minimizing
or removing my analysis.[7] In the end, though, I decided to proceed in the
spirit of chapter 1, which reads across Indigenous and non-Indigenous en-
gagements with and performances of the Serpent Mound effigy. Durham's
1992 intervention remains an instructive episode in the ongoing story of the
mound, and in what follows, I situate *The Banks of the Ohio* within the com-
plexities of its original contexts and, as far as possible, I assess its potential
for signification on its own artistic and rhetorical terms. As this approach
reveals, the political commentary achieved in Durham's composite instal-
lation not only encompasses the history of the effigy's near-destruction,
reconstruction, and ongoing colonial capture within the state memorial but
also exposes a broader, often disavowed history that extends across and
through the Ohio River's expansive valley—an erased history centered on
the violent expropriation and militarized settlement of Indigenous lands.

SMEARING THE WHITE WALLS OF THE WHITE MUSEUM

One of the ironies in staging a career retrospective, especially for an art-
ist celebrated for creating site-specific and site-dependent works, is that

most if not literally all of the pieces gathered for this special event will be removed from their original installations both temporally and spatially—geographically and, often, institutionally—and thus these works will be removed from a significant component of their interpretive contexts and have removed from them a significant component of their ability to produce certain kinds of meaning. It is an interesting museological and curatorial challenge, perhaps made all the more ironic in the context of work by an artist who claims descent from an Indigenous nation famously removed from its homelands, and it is similar to challenges raised within literary and cultural studies when we attempt to read, interpret, and understand all manner of texts outside their original contexts. That said, as a scholar whose work is anchored primarily in literary interpretation, I want to *focus on* rather than *blur* the distinction between visually encountering three-dimensional art objects that occupy physical space in particular locations at specific historical moments, on the one hand, and reading various kinds of (relatively mobile and transhistorical) alphabetic texts, on the other. At least for the moment. In a broad sense, my analysis depends upon remaining mindful of both the critical distinction and the tempting blur.

This chapter encounters, in order to read, one of Durham's art objects that was not on display at the Hammer Museum and other venues for the controversy-sparking retrospective in 2017 and 2018. *The Banks of the Ohio* is perhaps most accurately described as a large-scale sculptural assemblage. Constructed from multiple sizes of repurposed lengths of green PVC pipe, mud, and tree roots, Durham's horned serpent was site-specific and temporally bound; it was ephemeral in the sense that it existed as a three-dimensional *presence* only in a particular spatial location and only for a limited period of time. At the completion of the *Will/Power* exhibit for which it had been created, *The Banks of the Ohio* was dismantled and its principal components either scattered or destroyed. Access to the sculptural assemblage and to the afterlife of its material existence is now restricted to published and online images, such as the striking photograph shot from a perspective close to the serpent's mud head and tree-root horns showing part of the serpent's PVC pipe body supported by industrial cables and a section of gallery wall marked with smeared mud (Figure 5). There are also

FIGURE 5. Jimmie Durham, *The Banks of the Ohio*, 1992 (installation view). An image shot from a perspective close to the serpent's mud head and tree-root horns shows the PVC pipe body supported by industrial cables and a section of the white gallery wall marked by smeared mud. Photograph: Darnell Lautt. Collection of The Ohio State University (1993.001). Courtesy of the Wexner Center for the Arts.

several published accounts of the work in situ, written by the exhibit's cu-rator and by individual viewers, critics, and scholars. Finally, there is a set of less easily accessible archival materials stored at the Wexner Center for the Arts, where Durham researched, planned, and constructed this work. These lesser-known archival materials provide a primary driver for my own analysis and interpretation.

As already suggested, the cleverly worded title of Durham's sculptural assemblage makes an obvious gesture, if not a clear reference, to the Ohio

River, the anglicized name of which derives from the Iroquoian or Seneca *ohi:yó*, "good river." Popular historical accounts typically acknowledge that, following the Revolutionary War, between 1787 and 1803 the river served as southern border for the Northwest Territory (the full title of which was the Northwest Territory of the River Ohio). These accounts also typically acknowledge that, since 1803, the river has served as southern border for the U.S. state that bears the good river's name—and perhaps takes it in vain. What these dominant accounts often minimize or simply erase, however, is that during the turbulent years between the conclusion of the Revolutionary War and the creation of the state of Ohio, the "banks" of the river served as the asserted boundary between territory controlled by Indigenous peoples, represented by the large confederation known as the United Indian Nations, and territory controlled by the fledgling but already expanding United States. As Abenaki scholar Lisa Brooks demonstrates in *The Common Pot: The Recovery of Native Space in the Northeast* (2008), the United Indian Nations asserted that the bountiful lands and waterways situated between the River Ohio and Lake Erie served as a "Dish with One Spoon": a "geographic-social configuration" of Indigenous territory that was vital for providing communal support and sustenance, but also a "political concept" of mutual respect among sovereign Indigenous nations that was vital for enacting cooperative opposition to encroaching U.S. forces.[8] As we will see, Durham evokes the complexities of this often erased political history in the subtle gestures and seemingly obscure allusions of his installation.

The title for the present chapter gestures, however, not only to the fact of the River Ohio and the significant roles it has played regionally and nationally for both Indigenous and non-Indigenous peoples, but also to these evocative lines voiced by the persona Clan Sister in Allison Hedge Coke's *Blood Run*:

> Her lifespan eternal, star roads high.
> Her inimitable presence stippled,
> patterning our world.
> She River, we revere.[9]

In her sequence of highly patterned and mathematically encoded poems, discussed at some length in chapter 1, Hedge Coke gives precedence to the central and life-giving River—with a capital *R*—as the first persona to speak. Positioned as the first poem in section II ("Origin"), River asserts her memory of vibrant earthworks construction in the past, as quoted in the epigraph at the head of this chapter, as well as her continued devotion to the "cherished" dead who "from my wellspring / to my journey's foot / . . . rest along me still" (13). At the center of this opening soliloquy, River voices a detailed critique of the intrusion of non-Indigenous "others," those who refused to acknowledge the "generations lain out before them" in the mounds and "mostly respected only themselves," and whose descendants now "dare claim me . . . as if I were not betrothed" (13). In River's impassioned account, these "others" did not simply arrive at Blood Run but were "summoned" by a force she identifies as "the Changeling"—with a capital *C*—imbuing the history of European and U.S. colonialisms with connotations of malicious temper and voracious appetite, what she condenses as "reckless squander" (13). More subtly, despite the ongoing intrusions of the descendants of these summoned "others," River indicates her ability, when necessary, to breach her banks and reclaim what has been "harnessed" and "bridled." "Devoted" to her cherished "People"—with a capital *P*—River's "pace" remains ever "watchful" (13).

River makes a second appearance at another powerful numerical juncture in *Blood Run:* the sixteenth poem in the book's third section, which is simultaneously the forty-fourth poem in the overall sequence. Here River asserts her central role in facilitating the massive network of "trade" at Blood Run, the "Marketplaces from time before silver," and how all roads from near and far once led to the "private ways" between her banks (60). In the second half of the poem, River connects her ongoing presence to the maintenance of the site's accessible Memory—with a capital *M*—through "tooled stone," that is, through encoded material objects "still" on-site (60). Hedge Coke's positioning of the poem emphasizes River's relationship to the sacred number four (16 = 4 x 4, four squared, or four made two-dimensional), as well as to the 176 mounds that were extant when the Blood Run site was surveyed at the end of the nineteenth century (176 = 4 x 44).

As discussed in chapter 1, we can follow the math to note, further, that the total number of persona poems in the sequence, sixty-four, is the cube of four (64 = 4 x 4 x 4, or four made three-dimensional); these multiple mathematical alignments are part of the structural brilliance and Indigenous aesthetics of *Blood Run*.

Although River speaks only twice across Hedge Coke's sequence, other personae repeatedly allude to River and her unparalleled power, especially the collective physical entity The Mounds and the singular spiritual guide Clan Sister. In her fourth appearance, for instance, positioned in section III ("Intrusions"), Clan Sister prophesies: "River will come for them [the intruding "others"]. / She only rests till time / needs her to bathe, wash over" (62). In her sixth, penultimate appearance quoted above, positioned in section IV ("Portend"), Clan Sister links River—again, with a capital *R*—first to snakes, because of the similarity of their sinuous shapes and ability to remake themselves in the regular shedding of their skins, and then to the sense of reverence—fear and awe—provoked by River's sinuous movements and world-making power (80). The Mounds, in their seventh, final appearance, positioned as the seventh poem in section IV (seven is the fourth prime), reiterate this connection between Snake Mound, which they describe as an "elegant effigy" whose purpose is "immaculate," and Clan Sister's prophecy of River's power:

> When the animals leave this place,
> now without protective honorary sculpture.
> When River returns with her greatest force.
> .
> when The Reclaiming comes to pass,
> all will know our great wombed hollows,
> the stores of Story safely put by.
> All will come to truth. (82)

River makes her most powerful appearance in the book's second narrative poem and second poem in the epilogue, "When the Animals Leave This Place," with which Hedge Coke concludes her poetic sequence and fulfills

Clan Sister's prophecy. In eighty-nine lines (the twenty-fourth prime), and in the imagery of the serpentine River flooding her banks to reclaim Blood Run, Snake Mound's sinuous promise of world renewal is brought to physical fruition. The poem and the sequence end with the three words (and four syllables) "It has begun" (92).

One of my arguments in this chapter is that, similar to Hedge Coke's remarkable sequence of earthworks poems, Durham's mud-trailing sculptural assemblage links a central River both to the symbolic power of snakes and to the sense of awe provoked by River's dynamic and disruptive *presence* across space and time—a presence that is not only material but also political. Durham assembled *The Banks of the Ohio* in autumn 1992, the year of the Columbus Quincentenary, on-site at the Wexner Center located on the campus of The Ohio State University in Ohio's ironically named, landlocked capital city, Columbus. As already noted, the assemblage was part of the exhibit *Will/Power*, one of the many responses to the Columbian legacy staged by artists, writers, scholars, and activists across the Americas and parts of Europe during the several years leading up to and then throughout 1992.[10] The Columbus location only heightened the sense of the exhibit's irony and inevitability.[11] Curated by the Wexner Center's director of exhibitions, Sarah Rogers, *Will/Power* ran from September 26 to December 27; it featured aesthetically challenging works by six U.S. artists of color, including two identified as Native American: the celebrated Cheyenne and Arapaho provocateur Hachivi Edgar Heap of Birds and the equally celebrated if controversial Jimmie Durham.[12]

The images of Durham's assemblage included in the exhibition catalog emphasize the two ends of the long serpent constructed from one hundred running feet of multiple sizes of PVC pipe rather than the sculpture as a whole. At one end, the evocative mud head with horns of tree roots, followed by the broadest section of the PVC pipe body—the long throat, its diameter cradled and its weight supported by a metal harness suspended from the ceiling on industrial cables—is directed toward and rises above a narrow set of stairs (Figure 6). At the other end, the narrowing, trailing tail similarly rises from the gallery floor, angling toward the ceiling—no harness necessary for the lighter, smaller pipes (Figure 7). In this way, the

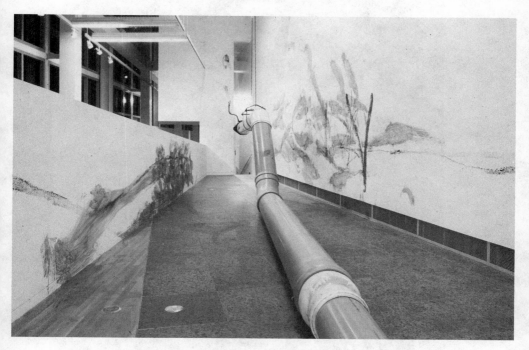

FIGURE 6. Jimmie Durham, *The Banks of the Ohio*, 1992 (installation view). An image from the *Will/Power* exhibit catalog shows how the serpent's PVC pipe body and mud head are directed toward the set of stairs located at the apex of the Wexner Center's triangle-shaped Gallery B. Photograph: Richard K. Loesch. Collection of The Ohio State University (1993.001). Courtesy of the Wexner Center for the Arts.

official images emphasize one of the difficulties experienced by visitors to the exhibit: just as no earthly location allows viewers to see a river from its "wellspring" to its "foot," and just as no location on the ground allows viewers to see the Serpent Mound from its coiled tail to its complex head, the physical space of the Wexner's wedge-shaped Gallery B affords no vantage from which viewers could see the large sculptural assemblage in its entirety. Visitors were forced to move through the exhibit space, around different parts of the assemblage, and into the adjacent Gallery A in order to visually piece together the components of the serpent from multiple partial

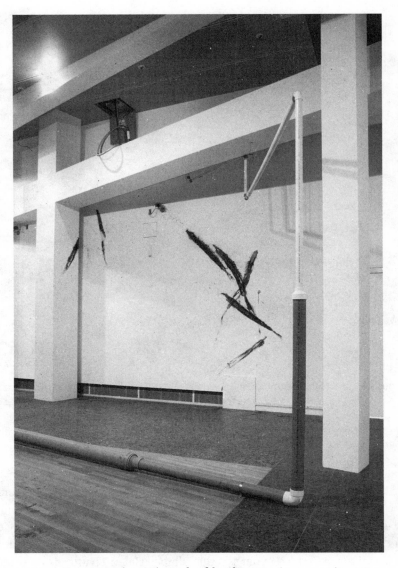

FIGURE 7. Jimmie Durham, *The Banks of the Ohio*, 1992 (in-process image). An image from the *Will/Power* exhibit catalog shows how the serpent's narrowing PVC pipe tail angles toward the ceiling. Photograph: Darnell Lautt. Collection of The Ohio State University (1993.001). Courtesy of the Wexner Center for the Arts.

perspectives. These images also emphasize the dark mud smeared on the floor and especially on the white walls of Gallery B, which evoke the serpent's own sinuous movements through the gallery and perhaps through other real, imagined, or symbolic spaces.

In the catalog these two primary images of the assemblage sit on facing pages, visually connecting the two ends of the serpent, while a third image, by itself on a subsequent page, shifts perspective again to demonstrate how the serpent's head cannot be viewed directly while standing within Gallery B. To view the serpent's head straight on, viewers had to exit Gallery B and walk down the access ramp to Gallery A. The two galleries are also joined by a narrow set of stairs, positioned at the apex of the triangle-shaped Gallery B and the northeast corner of the square-shaped Gallery A. To encounter the serpent's mud head and long PVC pipe throat rising in the narrow gap above the head of these stairs, viewers had to stand at the bottom of the narrow staircase in Gallery A. I will have more to say about the Wexner's distinctive architecture and the specific siting of Durham's assemblage further along in my analysis.

Only two works of scholarship offer detailed interpretations of *The Banks of the Ohio*, published twenty years apart. In 1995, three years after *Will/Power*, the feminist film theorist Laura Mulvey published "Changing Objects, Preserving Time" as part of the influential Phaidon book she co-edited titled *Jimmie Durham*.[13] In 2015, at a significant remove from the exhibit, the literature and culture scholar Monika Siebert published "Of Turtles, Snakes, Bones, and Precious Stones: Jimmie Durham's Indices of Indigeneity" as part of her monograph *Indians Playing Indians: Multiculturalism and Contemporary Indigenous Art in North America*. In addition to these scholarly interpretations, at least three works of early description and criticism of *The Banks of the Ohio* were published in 1993, immediately following the *Will/Power* exhibit. These include "Jimmie Durham: Postmodernist 'Savage'" by the highly respected art critic Lucy Lippard, published in the February 1993 issue of *Art in America;* a formal review of the *Will/Power* exhibit by the art critic and curator Brian Wallis, published in the same issue of *Art in America;* and the introduction to the *Will/Power* catalog by the exhibit's curator, Sarah Rogers. These early descriptions and criticism provide

important clues for more fully situating Durham's work in its multiple contexts that, surprisingly, the subsequent scholarship appears to have overlooked or ignored.

In her 1995 Phaidon essay, Mulvey takes a primarily psychoanalytic approach in her interpretation of Durham's sculptural assemblage. Her analysis is informed by two observations. First, that the multi-sized lengths of PVC pipe can evoke the modern conduits for sewage; and second, that the gallery's muddied white walls can evoke specifically human waste, that is, smeared excrement. Building from these observations, Mulvey interprets the assemblage as Durham's commentary on surfaces and what lies beneath them. "The piping is a conduit which connects the surface of the ground with its underneath," she writes; "it acts as a means of disposal . . . while also acting as a means of extracting."[14] Moreover, Mulvey explicitly links the physical conduit to a psychological conduit: "At the same time, Durham uses plastic piping as a conduit to the 'underneath' of memory." She brings these ideas together by stating: "The serpent carried or condensed the representation of the hidden and underground transformed into the visible and overground" (72). In her description of the mud smeared on the gallery's walls, Mulvey acknowledges the importance of visual perspective in apprehending the created image or images, but nonetheless she emphasizes her preferred idea that the mud represents sewage or, more specifically, excrement. She writes: "Close-by, the marks were shit-like in colour," while "seen from further back, the brown smears suddenly became elegant vegetal forms." But even at this remove, she argues that "the close-to effect remained and resonated with the presence of the pipes as cloaca, the transporters of contemporary shit through the landscape, usually invisible and underground but here monstrously visible and on display" (72). The anatomical term *cloaca* derives from the Latin for "sewer"; in zoological contexts, it refers to the opening located at the end of the digestive tract in birds, reptiles, amphibians, most fish, and monotremes, upon which these creatures depend for the release of both excretory and genital products. Whether or not she is aware of this possibility, Mulvey's provocative word choice thus suggests that Durham's PVC pipes may be conduits not only for waste matter but also for contents that are potentially *productive.*

Despite her (Western) psychoanalytic approach, Mulvey links Durham's snake-like sculptural assemblage to the effigy Serpent Mound. In fact, late in the essay she describes the assemblage as a "tribute to the Serpent" (74). This alignment may have been overdetermined by the assemblage's construction in an Ohio gallery. What is striking, therefore, is not that Mulvey makes the connection but that she provides so little context for Indigenous earthworks in general or for the Great Serpent in particular. Although Mulvey appears to have visited the Wexner Center in 1992, she seems not to have taken the opportunity to also visit the Serpent. If she had, she would have seen that the effigy is not located literally "on the banks of the Ohio," as Mulvey's statements suggest, but rather on a distinctively arced ridge rising above Brush Creek and one of its tributaries, which flow south into the Ohio. In her brief description, Mulvey repeats statements about the Serpent found in standard textbooks and tourist guides rather than exploring more specific ideas about the mound's potential meanings or functions, especially as these might be understood from Indigenous rather than non-Native perspectives. She ends her account of earthworks with these words:

> Some, like the Serpent, have survived and act as a sign inscribed into the landscape of the civilizations that existed in pre-Columbian America and a testimonial to the complexity of their history. They also stand as a testimonial to the way that the amnesia, imported by settler communities, was imposed, blanket-like, on the past of the country and on its landscape. (74)

Mulvey concludes her analysis by stating: "Materials act as conduits for ideas from level to level, exploring different topographies of time in space and space in time" (74). Although she gestures toward important ideas about how Durham's assemblage makes meaning within the gallery space of the Wexner Center and within the region of central Ohio, she appears unable to bring the divergent parts of her analysis together to create a fuller understanding.

Before leaving Mulvey, it will be useful to point out two small but significant errors in her account. First, throughout the essay she consistently

misnames Durham's piece, adding a preposition and calling it "On *the Banks of the Ohio*" rather than *The Banks of the Ohio* (72, 74). And second, Mulvey describes the snake-like assemblage as originating in the "wall" of the gallery, when in fact Durham's mixed media sculpture originates in the ceiling (72). The latter detail, in particular, is central to my own analysis.

Monika Siebert's interpretation builds from Mulvey's, and it appears Siebert did not conduct independent research on either Durham's assemblage or the larger *Will/Power* exhibit. Following Mulvey's analysis from 1995, Siebert writes in 2015: "The metaphors of excavating buried Indigenous histories recur throughout Durham's body of work and culminate in *The Banks of the Ohio*." And following Mulvey's description of the exhibit, Siebert describes the assemblage in somewhat contradictory terms as "emerging out of the gallery wall . . . an ancient snake rising up from the modern-day sewer."[15] It is unclear how the figure's emergence "out of the gallery wall" links it to "the modern-day sewer" located below ground. What Siebert adds to Mulvey's analysis is an interpretation of Durham's cleverly worded title. She writes: "The title of the piece, taken from a popular nineteenth-century murder ballad . . . reinforces this dynamic of burying and exposure while also evoking the idea of the American continent's original sin" (150). Like Siebert, I noticed the potential connection between Durham's title and the well-known murder ballad "The Banks of the Ohio" (also called "On the Banks of the Ohio" or "Down on the Banks of the Ohio"). Murder ballads are a fascinating if disturbing nineteenth-century genre of American music, and this particular example has been available in commercial recordings at least since 1927, including performances by popular folk singers and country music stars Bill Monroe, Johnny Cash, Joan Baez, Dolly Parton, and Olivia Newton-John.[16] Within the genre's conventions, lyrics are typically sung from the perspective of a man who has murdered a woman because she refused his romantic overtures. Occasionally roles are reversed and lyrics are sung from the perspective of a woman who has murdered a man for similar reasons. In "The Banks of the Ohio" our man is "Willie," and he murders an unnamed woman who rejects his proposal of marriage. In the refrain, Willie entreats:

Darlin' say that you'll be mine
In no other's arms entwine
Down beside where the waters flow
On the banks of the Ohio[17]

The song contains multiple verses, but the following lyrics convey the narrative of unrequited love that results in murder:

I took her by her lily white hand
And dragged her down that bank of sand
There I throwed her in to drown
I watched her as she floated down
Was walking home 'tween twelve and one
Thinkin' of what I had done
I killed a girl, my love you see
Because she would not marry me

Siebert invites readers to interpret the lyrics as metaphor for the tragic history of settler-Indigenous relations, with the masculine settler suitor rebuffed by the feminine Indigenous object of desire, which can include both Indigenous peoples writ large and the expansive landscape of North America itself. Before reading Siebert's account, I was tempted to draw a similar analogy. In the end, however, I concluded that the details of the woman's "lily white hand," "golden curls," and so forth cannot bear the specificity, complexity, or weight of the long history of relations among settlers and Indigenous peoples across North America. I also find the details of drowning do not fully align with the trope of "burying and exposure" Siebert asserts.

That said, I do think Durham intends to gesture to the murder ballad and its disturbing themes, and I think he has some fun with potential readers/viewers, like many in literary and cultural studies, prone to one-to-one comparisons that overlook nuance and oversimplify relevant contexts. In other words, Durham exploits a potential red herring with his title,

a move consistent with his artistic and literary practice. As art historian Jessica Horton describes in detail, Durham is known for his "characteristic tool kit of humor and irony."[18] He is also known for attempting to produce art "not connected to metaphor," art without what Durham describes as "this descriptive, metaphorical, architectural weight to it."[19] I think he means to mislead and distract at least some in his potential audience. Durham's assemblage does engage the history of settler-Indigenous relations across the American continents, but not through the melodramatic binary presented in the ballad, in which the violently romantic murderer easily overwhelms his victim, who is emotionally resistant but physically passive. Siebert's assertions are especially suspect in light of the ballad's concluding lyrics, in which Willie is apprehended by the local sheriff and brought to justice. These are details Siebert chooses not to include in an otherwise detailed analysis:

The very next morn about half past four
The sheriff came knocked at my door
He said now young man come now and go
Down to the banks of the Ohio.

As I articulate below, in my own analysis it is the murder ballad's refrain that offers the most compelling detail for interpreting Durham's assemblage: "Down beside where the waters *flow*."

To move beyond what are at best partial interpretations begun by Mulvey and extended by Siebert, we have to return to the original descriptions and early accounts of Durham's assemblage published in 1993. Lucy Lippard's article is informed by its own set of observations about Durham's work from this period. First, Lippard observes that Durham's installations "confront the histories of specific sites."[20] This observation is confirmed by subsequent critics and scholars. In the essay she wrote for the 2017 retrospective, for instance, art historian Jennifer Gonzalez describes Durham's works as "nearly always site specific in his choice of materials and references, explicitly indicating the institution, the city, or the infrastructure of

his exhibition's location through carefully researched citations and locally gathered materials."[21] Second, Lippard observes that Durham's "sculptures break through the Western time frame that is supposed to confine them" (66). And third, she observes that "his 'archeological' works are also based on the notion of translation, or mistranslation" (68). With Lippard's 1993 observations in mind, the question becomes: How might we understand Durham's "confrontation" with "the history of a specific site" in relation to *The Banks of the Ohio*? Is the specific site the actual banks of the Ohio River, which run an expansive 981 miles, or is it the ancestral Serpent Mound situated on the arced ridge rising above the banks of Brush Creek? Is the specific site the ironically named city of Columbus, situated at the confluence of the Olentangy and Scioto Rivers, which, like Brush Creek, flow south to join the Ohio? Is it the 1,777-acre campus of The Ohio State University set along the banks of the Olentangy? Or perhaps the institutional space of the Wexner Center for the Arts? Is the specific site the broader region of the Ohio Valley, which eventually becomes part of the massive valley of the Mississippi? Or, given the staging of the *Will/Power* exhibit during the year of the Columbus Quincentenary, is the specific site the even broader region of what is now the United States, North America, or the Americas as a whole?

The exhibit's curator, Sarah Rogers, offers clues for addressing the complexity of this question in her introduction to the *Will/Power* catalog. As quoted in the first epigraph, Rogers writes: "*The Banks of the Ohio* brings to form a serpent, an image common to many Native American traditions, including those of both the Moundbuilders of the Ohio River valley and Durham's own Cherokee culture."[22] Based on her conversations with Durham during the building of the installation, she states: "The horned serpent created here is for the Cherokee's [*sic*] a symbol of the evening star: an embodiment of the passage from day to night, a condition of transition" (11–12). In other words, she asserts the serpent's potential to produce meaning both as a Native American symbol and as a specifically Cherokee symbol.[23] Rogers adds, moreover, that "for Durham, the serpent is also an apt metaphor for this region's history, which he sees as a succession of

transitions and contradictions—rather than as the isolated 'great events' and 'discoveries' written about in history books" (12). This statement may be influenced by an essay Durham wrote for the catalog for a different exhibition, *The Decade Show: Frameworks of Identity in the 1980s*, published in 1990. In that essay, "A Central Margin," Durham contrasts dominant understandings of the history of the United States as "authorized texts about the past" with a conception of that history understood, instead, as "a continuity of events, of causes and effects."[24] For Rogers, this emphasis on "a succession of transitions and contradictions" and "a continuity of events" refocuses attention on the mud evocatively smeared on the gallery's floor and white walls. In contrast to Mulvey, who asserts the mud should be read primarily as excrement, Rogers describes how "the final detail of the installation is the serpent's tracks—mud-splattered traces on the walls that chart the serpent's conquest of this territory" (12). Note the difference between how Rogers assigns agency to the serpent and how agency is ascribed in the accounts produced by either Mulvey or Siebert.

Finally, in contrast to both Mulvey and Siebert, who incorrectly describe the serpent as originating from the gallery wall, Rogers accurately observes how "the serpent . . . emerges from the electrical box in the ceiling as if a creature of this odd technology" (12). This detail in particular broadens potential interpretations of Durham's assemblage. The serpent does not just originate from the ceiling; it emerges specifically from the electrical box. The image included in the exhibition catalog suggests this feature was not only visible to viewers standing in Gallery B but was perhaps prominent. (The prominence of the electrical box was confirmed during my own visits to the Wexner.) Of course, viewers would need to recognize what they were seeing in order to register why the detail might be significant. Two ideas immediately come to mind, especially in light of what we know about potential understandings of the extant Serpent Mound in southern Ohio and other earthworks sited across the North American continent. First, in originating from the ceiling rather than from the wall or floor, the horned serpent, typically a symbol of the below world, is connected to the above world.[25] And second, in emerging from the electrical box rather than

from an inert ceiling tile or panel, the serpent is connected to a source of energy—literally to a source of *power*. The serpent can be understood, and perhaps experienced, not only as static *object* but also as animate *presence*. Like the massive river suggested by Durham's title, the massive serpent emanating from the electrical box possesses not simply accumulated *charge* but dynamic *current*—power *on the move* in a particular direction.[26]

Adding Brian Wallis's review of the *Will/Power* exhibit provides an additional detail absent from other accounts as well as from most published photographs. In his brief description of Durham's installation, Wallis writes: "This work embraced complex references that were elucidated in the 'drawings' pinned up around the gallery: collages of real snakeskin, historical maps of the Ohio River, sketches of the Great Serpent Mound in Chillicothe."[27] What were these "drawings," and why does Wallis immediately raise questions about their status by placing *drawings* in scare quotes? Were there actual drawings in addition to collages, maps, and sketches? Where, precisely, were they "pinned up around the gallery"? And why are they not mentioned by Mulvey, Siebert, Lippard, or Rogers? The "drawings" are not visible in any of the photographs published in the exhibit catalog. They are also not clearly visible in any of the photographs included in the Phaidon book coedited by Mulvey—although, once a viewer has in mind that there should be "drawings," their presence can be discerned in one of the Phaidon photographs as indistinct marks on the gallery's north wall, the base of the wedge shape. No details, however, are visible. After reading Wallis's review and scrutinizing the published photographs, in February 2016 I contacted the Wexner Center to inquire whether they had retained any record of Durham's "drawings" from the 1992 *Will/Power* exhibit. What the registrar unearthed from the archives was unexpected, both for me and for the current curatorial staff, who also were unaware of these works.[28] The Wexner generously provided a range of relevant digital images; then, in April 2018, I was able to visit Columbus to examine the originals.[29] Contra Mulvey, Durham's pieces extracted from the bowels of the Wexner were not "shit" at all. Far from waste material (human or otherwise), the "drawings" proved highly productive for my own analysis.

SNAKES, CENTERS, AND CENTRAL MARGINS

The pieces Wallis describes as Durham's explanatory "drawings" comprise a series of eight works on paper. Most can be described as composite, and seven of the works might best be described as "collages." The seven collages range in size, but most measure between approximately 6" x 14" and 9" x 16". The backing for each is a section from a copy of either the architectural floor plans for one or more of the Wexner Center's main galleries, labeled A, B, and C, or the construction schematics for the Wexner Center complex, in part or as a whole. Onto these sections of floor plans and construction schematics Durham has added various elements, including his own drawings of sinuous, snake-like shapes or lines in black marker (these are perhaps what Wallis refers to as "sketches of the Great Serpent Mound"); fragments of "found" language carefully cut from what appear to be standard history texts (which Wallis does not mention); and lengths of "real snakeskin" (as Wallis suggests). There are no historical maps of the Ohio River among the collages. The eighth work better fits the conventional definition of a drawing, but it is more accurately described as a print, specifically as a woodcut. This work, also on paper, depicts a human portrait or portraits, although it too is composed from cut fragments.

As already noted, none of the eight works on paper appears in any of the photographs of *The Banks of the Ohio* included in the *Will/Power* exhibit catalog. If viewers know what to look for, two of the works are faintly visible in the distance in one of the photographs included in the Phaidon book *Jimmie Durham;* neither Mulvey nor Siebert, however, comments on the presence of these works in their analyses of the installation. As the Phaidon photograph makes clear, the works on paper were located at a distance from the assembled serpent's large mud head and massive PVC pipe body, as well as at a distance from the mud-smeared west and east walls of the wedge-shaped Gallery B, which, understandably, are the primary subjects of the published images. The seven collages were pinned to the three walls of an alcove-like space located at the north end of the gallery, the base of the wedge or triangle shape. The alcove is formed by a short west wall that conceals the narrow set of stairs leading from Gallery B up to Gallery C, the north "back" wall, and a short east wall next to the main entrance to Gal-

lery B from the access ramp. One or more of the collages were placed on
the short west wall that conceals the staircase; the Phaidon photograph in-
dicates that at least two of the collages were placed on the north back wall;
one or more of the collages were likely also placed on the short east wall of
the alcove. The collages were thus located as far away as possible from the
serpent's mud head, positioned at the apex of the triangle at the south end
of the gallery, where the east and west walls converge at the head of the
narrow set of stairs leading down to Gallery A. The eighth piece, the frag-
mented human portrait or portraits, was positioned behind one of the gal-
lery's supporting pillars, also at the north end near the alcove. It too was not
easily photographed from any angle that would have captured the drama
of the serpent's horned head and PVC pipe body or the gallery's white walls
provocatively smeared with mud.

Beyond the single photograph in the Phaidon book, evidence for the place-
ment of the works on paper comes primarily from the Wexner Center's ar-
chives. A September 1992 "Incoming Receipt" records an acquisition from
"J. Durham": "8 drawings," along with "PVC pipe" and a "paper-mache snake
head (constructed on-site)."[30] Attached to the typed form of the receipt is a
two-page handwritten "report" that briefly describes each work on paper
and its physical condition. Although the notes are undated, details such
as "single nail holes in each corner" suggest they were made after the ex-
hibit was taken down, as the items were prepared for storage in the archive.
Differences in handwriting and ink color suggest two individuals con-
tributed to the report. A first author, writing in blue ink, produced notes
for the seven collages. At the top of the first page, this author has written:
"Listed as pieces are displayed in gallery (from left to right)." A second au-
thor, writing in black ink, produced a single note for the eighth "work on
paper" and indicated the work's location as "(behind pillar)." During my
visit to the Wexner in April 2018, the staff conducted a thorough search of
the Wexner's extensive photographic files, and they were able to locate a
single image, taken during installation of the exhibit, in which part of the
first of Durham's collages is clearly visible at the right edge of the photo-
graph, confirming the work's location on the short west wall of the alcove at
the north end of the gallery, and confirming that the notes attached to the

"Incoming Receipt" are likely correct about the order in which the works were displayed in Gallery B "from left to right."[31] This photograph also indicates that viewers of the exhibit who stood in the alcove space to engage the works on paper would have been positioned behind the tail end of the serpent assemblage. Turning away from the seven collages and looking past the fragmented portrait or portraits of the eighth work pinned to the inconveniently placed pillar, viewers would see the smaller PVC pipes of the tail descending from the electrical box in the ceiling, the increasingly larger pipes of the body running south along the length of the wedge-shaped gallery floor, and the largest pipes rising as the throat and the horned mud head reached the apex of Gallery B's triangle at the head of the narrow set of stairs leading down to Gallery A (Figure 8).

For attentive viewers, the sequencing of the seven collages pinned to the three walls of the alcove creates a complex meditation on the multiple histories relevant to the site of the installation, a meditation that broadens the potential contexts in which the serpent might produce meaning and that expands the potential interpretive frameworks from which viewers might assess that meaning and form their own interpretations and understandings. The sequencing helps viewers see "a continuity of events, of causes and effects," despite the dominance of "authorized texts about the past."[32] Because they have not been viewed since they were exhibited in 1992, it will be useful to describe the collages in detail.

The base for the first collage is roughly square, and it is described in the handwritten notes as "11" x 15 3/4", Floor plan of Gallery B with snakeskin overlayed [sic]" (Figure 9). The wedge-shaped floor plan of the gallery and the access ramp that runs along its eastern wall fills the horizontal width of the paper, with the south-pointing apex of the triangle positioned on the left; the floor plan is nearly centered on the vertical axis of the paper, with similar margins of white space above and below. A printed label, centered below the floor plan, identifies the space as "Wexner Center for the Visual Arts/Exhibition Gallery B." In the upper left-hand corner of the paper, the word "copies" has been handwritten and underlined in pencil. Affixed to the triangular wedge of the gallery is a triangular wedge of snakeskin, bearing the distinctive brown-and-gold diamond pattern of rattlesnake.[33] The

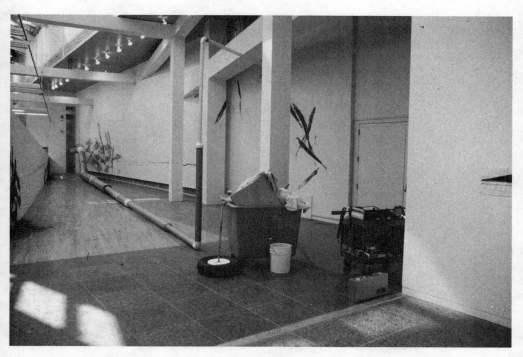

FIGURE 8. Jimmie Durham, *The Banks of the Ohio,* 1992 (in-process image). An image taken during installation shows the equipment used to apply mud to the gallery's floor and walls, as well as part of the first collage pinned to the wall of the alcove. Photograph: Darnell Lautt. Collection of The Ohio State University (1993.001). Courtesy of the Wexner Center for the Arts.

wedge of snakeskin completely covers the wedge of the exhibit space, leaving visible the access ramp that runs outside the east wall of the gallery, along with the printed descriptions of the wall's variable height. Near the south end of the ramp, the description states, "Wall height this end 42"," while just before the entrance to the gallery, near the north end of the access ramp, the description states, "Wall height this end 8' 3.5"."

The second collage is described in the notes as "9" x 16 3/16", Floor plan of Gallery B with snake tail drawn in marker" (Figure 10). The base of the

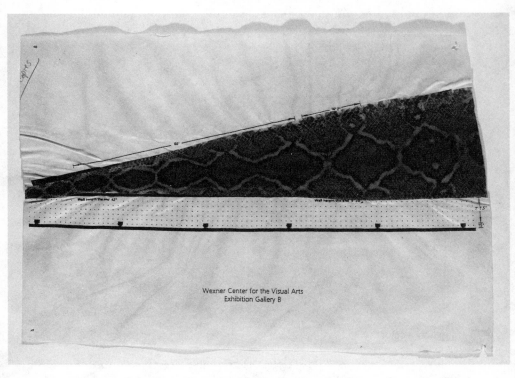

FIGURE 9. Jimmie Durham, *The Banks of the Ohio*, 1992. First collage: Xerox, snakeskin, glue on paper, 10 5/8" x 15 3/4". Photograph: Alan R. Geho/Ralphoto Studio. Collection of The Ohio State University (1993.001.003). Courtesy of the Wexner Center for the Arts.

collage is another "copy" of the floor plan for Gallery B; unlike in the first collage, however, the paper has been cut along the bottom so that the first line of the printed label, "Wexner Center for the Visual Arts," is only partially visible, and the second line, "Exhibition Gallery B," is completely missing. Durham has also cut a notch out of the upper left corner of the paper, where the word "copies" is written on the first collage, drawing attention to the narrow set of stairs located at the apex of the gallery's triangle. As indicated in the notes, Durham has drawn a snake-like, diamond-patterned shape across the floor plan in black marker. The drawing begins at the apex of the

FIGURE 10. Jimmie Durham, *The Banks of the Ohio*, 1992. Second collage: Xerox, ink, and found text collage on paper, 8 15/16" x 16 1/4". Photograph: Alan R. Geho/Ralphoto Studio. Collection of The Ohio State University (1993.001.004). Courtesy of the Wexner Center for the Arts.

triangle, as though the serpentine shape is an extension of the narrow set of stairs, briefly follows the angled line of the west wall, continues into the center of the gallery, more or less parallel to the straight east wall, passes one of the pillars, passes the entrance to the gallery from the ramp, moves into and through the alcove at the north end of the gallery and the base of the triangle. Unlike the snakeskin affixed to the first collage, the drawn snake shape in the second is not contained within the floor plan's outline of Gallery B; Durham's drawing extends past the gallery's north wall, past the printed notation of the wall's length, to and through the right edge of the paper base, suggesting the drawn snake continues to undulate beyond the frame. In addition to the drawing in black marker, Durham has affixed

FIGURE 11. Jimmie Durham, *The Banks of the Ohio*, 1992. Third collage: Xerox, ink, and found text collage on paper, 5 7/8" x 16 7/16". Photograph: Alan R. Geho/Ralphoto Studio. Collection of The Ohio State University (1993.001.005). Courtesy of the Wexner Center for the Arts.

to the paper base, in the upper left corner above the snake shape, a cutout fragment of "found" text. In line with the *Will/Power* exhibit's theme of response to the Columbus Quincentenary, the textual fragment alludes to details of Columbus's voyages to the so-called New World, and specifically to his economic motives for making the arduous journeys from Europe. The first printed line of the fragment has been carefully cut through the middle, so that the bottom half of the letters are visible but the text is largely indecipherable. The remaining lines read: "a crew of 140. He was looking for a western / passage to the Orient and its gold, silk and / spices."

The third collage is described in the Wexner notes in terms similar to those used for the second: "6 3/8" x 16 5/8", Floor plan of Gallery B with snake tail drawn in marker" (Figure 11). As the measurements indicate, Durham has cut a copy of the floor plan close to the outline of Gallery B, with no sig-

nificant border of white space above or below. He has drawn a similar snake shape, again appearing to emanate from the narrow set of stairs at the apex of the triangle and undulating through the gallery space and alcove, again exceeding the north wall at the base of the triangle and extending to the edge of the paper. Durham has also affixed a similarly cut-out fragment of "found" text, now placed along the access ramp at the left edge of the paper, below the narrow set of stairs at the apex of the gallery's triangle. Similar to the previous example, this fragment alludes to Columbus's voyages, now with a specific reference to the Admiral's interactions with Indigenous peoples. In addition, the fragment indicates one of the sources from which contemporary readers gain access to this history, namely, through the work of archaeologists. The fragment reads: "and the ways of the Arawak Indians who / traded with Columbus, the archaeologist / said." Note how the juxtaposition within the fragment's second line creates a sense of apposition: "Columbus" understood *as* "the archaeologist."

The fourth collage creates a shift both in scale and level of detail, zooming out from the relatively up-close aerial view presented by the simplified floor plan for Gallery B, which presents a basic outline of the gallery's interior space, to the more distant aerial view presented by the comprehensive construction schematic for the Wexner Center as a whole, which indicates intersecting interior and exterior spaces, as well as landscaping and adjacent structures, through a complex of lines, symbols, blocks, and both alphabetic and numeric notations. The notes describe this piece as "6 3/8" x 18 7/8", construction schematic of Wexner ramp, exterior walkway, and brick towers" (Figure 12). At first glance, the cutting of this long, thin section of the schematic appears haphazard, even poorly executed. Upon closer inspection, one sees a blunted wedge shape that emphasizes the orientation of the wedge-shaped Gallery B—and thus the orientation of Durham's PVC pipe serpent—toward the south, that is, pointing toward the Ohio River. Moreover, as indicated in the notes, Durham's cutting emphasizes how the central "spine" created by the parallel interior ramp and exterior walkway relates to the "brick towers" located outside the building, also toward the south. Indeed, Durham's careful cutting of this section of the schematic emphasizes how the wedge-shaped Gallery B points toward

FIGURE 12. Jimmie Durham, *The Banks of the Ohio*, 1992. Fourth collage: Xerox and glue on paper, 6 3/8" x 18 7/8". Photograph: Alan R. Geho/Ralphoto Studio. Collection of The Ohio State University (1993.001.006). Courtesy of the Wexner Center for the Arts.

the edge of one of the towers. Durham has added no drawing in marker and affixed no "found" text to this "collage"; the cut-out section of the schematic stands starkly on its own.

The fifth collage shifts back to the scale and relative simplicity of the floor plan. Rather than zoom all the way back to a focus on Gallery B, however, the base for this collage displays a middle view that encompasses plans for all three of the Wexner's galleries, clearly indicating how they are connected by the access ramp that runs along the east side and by the two narrow sets of stairs positioned on the west side. This collage is described in the notes as "6" x 14", Floor plan of all Wexner galleries" (Figure 13). Durham has left the expanse of white space above the plan but trimmed the bottom of the paper base just below the printed labels indicating Gallery A, Gallery B, and Gallery C. He has added no drawing in marker, but he has again affixed a cut-out fragment of "found" text, positioned to run above the angled west wall of

FIGURE 13. Jimmie Durham, *The Banks of the Ohio*, 1992. Fifth collage: Xerox and found text collage on paper, 5 15/16" x 13 15/16". Photograph: Alan R. Geho/Ralphoto Studio. Collection of The Ohio State University (1993.001.007). Courtesy of the Wexner Center for the Arts.

Gallery B, the site of his installation. In contrast to the previous fragments, this one does not refer to aspects of Columbus's Atlantic journeys that began in 1492 or his landings in the Caribbean and interactions with Indigenous peoples. Instead, this textual fragment focuses attention more locally on the region of what is now Ohio and more recently on the turn of the nineteenth century. Some of the letters at the edges of the fragment have been partially cut through; the discernible text reads:

> **nd Sales in Ohio.** William
> ison, the Northwest Territory's first delegate to Congress.
> introduced the legislation which became the Act of May 10, 1800. Thi
> Act opened the frontier to a "land office busin "
> (boldface in original)

With this third textual fragment, Lippard's observation that Durham's work "confronts" the "histories of specific sites" and Gonzalez's observation that Durham "explicitly indicat[es] the institution, the city, or the infrastructure of his exhibition's location through carefully researched citations and locally gathered materials" take on more focused meaning. Although Durham's assemblage engages the Columbus Quincentenary and the broad history of European "contact" and colonialism in the Americas, it also engages more locally with the specific history of Ohio. The fragment directs viewers to recall the figure of William Henry Harrison (1773–1841), who served as the Northwest Territory's first delegate to Congress in 1799. Although the brief fragment does not provide further details, some viewers will recall that, among his achievements, Harrison fought and defeated the Ohio-based Shawnee leader Tecumseh at the Battle of Tippecanoe in 1811, was promoted to the rank of major general during the War of 1812, and was elected the ninth U.S. president in 1840—and then died of pneumonia in April 1841, thirty-one days after taking the oath of office. The text does, however, direct viewers to recall a lesser-known detail from Harrison's biography, namely, that he introduced the federal legislation known as the Harrison Land Act. Durham's careful cutting of the fragment highlights the date of the legislation's enactment, May 10, 1800, as well as its primary effect: land sales. The key provision of the act was that settlers now had the opportunity to buy land in the Northwest Territory—that is, land claimed by the United Indian Nations—including land in what became the state of Ohio, directly from the federal government. Another provision was that settlers could make part of their purchase on credit. In this way, the act hastened the pace of non-Native settlement—and thus the pace of expropriation of lands claimed by the United Indian Nations—considerably. Ohio entered the Union as the seventeenth state in 1803; Columbus was named the state's capital in 1816; following passage of the infamous Indian Removal Act in 1830, all of Ohio's remaining Indigenous nations, including communities of Seneca, Delaware, Shawnee, Ottawa, and Wyandot, were forcibly removed by 1850; following passage of the Morrill Land Grant Act in 1862, the Ohio Agricultural and Mechanical College was founded in 1870.[34] The new college welcomed its first students in 1873, elevated its status

two of his leaky
a, Columbus de-
na and the Santiago
naica and built huts
crew while they

FIGURE 14. Jimmie Durham, *The Banks of the Ohio*, 1992. Sixth collage: Xerox, ink, and found text collage on paper, 5 7/16" x 13 7/16". Photograph: Alan R. Geho/Ralphoto Studio. Collection of The Ohio State University (1993.001.008). Courtesy of the Wexner Center for the Arts.

to Ohio State University in 1878, and, by the time of the Columbus Quincentenary and the *Will/Power* exhibit in 1992, asserted its prominence as *The* Ohio State University.

The sixth collage completes the shift in scale back to Gallery B. The notes describe this collage as "5 1/2" x 13 1/2", Floor plan of Gallery B with single marker line" (Figure 14). Durham has cut the paper so that the narrow set of stairs leading up to Gallery C, located at the northwest corner of the gallery, part of the base of the triangle, are no longer visible. As indicated in the note, Durham has drawn a single snake-like line through the gallery space, again beginning at the narrow set of stairs located at the apex of the triangle and extending through the north wall of the gallery to the edge of

the paper. Below this line, in the lower right corner, Durham has affixed another cut-out fragment of "found" text, again focused on Columbus and his voyages, now with an emphasis on the beginnings of settlement. Many words have been cut through, so that they can only hint at a specific reference. The fragment reads: "two of his leaky / a, Columbus de- / na and the Santiago / maica and built huts / e crew while they." The text appears to refer to Columbus's fourth voyage, when the *Santiago de Palos* numbered among his four ill-fated ships, and during which Columbus and his crew were stranded on the island of Jamaica.

Finally, the seventh collage, which completes the sequence, shifts scale again, zooming out to return to the construction schematic. This collage also returns to the medium of snakeskin. In the handwritten report, the components of the collage are described in two sub-notes: "1) 15" x 4 1/2", construction schematic of a portion of the Wexner Center" and "2) 13 5/8" x 1 1/8", section of snakeskin" (Figure 15). The length of snakeskin, again with the distinctive brown-and-gold diamond pattern of rattlesnake, was not affixed to the paper but rather pinned over the length of the construction schematic, so that only the edges of the schematic remain visible on either side. Durham thus begins and ends the sequence of seven collages with snakeskin, affixed to and filling the floor plan for the wedge-shaped Gallery B in the first collage, pinned to and running the length of the construction schematic for a portion of the Wexner Center in the last.

Across the works, the shifts in scale are highly evocative. Floor plans for the galleries form bases for five of the seven collages, while construction schematics for the Wexner form bases for two. Durham draws with marker on three of the collages with bases of floor plans for Gallery B, and he affixes fragments of "found" text to four collages, also with bases of floor plans for the galleries. Three of these fragments are cut from an unidentified text about Columbus and his voyages to the so-called New World; the fourth is cut from an unidentified text about Harrison and the settling of the Northwest Territory—the United Indian Nations' "Dish with One Spoon"—and the lands that became the state of Ohio. Similar to the placement of the snakeskin at the beginning and end of the sequence, the placement of the textual fragments creates a distinct pattern. Appearing in the

FIGURE 15. Jimmie Durham, *The Banks of the Ohio*, 1992. Seventh collage: Xerox on paper, 4 5/8" x 14 5/8", overlaid with snakeskin on canvas, 1 1/4" x 14 1/2". Photograph: Alan R. Geho/Ralphoto Studio. Collection of The Ohio State University (1993.001.009a and 1993.001.009b). Courtesy of the Wexner Center for the Arts.

second, third, fifth, and sixth works, the textual fragments are framed by the snakeskin in the first and seventh pieces and separated from each other by the unadorned piece of construction schematic in the fourth. This cut-out construction schematic is the only piece that is not technically a collage. It sits at the center of the sequence—its surface unaltered and thus seemingly "natural"—with three collages balanced before and three after. The unadorned section of construction schematic creates a central fulcrum or hinge—perhaps a version of Durham's idea of "a central margin."

For viewers of the installation, the unadorned language of the four fragments Durham affixes to the four collages balanced on either side of this fulcrum may have suggested they were sourced from a basic textbook. No one standing in Gallery B in 1992 could access a smartphone or tablet to check. A contemporary internet search, however, reveals that the three fragments focused on Columbus were cut from a newspaper article circulated by the Associated Press. Written by Chicago-based AP reporter Robert Glass (although his byline is often not included), the article was published under various headlines—"Archaeologists Near Pin-Pointing Columbus Vessels," "Remains of 2 of Columbus' Ships Might Soon Be Found in Jamaica"—in early April 1991, apparently meant to coincide with the April 3 anniversary of the launching of Columbus's fourth voyage in 1502.[35] The multiple versions of the article describe the ongoing work of a team of "nautical archaeologists," led by James Parrent of Texas A&M University, who were searching for the location of two of Columbus's caravels that were purposefully run aground on the island of Jamaica. The AP article reveals that the full paragraph of the first fragment reads: "Columbus' fourth voyage began from Spain on April 3, 1502, with four caravels and **a crew of 140. He was looking for a western passage to the Orient and its gold, silk and spices**" (*Anniston Star*, April 3, 1991, 5A; here and below, boldface added to indicate cut-out fragments). The full paragraph of the second fragment reads: "Artifacts could also provide new insights into shipboard life in the early 16th century **and the ways of the Arawak Indians who traded with Columbus, the archaeologist said.**" In most versions of the article, the paragraph from which the second fragment was cut is positioned immediately above the first fragment; Durham has chosen to reverse their order for his own purposes. The full

paragraph of the fourth fragment (third fragment from the article) reads: "Having abandoned **two of his leaky** caravels off Panam**a, Columbus de**-liberately ran the Capita**na and the Santiago** de Palos aground on Ja**maica and built huts** on them to house th**e crew while they** awaited rescue." In all versions of the article I have located, the paragraph from which the fourth fragment was cut is positioned several paragraphs after the first and second fragments.

The source for Durham's third fragment, focused on Harrison, is more challenging to locate. A combination of internet and conventional archival research reveals that it was cut from the 1991 third edition of the State Auditor of Ohio's perennial publication *Ohio Lands: A Short History.* The cover of the fifty-four-page booklet attributes the work to Thomas E. Ferguson, Ohio's auditor of state from 1975 to 1995, although the copyright page indicates that it was actually "Researched and written by Thomas Aquinas Burke."[36] The full paragraph from which Durham cut his fragment reads:

Federal Land Offices a**nd Sales in Ohio. William**
Henry Harr**ison, the Northwest Territory's first delegate to Congress, introduced the legislation that became the act of May 10, 1800. Thi**s **Act opened the frontier to "a land office busin**ess." (18; boldface added to indicate fragment)

Locating the sources for the four fragments provides additional insight not only into how Durham constructed his sequence of collages—why he cut out particular sections of language from these "found" texts rather than leave them intact—but also into how he conceived these works. He turned not to history textbooks written in previous decades or centuries, but to contemporary discourses about history and its significance (then) currently in circulation, both nationally (the AP article about Columbus) and locally (the State Auditor of Ohio's paragraph about Harrison). In other words, he turned to contemporary "authorized texts about the past." Moreover, locating the sources helps refocus attention on the specific placement of the fragments—their specific siting—within each work. We now notice that, whereas the pieces of snakeskin and the drawings that suggest snakes all

fill or cross the exhibit space diagrammed in the floor plans, the four textual fragments are all consistently placed *outside* the walls of Gallery B. The first fragment is placed above the west wall of the gallery on the left; the second is placed below the east wall, also on the left; the third is again placed above the west wall, also on the left; and the fourth is placed again below the east wall, but now on the right. In the sequence of collages, Durham surrounds the exhibit space of Gallery B with authoritative texts about the significance and centrality of Columbus, Harrison, and their ongoing legacies that were *currently* in circulation—that were powerful because they were literally *on the move*—in 1991 and 1992.

The four textual fragments function, in other words, as a pervasive and agile colonial context for the multiple snake shapes—for the multiple (Indigenous) discourses of the exhibit event itself—that attempt to produce (Indigenous) meaning within the walls of the Wexner's Gallery B. Although the operation is subtle, Durham's placement of the fragments articulates, within the space of the exhibit, a larger argument about the pervasive reality within which he and (other) Indigenous artists must necessarily produce their work. Art historian Richard Shiff, writing in a special issue of *Art Journal* published in autumn 1992, when the *Will/Power* exhibit opened, makes a similar point about Durham's understanding of this context: "Durham argues, in effect, that Native Americans . . . speak—and must live in a world created by—the language and discourse of the colonizing Euro-Americans."[37] And elsewhere in his own work, Durham states plainly: "The colonial reality is the only reality we have. All of our thoughts are a consequence of colonial structure; the universe we live in, to the extent that it is known, is known through this colonial mentality."[38] What strategies might one mobilize to produce (Indigenous) "thoughts" and meaning, to "speak" through and against this reality? In the years leading up to the Columbus Quincentenary, many Indigenous artists, writers, activists, scholars, and communities, along with their non-Native allies, attempted to shift the discourse "from the center of the universe of the white man to the centers of those of the different Indian peoples."[39] Durham's placement of the cut fragments draws attention to his own such attempt in *The Banks of the Ohio*.

Snakes	Floor plans	Text fragments
1. Snakeskin	Gallery B	[No text]
2. Snake shape	Gallery B	Columbus text
3. Snake shape	Gallery B	Columbus text
4. [No snake]	**Wexner Center**	**[No text]**
5. [No snake]	Galleries A, B, C	Harrison text
6. Snake line	Gallery B	Columbus text
7. Snakeskin	Wexner Center	[No text]

FIGURE 16. The multiple components of Durham's seven collages are arranged into three columns: (1) snakeskin, snake lines, and snake shapes; (2) floor plans and construction schematics; and (3) fragments of "found" text. Boldface emphasizes the role of the "central margin" created by the unadorned construction schematic in the fourth collage.

Similar patterns and alignments are highlighted in Durham's sequence of collages by tabulating the placements of their multiple components, including not only the four cut-out fragments of "found" text but also the two pieces of snakeskin and the three drawings of snake shapes and snake lines in black marker. In Figure 16, arranged in the order of the seven collages, boldface emphasizes the role of the fulcrum—the central margin—created by the piece of unadorned construction schematic.

The tables direct attention to how the collages work together to emphasize an "absence" present in the unadorned construction schematic located at the center of the sequence. The tables also direct attention to how Durham arranges the textual fragments in terms of neither a strict chronology nor a contiguous geography. Instead, Durham embeds the local story of the non-Native settlement of what is now the (landlocked) U.S. state of Ohio, with significant beginnings at the turn of the nineteenth century, within the broader story of Columbus's (oceanic) "discovery" of the so-called New World, beginning at the end of the fifteenth. The specific sequence of the fragments creates a narrative that moves from the economic interests that first motivated Columbus's voyages across the Atlantic to his early encounters with Indigenous peoples in the Caribbean to the passage of the Harrison Land Act on the North American continent to his shipwrecked crew building "huts" on the island of Jamaica—from settler

fantasies of uncontested conquest and the easy extraction of wealth to the complex realities of colonial settlement.

This is a good point to consider the final piece Durham created to help elucidate the serpent installation. Identified in the Wexner report only as an eighth "work on paper," the piece is distinctive from the others: it is representational and mimetic rather than diagrammatic and composite, and it incorporates added color. Moreover, the work does not fit the definition of a collage; nor does it engage as its base either the floor plans for the galleries or the construction schematics for the Wexner. Composed from five fragments, the work does, however, continue the practice of juxtaposition begun in the other pieces. That the fragments derive from two or more woodcuts, rather than from drawings, paintings, or other types of prints, links the work back to the Columbian encounter invoked by the textual fragments affixed to Durham's second, third, and sixth collages. Upon completion of the first voyage in 1493, Columbus penned a celebratory letter to the king and queen of Spain, which was subsequently published in 1494. Known as the Basel edition, this printed version famously includes a woodcut depicting Columbus and his crew engaging Indigenous peoples on the island of Hispaniola.[40]

In Durham's eighth work on paper, horned serpents cross the foreheads of what appear to be interleafed portraits of a Native man and woman. Indeed, the snakes present as "headbands" for the human figures, with the head of each snake positioned on the viewer's left and the tail on the right, and thus oriented similarly to the serpent installation (Figure 17). The first horned serpent is rendered in black and white: the snake's white head is followed by six alternating black-and-white bands along the body, which are followed by four white dots that comprise the tail. Durham has arranged the bands to contrast the dark and light sections of the woodcuts: the white horned head is positioned within the dark space that forms an outer frame for the entire image, while the first black band is positioned within the white space that forms an inner frame for the human figure; the first white band is positioned within the figure's dark hair, while the second black band is positioned within the white space of the figure's forehead; and so on. In the second horned serpent, all but one of the white bands and all but one of

FIGURE 17. Jimmie Durham, *The Banks of the Ohio*, 1992. Eighth "work on paper," woodcut, collage watercolor on paper, 22 3/4" x 15 1/4". Photograph: Alan R. Geho/Ralphoto Studio. Collection of The Ohio State University (1993.001.002). Courtesy of the Wexner Center for the Arts.

the white dots have been enhanced with color. In this version, the serpent's horned head is colored yellow, the first white band is colored red, the second white band is colored blue, and the third white band remains white. The tail repeats the sequence, with the four dots colored yellow, red, blue, and white. The positioning of the snakes across the human figures' foreheads suggests a relationship between the horned serpent and Indigenous "thought" and "cognition." The repeated color sequence—yellow, red, blue, white—suggests the four directions sacred to many Native American cultures, and thus suggests the color coding of the medicine wheel and other ceremonial technologies, in which yellow typically indicates the East and its associated phenomena and concepts, red indicates the South and its associated phenomena and concepts, blue indicates the West and its associated phenomena and concepts, and white indicates the North and its associated phenomena and concepts.[41]

This final work invites viewers to assume an Indigenous perspective within the wedge shape of the gallery, to think *with* and *through* the potentially sacred figure of the massive horned serpent stretched out before them—a counter to the pervasive context of colonial discourses indicated by the textual fragments affixed to the collages, which surround and thus frame the gallery's walls. Another potential counter to these pervasive discourses is Durham's enhancement of two of the work's five fragments with additional color. In the second fragment, below the horned serpent "headband" and the figure's hair, the forehead and the space around the figure's left eye have been shaded blue; the right eye has been completely obscured by color. In the fifth fragment, what appears to be the figure's chin or throat is also shaded blue. Similar to the blue added to the body and tail of the serpent, these enhancements may refer to the western direction and associated phenomena and concepts. But they may also allude to provocative color symbolism developed by Anishinaabe writer and intellectual Gerald Vizenor. In *The Heirs of Columbus*, his postmodernist and anticipatory novel published in 1991—before the opening of *Will/Power*—but set during the (then) near future of the quincentenary year, Vizenor significantly revises the accepted narratives of Columbus's ethnic identity (suggesting he may have counted among his ancestors both

Mayans and Sephardic Jews) and of his "discovery" of the New World (suggesting he may have had sexual relations with an Indigenous woman and produced Indigenous "heirs"). And, significantly, he evokes the idea of an Indigenous "blue radiance" of "creation" with the power to counter the devastations of the Columbian aftermath and ongoing legacies of colonial trauma.[42] Here and in subsequent works, Vizenor figures Indigenous "survivance"—survival understood as active and creative—as "blue" or, in some of these works, as "blue transmotion," that is, creative motion across multiple realms, including the material and the spiritual.[43] The "blue radiance" emanating from Durham's final work on paper invites viewers to see the serpent installation not simply as "a sign . . . of the civilizations that existed in pre-Columbian America," as Mulvey suggests, but as a manifestation of persistent Indigenous *presence*—a presence that includes the United Indian Nations that fought U.S. encroachment during the final decades of the eighteenth century as well as the Indian artists, writers, scholars, and activists who drew attention to a history of Indigenous resistance that remained ongoing during the final decades of the twentieth.

Durham's addition of color in the eighth piece draws attention to the absence of color in the other seven—with the notable exception of the rich golds and browns of the affixed and overlaid snakeskin. As highlighted by the tables, Durham frames the sequence of collages with this vibrant snakeskin but places a cut-out section of the black-and-white construction schematic, unaltered and unadorned, at the crucial center. To what effect? How does the centering of the bare schematic prompt viewers to "confront" the history of this site? What *is* the history of the Wexner Center complex, to which Durham draws considerable attention with his multiple iterations of the floor plans for the unconventionally shaped galleries and the construction schematics for the multicomponent structure and its multicomponent environment as a whole?

In 1992, when the *Will/Power* exhibit was planned and staged, the Wexner Center was relatively new, having opened in November 1989 and having hosted its first artists in residence during the 1991–92 academic year. Both the building and its principal architect had received considerable attention in the media. The conception, construction, and then opening of

the Wexner created quite a buzz, especially in architectural circles, since it was hailed as one of America's first major "postmodern" buildings— although some theorists immediately argued that it was neither "modern" nor "postmodern" but something "between"—and more specifically as one of the first large-scale experiments in architectural deconstructivism. Anticipation culminated in a special issue of *Progressive Architecture* devoted to the Wexner Center and its design, published in October 1989, followed on November 5, the day of the official opening, by a feature article in the *New York Times* titled "The Museum That Theory Built."[44] Indeed, the Wexner opened bare of any hung or installed art so that visitors could experience the high-concept of the structural design on its own, undistracted by additions of form, line, or color. Conceived by the architectural theorist Peter Eisenman, who had read and corresponded with the French philosopher and father of deconstruction Jacques Derrida, and who attempted to put Derrida's provocative concepts of *dissemination* and *différance* into architectural practice, the Wexner was explicitly meant to defy a functionalist approach to the public space of the museum or gallery.

Much has been written about the Wexner's avant-garde design and structural complexity, as well as about the challenges the building creates for artists, curators, and visitors alike. Two observations, however, stand out as especially relevant for broadening our understanding of the site specificity Durham nonetheless achieves—and confronts—in his composite installation *The Banks of the Ohio*: first, that Eisenman bases his architectural design in a pattern of intersecting grids that operate at multiple scales, emphasizing the measuring and mapping of space as well as the presence of temporality within space; and second, that Eisenman, similar to other "postmodern" architects, quotes earlier architectural forms within his contemporary design. What is significant in this second observation is that Eisenman does not quote the *construction* or *presence* of the prominent architecture that occupied the site during an earlier era. His design quotes, instead, that architecture's *destruction*, emphasizing not the remnant of the past visible in the present—the relic—but rather the visible presence of the *absence* of the past—the apparition. This simultaneous architectural

mourning and celebration of the act of destruction appears similar to those discursive operations that, within Indigenous literary and cultural studies, we know as acts of imperialist nostalgia.[45] Eisenman's avant-garde structure presents itself as mourning the destruction of that which it has itself replaced.

Typical images of the 108,000-square-foot, three-story building give a sense of how Eisenman designed the Wexner Center to fit within the wedge of space that was available between two existing buildings at The Ohio State University. As Paul Goldberger notes in his *New York Times* article from November 1989: "This building could be nowhere but its present site, wedged tightly between a limestone-clad auditorium and a modernist recital hall on the edge of campus." Moreover, these typical images indicate how Eisenman's superimposed and intersecting grids link the grid of the city of Columbus to the grid of the university campus, as well as how they create an "opening"—perhaps a "border" or "margin"—at what should be the "center" of the design. Goldberger writes:

The campus of Ohio State University is set on a grid that is roughly 12 degrees off from the street grid of the city of Columbus, and Mr. Eisenman has taken this skew and made it the basis for the Wexner Center's layout. Thus the long scaffoldlike steel structure, which serves as a walkway through the complex, is set on the city grid, making it appear to slice a diagonal swatch through the campus and through this building. The walls of the rooms inside the building are set on either the city grid or the campus grid, making the internal organization of the building emphasize this city-campus duality further.[46]

The October 1989 special issue of *Progressive Architecture* includes an illustration of how the Wexner fits within the larger grids of the city and campus. The caption states:

The red line that Eisenman drew on a plan of the Ohio State University campus originates in the city grid . . . enters the campus at the end of

15th Avenue, skims one edge of the central Oval, and crosses the end of the football stadium; it also marks the major flight path into Columbus airport (see Cover).[47]

Eisenman's "red line" runs through the scaffold-like walkway at the "center" of the complex, along which runs the access ramp to the major galleries, including Gallery B. And as illustrated on the cover of *Progressive Architecture* in a dramatic photograph of a commercial airplane framed by the Wexner's external scaffolding that rises above the central walkway, this "center" aligns under one of the Columbus airport's major flight paths—linking the open passage not only to the city and campus grids that mark and organize the ground but also to patterns written across the sky-world above.

In addition, the Wexner's intersecting grids and the centerless center or "central margin" of the walkway under steel scaffolding evoke the specific history of the early surveying of Ohio. Architectural scholar Mark Taylor explains:

> The territory of Ohio was initially plotted by two teams of surveyors: one working from north to south, the other working from south to north. One of the aims of the surveyors was to integrate the traditional Jefferson grid with smaller, more localized grids. The grids were supposed to meet on an axis that passes through Columbus. But the surveyors failed; they missed the mark, and thus the grid was disrupted by a gap. This gap is named the Greenville Trace. Eisenman figures this trace in the labyrinth of gardens that falls between Wexner's ornamental grid and the streets of Columbus. In one of the walls of this underground that is above ground, there is a fissure that disfigures what is supposed to be an all-inclusive grid. This figureless figure is a trace of the spacing of time that can never be re-covered.[48]

Taken together, these analyses of the Wexner's siting at the intersection of multiple contemporary and historical grids, and of the formation of a "centerless" center in the space of the central walkway, help to locate the significance of Durham's unaltered and unadorned section of construction

schematic placed as the "central margin" of his sequence of explanatory collages.

Typical images of the Wexner also provide a sense of how Eisenman incorporates the citation of the destruction of previous architecture into the avant-garde design of the new building and complex. The prominent turrets and arches located near the main entrance, for instance, highlighted as "brick towers" in the cut construction schematic, allude to the medieval-style Armory that stood on the site between 1897 and 1959, when the building was badly damaged in a fire and subsequently demolished. The Armory was used as a gymnasium for (white) men's and women's physical education, but also as a classroom for the teaching of (Euro-American) military science. Design critics have argued that, unlike more typical postmodern quotations of previous architecture, which tend to be overtly ornamental and nostalgic—suggesting a part of the past carried forward into the present—Eisenman's blown-apart turrets and partial brick arches index a history of destruction and thus gesture toward the impossibility of actually re-presenting the past. As Taylor writes in his contribution to the special issue of *Progressive Architecture:* "From a certain perspective, Eisenman's tower appears to be whole. As such, it looks like a direct quotation of the past. As one shifts his or her angle of vision, however, the whole falls apart. More precisely, one discovers that the whole was never whole but was 'originally' a fragment."[49] From an Indigenous studies perspective, however, Taylor's analysis bolsters an argument for labeling Eisenman's quotation as a version of "imperialist nostalgia"—a *performative* mourning for that which one has destroyed that is, in fact, more of a celebration for the (assumed to be successful) processes of that destruction. Taylor's analysis also bolsters Durham's argument in his 1990 essay "A Central Margin":

We might all "know" that the United States was founded upon the invasion and genocide of other nations, nations comprising millions of people who were slaughtered officially. I want to consider that phenomenon not as a moral issue, not to plead a case, but as an integral yet invisible (dangerously invisible) part of a power-producing apparatus not separated from the overall machinery; it is the center of the

machinery. If we place the scenario in a context of history seen as a continuity of events, of causes and effects instead of as authorized texts about the past, we must see that the invasion and the denial of the invasion are the cultural and political foundation of the United States. By foundation I do not mean something that the country is "built up on"; I mean, again, the center.[50]

Finally, Taylor's analysis applies equally well to Durham's tactical use of the Wexner's construction schematic: what at first appears to offer a complete (settler) worldview is revealed, "as one shifts his or her angle of vision," to be full of (Indigenous) erasures and absence. Durham turns Eisenman's performance of imperialist nostalgia on its postmodernist (mud) head.[51]

All of these details engage the colonial history of military conquest and the white expropriation of lands in what is now the state of Ohio. A map of the Northwest Territory shows how the Ohio River formed its undulating southern border. The process by which the federal government opened these lands to settlement was complex, in part because they were still actively claimed by the United Indian Nations. In the period leading up to the passage of the Harrison Act in 1800, lands in Ohio were divided into tracts reserved for specific categories of settlers. For instance, all of Adams County, in which the Serpent Mound is located, was part of the large Virginia Military District (VMD), a tract set aside for veterans of the Revolutionary War. The wedge-shaped VMD extended north to include part of Franklin County, in which the capital city of Columbus and the campus of The Ohio State University are located, creating a historical link between the site of the Wexner Center and the site of the Serpent Mound as each relates to the expropriation of Indigenous lands and the colonial settlement of Ohio.[52] Indeed, the "irregularly shaped" VMD, which ranged north from the Ohio River and extended from the banks of the Scioto River in the east to the banks of the Miami River in the west, encompassing "over 6,570 square miles," was the only tract of the "original nine major subdivisions of Ohio lands" that did not employ a "rectangular survey system" but rather an older system of "metes and bounds."[53] The uniqueness of the district's

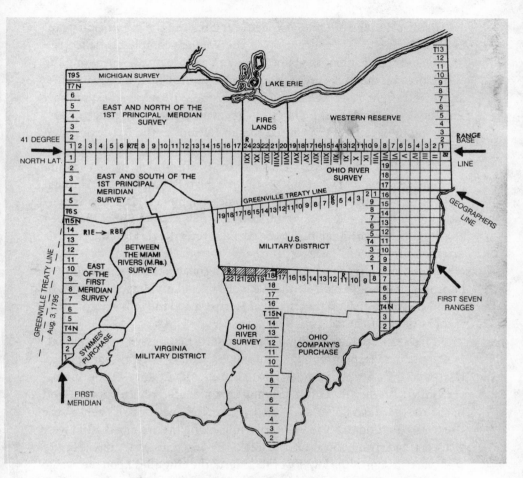

FIGURE 18. Map of Ohio's major land surveys, showing the Greenville Treaty Line crossing the Virginia Military District, printed on the back cover of *Ohio Lands: A Short History* (1991).

river-bounded wedge shape is emphasized in the map printed on the back cover of the 1991 edition of *Ohio Lands: A Short History*—the (then) currently circulating authoritative text from which Durham cut his explanatory fragment (Figure 18).

Historical maps of Ohio also help explain why the significant "gap" Eisenman cites in his conception of the Wexner complex is called the Greenville Trace: namely, the faint presence on these maps—including the one printed on the back cover of *Ohio Lands*—of the Greenville Treaty Line, drawn at a slight angle across the width of the state north of Columbus. The line was a result of the Treaty of Greenville signed on August 3, 1795, following the defeat of the United Indian Nations at the Battle of Fallen Timbers in 1794, often considered the final battle in the so-called Northwest Indian War, which paved the way for the Harrison Land Act of 1800 and the rapid settlement of what quickly became the U.S. state of Ohio. Through these historical associations and geographical alignments, Eisenman's quotation of the destroyed Armory links directly to his quotation of the failed attempts of the original surveyors to fully reterritorialize Ohio that is marked by the Greenville Trace. Durham confronts Eisenman's quotations of these colonial lines and traces in his fifth collage: the textual fragment he affixes to the floor plan for the Wexner's irregularly shaped Galleries A, B, and C invokes the military figure of Harrison and the militarized settlement he helped to hasten.

Moreover, both historical and contemporary maps assist in conceptualizing how the Wexner Center, located in Franklin County in central Ohio, relates to the Serpent Mound, located in Adams County in southwestern Ohio, with the Ohio River forming its sinuous southern border. Sited in the northern part of Adams County, near the township of Peebles, the Great Serpent undulates for a quarter mile along the arc of a distinctively shaped ridge rising above Brush Creek, the Serpent's head appearing to seek water, a sign of the lower world. Indeed, the effigy lies upon the wedge of land formed by the confluence of Brush Creek and its tributary East Creek, so that the Serpent is surrounded by water on three sides—not unlike how Durham's serpent assemblage fits into the architectural wedge of the Wexner Center's triangle-shaped Gallery B, its mud head appearing to seek the "below world" indicated by the narrow set of stairs leading down to Gallery A. The iconic nineteenth-century "map" of the Great Serpent drawn by Squier and Davis in 1846, which reduces the effigy and its environment to the stark elegance of a silhouette, makes these connections

even more obvious, as does a contemporary aerial photograph (see Figure 3 in chapter 1 and Plate 3). Considered together, the nineteenth-century Squier and Davis "map" of the Great Serpent and the contemporary aerial photograph link back to Durham's multiple manipulations of the Wexner's floor plans and construction schematics into evocative collage. How do Durham's "works on paper" connect two-dimensional, small-scale, static architectural drawings to the three-dimensional materiality, large scale, and electric trans-worlds *presence* of his serpent assemblage?

EARTH AND ENERGY CROSSING WORLDS

I note in the introduction that most contemporary viewers of Indigenous earthworks must be taught *how to see* the complex materiality and large scale of individual mounds and mound complexes, and thus that most contemporary viewers must be taught *how to perceive* the earthworks' beauty, potential meanings, and potential significance—in the past, in our present moment, in possible futures. What tools do we have for seeing and understanding the remarkable accomplishments of North America's diverse mound-building cultures? Since at least the nineteenth century, non-Native researchers, hobbyists, and tourists have relied primarily on overhead perspectives, whether in the form of drawn or painted maps, diagrams, illustrations, or physical models built to scale. The twentieth century saw the addition of aerial photography and, in the late twentieth and early twenty-first centuries, 3D computer modeling and color-coded topographic LiDAR imaging.[54] Although these diagrams, models, and increasingly data-rich aerial and computer-generated images convey essential information about the forms, relative sizes, and multiple alignments of mounds in their surrounding environments, they tell us little about the embodied human experience of either visually or physically encountering earthworks on the ground. Representing those experiences requires yet additional methods.

Here it is useful to invoke the work of Mary Weismantel, a relational archaeologist and a specialist on pre-Incan Indigenous cultures in Peru. Her practical and theoretical work helps us think about how large and monumental built structures require theory "adequate to their particular form

of visuality." She argues that objects are constructed to engage our senses and our bodies in culturally sanctioned ways, and she asks us to consider how particular objects constrain, prevent, or enable specific forms of inter- action and perception. In her attempts to understand the meaning-making operations of large or monumental Indigenous structures, Weismantel has developed an idea of "slow seeing."[55] The concept of slow seeing helps explain why aerial photographs, models, maps, and diagrams are easier to "read" than are large, three-dimensional structures like earthworks. It also helps explain how monumental structures "deliberately slow down the process of seeing" and thus delay "the moment of recognition" (27). Finally, the concept of slow seeing, which Weismantel also describes as "conscious seeing," helps explain how a slowed temporality of recognition can provoke viewers into an awareness of "the physical and cognitive effort" involved in seeing, and thus to engage in "seeing that sees itself" (27).[56] In other words, through the experience of the *difficulty* of the perceptual encounter with large, three-dimensional objects, we become newly aware of our seeing as action that takes place in time. Such awareness may be one of the messages conveyed in Durham's eighth work on paper. The foreheads of the Native figures, the seat of their perception and cognition, are literally banded— both constrained and exceeded—by the enormous horned serpent that stretches out before viewers, filling the length of Gallery B.

The relatively large scale of Durham's *The Banks of the Ohio*, staged within the confined, wedge-shaped, and both theoretically and historically over- determined space of the Wexner Center's Gallery B, works to slow viewers' seeing and thus to slow viewers' recognition of the assemblage. Moreover, Durham's juxtaposition of the monumental serpent with a series of smaller- scale works on paper that emphasize the abstract floor plans of the galleries and the aerial construction schematics of the Wexner, overlaid with snake- skin, drawn shapes and lines, and textual fragments, furthers this work of slow seeing and delayed recognition. It may even slow how viewers see and recognize the Wexner itself. For as we've seen, despite its avant-garde theo- retical virtuosity and the nuance of its historical and contemporary cita- tions, Eisenman's structural vision of interlocking grids and exploding tur- rets presents a militarized settler-colonial vision of the reterritorialization

of the lands now known as Ohio. From conception to construction to ongoing use, the Wexner complex reifies the idea of the inevitability of white settlement and rehearses the U.S. settler nation-state's violent practices for displacing and erasing Native histories, cultures, and peoples.

Within the confined wedge of Eisenman's settler-colonial floor plan and construction schematic, Durham inserts *The Banks of the Ohio* as both an active Indigenous presence and the (apparitional) presence of the land itself, in the form of an embodied and animated Ohio River, with the intention to confront and disrupt the Wexner's rigid modernist grids with older, more sinuous forms of world-making and life-affirming *current*. In this vein, one might argue that the juxtapositions of scale, and of abstracted, aerial perspectives with massive, embodied *presence* shifts the tenor of viewers' encounters. A primarily intellectual exercise of considering the work's composition and understanding how it provokes particular ideas becomes an active experience of what the work *does*—how the serpent occupies, moves through, disrupts, and transforms space, and thus how the serpent interacts with both the site and viewers. Durham's serpent confronts viewers not only aesthetically and intellectually, but also physically and, through embodied encounter, emotionally and psychologically as well, and perhaps spiritually.

Here it is important to indicate the specific ways Durham's serpent cites key physical and symbolic features of the extant Serpent in southern Ohio. Like the massive body of the Great Serpent, the body of Durham's massive assemblage is marked by seven convolutions, or "turns," in the seven prominent joints that connect the lengths of its different-sized PVC pipes. (This detail aligns, as well, with the seven collages in Durham's sequence; the seven collages then juxtapose the three walls of the alcove, which align with the three coils of the Serpent's spiral tail.) Also similar to the Great Serpent, Durham's assemblage holds in productive tension upper and lower worlds, with its tail literally plugged into the electrical box in the ceiling of Gallery B and its mud head positioned above the narrow set of stairs leading down to the lower level of Gallery A. The mud head itself links Durham's serpent assemblage to the lower world, and particularly to the supersaturated, water-laden soils that form the bottoms of ponds,

lakes, rivers, and creeks—a type of soil that Native intellectuals link to the foundational story of the Earth Diver and that archaeologists have revealed is deployed in specific ways in the building of certain earthworks in Ohio, literally layering the Earth Diver's story within the very structure of these works.[57] The serpent's horns constructed from tree roots, rather than branches, similarly link the assemblage to the lower world.

Allison Hedge Coke's persona Clan Sister reminds us there are long traditions of aligning snakes and rivers, and the extant Serpent Mound rising above Brush Creek can be placed within such traditions. Like living snakes, the effigy of mounded earth possesses aesthetic beauty both in its sinuous form and in its vibrant "skin"—features that are arguably absent from Durham's installation. The form of Durham's assemblage is more accurately described as *articulated* rather than sinuous, and its jointed sections of rigid PVC pipe lack the overlay of an idealized surface. Instead of aesthetics—as Mulvey's early interpretation understands—Durham's serpent emphasizes practical function. The serpent is a conduit, yes, but it is not a sewer; it is River, with a capital *R*, alive with power. The mud head appears to emerge from the PVC pipe throat, as though propelled through the narrow channel. In this detail is the suggestion of earth literally moving *through* the articulated body. Here, again, it is significant that the assemblage is plugged into the electrical box. Like a river that carries and deposits enriched sediment, Durham's serpent possesses live current with the power to move and reform the earth.

To conclude, a final observation about Durham's serpents and a return to Hedge Coke's *Blood Run*. Durham's serpent assemblage is oriented within the space of the Wexner's wedge-shaped Gallery B as moving *from* the upper world (represented by the electrical box in the ceiling near the base of the triangle) *to* the lower world (represented by the narrow set of stairs leading down to Gallery A at the apex of the triangle) and thus from north to south—as moving toward the River Ohio. The horned serpents in the eighth work on paper appear oriented in the same direction. The snakeskin overlay in the first collage, however, as well as the drawn snake shapes in the second and third collages and the drawn snake line in the sixth collage, all appear oriented in the opposite direction: moving *from* the lower

world *to* the upper world and from south to north—that is, as moving away from the Ohio River. Taken together, the multiple serpents in multiple media suggest the potential for shifts in cycles, rather than an exclusively unidirectional *flow*. There are hints of danger here, but this is no simple ballad about murder or original sin. In Clan Sister's penultimate appearance in *Blood Run*, quoted at the beginning of the chapter, Hedge Coke's guiding and shape-shifting persona aligns the steady yet ever-changing River with snakes through their similar powers of renewal: "She remakes herself / in each made thing" (80). And earlier in *Blood Run*, in her fourth appearance, Clan Sister prophesies that one day the central River's cycle will turn to reclaim the massive earthworks site from settler intrusions. Through the initial destruction of her cyclical flooding, River will cleanse, reclaim, and remake the (Indigenous) world anew. "Without offerings / She will come swollen," Clan Sister asserts, "snatch them up like pollen, / disperse, dispense, derogate" (62). The poem's final line, set off as its own stanza, evokes the primal story of the Earth Diver: "Wet earth profuse once more" (62).

Earth Bodies in Motion

The underwater animal constellations, panther, serpent, and others
returned from beneath dark waters to their places in the sky.
— Linda Hogan, "Turning Earth, Circling Sky" (2018)

During the years I actively engaged the Great Serpent, its representations and performances, on my own and in conversation with fellow researchers, I often wondered if effigies and other earthworks do more physically than mark territory, do more than align with natural features in the landscape and with each other, do more than record astronomical knowledge of the sky-world literally in the ground beneath our feet. It seems indisputable that these structures record traces of the physical activities of their building, regular upkeep and repair, the movements of their making and remaking over time. Is it possible earthworks record the recurrence of other multi- and transmedia activities? Is it possible that the shapes and forms of mounds—perhaps especially effigies but also platforms, burials, and enclosures—record traces of musical processions, rituals, ceremonies, dances, storytelling events, or other kinds of performance? What about political debates and councils, communal games and competitions, or other forms of social interaction? Choctaw writer and intellectual LeAnne Howe makes a compelling argument, as noted in chapter 1, that Bird Mound, part of the massive earthworks complex at Poverty Point in northeastern Louisiana, is a "performance mound that embodies the story of the red-tailed hawk from conception to first flight—the story of its creation."[1] What other stories might mounds embody?

My thinking about the implications of Howe's ideas had already begun to expand in May 2013, before Howe had made the "story mound" argument in print, when my Ohio State colleague Marti Chaatsmith and I assisted

Howe and Kuna and Rappahannock actress and playwright Monique Mojica in their research for the performance *Sideshow Freaks and Circus Injuns*.[2] When the four of us visited the obscure effigy located near Granville, Ohio, known as Alligator Mound, we first offered tobacco and exclamations of regret at the structure's current condition, then walked the contours of what remains of this large animal form—which looks nothing like an alligator—made physical contact with its still-present body, and contemplated its significant location in the landscape (Plate 4).

The Alligator is similar, we noticed, to Jeffers Mound, the conical burial located in what is now a close suburb of Columbus, in that it is an isolated captive: its degraded but still discernible body is literally surrounded by a circular residential street, which is itself ringed with middle-class houses. Also similar to Jeffers, the Alligator is difficult to locate—perhaps purposely so. No helpful signage announces a route to the site; visitors have to know what they are looking for and where to go. Nonetheless, because this figure was constructed on the highest point in the landscape, even with houses all around the effigy still commands panoramic views of the valley below. But the effigy is similar, as well, to the Serpent Mound located in southern Ohio, which uncoils along a ridge above the waters of Brush Creek and its tributary East Creek, in that the Alligator crouches atop a prominent bluff that rises above the waters of Raccoon Creek, which meanders along three sides of the bluff's base. In effect, like its counterpart to the south, the effigy appears encircled by water. Moreover, and also similar to the Serpent, the Alligator's raised body appears distinctly arched, as if caught in motion or preparing to spring into action. This effigy, too, is a performance of energy.

Howe and Mojica intuited that the two-hundred-foot-long, forty-foot-wide, four-legged creature mounded to a height of approximately five feet models not a crocodilian reptile but more likely a species of cat: it possesses a notably rounded head and rounded "paws" and a long, hooked tail. The effigy is perhaps a version of the underwater panther, common to many Indigenous North American traditions, which is often also a sky panther.[3] The panther crosses and joins significant realms of our experience. In her essay "Turning Earth, Circling Sky," noted Chickasaw author Linda Hogan describes this connection across worlds:

Everything above moves in its circle and in most traditions, what exists on earth often appears in the sky as constellations, as mythologies or stories humans tell. All are part of the same continuing movement of life's cycles. For our ancestral stories, the wheel of sky changed to its winter constellations. Some sky animals dove into the waters underneath the solid world from which they would rise again in late spring. The underwater panther. The horned serpent.[4]

In Ohio, the crouching, world-crossing panther faces west, away from the geometric earthworks located nearby at Newark. Howe and Mojica imagined the transformative feline as a protector for the region as well as an iconic emblem for the cyclical movements and reciprocal relationships among upper, middle, and lower worlds—sky, earth, and water. And the researchers suspected that the round appendage that extends from the animal's midsection—what archaeologists have described as an altar upon which offerings were ritually burnt—functions as an externalized womb, marking the dynamic figure as female and productive.[5] Finally, all of us were heartened by a distinct sense that this female protector mounded from layered earth was not only poised for action but still breathing. "Let that sink in for a moment," Howe would later remark. "The female underwater panther was moving in tandem with earth."[6] I was reminded of lines from the opening poem in Allison Hedge Coke's *Blood Run:* "May she breathe. / May she breathe again."[7] The panther remained an earth body in motion, still breathing, still performing her primary functions for the valley.

After spending time with the panther and contemplating her rounded features and external womb, since we were close to Newark we decided to make an unplanned return visit to the geometrical enclosure known as the Great Circle (Plate 2). Was is possible that this monumental structure also functioned as an emblematic womb? Earlier in the week we had spent significant time at the Circle during the middle part of the day, under supposedly ideal viewing conditions and in the presence of other visitors, but now we arrived at the small state park that protects the site as dusk was turning to twilight. The parking lot was empty. As noted in the introduction, the Great Circle Earthworks features a large circular enclosure with

a diameter measuring nearly twelve hundred feet; its impressive embankment wall of packed earth ranges in height between eight and fourteen feet. This evening encounter with the massive enclosure was a first for all of us; Chaatsmith and I remarked that we had never thought to organize an evening or nighttime visit. In part, we joked, that was because we were now violating state rules, since the park is open to visitors only during the hours of daylight. The small museum and interpretive center had already locked its doors, and any other tourists that day had long departed. A sense of breaking the colonizer's directive heightened our sense of the evening's mission. And our unauthorized visit would turn out to be especially productive. It allowed—no, it propelled—the four of us to imagine together the types of performances that might have taken place at this Great Circle in the past.

The Circle's embankment opens to sunrise. Burning sage, which was likely also against the rules, our small party processed through this eastern gateway into the contained circular space. As we walked slowly toward center, the sun set behind the curved western wall rising before us, the sky darkened, and lights from the surrounding town began to glow in the distance. What happened next was both a surprise and not a surprise. First, a series of large pale moths appeared in a slow procession of their own. Similar to the butterflies and caterpillars we had encountered when a colleague and I took Mojica to visit the Serpent in 2011, the delicate moths connected across worlds and served as living symbols of transformation. Next appeared a series of small dark bats. One by one, they too made a slow if more erratic procession toward the center of the enclosure. Watching the complex dance of their flight, we were reminded that they too are living symbols of transformation and the in-between: four-legged mammals that fly like winged birds. Certain of the old stories honor their metamorphosis and special abilities.[8] We imagined past visitors following the lead of these respected relatives to gather for evening ceremony. After a time, we arrived at the low, "winged" mound at the Great Circle's center, often suspected of being an effigy and known as Eagle Mound, although its three-lobed shape is not distinctly avian. Some have speculated that the mound may repre-

sent the form of a bear's paw rather than an eagle in flight. Once we had arrived at this center, we felt a strong, warm force emanating from beyond the curve of the Circle's western wall, from the direction of the Panther we had encountered only a few hours earlier. Standing on the three lobes of the raised center mound, leaning into the strength of the warm force, we were reminded again of the Panther's arched stance on the high bluff, her round head and round paws, her hooked tail . . . her circular appendage.

If the Circle is an altar, perhaps with our physical presence and with our embodied movements, with our open imaginations, we are making an offering. Perhaps we, too, are earth bodies in motion.

At the base of the Great Circle's high embankment wall, a moat dug to a depth ranging between five and eight feet follows the interior circumference. Archaeologists believe both moat and embankment were covered in clay when the geometrical enclosure was a fully functioning site for communal gathering. Following spring rains, the clay-covered moat would have become a standing vernal pool, host to a chorus of chirruping small frogs known today as peepers—more living symbols of world-crossing and transformation. Moonlight from above or ceremonial firelight from atop or within the embankment would have danced as vibrant reflections on the singing water. The clay-covered Circle would have become a multimedia event space, alive not only with human and other-than-human movement but also with atmospheric color, with light and shadow, with reverberating sound. Perhaps people perched along the rim of the thick circular wall to watch activities on the central plaza below, or gathered in groups outside the embankment to listen to the sounds and to imagine what might be seen within.

As the sky darkened to full night and the warm force from the west fully enveloped our small party, we reversed direction to proceed back to the eastern gateway. Smudging at the entrance, we spoke quietly about how the Great Circle had been engineered not simply to endure for millennia, which it has—despite lack of appropriate human upkeep for two or more centuries and despite all manner of settler-colonial desecrations[9]— but also, and perhaps more profoundly, to spark *future* performances and

offerings, future communal encounters that crossed worlds and species, such as our own that evening. Under the watchful guard of the female Panther, the massive womb of the Great Circle had been designed to spark future renewal.

Platforms

Networking Systems

Cardinal Directions

CHAPTER 3

Walking the Mounds

And this drama was at the heart of a place we now call Cahokia, ancient America's one true city north of Mexico—as large in its day as London— and the political capital of a most unusual Indian nation.

— Timothy Pauketat, *Cahokia: Ancient America's Great City on the Mississippi* (2009)

The panorama would have pleased rulers of any age. The sprawling, walled city with its sacred mounds, public plaza, ball fields, and ceremonial sites, and its surrounding community of houses, merchants' buildings and huts, ponds, pens, granaries, and crop fields looked impressive enough, but the new mounded arena was its crowning achievement, Yoshoba thought— the zenith of an old civilization grown rich. And sustaining this great city, he reflected with pride like that of an owner of a precious object, was the great river—the river beyond all ages.

— Phillip Carroll Morgan, *Anompolichi: The Wordmaster* (2014)

Massive platforms and extensive plazas loomed large in my first attempt to describe contemporary engagements with ancient Indigenous earthworks. The year was 1990. I was completing a master's degree in creative writing at Washington University in Saint Louis, and thus I was living within the floodplain of "the river beyond all ages" in the shadow of what remains of the Mississippian city known as Cahokia. My first publication about earthworks was not a work of fiction or poetry, however, but a journalistic piece I wrote for *Nine* magazine, a promotional arm of the local PBS station. In the 1950s, Saint Louis had been one of the Bureau of Indian Affairs' relocation centers for Native Americans offered—or forced into—opportunities to leave their reservations and build new lives in cities, and I had been introduced to members of Saint Louis's now third- and fourth-generation urban

151

Indian community, led by the Voelker family, by one of my Washington University advisers, the brilliant Osage poet, renowned scholar of medieval literature, and famously gregarious interlocutor Carter Revard. Like those of his good friends the Voelkers, who were Comanche, Revard's familial and tribal histories were anchored in Oklahoma, as were my own, and so we built bonds of trust and mutual affection on more than simply a love of language and literature. It was Revard who introduced me, as well, to Cahokia Mounds State Historic Site, located across the Mississippi near what is now Collinsville, Illinois, where members of the Saint Louis Indian community sometimes gathered to conduct ceremony or to demonstrate storytelling, dance, and craft traditions for tourists.

My brief article in *Nine* was titled "Solstice at the Mounds," and it appeared in the June issue with the intention of alerting readers to the possibility of visiting Cahokia at dawn on the first day of summer, when they could witness firsthand one of the site's primary solar alignments. The article's subtitle made clear that "Early Risers Can Greet Summer's First Light at Cahokia Mounds' Prehistoric Solar Observatory."[1] Part of the then-recent history of Cahokia was its designation in 1982 as a UNESCO World Heritage Site, making it one of only fifteen such designations in the United States at the time. In addition, in 1985 the site's caretakers had re-created one of the known solar calendars at Cahokia, which comprised forty-eight timber posts evenly spaced and set upright to form a large open circle measuring 410 feet in diameter. The staff archaeologists—no doubt in consultation with colleagues in marketing and publicity—named the structure "Woodhenge" as an homage to the better-known Stonehenge calendar in England.[2] And in 1989, only a year before my article appeared in print, Cahokia Mounds State Historic Site had opened its new, state-of-the-art Interpretive Center.

As I recount in chapter 1, Indigenous earthworks, the complexity of their forms, and the sophistication of their technologies first entered my consciousness through the articles and book chapters I was assigned to read in an undergraduate course on North American archaeology. It was the time I spent walking the mounds and plazas at Cahokia during the two years I pursued my master's degree in Saint Louis, however, that mark the real beginnings of my earthworks education. The brief article I published

FIGURE 19. Fall equinox sunrise at the reconstructed Woodhenge calendar, the sun emerging from behind Monks Mound in the distance. Courtesy of Cahokia Mounds State Historic Site.

in 1990 captures my early enthusiasm for what I had by then learned—and, importantly, for what I had by then experienced. Most notably, I had felt the exhilaration of standing at the center of the reconstructed Woodhenge calendar on the first day of autumn to witness the sun rise precisely behind the equinox pole—remarkable in its own right—and simultaneously rise precisely behind Cahokia's massive central platform, known as Monks Mound (Figure 19). But the article also reveals, perhaps inevitably,

my early reliance on non-Native discourses for framing my understanding of the mounds. Given the pervasiveness of those discourses, and given the overwhelming lack of scholarly interest in Indigenous perspectives then (and, largely, now), how could it have been otherwise?

I recall exerting significant labor to produce what I considered a well-researched, well-structured, and well-argued essay, which meant I defined key terms, arranged evidence in an increasing order of importance, and built my analysis toward a well-earned conclusion. Even if I was an in-experienced journalist, I was a good student, and so I felt confident that the carefully proofread draft I surrendered to the magazine had done the trick. A few days later, the editor, whom I had met through a mutual friend but did not know well, called to say she liked the essay a lot, espe-cially the concluding section about the sunrise alignment at the equinox, which she found "thrilling." So far, so good. She thought, however, that the essay needed to be reorganized and perhaps restructured and—at least in places—reworded in order to appeal to her audience. The magazine's read-ers were well-educated, inquisitive viewers of PBS, she explained, but they were not scholars; they might not admit it, but they bored easily, and they were unlikely to wade through the archaeological details of my article to get to the more exciting personal experience at the end. The payoff, as it were, needed to be front-loaded—a concept with which I was not yet familiar—and supported by the remaining details in *descending* rather than ascending order of interest, since many readers were likely to stop paying attention before the end. Over the next weeks, she and her copy editor turned my well-crafted scholarly essay upside down and inside out.

After several rounds of revision and additional phone calls, a reconsti-tuted version of my essay appeared in the June issue of *Nine*. The published article begins in a manner the editor considered appropriately journalistic:

> From the highway, they may look like nothing more than odd-shaped hills, but the 65 earthen mounds preserved in the Cahokia Mounds State Historic Site in Collinsville, Illinois, are the archaeological rem-nants of the most sophisticated prehistoric Indian civilization north of Mexico. (18)

Rereading the opening now, three decades after it was written, I notice less the hook's invitation to new knowledge than the way its single sentence accrues so many dominant tropes about Indigenous North America. The accumulation begins with the invocation of a modern glance speeding along the highway rather than a more pedestrian view of the "odd-shaped hills" from the ground (the pun on *pedestrian* intended), moves to the ready discourse of "preserved . . . remnants," adds the backhanded compliment contained in the juxtaposition of the positive adjective "sophisticated" with the more ambiguously coded but typically less-positive adjective "prehistoric," and concludes with a comparison of Cahokia to a better-known (if equally prehistoric) "civilization." I read the last as implying that, although the Illinois example is similar to the Mexican, it is somewhat lacking; in other words, the promotional comparison implies that, while this may not be one of your first-rate prehistoric civilizations, it *is* local, and it will do for a visit of an afternoon—or perhaps of an extremely early morning.

The article then details how Cahokia had recently been named a UNESCO World Heritage Site, placing it "among an elite group of international cultural and natural landmarks" that includes "the Great Wall of China and the Pyramids in Egypt"—more backhanded complimentary comparisons—before moving directly into a description of the exciting discovery, interpretation, and reconstruction of the Woodhenge calendar and a thinly veiled promotional advertisement for the magazine's esteemed but easily bored readers to visit Cahokia during the observation of the upcoming summer solstice sunrise (18). Unlike the actual solstice that year, which would occur on a weekday, the Interpretive Center's dawn ceremony would be held more conveniently on the weekend. To ensure readers fully understood the significance of that event, the article explains the meaning of *solstice*—derived from the Latin *sol sistere*, "sun" "to stand"—and describes how the several days each year around June 21 and December 21, when the sun's noon height changes very little and the sun "literally appears to stand still," were marked not only at England's renowned Stonehenge but also—wait for the additional comparisons and backhanded compliments—at "elaborate prehistoric South American and Mesoamerican constructions" (18). All that in the initial six paragraphs.

Beginning at paragraph seven the article delivers a revised version of what had served as the well-earned conclusion to my original draft, a three-paragraph description of witnessing the equinox sunrise from within the circle of upright posts that comprise the reconstructed Woodhenge calendar. As removed and analytical as I try to be, rereading this section takes me back to my younger self witnessing the alignment for the first time:

Last September, I attended the fall equinox sunrise ceremony at Woodhenge, which coincided with the grand opening of the new Cahokia Mounds Interpretive Center. Though it was only the first official morning of autumn, before the sun came up the wind off the Mississippi bit near the bone. Veterans of the sunrise ceremony had come equipped with down jackets and stocking caps, thermoses and quilts. A friend and I huddled inside Woodhenge in the dark, watching the crest of Monks Mound for the first signs of light. At the equinoxes, the rising sun aligns with Monks Mound, on top of which Cahokia's principal leader, who researchers speculate may have been called the "Great Sun," resided in a massive building 105 feet long that probably had clay-plastered walls and a grass-thatched roof. Viewed from Woodhenge, it would have looked like the leader's residence was giving birth to the sun.

In conjunction with the grand opening of the Interpretive Center, Native American drumming performed by Southern Drum, a local group of both Native and non–Native Americans, called in the sun at the equinox ceremony, recalling the spiritual significance of solar phenomena to traditional North American Indian cultures. Cahokia Mounds has a long-standing relationship with the local Native American community, and through the American Indian Center in St. Louis, Native Americans often participate in special events at Cahokia, sharing their craft and storytelling traditions with the public.

When the eastern horizon began to pink that morning behind Monks Mound, veterans of the ceremony and we newcomers alike readied our cameras, vying for position near the post that marks the center of Woodhenge. There we poised, hoping to capture the emerging

sun as it rose over the equinox post. Waiting in the shadowy light, still freezing, I had my doubts the alignment would prove precise or spectacular. But to the rhythm of the traditional Native American drum and the cheers of the crowd, autumn arrived as a gold ball set between prehistoric mounds—and, as promised, climbed the wooden post marking the equinox. The summer solstice sunrise ceremony should prove equally as breathtaking an introduction to Cahokia Mounds. (18–20)

What I notice in these paragraphs—and what I remember most deeply about that early morning thirty years ago—is the calling up of the equinox sun with our collective spirit and with the drum. Despite the article's reliance on dominant tropes and gestures toward sly promotion—the fantasy of creating a perfectly disposable Kodak moment—these paragraphs still evoke the communal and ceremonial nature of that first encounter.

The remaining paragraphs in the body of the article present what had been, in my draft, a careful setup for describing the equinox sunrise, including details about what was then known about mound building at Cahokia, details specifically about what was then known by archaeologists about the monumental Monks Mound, and details about what was then known by archaeologists about Cahokia's so-called decline and the city's ultimate abandonment. The article's final paragraphs, in keeping with its promotional theme, offer a detailed description of the recently opened Interpretive Center:

Completed last fall, the center, which is free to the public and open from 9:00 a.m. to 5:00 p.m. daily, is a state-funded, $8.2 million facility which incorporates Western science and Mississippian knowledge in a multimedia presentation about Cahokia Mounds. The 33,000-square-foot center was designed to fit in well with its surrounding environment and is situated such that the large windows that are its back wall overlook several of the principal mounds—in effect bringing them into the facility. In the center's open foyer area visitors can consult a large model of the 2,200-acre Cahokia site, which shows the positions and relative

sizes of its 65 mounds and solar calendar, and view "City of the Sun," a 15-minute audiovisual presentation of urban life in prehistoric Cahokia shown regularly in the Orientation Theater.

The Interpretive Center also contains an extensive exhibit gallery, which features artifacts found on the Cahokia site and hands-on exhibits of government, social organization, agriculture, city planning and other facets of daily life in prehistoric Cahokia. The gallery is organized as a running bicultural commentary by "The Archaeologist" and "The Storyteller," who explain, respectively, how scientists make their discoveries about prehistoric life at Cahokia and how the Cahokians probably viewed themselves and their cultural artifacts. Central to the gallery is a well-marked, large-scale diorama which recreates a Cahokian neighborhood. Visitors can walk through this panoramic, mirrored exhibit and view typical family and ceremonial activities. At the end of the gallery, a short video and a life-size simulation of an actual excavation detail how archaeologists do their work. Visitors are encouraged to view the principal mounds and Woodhenge up close, and walking and audio tape tours are available from the information desk. (21, 46)

At the time, the scale and design of the center's architecture felt utterly impressive (*huge* windows showcasing the mounds), the exhibits seemed highly innovative (*life-size* dioramas of ancient village life and current archaeological practice, signage that included a *Cahokian perspective*), and the theater appeared a wonder of contemporary audiovisual technology. At the video's end, as the gravelly voiced, authoritative narration concludes with the mystery of Cahokia's decline and demise, the screen suddenly *rises*, lifting, as it were, the veil of history to reveal the life-size diorama of the Cahokian village. The first time I witnessed this technological marvel in 1989, people gasped out loud. Reading my account now, though, I am most struck by what is not discussed. There is the issue of how the so-called Mississippian knowledge included in the exhibits and voiced in the video was controlled by non-Native research methods and epistemologies. There is the issue of how the Cahokian perspective in the exhibit signage is presented through the figure of a "Storyteller" speaking from time im-

memorial (suggesting ancient mythology rather than contemp...
and how this purported Native perspective is set in opposition to the fig...
of a non-Native "Archaeologist" speaking in the present (suggesting verifi-
able fact bolstered by scholarly authority). And there is the issue of how
the mirrors strategically deployed in the diorama of an imagined Cahokian
village—although meant to produce the illusion of expansive space—
accurately demonstrate the center's self-reflexive agenda, which is then
affirmed in the self-referential exhibit of a working (non-Native) archaeo-
logical excavation. Although living Native Americans had served as models
for the mannequin bodies posed in the diorama, and although other living
Native Americans had drummed in the equinox sunrise on the morning of
the center's official opening and demonstrated storytelling and crafts on
the grounds throughout the day, contemporary Native voices and perspec-
tives were not included in the official interpretations.[3]

Needing a new conclusion, since the draft conclusion about the equinox
sunrise had been revised as paragraphs seven through ten, the piece ends
by bringing the previous components together and by emphasizing, again,
the article's less-than-subtle promotional subtext:

> In addition to the equinox and solstice sunrise ceremonies, the Inter-
> pretive Center offers the public a variety of activities throughout the
> year. Regularly scheduled are tours, Native American crafts classes for
> adults and children, films, lectures and special exhibits. Each sum-
> mer, in conjunction with Southern Illinois University at Edwardsville,
> Cahokia offers a field school in geo-archaeology for student and ama-
> teur archaeologists. The equinox and solstice ceremonies, however, will
> no doubt remain the most popular events at Cahokia. It's an early wake
> up call, but when we gather together at Woodhenge to witness the sun-
> rise alignment on the first day of the season, we not only celebrate the
> mystery still present in our modern world but continue a tradition that
> links us with our prehistoric past. (46)

I find the final sentiment expressed here accurate and powerful: witnessing
the cycle of seasonal time from within the circle of Cahokia's reconstructed

... of portal to the significant Indigenous
...ck by how difficult it was in 1990—and con-
...ss admiration for the mounds and respect for
...unities who built and first used them from within
...es. The problematic and often inaccurate assumptions
...hose discourses keep getting in the way.

...rack of my 1990 article for a number of years and only reread it ...unearthed several copies of *Nine* during the summer of 2015, as I was going through boxes of stored books and papers in preparation for a cross-country move away from Ohio. I did not return to Cahokia itself, however, until autumn 2018, when the Western Literature Association (WLA) held its annual meeting in Saint Louis. Already deep into the research for this book as the conference was being planned, I organized a collaborative earthworks performance at WLA that featured the Native writers and intellectuals LeAnne Howe (Choctaw), Allison Hedge Coke (Cherokee, Huron, and Creek ancestry), and Philip Carroll Morgan (Choctaw and Chickasaw), which became a Friday plenary titled "A Reading for the Mound Builders." The following day, the members of our plenary along with about fifty other WLA participants boarded a chartered bus to travel east through downtown, past the iconic Saint Louis Arch—"Gateway to the West"—cross the wide Mississippi, and tour Cahokia. I return briefly to the plenary performance and visit to Cahokia at the end of this chapter. Here I will note that surprisingly little had changed at the Interpretive Center. After thirty years, the Orientation Theatre was still showing *City of the Sun.* When the video's gravelly voiced narration concludes, emphasizing Cahokia's mysterious decline and the enigma of what happened to its builders, the screen still rises. Waiting behind the veil are the same life-size mannequins, frozen in an array of "prehistoric" activities within the village diorama, the same self-reflexive mirrors returning the gazes of tourists and other modern visitors.

That afternoon, however, there were at least a few in the audience with ideas about what had happened to the supposedly missing Mississippians. When the video's narrator solemnly intoned the familiar discourse of "no one knows what became of them . . ." and paused dramatically, Howe raised

her hand high. Waving with the enthusiasm of an eager student, she called out to the screen, "Oh, oh! We do! We do!"

THROUGH THE CAHOKIAN LOOKING GLASS

My intention for this chapter is not to recenter dominant representations of Cahokia or other Mississippian sites, but rather to conduct an earthworks-focused reading of Phillip Carroll Morgan's 2014 novel *Anompolichi: The Word-master* and to follow at least some of the implications of that interpretive itinerary. Morgan is most widely known as a poet, having won the Native Writers' Circle of the Americas First Book Award for his 2006 collection *The Fork-in-the-Road Indian Poetry Store.* He is also an award-winning author and coauthor of several works of nonfiction, beautifully designed and illustrated by the Chickasaw Press, including *Chickasaw Renaissance* (2009), *Riding Out the Storm: 19th Century Chickasaw Governors and Their Intellectual Legacy* (2013), and *Dynamic Chickasaw Women* (with Judy Goforth Parker, 2011). *Anompolichi* is Morgan's first novel, published by White Dog Press, an imprint of the Chickasaw Press that emphasizes self-representation through poetry and fiction. Morgan's novel is best described as a work of historical fiction written in a style accessible to a broad audience, including young adult (YA) readers. It is set in 1399, the end of the fourteenth century—what dominant discourses typically designate as "prehistory" for North America—at the height of Mississippian mound-building cultures spread across the expansive southeastern and midwestern parts of what is now the United States, from the Atlantic and Gulf Coasts to the valley of the Mississippi River and beyond. The precision of 1399 sparks interest because it immediately precedes 1400, the year archaeologists, historians, and other researchers often use to mark the "decline" or "demise" of Cahokia.

There is much to say about Morgan's engaging novel, which, not unlike platform mounds and other earthworks themselves, can be characterized as deceptively simple on its manicured surface but surprisingly complex in its underlying structures, multiple functions, and multiple alignments. My particular interest in centering *Anompolichi* within *Earthworks Rising*—siting it in Part II, at the center of the larger study—is to highlight the

novel's depiction of a vast, complex, and interconnected *world* of mound-building cultures and mound-based towns and cities, and to highlight the ways Morgan's novel intersects with the work of other contemporary Native American writers, artists, and intellectuals who are engaging Indigenous earthworks and earthworks principles across genres, media, and forms. More precisely, I engage Morgan's novel within the contexts of two ongoing conversations. First, I place *Anompolichi* in dialogue with a contemporary archaeological account of Mississippian mound-building cultures written for a popular rather than a scholarly audience, namely, the highly acclaimed *Cahokia: Ancient America's Great City on the Mississippi*, published by Penguin in 2009, written by the well-respected academic archaeologist Timothy Pauketat, who is based at the University of Illinois. Pauketat, his colleagues, and his students have shaped much of the contemporary conversation about Cahokia, its residents, and its legacies, and this group of researchers has helped establish orthodox archaeological understandings of Mississippian culture and history. And second, I place *Anompolichi* in dialogue with other YA historical fiction—or, as dominant discourses would have it, YA "prehistorical" fiction—set among Indigenous mound-building cultures. One evocative example is *Mog, the Mound Builder*, written by Irving Crump and published in 1931 by Dodd, Mead, then immediately reprinted in a second edition by Grosset and Dunlap, the well-known publishers of juvenile book series in the early and mid-twentieth century. The eponymous Mog was an Americanized version of the popular Og, Crump's fictional European "prehistoric boy" who lived among "cave people." Crump had already published a long series of stories about Og in *Boys' Life* magazine, the Boy Scouts of America's official periodical, for which Crump also served as a longtime editor. In the 1920s, Crump's European-focused prehistoric boy stories had been collected into two successful YA novels, *Og—Son of Fire* (1922) and *Og, Boy of Battle* (1925).[4]

As I describe later in the chapter, a surprisingly large number of these mound-builder YA novels were published during the twentieth century; perhaps not surprisingly, the tradition has continued into the twenty-first. Like *Mog*, many of these books feature highly evocative eponymous titles, as well as highly stereotypical images in their cover art (Figure 20). I spot-

light Crump's novel from 1931 because of its explicit connections to popular archaeological accounts. In his foreword, Crump acknowledges his debt to the work of Henry Shetrone, director of the Ohio State Archaeological and Historical Society and author of the massive 1930 study *The Mound-Builders* (which I discuss in the Introduction). Crump persuaded Shetrone to write an authenticating introduction for *Mog*. What the archaeologist chose to emphasize about this fictional story of a "prehistoric American boy" is worth reproducing in full:

> In view of the present-day tendency to write about scientific things in language intended for the average reader, and especially for juveniles, it is a pleasure to furnish an introduction for this little volume.
>
> In choosing the so-called Mound-builders as his subject, the author has not attempted to discuss the many mooted questions attaching to their story, and thus has averted danger of criticism. He has produced a simple and readable narrative which, although from the very nature of the subject must be based on surmise, depicts in a plausible manner what might have occurred in the lives of those mysterious people who lived, loved, fought and died on American soil long before the Old World dreamed of such a place as the New.
>
> We have been too prone to attribute treachery and unjustified cruelty to so-called uncivilized peoples; and while undoubtedly the Mound-builders and the prehistoric Indians possessed their share of these, beyond question they also had their share of the virtues. "Mog, the Mound Builder," depicts its characters as human beings which, of course, they were.[5]

Shetrone praises Crump for *not* offering too many of his own speculations on the many questions about the builders of the mounds that were still under debate in the early decades of the twentieth century, and thus Shetrone praises Crump for simply re-presenting in plain language and within the structure of an engaging plot the prevailing "scientific" orthodoxy of the day. Part of that orthodoxy was the assumption of a non-Native point of view: the so-called Old World dreaming about the New. At the same time,

Shetrone subtly introduces the language of "mystery" and the binary of "savagery versus civilization" (although "savagery" is implied rather than overtly stated in his use of the adjective "uncivilized"), neither of which appears in Crump's own foreword.

As will become clear in my analysis of Morgan's work from 2014, *Anompolichi* offers a marked contrast to *Mog*, its contemporaries, and its literary descendants. Although Morgan also writes in accessible language and develops an engaging plot suitable for juvenile as well as adult audiences, he does not shy away from the "danger of criticism": he presents his own speculations about the builders and first users of the mounds, based not only in the prevailing "scientific" orthodoxy, with which he is clearly familiar, but also in distinctly Indigenous understandings and perspectives. Morgan gives his novel a primary title in the Chickasaw language, and he sets *Anompolichi* in the Mississippian era of extensive mound building and expansive trade, social, and political networks stretching across the Southeast and up and down the Midwest. And rather than begin by acknowledging archaeological sources of inspiration, Morgan dedicates his novel "to our ancestors who built and inhabited great towns and colorful cities during a better era of life in North America."[6] I draw attention to the dedication because Morgan's emphasis falls not on individual examples of mounds but rather on Indigenous *towns* and *cities*, directly countering age-old stereotypes that, prior to the coming of Europeans, all Native peoples in North America were either "nomadic" or lived in small-scale "villages" and "camps." I draw attention to the dedication, as well, because of Morgan's portrayal of the Indigenous North American past in terms that are unambiguously positive rather than negative or equivocal.

Like the novel's dedication to Southeastern ancestors who built towns and cities, the summary of the novel's plot on the dust jacket offers a surprising emphasis. The summary reads:

> Fourteenth-century Scottish sailing master Robert Williams leaves port for a short, but profitable voyage around the British Isles, his ship laden with cargo including the king's goat.

FIGURE 20. Cover of *Mog, the Mound Builder*, by Irving Crump (1931). Scan courtesy of the University of Washington Libraries.

A sudden and powerful storm erupts, sending his ship farther off course than he or any of his seasoned crew have journeyed before, driving them into astonishing discovery and relentless tragedy, and flinging Robert into a world unlike any he has imagined. In that new world, he meets a remarkable Native man who recognizes him from a dream— Iskifa Ahalopa, known by his people as an *anompolichi*, a wordmaster.

Robert and his new friend soon find themselves caught up in unforeseen depths of intrigue and danger, brought before astounding spectacle, and plunged into perilous adventure in the New World long before history recorded its discovery.

One aspect of Morgan's novel that is immediately striking is the way it is built around a central non-Native but pre-Columbian character, Robert Williams, a fourteenth-century Scottish sea captain. This European character provides an outsider's perspective with which contemporary and, perhaps especially, non-Native readers can more easily identify, but this character also forces European "history" into significant contact with North American "prehistory." The novel's principal Native character, Iskifa Ahalopa, is the *anompolichi* of the novel's title, an experienced wordmaster, part of a class of translators trained to speak many languages so that they can help facilitate trade and politics and thus help maintain peace among diverse Indigenous peoples. Readers learn that Iskifa has traveled widely and speaks no less than nineteen languages. Robert and Iskifa meet because, in a dream, the sixty-five-year-old elder is told by the spirit world that he should journey to the coast of *okhata ishto*, the eastern ocean, where he will find a "strange, pale-skinned man"—and, indeed, Iskifa discovers Robert and the king's goat, along with one of Robert's deceased comrades, washed onshore after their ship is wrecked in a storm.

Part of the adventure of Morgan's story is the journey the shipwrecked Robert and his new Native friend will make from the coast of the eastern ocean inland to a massive earthworks city sited on the Mississippi River near its confluences with the Missouri and Illinois Rivers, a city clearly modeled on Cahokia. Called Tochina, the word for the number three in Chickasaw and Choctaw languages, the city's name refers to "where the three rivers

meet." The earthworks city is preparing to host the Yamohmi, "the fashionable event," an intertribal stickball competition held every ten years between players representing Iskifa's people from the Yukpan Confederacy of Southeastern mound-building cultures and players representing the northern Allahashi Confederacy of mound-building cultures centered at Tochina—that is, Cahokia. The Yukpan Confederacy, which includes the ancestors of Morgan's Choctaw and Chickasaw Nations along with the ancestors of other Southeastern peoples, still embrace an older form of spiritual practice aligned with Aba Binnili, Creator of All, while the Allahashi have adopted a newer form of religious worship centered on the Sun, which has been imported from Mexico. The Allahashi have ostensibly invited the Yukpan to the stickball tournament as a grand gesture of friendly competition, but the secret plan of the Allahashi ruler, Yoshoba, is to ambush the Yukpan players and spectators in order to subdue, kill, or enslave them. Ultimately, Yoshoba plans to bring the entire Yukpan Confederacy under Allahashi political control. It is the kind of intrigue and violence one expects from a work of YA historical—or "prehistorical"—fiction.

As already noted, there is much to say about the novel's engaging plot and characters, its use of English and Indigenous languages, and how it connects to the work of other Native writers and artists. Placing *Anompolichi* in dialogue with a non-Native popular archaeological account and with non-Native YA historical and "prehistorical" fiction helps us focus on how Morgan, like other writers interested in Indigenous mound-building cultures, grapples with two central and complex questions. First, how might we know, understand, or even *imagine* Indigenous earthworks cities like Cahokia—built a thousand years ago—in the ways they were known, understood, or imagined by the peoples who planned, constructed, and first experienced them? And second, how might we represent such knowledge, understandings, or even imaginings of the distant North American past within the conventions, limitations, and possibilities of contemporary genres and individual texts? What is possible within the confines of the alphabetic writing and the (mostly) English language Morgan has at his disposal?

BEYOND THE STILL LIFE OF THE CAHOKIAN DIORAMA

Although Morgan and non-Native archaeologist Timothy Pauketat, author of the popular nonfiction account *Cahokia: Ancient America's Great City on the Mississippi*, begin from divergent contexts, write within distinct genres, and ultimately work toward different purposes, both must confront the need to teach twenty-first-century readers *how to see* the complex materiality and scale of mound cities and thus *how to perceive* the potential of this materiality to make meaning and create significance—in the past, in our present, in possible futures.

Popular reviews of Pauketat's book were overwhelmingly positive. These reviews highlight Pauketat's ability to tell an engrossing story about a "lost civilization," to bring dry archaeological detail to life, and to "balance" his own "speculations" with "empirical evidence." The review that appeared in *Salon,* for instance, which was then emblazoned across the cover of the Penguin paperback, declares Pauketat's book "Mesmerizing" and asserts that "one constantly marvels at the hair-raising archaeological discoveries that fly in the face of conventional understandings of Native American life." Scholarly reviewers, necessarily writing at some temporal distance (since scholarly reviewing typically occurs at a much slower pace) and with a higher degree of specialized knowledge, have been more willing than the popular reviewers to raise questions about Pauketat's presentation of speculative theories as more-or-less well-substantiated facts. These reviewers, however, similarly praise Pauketat for bringing Cahokia to life for popular audiences through the vehicles of lively prose and compelling detail.[7] Both sets of reviewers praise, in particular, Pauketat's attempt to produce an account of Cahokia that is human in scale, an account that at least begins to suggest what it might have been like to experience the city at the height of its so-called grandeur.

What tools are available to authors such as Pauketat that will help readers to see and understand the monumental accomplishments of one of North America's most impressive mound-building cultures? As I note in the introduction and across the chapters in Part I, since at least the nineteenth century amateur hobbyists and professional researchers alike have relied primarily on tools that are based in abstract renderings and over-

FIGURE 21. The scale model of Cahokia on display in the Interpretive Center indicates the relative positions and relative sizes of the site's major features, including Monks Mound and Woodhenge. Courtesy of Cahokia Mounds State Historic Site.

head perspectives, whether in the form of maps, surveys, diagrams, other kinds of schematics, illustrations, models, aerial photography, or, more recently, 3D computer imaging, including LiDAR. In the case of Cahokia, we have become accustomed to viewing the site—and thus we have become accustomed to conceiving the site's overall design—through the kind of abstracted and idealized scale model that is a central feature of the State Historic Site's Interpretive Center. Cast in metal, the model freezes Cahokia at a particular stage of construction and completion. It also provides a uniformly flat and monochromatic surface upon which the mounds and the upright posts of the Woodhenge calendar rise in stark relief (Figure 21). This kind of 3D model allows viewers to easily distinguish the mounds and selected additional built structures in relation to each other within a single plane, from an overhead perspective, and as though observed from a

great height. It gives the proverbial "bird's-eye view" (sometimes expressed as *God's-eye view*, which more clearly exposes the implication of providing complete knowledge).

We have also become accustomed to viewing drawn or painted illustrations of Cahokia produced from similar overhead perspectives; several examples of these are also prominent features of the Interpretive Center and its public-facing website. Similar to the 3D scale model, these illustrations allow viewers to observe mounds, stockades, houses, and other built structures not only in relation to each other but also in relation to additional features in the landscape, such as rivers, creeks, and ponds. Typically, such illustrations depict sites at midday, in the summer season, and during fine weather; one rarely encounters depictions of sites at night, in the winter, or during a storm (Figure 22). For our convenience as contemporary viewers, these overhead and scaled representations often include helpful labels, providing an enhanced sense of overall comprehension and perhaps mastery. Although scale models and labeled aerial images convey quite a bit of information about the physical forms and relative siting of mounds— frozen at a particular stage of construction and completion, and shown under idealized conditions—they tell us little about the embodied human experience of either visually or physically encountering earthworks on the ground. As I note throughout *Earthworks Rising*, attempting to represent these embodied experiences, especially for broad audiences, requires other methods.

To that end, Pauketat introduces into his popular (and at times highly speculative) archaeologically based account of Cahokia the idea of "walking" as a mode of perception. This feature of the book is repeatedly praised by both popular and scholarly reviewers. Pauketat organizes *Cahokia* into twelve chapters, with the trope of walking developed in chapter 3, "Walking into Cahokia." In the chapter's opening line, the archaeologist states in a casual tone: "It's difficult to know exactly what Cahokia was like at its height."[8] Pauketat then briefly details how the mounds and other features at the extensive site have been eroded because of human neglect and how they have been damaged, diminished, or destroyed by the active human intervention of European and American settlers, primarily through agri-

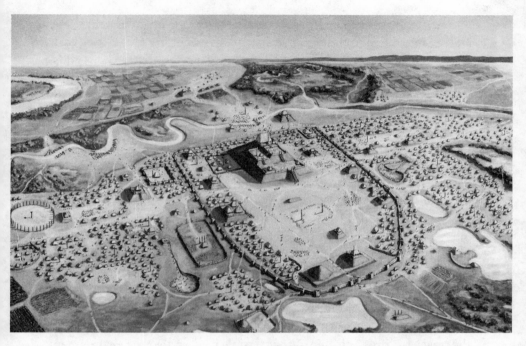

FIGURE 22. A large mural on display at the Interpretive Center depicts an aerial view of Cahokia circa A.D. 1150–1200 under ideal conditions. Painting by William R. Iseminger. Courtesy of Cahokia Mounds State Historic Site.

cultural cropping and the building of roads, highways, towns, and subdivisions. "Not that long ago," Pauketat states, "almost half of the Grand Plaza was covered by a residential subdivision (at the time, no one knew it was the central plaza). Some sixty trim little houses, built in the 1940s, were sprinkled in the middle of the sacred core of the site" (23). Moreover, "Of Cahokia's more than 120 mounds, only about half remain in anything near their former proportions" (26). Since these diminished remnants make it impossible for contemporary visitors to see and experience the original size or precision of the mounds, Pauketat invites readers to *imagine* what it would have been like to "encounter" Cahokia at the "height of its grandeur nine centuries ago" (29). To organize this personalized and embodied

reconstruction of encounter, Pauketat asks readers to imagine "a traveler's journey into the central city from a distance of, say, thirty miles to the east, where Cahokia's extensive farming district began." The archaeologist adds: "If the traveler set off on foot at sunrise, it would take the better part of two days to make it into downtown Cahokia" (29). For the next six pages, Pauketat narrates what this generic traveler would see and experience on his two-day journey. (Pauketat consistently designates the traveler as "he.")

Although Pauketat deploys a number of strategies typical of narrative fiction, he nonetheless maintains the perspective of a non-Native researcher and an academic archaeologist. No reader will mistake this brief section for a short story or an excerpt from a novel. The character of the traveler remains undeveloped beyond the fact that he is male; no descriptions are offered of his person or dress, his backstory, or his motivations for walking into Cahokia. Occasionally, Pauketat switches the perspective from "the traveler" to a similarly generic but more personal "one." Also of interest, Pauketat privileges the passage of time—the movement of the sun across the sky and the resulting shadows cast across the land—nearly as much as he privileges the organization of space. In this way, he foregrounds the traveler's "pace," his rate of travel, while he describes the environment through which the traveler passes. Early in the section, Pauketat writes: "He begins by walking westward along one of the many well-worn foot highways (most of which, as with Rome, led to Cahokia), the morning sun casting long shadows across the patches of prairie grass or deciduous forest interspersed with fields of corn, squash, local grains, and sunflowers" (29–30). As the traveler walks, the narrator emphasizes details that will be of interest to non-Native outsiders (and, as in the previous passage, occasionally makes comparisons to places either in Europe or in other parts of non-Native America). When the traveler walks past "a rural temple complex," the narrator notes that the complex consists of "a well-constructed and immaculate pole-and-thatch building, a free-standing wooden post, and the adjacent home and outbuildings of a priest or temple attendant clustered together on a cleared hilltop" (30). And when he walks past "ordinary home sites," the narrator compares the structures the traveler sees

to "the vertical-log cabins built by the French colonists who moved into the region six hundred years later." Tellingly, the narrator describes these "ordinary" home sites as "*Indian* houses" (30, emphasis added).

Roughly midway through the section, Pauketat describes the traveler's arrival, "late in the afternoon" of his first day of walking, at the bluff above the east bank of the Mississippi River: "The setting sun's rays reveal a great vista as he stands some hundred feet above the enormous floodplain to the west" (32). This location affords a commanding view:

> It is here, at the bluff escarpment's edge, that the well-ordered space of the district of Cahokia would fully engulf one's senses. Looking left and right along the crest, the traveler realizes that he is standing in the middle of a blufftop mortuary zone. The hills to either side are studded with low earthen burial mounds, thatched-roof temples or charnel houses, marker posts, and mortuary scaffolds that offer the bodies of the dead skyward. A few vultures and a dozen crows mount the scaffolds, flapping their wings and picking at the remains laid there. The traveler then searches for a path by which he can wend his way down and around the scaffolds, mounds, and buildings.
>
> As the sun sets, he enters the floodplain. (32)

The detail of the scavenging vultures and crows at work atop the burial scaffolds is especially evocative. Pauketat misses, however—or perhaps avoids—an opportunity to offer an Indigenous understanding of the actual complexity of "mortuary" rites involving scaffolds, flesh-eating birds, charnel houses, and mounds, as well as the importance of the proximity to water.[9]

It is well into his second day of walking that Pauketat's generic traveler reaches the outskirts of central Cahokia. "With the sun directly overhead now," the narrator states, emphasizing the ideal conditions for viewing, "the traveler is completely enveloped by pyramids, plazas, posts, dwellings, and people. In the distance, the deep, rhythmic, booming sounds of great skin-covered drums are audible, overlaid by a chorus of singers" (34). And, finally:

Half an hour later, the traveler reaches Cahokia's center, the focus of civic and ceremonial life. Here, between the walls and mounds in the foreground, is a flat public square 1,600-plus feet in length and 900-plus feet in width. A host of people gathered in and around this grand precinct are drumming, moving, and singing. This is sacred space, not to be traversed casually, and foot traffic is directed around the ceremony taking place. Were the traveler allowed to pass, he would see this plaza—constructed of weedless, packed fine sand—edged with the finest of buildings astride the largest of earthen pyramids. (34)

Although the narration of the traveler's walk is engaging, I think it is fair to say that—the expressed enthusiasm of the *Salon* review notwithstanding—the account is less than fully "mesmerizing"; the details are surprisingly spare and generic. Readers are kept at a scholarly distance, and we are never prompted to imagine the site, its features, or its inhabitants from insider perspectives. What, for instance, might the concept of "sacred space" evoke within this particular cultural and historical context? And why, specifically, is *this* traveler not allowed to see the ceremony taking place? Is he not yet appropriately initiated? Is he too young? From the wrong clan or of the wrong profession? Something else? Also surprising is Pauketat's choice to limit his traveler's access and vision just as he enters Cahokia's central zone: "*Were* the traveler allowed to pass, he *would* see . . ." (34, emphasis added). Similar to the limited narration of the traveler's encounter with human burials on raised scaffolds, this feels like a missed opportunity. "From the plaza," the narrator states as the section moves toward conclusion, "the traveler *cannot see* the great pyramid's summit" (35, emphasis added). After two days of walking alongside the generic traveler, our guided tour ends on a low note of limited vision.

The trope of imaginative "walking" allows the archaeologist to describe Cahokia in human terms and at a human scale, to emphasize the complexity of the mound city's multiple districts and multiple economic and social zones, and to demonstrate a certain, if limited, level of empathy with Native people of the past. Pauketat's account is successful in evoking embodied human movement and perceptual process through connected space; the

chapter offers an inviting contrast to more typical archaeological accounts of overly schematized and fixed abstractions. At the same time, the account is notable for its lack of characterization of the generic traveler, for its emphasis on describing items of material culture—and, especially, the *surfaces* of things—and for its multiple comparisons to non-Indigenous benchmarks. The account is notable, as well, for how it restricts its imaginative depiction of the Cahokian world to a relatively limited area, a distance of only thirty miles, and to a single (male) perspective. Finally, and perhaps most significantly, Pauketat's account of moving through Cahokian space is notable for how it disconnects the process of walking from explicit practices of mapping or other systematic forms of knowledge production.

It is something of a surprise that Pauketat does not use his account as an opportunity to theorize how walking affects human perception in general or how it affects, in particular, the human perception of large, three-dimensional structures like earthen mounds. The trope of walking is used primarily to emphasize a human perspective and the amount of time required for an adult human to move across a particular distance on foot. Other archaeologists, however, have been developing theories about the relationship between movement and perception, especially those engaged in what are called "relational" archaeologies, that is, archaeologies concerned with how humans interact not only with each other and with various aspects of the gross physical world but also with nonhuman animals and with a broad range of material "things" situated within the gross physical world. To take one example, as mentioned in the introduction and described in some detail in chapter 2, the work of the relational archaeologist Mary Weismantel, a specialist on pre-Incan Indigenous cultures in Peru, helps us think about how large and monumental built structures require theory "adequate to their particular form of visuality." As already noted, Weismantel argues that objects are constructed to engage our senses and our bodies in culturally sanctioned ways, and she asks us to think about how particular objects constrain, prevent, or enable specific forms of interaction and perception. Thinking about large or monumental Indigenous structures, she develops an idea of "slow" or "conscious" seeing.[10] She helps us understand why aerial photographs, models, maps, and diagrams are much easier to

"read" than are large, three-dimensional structures like earthworks. Large structures delay the moment of visual recognition, she argues, and this slowed recognition in the visual encounter makes the viewer aware of the physical and cognitive effort involved in seeing. Moreover, Weismantel argues that at least some large Indigenous structures demand "an active body that absorbs knowledge kinetically" to enable their adequate perception.[11] We might say that mounds *require* our purposeful movement in order to perceive them on their own terms.

Pauketat's chapter helps readers experience this kind of "slow seeing" at Cahokia—one reviewer describes it as a "fabulous virtual walk through the city"—but, unfortunately, the account stops short of explicitly linking slow seeing to the production of specifically Indigenous forms of knowledge, such as Indigenous mapping.[12] The remaining nine chapters are focused not on imagining what it might have been like to see, experience, and understand Cahokia from embodied and kinetic Indigenous perspectives, but rather on providing detailed accounts of how non-Native archaeologists came to know Cahokia and to develop theories about its functions, systems, and potential meanings. I think it is fair to say Pauketat's primary interest is in developing a celebratory—even heroic—account of archaeological discovery in the nineteenth and twentieth centuries. As one scholarly reviewer noted, Pauketat casts "investigators as major characters in the Cahokia story."[13] Another stated that Pauketat positions twentieth-century archaeologists as effecting Cahokia's "rescue."[14] Like most non-Native archaeologists, Pauketat is less interested in engaging, representing, or imagining perspectives that are Indigenous.

We can contrast Pauketat's limited use of imaginative walking as a critical mode of perception in his nonfiction account with Morgan's more elaborate development in his novel. Rather than a brief chapter focused on a single generic "traveler" walking thirty miles over two days toward the center of Cahokia, Morgan devotes the majority of *Anompolichi* to describing multiple Native characters and one non-Native character who walk from the coast of the eastern ocean, through multiple parts of the Southeast, all the way to Tochina on the banks of the Mississippi. And rather than walk into a single, contained mound site, Morgan's characters walk through a complex

world of diverse and interconnected mound-building cultures: from agricultural outposts that support villages and towns, to small towns with only a few mounds, to larger towns and cities, such as Anoli, built around many mounds and "protected by a massive timber wall" (99). Moreover, across his chapters Morgan has his characters not only walk toward, among, and on top of mounds of various sizes; in the climactic scenes of Allahashi treachery at the massive stickball tournament staged in the grand mound city of Tochina, he takes readers, as well, literally inside the earthworks. The conniving ruler Yoshoba has had large, timber-lined vaults installed beneath the newly built spectator mounds upon which the Yukpan will gather to watch the tournament. Hidden within these vaults are Yoshoba's army of warriors, who plan to surprise and ambush the unsuspecting guests. Once subdued, the surviving Yukpan are then held prisoner within these timber vaults built inside the mounds. (I say more about this intriguing aspect of Morgan's novel in chapter 5.)

We can also contrast how Pauketat disconnects walking from explicit mapmaking and other kinds of systematic knowledge production with Morgan's depiction of Indigenous maps and mapping in *Anompolichi*. In the early chapters of the novel, Robert, the Scottish sea captain, is described as being familiar with navigational charts and maps from Europe. As he walks with Iskifa inland from the place of his shipwreck and encounters increasingly large and complex settlements, Morgan depicts Robert's increasing ability to perceive, understand, and navigate the unfamiliar built environment all around him. Two-thirds into book 1, in chapter 8, titled "Inland," before they arrive at the first settlement Robert is surprised to learn that Iskifa understands the concept of mapping when the Indigenous elder uses a stick to draw "pictures in the sand." The figures in this "sketch" indicate where Robert and Iskifa are situated in the landscape at that moment as well as their intended destination (69). A few pages later, Robert is surprised again when he learns Iskifa possesses a map of the entire region, painted on a "scroll" of "light-colored buckskin" (71). The description of the map as painted on buckskin subtly but explicitly links Iskifa's map—a scaled abstract image of the coastline with groups of house icons representing settlements—to the embodied act of walking, since the first things Robert

perceives when he meets Iskifa on the coast are the elder's "buckskin shoes" (48). In fact, one of the first descriptions of Iskifa given from Robert's perspective is "the figure in buckskin shoes" (48). Moreover, Morgan stages the encounter as an explicit scene of instruction, in which the Native character teaches the supposedly "experienced eye" of the European how to engage the abstract signs encoded on the tanned buckskin in order to understand his place in an unfamiliar world (71).[15] Iskifa uses "his bone whistle for a pointer" to show Robert where on the painted map they have traveled thus far, ending at "a circle with a sign of fire inside—the very place where they sat" (71). Later, near the end of book 1, in chapter 11, "Civilization," when Robert first encounters an Indigenous town built on and among mounds, Iskifa's buckskin map is brought out again. In this instance, the map helps Robert learn to understand relationships between space and time in his new environment:

> Iskifa unrolled his map for Robert, directing him to look at the six sun symbols between Chilantak's town and the next, signified by a cluster of houses. Robert reasoned it meant six days' travel to the next big town. "Six days walk," Robert pronounced to Iskifa, holding up six fingers and making a sweeping arc sign with his right hand cupped, as if to hold the sun.
>
> "Ii," Iskifa replied, nodding and mimicking his six fingers and arc-of-the-sun sign. (97)

One can imagine Pauketat's generic traveler producing a similar kind of map to indicate his days of walking into Cahokia, which he then might share with others.

It seems significant that it is only *after* Robert has been given his first explicit lessons in how to perceive the Indigenous world through Iskifa's drawn and painted maps that the non-Native character actually encounters physical mounds. The language Morgan uses to describe Robert's shifting perception also seems significant. In contrast to Pauketat, Morgan creates a deliberate sequence of terms that simulate the experience of "slow" or "conscious" seeing when encountering mounds for the first time, that is,

the experience of delayed visual and conceptual recognition. At first, Robert sees a "hill in the middle of the fields" (91). Next, he sees a "shaped hill, level as water in a glass, its four sides sloping upward with geometric precision" (91). Robert thinks, "It must be manmade" (91), and the narrator explains, further, that "He had never seen such a hill, without any roundness or irregularity in its shape. It was beautifully landscaped with uniform grass on its sides" (91). Later in the chapter, after some exploration of the "shaped" and "sculptured" hill (91, 92), Robert sees a "mound" (93). This is the novel's first use of the specific term. Finally, at the end of the chapter, the narrator reports that Robert now sees an "earthwork" (103). Morgan's shifts in language indicate Robert's shifts in the level and quality of his perception as he moves his body—as he "walks"—through an unfamiliar built environment. Readers experience Robert's experience of slow seeing in his encounter with the monumental three-dimensional materiality of Southeastern mounds.

MOG AND CHULA AND IKWA AND ANONA AND . . .

Perhaps I should not have been, but I was surprised to discover how many "prehistoric" novels set among mound-building cultures have been written for YA audiences. And this array of fiction sits next to a similarly large companion genre of nonfiction books about mound-building cultures also written for YA audiences.[16] Some of the novels, similar to Morgan's YA-accessible *Anompolichi*, are set within Mississippian mound-building cultures of the Southeast and Midwest. Others are set among the so-called Adena, Hopewell, or Fort Ancient mound-building cultures of the Ohio Valley. As mentioned early in the chapter, many of the titles are eponymous, focusing attention on a prominent individual, often an adolescent or young adult protagonist, such as the teenage boys Mog and Chula or the girls Ikwa and Anona, but occasionally on an older adult, such as the elder woman called Cricket Sings. Many of the novels' illustrated covers include artwork that is highly evocative of a "primitive" or "savage" Indigenous past. An example of this canon from the twenty-first century is *The Gold Disc of Coosa: A Boy of the Mound Builders Meets DeSoto* (2007), written by Virginia Pounds Brown and set among Alabama Indians in 1540. But most of the works I reviewed

for this project appeared across the twentieth century: *Cricket Sings: A Novel of Pre-Columbian Cahokia* (1983), set in what is now southern Illinois; *The Eye in the Forest* (1975), set in what is now Ohio and Tennessee; *Ikwa of the Temple Mounds* (1974), in two versions, set in the Southeast; *Chula, Son of the Mound Builders* (1942), set in what is now southeastern Tennessee; *The Black Spearman: A Story of the Builders of the Great Mounds* (1939), set in what is now Ohio; *Winged Moccasins: A Tale of the Adventurous Mound-Builders* (1933), set in what is now Indiana, Ohio, and Wisconsin; *Mog, the Mound Builder* (1931), mentioned earlier, set in what is now Ohio; and *Anona of the Moundbuilders: A Story of Many Thousands of Years Ago* (1920), set in what is now the Ohio Valley and the Southeast.[17]

I won't bore readers with the plots of all these YA "prehistorical" novels, which were intended to present "archeological facts in story form" to an audience of "boys and girls of today" so that these young readers might "appreciate the works of the First Americans."[18] It likely goes without saying, but none of the authors who wrote across the decades of the twentieth century appears to have contemplated the inclusion of Indigenous readers (or any nonwhite readers) within their audiences. It also likely goes without saying that some of the books are more competently conceived, more skillfully researched and written, and more engaging than others. One observation I made from reading across this odd canon, however, surprised me— although, in retrospect, it probably should not have—and this observation seems especially relevant to a focused analysis of Morgan's *Anompolichi*. All of the YA novels I read are set entirely in the distant past of active mound-building cultures in the Southeast, Midwest, or Ohio Valley. And with the exception of *The Gold Disc of Coosa* (2007), which relates the story of the European de Soto expedition from a Native point of view, all of the novels' many characters are (ostensibly) Native. And yet a surprising number of the novels go to great lengths to reinscribe civilizational and racial hierarchies. The contrasting depictions of the mound builders and their non-mound-building neighbors—and especially their non-mound-building enemies—are disturbingly familiar. In twentieth-century novels like *Winged Moccasins*, *Chula*, and *Mog*, the mound builders are uniformly described as the most "civilized" communities within a hierarchical spectrum

of more- and less-civilized and more- and less-evolved North American peoples. The less-civilized and less-evolved communities are described in stereotypical terms as "warlike . . . invaders," "simple" peoples, "nomads," even "cave dwellers," "primitives," and "savages." *Chula* distinguishes its young mound builder hero by describing him as "olive-skinned." *Anona* pushes the issue of superior complexion further, describing the mound builders as "fair skinned" and their non-mound-building enemies to the south as "black savages." Many of these novels culminate in a fierce battle between the more-civilized and more culturally, physically, and techno-logically evolved mound builders and the less-civilized and less-evolved "nomads," "primitives," or "savages" who fiendishly attack them. Since the predominantly (if not exclusively) white YA readers are encouraged to identify with the "civilized," "evolved," and sometimes "fair skinned" mound builders, these novels appear to inscribe not only civilizational and racial hierarchies but also, and more specifically, a thinly disguised trope of white supremacy. In this way, the twentieth-century YA novels offer a less-than-subtle justification for the contemporary dominance of non-Indigenous peoples in North America.

This context makes Morgan's decision to place a white European char-acter at the center of *Anompolichi*'s historical fiction all the more interest-ing.[19] From the jacket copy, readers may assume that Robert Williams, the Scottish "sailing master," serves as the novel's protagonist and thus that his character provides the central point of view, an outsider's perspec-tive with which contemporary and predominantly non-Native readers can more easily identify. This technique of centering an outsider perspective is common to many genres of travel writing and to many stories of "exotic" adventure in "far-away lands." But Morgan's use of the white European character turns out to be more complex and nuanced. And similar to the innovative work of Native writers Allison Hedge Coke and LeAnne Howe, discussed in other chapters, much of that complexity and nuance is em-bedded in the novel's structures.

Anompolichi is composed of twenty-four chapters divided evenly into two *holisso* ("books") of twelve chapters each. Across these, Morgan's third-person omniscient narrator moves among a limited set of perspectives. In

"Holisso Chaffa / Book One" the narrative perspective shifts between Iskifa and Robert in a regular pattern. A brief chapter is told from Iskifa's point of view, followed by two longer chapters told from Robert's. This three-part sequence repeats four times, creating a productive tension between Native and non-Native perspectives, but also creating a structural balance and a sense of completion across book 1: Iskifa, Robert, Robert; Iskifa, Robert, Robert; Iskifa, Robert, Robert; Iskifa, Robert, Robert. We can think of the pattern as a mathematic ratio of 1 to 2 repeated four times, producing an overall ratio of 4 to 8. Since neither character understands or speaks the other's language, much of this first half of the novel is devoted to scenes of mutual learning as the two men—along with the king's goat—walk from the coast of the eastern ocean, where Iskifa discovers Robert and the strange animal washed onshore, inland to increasingly complex settlements and cities built around mounds. As mentioned earlier, two-thirds into book 1, in chapter 8, Robert first learns about Iskifa's maps. In the final paragraphs of chapter 11, as Robert becomes increasingly familiar with his new surroundings, he is introduced to Iskifa's apprentice wordmaster, the young woman Taloa, who has been sent to "the great walled town of Anoli" to study additional languages (104).

The big shock at the end of chapter 11—and it is a genuinely big shock in the narrative—is that Taloa speaks not only a large number of Indigenous languages, similar to her mentor Iskifa, but also *English*. Robert Williams is not, in fact, the first European to enter this complex North American world. Indeed, in chapter 12 we learn that Taloa has studied English with another man originally from Great Britain, who has since passed away. Given these revelations related to language and comprehension, the final sentences of chapters 11 and 12 turn out to be highly significant. The final sentence of chapter 11 reads: "Robert gaped at her [Taloa], *speechless*" (103, emphasis added). The final sentence of chapter 12, in which Robert is suspected of being a foreign spy and put on trial by the local judge of the mound city, reads: "Taloa finished translating, watching Robert slump down to sit on the bench, lean wearily on his knees, and stare blankly at the floor, *struggling to comprehend*" (118, emphasis added). Book 1 thus ends with the non-Native central character, despite all he has learned in the preceding chapters, un-

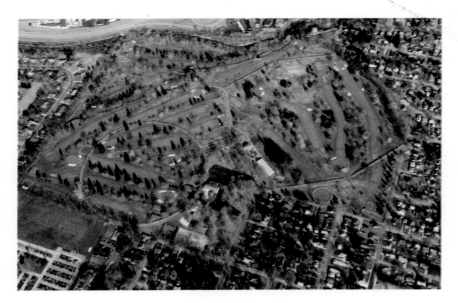

PLATE 1. Aerial view of the Octagon Earthworks, Newark, Ohio. Newark Earthworks Center. Photograph by Timothy E. Black.

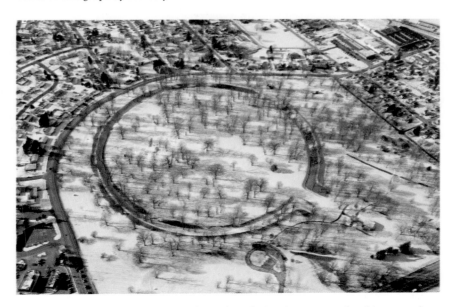

PLATE 2. Aerial view of the Great Circle Earthworks in winter, Newark, Ohio. Newark Earthworks Center. Photograph by Timothy E. Black.

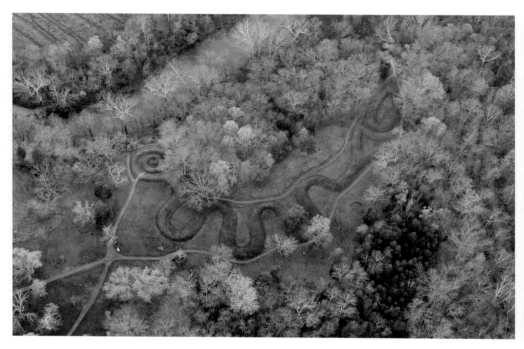

PLATE 3. Aerial view of the Serpent Mound in southern Ohio. Newark Earthworks Center. Photograph by Timothy E. Black.

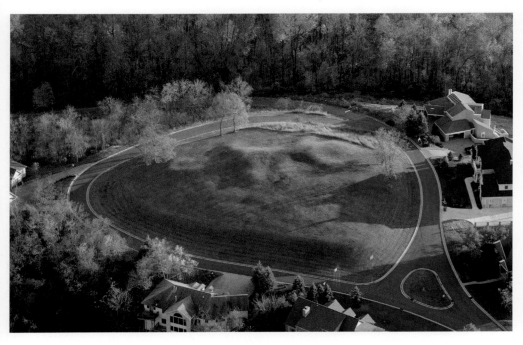

PLATE 4. Aerial view of the Alligator Mound, Granville, Ohio. Newark Earthworks Center. Photograph by Timothy E. Black.

PLATE 5. Alyssa Hinton, *Ancestral Plane*, copyright 1998. Digital collage assembled from thirty-three image fragments.

PLATE 6. Detail of interred ancestral bodies glowing like heat maps. Alyssa Hinton, *Ancestral Plane*, copyright 1998.

PLATE 7. Detail of electric-blue embryo floating in amniotic soil. Alyssa Hinton, *Ancestral Plane*, copyright 1998.

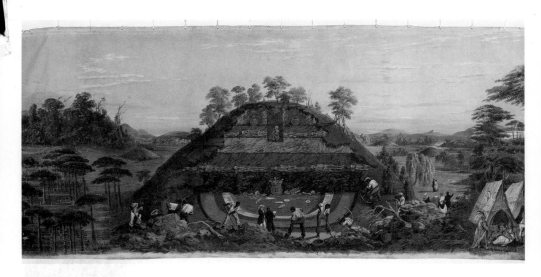

PLATE 8. John J. Egan, American (born Ireland), active mid-nineteenth century; *Huge Mound and the Manner of Opening Them*, scene twenty from *Panorama of the Monumental Grandeur of the Mississippi Valley*, circa 1850; distemper on cotton muslin; 90 inches x 348 feet; Saint Louis Art Museum, Eliza McMillan Trust 34:1953.

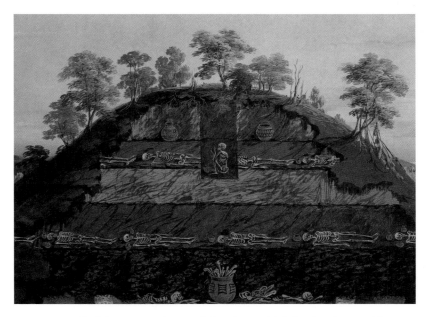

PLATE 9. Detail of the excavated mound showing multiple levels of exposed human remains and clay urns, John J. Egan, *Huge Mound and the Manner of Opening Them*.

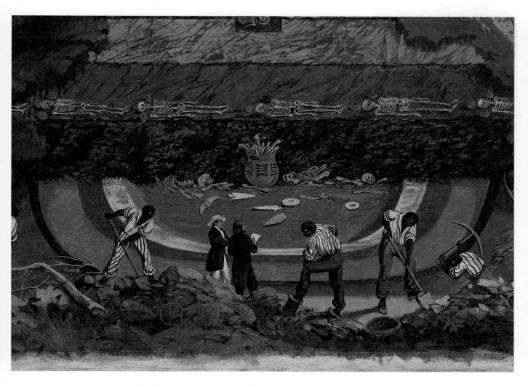

PLATE 10. Detail of white supervision and Black labor in the excavation of the mound, John J. Egan, *Huge Mound and the Manner of Opening Them*.

PLATE 11. Detail of living Indians in the far right corner of the foreground, John J. Egan, *Huge Mound and the Manner of Opening Them*.

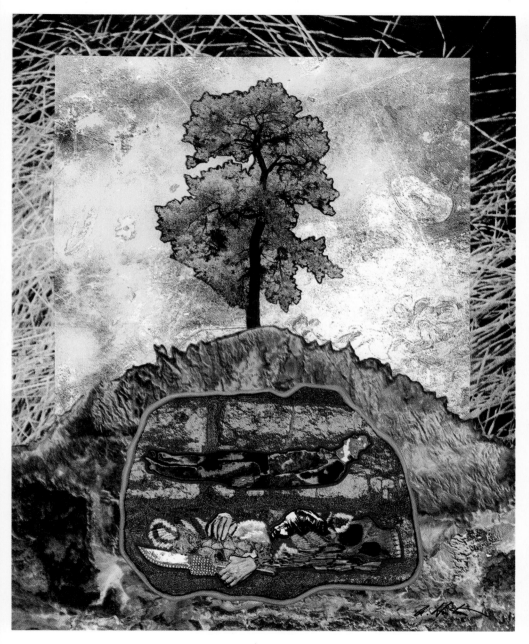

PLATE 12. Alyssa Hinton, *Slumber,* copyright 1996. Digital collage assembled from twenty-four image fragments.

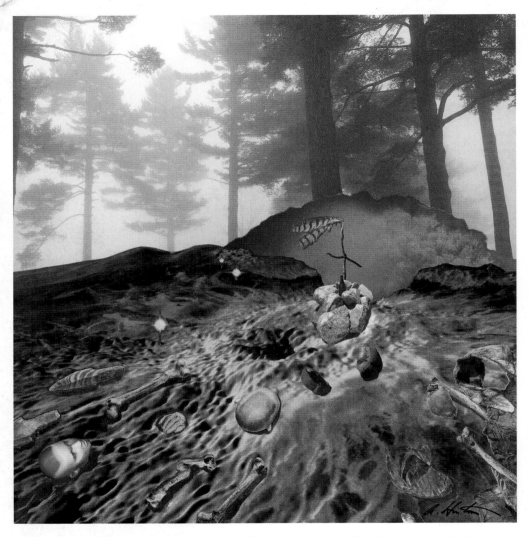

PLATE 13. Alyssa Hinton, *Spiritual Archaeology,* copyright 1997. Digital collage assembled from forty image fragments.

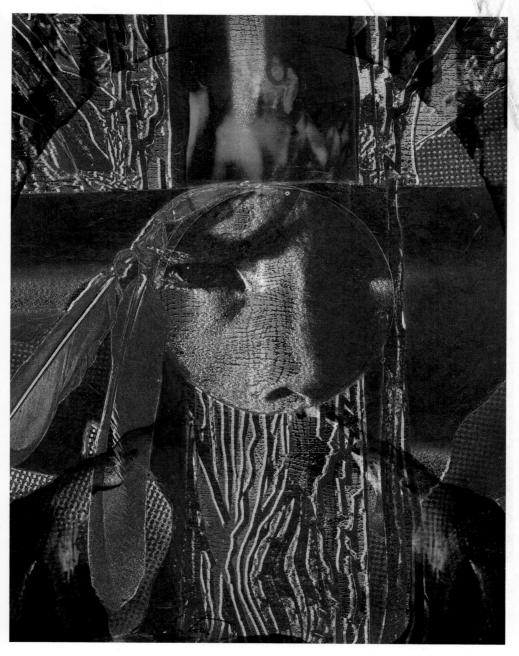

PLATE 14. Alyssa Hinton, *Awaken 7*, copyright 2005. Mixed media composite using photographs, original acrylic paintings, found papers, relief print, and digital editing.

PLATE 15. Cover of *Blood Run: Free Verse Play* by Allison Adelle Hedge Coke (2006) with Hedge Coke's evocative photograph of The Tree at Eminija Mounds.

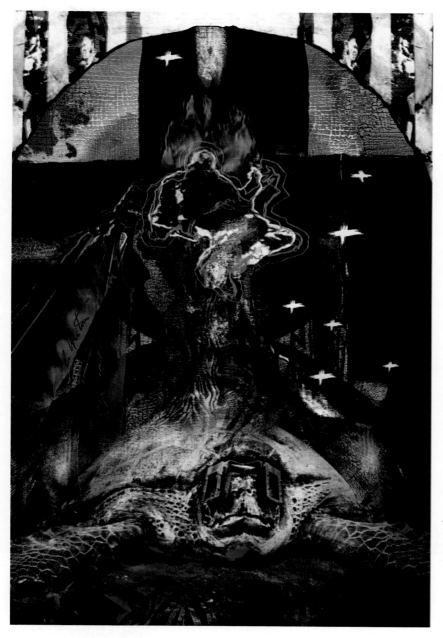

PLATE 16. Alyssa Hinton, *See No Evil: Resurrection of Chief Big Foot*, copyright 2002. Mixed media composite using photographs, feathers, original acrylic paintings, pencil drawings, relief prints, & digital editing.

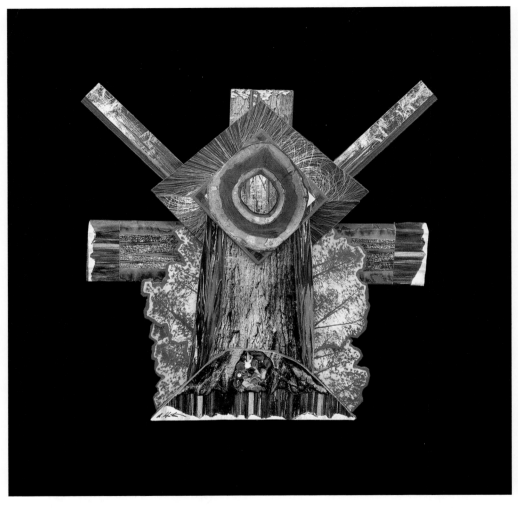

PLATE 17. Alyssa Hinton, *Burning Tree*, copyright 2013. Mixed media sculptural assemblage.

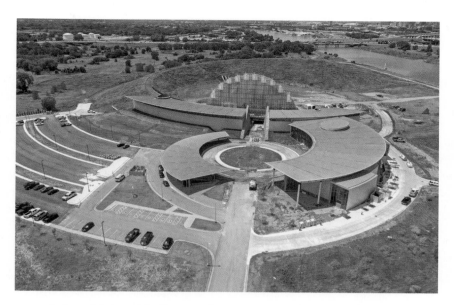

PLATE 18. An aerial view of the First Americans Museum under construction in Oklahoma City shows the intersecting arcs of the buildings and the spiraling promontory mound sited on the south bank of the Oklahoma River. Photograph courtesy of Waystone.

PLATE 19. The winter solstice sunset aligns with the tunnel carved through the arc of the promontory mound at the First Americans Museum in Oklahoma City. Photograph courtesy of James Pepper Henry.

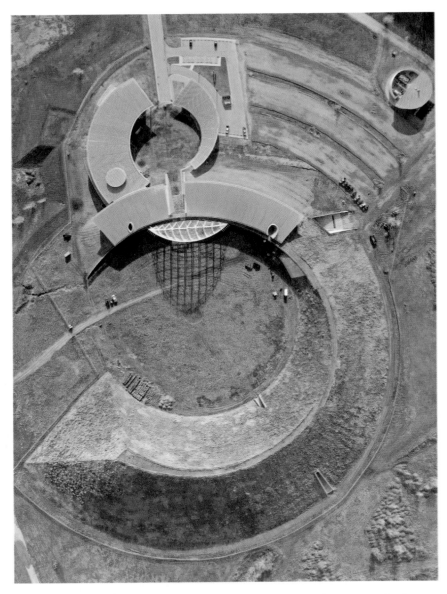

PLATE 20. An overhead view of the First Americans Museum under construction in Oklahoma City shows the spiral of the promontory mound emerging from the curve of the central exhibit hall. Also visible are both ends of the tunnel that aligns with the winter solstice sunset point on the horizon. Photograph courtesy of Waystone.

Holisso Chaffa / Book One		Holisso Toklo / Book Two	
Ch 1	*Iskifa*	<u>Ch 13</u>	<u>Yoshoba</u>
Ch 2	Robert	Ch 14	Robert
Ch 3	Robert	<u>Ch 15</u>	<u>Yoshoba</u>
Ch 4	*Iskifa*	*Ch 16*	*Iskifa*
Ch 5	Robert	***Ch 17***	***Taloa***
Ch 6	Robert	***Ch 18***	***Taloa***
Ch 7	*Iskifa*	<u>Ch 19</u>	<u>Yoshoba</u>
Ch 8	Robert	*Ch 20*	*Iskifa*
Ch 9	Robert	<u>Ch 21</u>	<u>Yoshoba</u>
Ch 10	*Iskifa*	*Ch 22*	*Iskifa*
Ch 11	Robert	*Ch 23*	*Iskifa*
Ch 12	Robert	*Ch 24*	*Iskifa*

FIGURE 23. Sequencing of narrative perspectives across the chapters of book 1 and book 2 of *Anompolichi*. Roman type indicates Robert's perspective, italics indicates Iskifa's perspective, bold italics indicates Taloa's perspective, and underscore indicates Yoshoba's perspective.

able to communicate and unable to understand. The Scottish master sailor is no master of this Indigenous world.

In "Halisso Toklo / Book Two," the limited omniscient narrator shifts among the perspectives of four distinct characters rather than two. The perspectives of Iskifa and Robert continue from book 1, but readers also encounter the perspectives of Taloa, who translates for Robert, and that of a new character, Yoshoba, leader of the Allahashi Confederacy and the great mound city Tochina. Unlike in book 1, in book 2 there is no immediately obvious pattern (Figure 23). In book 2, the narrative is focused through Robert's perspective in only a single chapter, whereas five chapters are focused through Iskifa's perspective, two through Taloa's, and four through Yoshoba's. When we map these shifts we see that, despite the lack of exact repetition, as in book 1 the chapters divide neatly into four sequences of three, again creating a regular pattern but with variation. The pattern created in the first three-chapter sequence, for instance, repeats with variation in the third. In the first, the perspective of Yoshoba precedes and follows the perspective of Robert, in effect surrounding him; in the third, the perspective of

the Allahashi villain now precedes and follows—surrounds—that of Iskifa. In mapping these shifts, we also see that chapter 14, focused through Robert but surrounded by chapters focused through Yoshoba, works as a transition between books 1 and 2. It seems telling that what is provided by Robert's perspective in chapter 14 is primarily a review of his adventure thus far; following this recounting of what happened in book 1, the remainder of the chapter focuses on Iskifa's retelling of a local story, which Taloa translates for Robert's understanding. When the story concludes, the narrator states, "Robert struggled to muster an intelligent question," and then Robert's perspective quickly fades from the novel. Similarly, the pattern created in the second sequence of three chapters repeats in the fourth, but with even greater variation. In the second, in the buildup to the novel's central conflict and violent climax at the stickball tournament, the perspective of Iskifa precedes that of Taloa; in effect, Iskifa introduces and opens a space for his apprentice. Then, in the fourth sequence, the perspective of the Yukpan elder takes over completely to control the novel's conclusion.

In the macrostructure of book 1, four chapters focused through the perspective of the central Native character, Iskifa, are held in productive tension with eight chapters focused through the perspective of the central non-Native character, Robert. In the macrostructure of book 2, this pattern repeats with variation: four chapters focused through the perspective of the villain, Yoshoba, are held in productive tension with eight chapters focused through the perspectives of the three primary heroes, Robert (one chapter), Iskifa (five chapters), and Taloa (two chapters). The ratio remains 4 to 8, or 1 to 2, but produces a radically different emphasis. Another way of understanding the macrostructure of book 2 is that a single, early chapter focused through the perspective of the white European character is held in productive tension with eleven chapters focused through the perspectives of diverse Native characters. In effect, what readers experience is the non-Native, outsider's perspective, which is dominant and increasingly perceptive across most of book 1, almost completely fall away in book 2.

Morgan's strategy of shifting the narrative perspective and thus realigning the power dynamics at this macrostructural level works to decenter the civilizational and racial hierarchies that, within dominant discourses,

typically work to denigrate Indigenous peoples, cultures, and technologies. Morgan explicitly inscribes a European perspective and the presence of whiteness into his narrative of Indigenous mound-building cultures, and he does so at a level that appears, across most of book 1, to be on par with, if not superior to, that of the primary Indigenous perspective and presence. But then, in book 2—and here is the unexpected but crucial narrative maneuver—Morgan actively decenters the European perspective and the presence of whiteness. Importantly, he does not completely remove or erase European presence or whiteness from the Indigenous world he creates in *Anompolichi*. Rather, he increasingly embeds European presence, whiteness, and non-Native perspective *within* an Indigenous world that is revealed to be not only complex but diverse and changing.

The white European character becomes less, rather than more central as the narrative progresses. In this way, Morgan overturns the common structure of marking a shift from North American "prehistory" to "history" through European "first arrival." As already suggested, he disrupts reader expectations of the YA adventure genre by denying the central European character a means of writing—although literate, the shipwrecked Robert possesses no journal, no paper and ink, with which he might record his unfamiliar experiences in either alphabetic writing or European-style sketches. Instead, it is the central Native character who possesses the tools for "drawing" in the sand and "painting" on buckskin. We might say that Morgan's narrative strategies actively deny the European character the means through which to effect what literary scholar Mary Louise Pratt designates "the anti-conquest," which she defines in *Imperial Eyes: Travel Writing and Transculturation* as "the strategies of representation whereby European bourgeois subjects seek to secure their innocence in the same moment as they assert European hegemony."[20] In other words, Morgan does not allow the white European character to control the record of his narrative, and thus he is not allowed to turn his unexpected North American adventure into the expected story of "discovery," with its expected acts of colonialism, such as the systematic surveillance of territory, the appropriation of valuable resources, or the imposition of outside administrative control. Unlike Pratt's examples of how seemingly innocent forms of

European knowledge production—such as "travel writing" and "natural history writing"—actually produce colonial subjectivities, Morgan's narrative works to systematically initiate Robert into Indigenous landscapes and communities and to increasingly embed him within Indigenous systems of knowledge.

An illustrative example occurs in chapter 8, "Inland," where Robert learns of Iskifa's ability to draw, read, and deploy maps. After revealing the icon for fire, Iskifa uses gestures to instruct Robert to gather wood for their overnight camp. Alone in the strange landscape, as Robert moves past the edge of the clearing he is startled when he suddenly encounters another man—we eventually learn there are actually three men, a father and his two adult sons. The men's minimal dress, painted faces, and prominent weapons suggest they are fierce warriors. Robert immediately fears for his life but soon realizes that, although he will have to fight this strange man, he is not being attacked; the Native men's intention is something other than murder. The first man encountered, one of the adult sons, engages Robert in a challenge, a formal test of strength and martial prowess. He gestures at Robert offensively with his fighting staff, but he lays his bow and quiver of arrows on the ground, then waits for Robert to respond appropriately. Although he is injured from his shipwreck, Robert has no choice but to comply with the challenge as best he can while the man's brother and father watch the contest and cheer for their favorite. Robert is knocked to the ground multiple times, writhing in the pain of new injuries struck upon old, but blood is drawn on both sides, and Robert, who is no stranger to fighting back home, manages to land a blow that knocks a tooth from his opponent's mouth. Throughout, he remains aware that, although the Native man fights with gusto, he never strikes Robert when he is down; this ordeal is some kind of regulated ritual exchange, not a battle to the death. And just when Robert and his opponent appear to have pushed each other to their limits, "blinking through blood and sweat and dirt in locked gazes," Iskifa appears "as if from nowhere," makes a ritualized gesture the other men immediately recognize and understand, and formally ends the challenge (76, 77). Once the martial ritual has concluded, the wordmaster engages the father and brothers in "genial conversation" and leads them toward camp

(77). Despite the bloodshed, there are apparently no hard feelings. Robert follows "at a distance, trying to interpret what just happened," but Iskifa stops abruptly to redirect him back to the edge of the clearing. Despite the addition of the strange men and the heated battle, Robert is still expected to contribute his labor. He remains in charge of gathering firewood.

In typical accounts of "first" encounter, the white protagonist imposes a European narrative through the force of his personality and foreign technologies. In Morgan's novel, however, Robert is physically and psychologically initiated *into* a larger Indigenous narrative. As the chapter title "Inland" subtly hints, as his opponent repeatedly knocks him to the ground the Native man helps Robert become less foreign, less of an outsider, literally more *in* the land. Robert's European difference remains present—albeit bloodied, tattered, and somewhat broken—but beginning with this scene of ritualized physical encounter and exchange, that difference becomes increasingly less conspicuous, less disruptive, less central. In this way, similar to other contemporary Native writers and intellectuals, Morgan works to redress the asymmetry of typical narrative representations of Indigenous so-called prehistory. His novel can be read as an exposure of the coloniality of power and knowledge in orthodox representations of Indigenous mound-building cultures, which typically reinscribe racialized hierarchies and which typically distort or erase Indigenous knowledge and power. Centering the Indigenous, Morgan never lets his readers forget that European presence in North America, in every era, whether ill-intentioned or benign, is migrant and diasporic, not native.[21] Robert's experiences in the land change him significantly, but he does not take over either physically or discursively.

LIVING EARTHWORKS VOCABULARIES

Anompolichi situates a fully functioning Cahokia within a larger world that is multiply complex and multiply interconnected, both Indigenous North American and non-Indigenous European. In an unpublished map titled "Mississippian Ideological Interaction Sphere," which Morgan annotated in 2018 as a companion to his novel and as a tool for helping him conceive

its sequel, he illustrates how the European vessel shipwrecked on the Atlantic coast in 1399 intersects the complex, river-based networks of the greater Mississippian world. And in an unpublished essay, also produced in 2018, Morgan describes how he came to conceive his historical novel within this interconnected Mississippian interaction sphere, its climax located far from the coast of the eastern ocean at the massive mound city Tochina.[22] He recalls an early interest in learning about Indigenous ancestors from both the recent and distant past, but also an early discovery—and disappointment—that even among "Native intellectuals, consciousness of pre-Columbian North America was largely a void." He continues:

> I couldn't find any substantive discussion of the subject in the contemporary literature (or in the Native lit of the nineteenth and twentieth centuries), except for the arid scenarios of ancient America offered by archaeologists and anthropologists, who were predominantly Euro-American in ethnicity and academic bias. Within this context, I developed a thirst for knowledge of the earlier periods of our homelands. (1)

Morgan visited the Spiro Mounds site in eastern Oklahoma as a young man in the 1970s, but it was not until the winter of 2003, after he had returned to higher education to study Native American literatures at the University of Oklahoma, that he had the opportunity to visit Cahokia in southern Illinois as well as the geometric earthworks in Newark, Ohio. He and his wife were driving to Pennsylvania to visit their adult daughter and her family. Morgan recounts:

> We passed through St. Louis too late in the day to visit Cahokia, so we camped at Horseshoe Lake State Park in Illinois, which is a slightly spooky, heavily forested reserve near the river about 10 miles north of Cahokia. There was only one other camper in the park and we enjoyed a camp meal and a good night's sleep. At 8:00 the next morning we drove straight to Cahokia under a white sky. A shower of fine light snow was falling. After entering the archaeological park, amazed by what we were

seeing, we made our way straight to Monks Mound and climbed the long stairway to the top of the largest earthwork north of Mexico.

A fine but intermittent carpet of snow by that moment lay on the blend of blonde dormant summer grass and green winter grass atop the mound. There was no wind, so a sense of cold was not foremost as the white fine powder fell upon our windbreaker hoods, but rather I registered only a sense of grandeur in standing on the palace mound in the magnificent metropolis of our ancestors. I immediately began to imagine the grand structures built on top of the complex of platform mounds and the bustle of commerce and culture in the plaza below. The ideas for *Anompolichi the Wordmaster* rose up in my mind like apples in a barrel. After descending the long stairway, enjoying the differing views of the city afforded by each terrace, we toured the well-funded museum, which largely offended me in its conceptualization and treatment of the site. After a couple of hours there, absorbing data and establishing our own hypotheses, we left the ancient city heading for the amazing Newark Mounds in Ohio. (3)

Morgan's retrospective account engages the symbolism of green winter grass growing among dormant summer grass—an apt metaphor for Indigenous survivance (survival as active presence) and for the resurgence of interest in mounds and mound principles among contemporary Native writers, artists, and intellectuals. The account also engages the symbolism of Native sites, cultures, histories, and contemporary peoples enveloped in "white" discourses—including those on display at the Interpretive Center—but surviving nonetheless.

Undoubtedly, there are multiple additional contexts for the writing of *Anompolichi*. To move toward conclusion for this chapter, I explore one of these in detail, namely, the creation of the Chickasaw Cultural Center, which opened outside Sulphur, Oklahoma, in 2010. Morgan was employed by the Chickasaw Press during the years of the center's completion and opening, and I want to argue that aspects of the center's conception and design, and especially its significant contrasts to the Interpretive Center at Cahokia, are relevant to reading Morgan's novel published in 2014.

The 184-acre campus of the Chickasaw Cultural Center sits adjacent to the renowned Chickasaw National Recreation Area, just outside the town of Sulphur and south of the town of Ada, the contemporary seat of government for the Chickasaw Nation. The center's beautiful grounds and extensive facilities boast state-of-the-art historical and cultural exhibits, a well-equipped research center and growing archive, formal meeting and conference space, a high-tech theater, an art gallery, indoor and outdoor performance spaces, a large pond and water pavilion, an honor garden marking the achievements of inductees to the Chickasaw Hall of Fame, two working vegetable gardens, two well-stocked gift shops, and a café, as well as a large staff of Chickasaw citizens who demonstrate "traditional" and "contemporary" handcrafts and skills and who serve as friendly, knowledgeable interpreters of Chickasaw history and *living* culture. In addition, the Nation has reconstructed a Chikasha Inchokka', a Southeastern-style village surrounded by a wood stockade. This "traditional" village can be viewed aerially, from a height of three stories, standing on the Sky Bridge adjacent to the main exhibit hall and conference space (Figure 24). But visitors are not limited to this bird's-eye view of the site's structures, open spaces, wood palisade, and surrounding landscape, including the adjacent Rock Creek, a subtle reminder of the importance of siting villages near running water. They can also walk *into* the village to explore a large council house, examples of summer and winter family houses, a corncrib, gardens, a ceremonial arena with a central fire pit flanked by brush arbors, and a stickball court. The village's most impressive structure, but perhaps also its most subtle, is a full-scale replica of a Southeastern earthwork: a ceremonial platform mound newly constructed by the Nation on behalf of Chickasaw and other Southeastern peoples.[23]

The campus as a whole has been designed to enable immersive experiences. In the Chikasha Poya Exhibit Center, a series of brief videos running at multiple viewing stations orient visitors to aspects of Chickasaw landscapes and histories. ("Chikasha Poya" translates as "We are Chickasaw!") Specific exhibits encourage visitors to handle material objects, practice basic Chickasaw vocabulary, listen to oral storytelling, or contemplate the veracity and usefulness of different forms of historical evidence—a diary

FIGURE 24. View from the Sky Bridge at the Chickasaw Cultural Center during a stomp dance performed before the reconstruction of a ceremonial platform mound at the Chikasha Inchokka', the center's Southeastern-style village surrounded by a wood stockade. Photograph by Chadwick Allen.

written by a European or American visitor to the Southeast, for example, compared to a Chickasaw map painted on a tanned deer hide. After learning about thousands of years of changing life in the Southeastern homeland, visitors are guided along a difficult, upward-slanting path representing the 1830s forced removal to the Indian Territory, now Oklahoma, then invited to participate in the renewing, counterclockwise movement of a stomp dance they can perform in community and around the central fire through an interactive holographic display. At the Aaimpa' Café, visitors

can taste pashofa (corn soup) and highly prized grape dumplings. At the Chikasha Inchokka', they can enter and explore houses, try their hand at stickball and other games, watch a live performance of a stomp dance around the central fire while sitting beneath the shade of brush arbors, and walk the circumference of an actual mound.

The contemporary earthwork is but one component within a broader Chickasaw assertion of political, cultural, artistic, and intellectual sovereignty. The Nation is actively asserting control over how its history is written and interpreted, in printed books in multiple genres published by the Chickasaw Press and White Dog Press, in videos and digital media produced through Chickasaw TV and posted online, and in a variety of built environments—from the deep past to the present and forward into the future.[24] To build an earthwork is literally to move and reshape earth to align with surrounding waterways, with other natural features in the landscape, with the sky-world above. But to build an earthwork is also to move and reshape earth to align with the symbolic systems that undergird, express, and shape *living* cultures. As forms of spatialized knowledge—as forms of Indigenous writing—earthworks intersect traditions of place-naming and place-mapping, intersect traditions of rhythmic sound and choreographed movement, intersect traditions of visual and tactile encoding, intersect traditions of drawn, painted, and incised marks on multiple surfaces. They serve as evocative mnemonics that help transfer communal memory across time.[25] At the Chickasaw Cultural Center, signage posted in the Chikasha Poya Exhibit Hall, at the Sky Bridge overlooking the Chikasha Inchokka', and at points along the periphery of the reconstructed platform mound inform Native and non-Native visitors alike—and remind Chickasaw citizens and descendants in particular—that while earthworks are part of very old Southeastern cultures, they are also part of *living* vocabularies and worldviews. They represent ways of understanding and interacting with land and place that, despite violent attack and forced removal, have not only survived but incited renewal.[26]

The specific earthworks vocabularies on display at the Chickasaw Cultural Center are suggestive of not only the multiple ways Southeastern

peoples have understood mounds and mound principles in the past but also the multiple ways they continue to develop their understandings in the present.[27] Over repeated visits, I became fascinated by these vocabularies and, more precisely, how they create a conversation—a ritual call-and-response—between the language used in the signage at the Chikasha Inchokka' Traditional Village and the language used in the signage in the Chikasha Poya Exhibit Center. At the Chikasha Inchokka', near the platform mound, a prominent sign reads:

> This mound, or *aayampo' chaaha'*, is a reconstruction of a precontact platform mound or "temple mound." The mounds were built by our Chickasaw ancestors working together, carrying individual baskets of dirt from nearby. Symbolic colors of clay such as red and white were sometimes used. Our Chickasaw ancestors living in the 1700s referred to the mounds as *aayampo' chaaha'*, *aayampo'* then meaning "crockery" or "pottery," *chaaha'* meaning "to be tall," suggesting that our ancestors thought mounds resembled inverted pots. Today, speakers of *Chikashshanompa'* (the Chickasaw language) might call mounds *onchaba chaaha'*, meaning "tall hill."

The brief account, intended for a public audience, offers a surprisingly sophisticated lesson in Chickasaw historical linguistics: the vocabulary used to describe mounds has shifted over time (from the noun *aayampo'* [pottery] to the noun *onchaba* [hill]), but it has also maintained some continuity (in the consistent use of the adjective *chaaha'* [tall]). Moreover, the account's reference to ancestors living in the 1700s provides a clue about the likely sources of this linguistic knowledge, namely, the presence of French and English traders, who lived among the Chickasaw and their neighbors beginning in the early eighteenth century and who recorded Southeastern vocabularies in their journals and other writings. Along with subsequent non-Native works, such as word lists, grammars, and dictionaries compiled by American missionaries, government agents, and settlers in the nineteenth century, these early records have become key sources for the Nation that

augment the knowledge that remains within Indigenous oral, graphic, and other traditions. And finally, the older phrase used for mounds, *aayampo' chaaha'* (written here using a modern orthography), is described as based primarily in mimesis. The account articulates a specific theory of meaning-making: contemporary Chickasaw think their ancestors thought the shapes of the mounds bore a physical resemblance to the shapes of inverted pots.

Unlike the signage posted at the Chikasha Inchokka', which emphasizes this older earthworks vocabulary, the signage posted in the Chikasha Poya Exhibit Center emphasizes a vocabulary that is more contemporary. This signage also shifts emphasis from the material forms of the mounds to the expansive reach of the precontact Chickasaw homeland and to the expansive temporality of what is today the Chickasaw Nation. Under the tripartite heading "A Great Civilization / *Moundbuilders* / onchaba ikbi'," with each part printed in a distinct font and color, a prominent sign reads in two parts:

> Our ancestors were *onchaba ikbi'*, the moundbuilders of the Mississippi and Ohio river valleys. Our territory stretched from the Midwest, to New England, and through the southeastern United States. Mounds were constructed from 500 to over 2,000 years ago in this region.
>
> In our tradition, the Chickasaws, as well as dozens of tribes, are the direct descendants of Mississippian civilization, which was active from about AD 900 to 1700. The powerful and far-reaching Mississippian economic and political structure greatly influenced and shaped our culture.

One notes immediately the ways in which this account contradicts typical archaeological, anthropological, and historical accounts from across the twentieth century. Written from an Indigenous perspective, the signage rejects the discourse of "mystery" about Mississippian peoples and actively asserts the status of their "civilization." Instead of the orthodox discourse of "they were on their way to civilization but did not quite get there" and "nobody knows what became of them," visitors learn that the supposedly *missing* Mississippians continued to change over time, to develop over gen-

erations, evolving into new peoples like the Chikasha encountered by the Spanish in the sixteenth century and re-forming into new nations like the Chickasaw the U.S. government forcibly removed to what is now Oklahoma in the 1830s. The image included as background for this sign is a piece of pottery—the *aayampo'* foregrounded in the prominent sign at the Chikasha Inchokka'. This *aayampo'* features multiple layers of curvilinear decorations in the emblematic colors black, red, and white. But the pot's round body and fluted neck bear little physical resemblance to a flat-topped ceremonial mound or "tall hill," and thus the image appears to question the outdoor sign's assertion of mimesis.

Another prominent sign inside the Chikasha Poya Exhibit Center bears the tripartite heading "Ancestral Ties / *Connecting with our homeland* / onchaba," with each part again printed in a distinct font and color. Here, as in Morgan's dedication for *Anompolichi*, emphasis is placed on how mounds were typically created not in isolation, but rather as part of "towns and cities." The account also emphasizes how contemporary Chickasaws—despite their ancestors' forced physical removal from Southeastern sites and despite their own increasing temporal distance from the traditions of large-scale mound building—continue to feel connected to these ancient structures. The primary parts of the sign read:

> There are many *onchaba* (mounds) and mound groups in the ancestral homeland of the Chickasaws. They were associated with towns and cities. The largest was Moundville. Others include: Shiloh Mounds, Pinson Mounds, Ingomar Mounds, Wickliffe Mounds and Emerald Mound.
>
> Some Chickasaws who have visited mounds sense a special feeling of kinship. For every site that remains, thousands have been destroyed.

In language that is scrupulously understated, the penultimate sentence articulates what is for many a highly personal experience. The sign is careful to present neither an unauthorized exposure of private Indigenous feelings nor a hyperbolic statement of New Age mysticism. It is the final sentence, however, despite similar restraint, that is especially poignant. Although

the sentence conceals the agency of mound site destruction—this polite-ness is perhaps not inappropriate for an Indigenous cultural center open to a mostly non-Native public—many readers will infer the agents implied. The background for this sign illustrates its primary themes by juxtaposing three distinct images. First, under the initial headings and set partially be-hind the language quoted above, there is a ghosted image of Mississippian-era pottery designs. To the right, beneath the third heading, there is a con-temporary photograph of one of the prominent Southeastern mound sites mentioned in the account. And to its right is a large map of the eastern half of North America that marks prominent mound sites located across the Southeast and the Mississippi Valley. Brief explanatory captions are attached to the mound photograph and map.

My sense of the importance of the call-and-response created between the outdoor signage at the Chikasha Inchokka' Traditional Village, with its emphasis on *aayampo' chaaha'*, and the indoor signage in the Chikasha Poya Exhibit Center, with its emphasis on *onchaba*, became more focused when Morgan pointed me to the book *The Early Chickasaw Homeland*, published by the Chickasaw Press in 2014, written by the non-Native historical linguist John Dyson, whom the Nation contracted to produce this work. Morgan told me he had found Dyson's book especially inspiring as he began to plan and draft the sequel to *Anompolichi*.[28] Dyson's research engages not only the early French, English, and subsequent American records of Chickasaw vocabularies but also the earliest known records produced by the Spanish, including members of the de Soto expedition in 1539 to 1542. Dyson places these multiple records within their comparative linguistic contexts, and his painstaking collations help piece together a remarkably comprehensive account of Chickasaw life, social organization, and history in the South-eastern homeland.

Although it is not his primary emphasis, Dyson's expansive investiga-tion touches upon earthworks vocabularies. He writes, for instance:

The nineteenth-century geographer and ethnologist Henry Schoolcraft recorded that the Chickasaw tribe referred to prehistoric southeastern

mounds as "navels" *(ittalbish)*, and John Swanton [another prominent anthropologist, folklorist, and linguist] also remarked that the Creek used the same terminology in their own language. Those mounds were obviously regarded by both the Chickasaw and the Creek as symbols of human birth.[29]

This aspect of mound symbolism intersects the signage adjacent to the reconstructed ceremonial mound at the Chikasha Inchokka'. Dyson continues:

> The mound stood for the center of the earth in the same way that the navel represented the center of the maternal body. Yet it bears mentioning that the Chickasaw also referred to those prehistoric mounds as *ampo' chaaha'*, tall pottery vessels or clay urns which have long been associated with Southeastern burials, including urn interments in the traditional Chickasaw homeland. (28)

Dyson uses an older Chickasaw orthography, rendering *aayampo' chaaha'* as the more streamlined *ampo' chaaha'*, which is more obviously similar to the closely related Choctaw, *ampo chaha*. His research suggests the phrasing may function differently than simple mimesis—or that it may function in one or more ways *in addition to* simple mimesis—expanding its potential to make meaning for multiple audiences. Rather than (or in addition to) recording a sense that the shapes of the mounds resemble the shapes of inverted pots, *aayampo' chaaha'* may (also) record a sense that the mounds represent—and perhaps function as—points of intersection for human birth (the mounds are symbolic navels) and human death (the mounds are symbolic clay urns used for interment).[30]

When Morgan pointed me to Dyson's book, he also mentioned an earlier source of linguistic knowledge, Cyrus Byington's *A Dictionary of the Choctaw Language*, which Choctaw and Chickasaw intellectuals continue to find useful despite its colonial provenance. The non-Native Reverend Byington, born in Massachusetts in 1793, worked as a Christian missionary among the Choctaw for nearly fifty years, beginning in 1819, almost two decades prior

to their forced removal from the Southeast. Although Byington completed a first draft of a Choctaw grammar in 1834 and continued to revise this and related documents until his death in 1868, his dictionary was not published until 1915, when the manuscript was edited by the prominent non-Native anthropologists John Swanton, previously mentioned, and Henry Halbert. *A Dictionary of the Choctaw Language* appeared as Bulletin 46 in the series produced by the Bureau of American Ethnology. Choctaw writer LeAnne Howe had also mentioned the usefulness of Byington's dictionary, and I had already begun to work with this resource, but Morgan's urging and Dyson's suggestive research sent me back to Byington to cross-check entries related to pottery and mounds. Reading Byington through Dyson, I noted the following possibilities. The Chickasaw *aayampo' chaaha'*, or the Choctaw *ampo chaha*, can definitely mean "tall clay pot," as suggested on the signage at the Chikasha Inchokka'. But the phrase can also mean something more metaphorical or symbolic—or possibly more descriptive of the agentive force of the mounds—related to the idea that mounds stand at the profound intersections of human birth and death. As Byington records in his dictionary, the noun *ampo* can mean a bowl or pan, pottery more generally, or any kind of vessel. But *ampo* can also mean the specific kind of clay pottery referred to in English as *earthenware*. In other words, *ampo* can emphasize a container made specifically from "earth" in the form of porous clay.[31] The connection between the English-language terms *earthenware* and *earthworks* is notable and provocative. Similarly, Byington records that the adjective *chaha* can mean high, lofty, or tall. But *chaha* can also mean steep or elevated, as well as eminent, grand, and *sublime*. In other words, *chaha* possesses not only literal meanings related to height, but also figurative and possibly spiritual meanings related to prominence, importance, and power. In addition to "tall clay pot," *ampo chaha* may mean something like "sublime earthenware vessel"—a porous and productive conduit between worlds, a portal between the living and the dead.[32]

About the time I was making these connections, I also happened to read a fascinating analysis of the Cahokia site and its broader environment on the Mississippi floodplain. I had purchased this book, published in 2003, at the Interpretive Center's gift shop when I visited Cahokia with Morgan,

Howe, and Hedge Coke in September 2018 during the Western Literature Association conference. Titled *Envisioning Cahokia: A Landscape Perspective,* this innovative study was written collaboratively by an interdisciplinary team of non-Native academic researchers: two anthropologists who are also earth scientists, two geographers who are also archaeologists, and a landscape architect. Shifting emphasis away from an exclusively archaeological perspective to a more comprehensive "landscape perspective" on Cahokia, the research collective states in their introduction: "Communicating Cahokia's importance has always been a challenge. The key to success is building a context for the site, together with its effective interpretation."[33] Moreover, the collective notes that "For the most part, the archaeological community does not have the information that it needs to place the Cahokia site in context. . . . There remains a lack of volume-length, holistic considerations of the cultural dynamics at Cahokia. We maintain that a landscape approach can be used to synthesize our knowledge about the Cahokia site and to provide a robust account of how a people interacted with the environment at a critical point in human history" (13). Stated succinctly: "At the heart of [their] landscape approach at Cahokia lies a desire to document the relationship that the Mississippians had with the land" (15). After visiting the Chickasaw Cultural Center and contemplating its provocative signage, what I hoped to learn from this study, more precisely, was what kind of relationship these Mississippians might have had with the porous clay used to make *ampo chaha.*

Envisioning Cahokia provides a high level of detail about the design, engineering, and construction of large platform mounds I had not come across elsewhere. And although its non-Native authors did not consult Indigenous communities, the study nonetheless provides details that intersect the living earthworks vocabularies displayed in the signage at the Chickasaw Cultural Center and, especially, the idea that *ampo chaha* may mean something like "sublime earthenware vessel." In describing the monumental, multiterraced, nearly one-hundred-foot-high platform at Cahokia known as Monks Mound, the researchers note the specific functions of porous clay as a key building material:

A significant portion of the mound mass was composed of clays with a high shrink-swell capacity and low hydraulic conductivity. When wet, these clays displaced significantly more volume than in the dry condition, whereas upon drying they contracted and tended to crack. The consequences of repeated episodes of drying and wetting are obvious: they produced great instability. Given a high local water table and an annual average of over 65,000 cubic meters of precipitation on the surface of the mound, continual water control was clearly essential for maintenance. (138)

The builders of the massive platform had to contend with the multiple conditions and contingencies of the floodplain environment, including the types of soils and other materials readily available, a high water table, and regular seasons in which the weather shifted from one extreme to another. Such conditions and contingencies work against the stability of mounds constructed from borrowed and re-formed earth. How did the Mississippians at Cahokia adjust their design and building techniques to accommodate these variables? The researchers describe the builders' clay-based solutions in these terms:

The base or core of the mound was composed of a 6- to 7-meter-high clay platform. Water pulled up into the mound by capillary action to a height of up to 10 meters kept the smectite clays in this core perennially saturated with capillary water (in an expanded state), thus forming an excellent supporting base for the enormous weight above it. A fair amount of earth would have been needed on top of this core in order to pull up the capillary water; without it, the core would have cycled through wet and dry states throughout the year and hence been unstable. Thus, from an engineering standpoint, it made sense for the bulk of the mound to be constructed relatively rapidly. (138)

The designers, engineers, and builders of the mound discovered how to create a tall and porous clay core that, once compressed by a large mass of soil, would pull water up from the ground and remain saturated. In this

expanded state the clay core maintained its stability over time; in turn, the expanded clay base helped the larger mound maintain its stability over time as well. It was a remarkably successful solution. The researchers conclude:

> The degree of success of all these efforts can be measured by the long-term stability of the mound. . . . No major failures occurred for a thousand years in spite of the instability of materials and the enormous mass and surface area of the structure. Only in the last two decades has the mound experienced major failure [because of changes in the water table due to modern industries], with the several hundred years of stability testifying to the skills of the makers. (139)

As already noted, I read this account of the clay-core design of Monks Mound while contemplating the living earthworks vocabularies on display at the Chickasaw Cultural Center. I could now push my speculative linguistic analysis even further. The term *ampo chaha* can mean "tall clay pot" and construct meaning mimetically, indicating a physical resemblance between the shapes of platform mounds and the shapes of (some if not all) inverted pots. The term can mean "sublime earthenware vessel" and construct meaning archetypally, indicating fundamental cycles of birth leading to death leading to birth. And the term can also mean "smectite clay core" and construct meaning architectonically, indicating proven techniques for harnessing the properties of porous clay in order to guarantee mound stability over time. It is possible, I came to realize, that the living earthworks vocabulary of *aayampo' chaaha'* encodes in its precise language and in its condensed, polysemic phrasing both a metaphysical understanding of how humans can make connections between worlds and a critical technique for physical construction that can help ensure long-term duration.

Time and again, we learn the lesson of the ancestors' genius and practical sense, long before the invention of supposedly modern technologies and long before the designation of the supposedly "new" materialisms.

To conclude this section, I draw attention to additional signage displayed in the Chikasha Poya Exhibit Center. Under the four-part heading

"Where We Began / *Stories of Chickasaw origins* / shakchi / wihat tanowa," the two-part sign reads:

> We have tribal stories that tell of the creation of our world. In the begin-ning, *shakchi* (crawfish) brought mud from below the water. This was used to form the earth from which people were created.
>
> Many stories tell of how the Chickasaws became a tribe. All speak of *wihat tanowa* (migration). After traveling for generations, we settled in our homeland centered in northeastern Mississippi.

Note the assertion of evocative juxtaposition—rather than disabling con-tradiction—in this coupling of the divergent concepts of emergence *and* migration. Additional details of the Chickasaw version of the Earth Diver story, in which the small and seemingly insignificant Crawfish plays a star-ring role, are provided in other parts of the exhibit center. Additional de-tails are provided, as well, of the migration story in which the ancestors who become the Chickasaw, along with their close relations who become the Choctaw, are led on their extensive journey by a sacred White Dog, a being who represents the visible stars of the Milky Way. (This is the same White Dog referenced in the Nation's White Dog Press.) The juxtaposi-tion is evocative of the majestic Serpent Mound effigy located in what is now southern Ohio, discussed at length in Part I, with its own juxtaposi-tion of an uncoiling horned snake representing the below world and an oval disk representing the sun in the above world, both set on the arced bluff above the life-giving waters of Brush Creek and above the geological evi-dence of a meteor impact some two hundred million years ago. The site's multiple juxtapositions hold in productive tension two ideas fundamental to Chickasaw and other Southeastern identities in relation to place: their origins are simultaneously from below *and* above. The Chickasaw emerged into the Southeastern homeland from the watery below world through the productive vehicle of the earthen mound. The Chickasaw migrated into the Southeastern homeland led by the glittering above world through the guiding vehicle of bright white stars. The juxtaposition resolves in the knowledge that generations of Chickasaw were born, lived, died, then born

again into these cycles in the space between worlds below and above, that is, upon the vibrant, highly constructed surface world of the Southeastern homeland.

READING FOR THE MOUND BUILDERS

The title I submitted for the plenary performance that would feature LeAnne Howe, Allison Hedge Coke, Phillip Morgan, and myself at the 2018 Western Literature Association conference held in Saint Louis was "Reading for the Mound Builders." It was meant to shift emphasis away from the mounds themselves, which are typically understood within dominant discourses as dead relics and inert objects from the past, to the active builders of mounds—in the past, yes, but also in the present and moving into the future. I omitted an article—either "The Reading" or "A Reading"—on purpose. My idea was to suggest something beyond the confines of a singular event, such as an academic or literary presentation, to instead suggest something more continuous and ongoing. I wanted to suggest a *practice* of reading *for*, where the preposition serves as a function word with multiple meanings, including not only an indication of the recipient of an activity (*our reading will honor the ancestors*), but also an indication of an activity's specific purpose or goal (*our reading will endeavor to align us with the ancestors, their intellectual genius and significant practices*). I wanted the four of us to perform for the WLA audience a practice of reading *for* the mound builders, in the sense of performing in a way that simulates and continues the physical activities and philosophical principles of those who built the mounds. We would have to select from the materials of our individual literary and analytical efforts carefully, design a layered structure that would become greater than the sum of its constituent parts, weave our thoughts and voices and performing bodies together into a collaborative and generative structure, a well-engineered "earthwork" located in specific space and time but simultaneously a vibrant portal linking upper and lower worlds.

Perhaps inevitably, the conference organizers made what I am sure they assumed was a minor change to my proposed title, from "Reading for the Mound Builders" to "A Reading for the Mound Builders." And thus with the

addition of a single letter the official announcement reverted to the idea of a singular event, firmly embedding our plenary within linear conceptions of time. But no matter the listing in the program, our actual performance worked toward our initial goals. Rather than have each of us read from our work individually for a prescribed amount of time onstage, we read together in an orchestrated series of three four-part rounds. We each read or spoke or sang for approximately five minutes per round, so that our voices and perspectives alternated, building upon and complementing each other. In each round, I performed my work, then Howe, then Morgan, then Hedge Coke. I read two brief prose pieces and a short poem about the destruction of mounds in Saint Louis, including the sixteen mounds destroyed in 1903 in preparation for the 1904 World's Fair, held in the city's thirteen-hundred-acre Forest Park immediately adjacent to the conference venue.[34] In her contributions, Howe performed a brief song text included in the nineteenth-century Choctaw hymnal, titled there "Evening Song 93," and offered a detailed analysis of the evocative lyrics, which can be translated into English as "Because you are holding onto me I am not dead yet." Howe believes the words predate the nineteenth century and missionization, and that they originate in a much older song that was sung to the mounds.[35] Morgan read excerpts from chapter 4, "Dead Man," focused through the perspective of Iskifa, and chapter 13, "Power," focused through the perspective of Yoshoba, from his novel *Anompolichi*, as well as a newer poem titled "Postcards from Moundville," which I include as an epigraph to the introduction. And Hedge Coke read multiple poems from her book-length sequence *Blood Run*, remixing the order of these multiple voices to create a sense of the complex liveliness of earthworks sites and to demonstrate their ability to continue to speak to us across space and time. I know I am biased, but from my vantage onstage the interconnected performance felt like an act of communal magic.

When our three rounds of four interwoven voices were complete, we performed a more deeply collaborative piece titled "Healing Song" that Howe had created from fragments taken from the performance piece *Sideshow Freaks and Circus Injuns* she has been developing with Native actress and playwright Monique Mojica. We each read multiple fragments,

some only a few words, others a few lines, in different orderings and configurations of our male and female voices. We began with the evocation of loss, but built toward a promise of healing. "Healing Song" ended with the four of us blending our voices in actual song, a single line of Choctaw repeated four times:

> *Hatak okla hut okchaya bilia hoh illi bilia*
> *Hatak okla hut okchaya bilia hoh illi bilia*
> *Hatak okla hut okchaya bilia hoh illi bilia*
> *Hatak okla hut okchaya bilia hoh illi bilia*

In the final repetition, we repeated the final phrase *bilia hoh illi bilia* three times, the third repetition slowing and falling away on the final word—as if to ground—indicating a kind of continuance. The Choctaw can be translated into English: "The people are ever living, ever dying, ever alive."[36] As Howe remarked in Saint Louis, the words mean "life everlasting." The following afternoon, in that spirit of healing, we walked together the mounds and plazas at Cahokia, offered tobacco, and considered all that remains—and all that might yet be in Indigenous futures whose imaginings we have only barely begun.

Walking the Mounds at Aztalan

> Walking, I am listening to a deeper way. Suddenly all my ancestors are behind me. Be still, they say. Watch and listen. You are the result of the love of thousands.
>
> – Linda Hogan, "Walking" (1996)

The network of relations that brought me to the northern Mississippian site known as Aztalan began with Janet McAdams, an award-winning poet, editor, and intellectual of Creek descent. Although McAdams is originally from Alabama, her creative and scholarly career, similar to my own, includes many years working in central Ohio, and thus many years living in close proximity to the mounds, embankments, and other Indigenous earthworks there. McAdams was the founding editor for the Earthworks poetry series from Salt Publishing that brought forward Allison Hedge Coke's *Blood Run*, and she performed alongside Hedge Coke during the poetry reading at the first celebration of Newark Earthworks Day in 2005. At some point in our conversations, McAdams mentioned that the Native poet Alice Azure had written about the mounds at Cahokia. I knew Azure, a Mi'kmaq Métis originally from New England with genealogical roots in Nova Scotia, primarily through her anthologized poetry but also through a brief correspondence when I served as editor for the journal *Studies in American Indian Literatures*. Until prompted by McAdams, though, I was unaware that Azure has lived for some time within the greater Saint Louis metropolitan area and that she has been a frequent visitor to Cahokia and a longtime student of Mississippian cultures. When I inquired about her earthworks poems, she graciously sent me a copy of her 2011 collection *Games of Transformation*.

In the preface, "A Poet's Immersion in Cahokia," Azure outlines an

origin story for her connection to the city of mounds. Like many of us, she traces her relationship and its transformations to an initial awe at Cahokia's scale—the number and size of its known structures, the density of its resident population—and to a dawning appreciation for the expansive reach of the urban center's influence far beyond its local precincts by means of the branches, tributaries, and confluences of rivers and creeks, those super-highways of the Indigenous past. Azure writes:

> For some strange reason, I am drawn there. Having come of age in the woodlands of the northeast, it seemed so fantastic that this area was the center of an American Indian metropolis supporting 20,000 people— the largest north of Mexico! From the air, the geography of great rivers merging together is breath-taking—the Father of Waters receiving the Illinois, Missouri and Ohio. I couldn't contain myself and started to think about a series of Cahokia poems.
>
> I had no hypothesis, or central question. I wasn't trained in archaeology. There was little I knew about this ancient city in our midst. Not knowing where to begin, I made an appointment with Mark Esarey and Bill Isenminger, co-directors of Cahokia Mounds State Historical Site.[1]

The directors invited Azure to explore the interpretive center's public exhibits and granted her access to its library and archives. Given her background in urban planning, she was especially drawn to materials describing land development and use at this and other Mississippian sites, as well as to information about how the massive system of North America's rivers had become routes for extensive movement and trade. Moreover, she began "hiking around the central city's perimeters"—walking the land— to build an embodied "sense of the geography and spatial placements of the mounds, borrow pits, stockades, plant life and ancient channel beds of the Mississippi River" (x). The moment of her inspiration for writing "a series of Cahokia poems" followed soon after:

> During this same time that I was consulting archaeology texts, I experienced an extraordinary visit. Early one October morning just before

dawn, an androgynous sounding voice spoke above my head—in my face, almost—as I lay in bed. Calmly and with obvious authority, s/he asked, "What are your intentions?" Caught off guard, I felt like a student being reined in—called to account for an absence of some focused statement of inquiry. What did this spirit—whom I chose to call Red Cedar—want of me? (x)

The spirit's question is pertinent—and represents a pertinent challenge—for us all. How should Native descendants account to the ancestors for their contemporary interest in mounds and mound principles? What, in our own era, might count as appropriate inquiry? And what might count as productive response to the facts of mound destructions and chance survivals? At "protected" sites such as Cahokia, what might count as productive response to settler-controlled preservations and reconstructions, or to assertions of "objective" analysis? For Azure, a sense of an answer, and a sense of specific focus for her poetic inquiry, came while watching the performance of contemporary Indigenous identities on the stage of a Saint Louis theater. From that embodied and affective encounter—from that experience of feeling *moved* toward action—she realized her Cahokia poems would need to engage the abstract significance of broad Indigenous concepts, such as "we are all related," but also to contemplate the complex workings of such deceptively simple ideals within specific terms of familial and intergenerational responsibility.

In the early poem "Red Cedar's Sign," Azure evokes this sense of responsibility through the voice of the inquisitive spirit:

You know our layout of majestic mounds
bespoke mathematics tuned to stars, people
attending to their Sun, waiting on Heaven
for instructions. But something as important
you clearly understand—our ancient, still
abiding care for family circles, clans
enabling, sustaining all the People's dreams. (9)

In "Quotidian Dimensions" she expands the ancestor's vision outward from extended family and clan to more complex relations of reciprocal alliance built across the massive reach of the Mississippi floodplain:

> Passing back and forth across
> the Mississippi, my other pair of eyes
> sees all the dugouts gliding by.
> Their material loads of pretty shells,
> axes, plant foods and flint-clay pipes
> belie much more than simple commerce.
> Intangible webs of regional peace
> are being plied. (13–14)

More than an imaginative glimpse into the past, a heightened sense of the ancestors' material culture, this "other" seeing provides the poet with a vision of the "intangible webs," the Indigenous systems of relations, grounded in the movements of water.

During our correspondence, I asked Azure if she was aware of other Native writers who were exploring the transformations of their own relationships to the mounds at Cahokia—or to mounds at additional sites. And so it was Azure who introduced me to the work of Jim Stevens, a poet of Seneca descent, and his accounts of intense alignments with what is believed to be one of the northernmost sites for Mississippian platforms. Located in what is now southern Wisconsin, where Stevens was born and raised, these relatively obscure mounds are known by the seemingly incongruous name Aztalan. Intrigued, I ordered a copy of Stevens's 2013 volume *The Book of Big Down Town: Poems and Stories from Aztalan and Around.*

As I awaited the book's arrival, I conducted a quick search on the internet. Much of what remains of Aztalan, I learned, was made into a small state park in rural Jefferson County—named, undoubtedly, for the founding father and amateur archaeologist—about an hour west of Milwaukee along the banks of the Crawfish River, within what geologists describe as a "glacial drift region" created by a much older history. The park opened in 1952. By that point, the site had suffered centuries of human neglect prior

to the arrival of non-Native settlers and then, with their arrival in signifi-cant numbers early in the nineteenth century, decades of physical abuse and looting, followed by additional decades of (suddenly) concerned peti-tions and fund-raising on behalf of "saving" the mounds in the (suppos-edly) more enlightened early twentieth century. In 1964, a decade after the opening of the state park, Aztalan achieved its designation as a National Historic Landmark.[2]

Maps and photographs available online reveal that a series of nine coni-cal mounds is still visible near the two-lane highway, access road, and park-ing lots that deliver contemporary visitors to the site, although many more mounds, destroyed by agricultural cropping in the nineteenth century, are known to have been constructed in close proximity to these few survivors. Described collectively as the Ceremonial Post Mounds—archaeological evi-dence indicates that several of the extant structures were built over loca-tions where large, presumably ceremonial posts once stood—the series of conical mounds also includes a single known interment, the so-called Princess Burial. Here, non-Native excavation exposed remains of a young woman wrapped in an elaborate shroud woven from thousands of shell beads.[3] Nothing, of course, is known about the woman's actual rank within her community or status within her family. But these lines from Azure are suggestive: "Their material loads of pretty shells, / . . . / belie much more than simple commerce. / Intangible webs of regional peace / are being plied" (13–14). Whatever the original intention behind the naming of the mound—whatever gestures were made toward honoring Indigenous ancestors—the ongoing misattribution confines and demeans the woman's memory by endorsing the limitations of a well-worn settler fantasy.

In addition, two of the three platforms constructed at the site continue to rise as the land falls away from the parking lots down to the western bank of the river. Although not on the same scale as Cahokia's Monks Mound, the platforms at Aztalan are impressive: they demonstrate the large size and classic, flat-topped forms of truncated earthen pyramids. Given what I had read of the history, I was not surprised to learn that the extant mounds are reconstructions. Beyond the years of random looting, multiple seasons of excavations by amateur and professional archaeologists had systematically

destroyed what remained of the ancient structures. Also reconstructed are short segments of the palisade, which have been placed at strategic points along the site's perimeter, including adjacent to the reconstructed platforms.[4] Originally, these stockade walls were built from wood posts set upright in the soil—similar to the ceremonial posts—then covered in a hard plaster of clay mixed with dried grasses. When early settlers found pieces of the plaster scattered about the site, they mistook the durable chunks for adobe, which they called Aztalan "brick." I was not surprised to learn, as well, that the name given to the site has been an arresting misnomer since the 1830s, when, distracted by thoughts of adobe and the pyramidal shapes of the mounds, white settlers attributed construction to Aztecs from Mexico in yet another version of the durable discourse of disbelief about the abilities of local American Indians or their ancestors. The (mis)use of the name for the Aztec homeland is notable, too, for its misspelling, which makes the name not only inaccurate but awkward to pronounce: Az*t*alan rather than the more familiar Aztlan.

Online photographs of the prominent Wisconsin Official Marker erected at Aztalan State Park in 1991—on the eve of the official observations of the Columbus Quincentenary—indicate how a visitor's encounter with the site is framed within standard non-Native discourses. The bare facts of subsistence are juxtaposed with rumors of more advanced technologies, despotic intrigue, and the always appealing "mystery" of vanishing civilizations. The authoritative marker reads, in part:

> Indian people lived at Aztalan between AD 900 and 1200. The village encompassed 20 acres and was well-planned. The inhabitants planted corn, beans and squash, hunted wild game, fished and collected native plants for food. An elite group of individuals organized ceremonies and village life. A stockade surrounded the major portion of the village. Inside, three platform mounds and a natural knoll marked four corners of a large plaza. The village was abandoned for reasons that remain a mystery.
>
> Aztalan is one of the most important archaeological sites in Wisconsin, representing a complex life-style rarely found in the Great Lakes region: a unique blend of native and exotic cultures.[5]

Although the language here is careful and feels purposely oblique, note the suggestion that the "elite group of individuals" in charge of ceremonies were not "native" to the region. Rather, they were emissaries from an "exotic" culture that presumably dazzled and perhaps overwhelmed the less sophisticated locals. Why, visitors are primed to wonder, would exotic individuals choose to build large platforms and a fortified village in the seeming middle of nowhere? Just what kind of ceremonies did these elites organize, and to what ends? And why, after going to so much trouble to establish a remote outpost, would they simply "abandon" their village? What terrible catastrophe must have befallen them?

Less expectedly, my online research led to a black-and-white photograph of a previous official marker for Aztalan, no longer extant, which appears to have been erected decades prior to 1991, perhaps as early as when the park opened in the 1950s. Much less subtle than its replacement, the earlier marker evokes a salacious backstory that is only hinted at in the current signage. The older discourse not only states as fact that "strangers" from an exotic culture dominated less-advanced and less-depraved local "tribes," but it does so in the starkest terms possible, evoking practices beyond the pale of (truly) civilized societies. The earlier marker reads in full:

> Indians of more advanced culture than surrounding tribes occupied a village on this site around the year 1500. They were strangers to this region and their cannibalism made them unsatisfactory neighbors. The strength of their stockade walls proves they lived in a hostile world. The original village had a population of about 500. The area enclosed by the stockade contained about 21 acres and within the stockade were corn fields as well as houses and temples.
>
> Eventually the village was destroyed by other local Indian tribes, leaving no known survivors of the Aztalan people.

Unsatisfactory neighbors, indeed—and ones who appear to have received exactly the treatment they deserved. Through the familiar discourses of savage depravity (those cannibalistic strangers) and primitive innocence (those defenseless locals forced into genocidal violence), the marker

manages to sully the reputations of all Native American peoples. Unlike our enlightened era, the sign suggests, theirs was an inherently "hostile world." Contemporary archaeologists, historians, and park advocates paint a more even-keeled and complex picture of the people or peoples who lived at Aztalan, but across the decades most visitors' understandings would have been influenced by these public markers and other accessible media rather than by academic articles or book-length works of scholarship.[6]

At last Stevens's volume arrived by mail. An alternate conception of Aztalan begins on the book's cover: an attractive painting of the site, conceived from an aerial position just across the river, reveals the inspiration for Stevens's title. From this westward-facing perspective, the elaborate palisade that once fully enclosed the village and subdivided its twenty acres into multiple precincts is shown to form the distinctive outline of an animal in profile. The image suggests a small horse or, in Stevens's account, a "big dog." The positions of the two extant platforms give prominence to the animal's chest and hindquarters; the outlines of legs and feet formed by intersecting palisades suggest the big dog "walks" along the western bank of the Crawfish River—heading south toward the great mound city Cahokia (Figure 25).[7]

In an opening essay, Stevens declares Aztalan a "sacred site" and "sacred city," and he recounts the origins of his habit since "1972 or 1973" of walking the land there.[8] His early visits began when he had "just quit graduate school" and, thinking about what he had learned from his Seneca father, was "wanting to find out who I was. Somehow, I thought that the mounds had something to do with this. . . . I was being called there" (1, 2). About this time he also made an inaugural pilgrimage downriver to Cahokia, "a sister community to Aztalan" (2). Echoing Phillip Morgan's account of his own invigorating first visit, quoted in chapter 3, Stevens writes: "There is nothing that prepares a person for the experience of being there, in the midst of dozens of spiritual hills, and nothing that will prepare one for the looming omnipresence, the height and breadth of Monk's Mound. In walking to the top of that mound, one is in another world" (2). And similar to Azure, Stevens describes a singular encounter he experienced after spending time among the mounds and plazas:

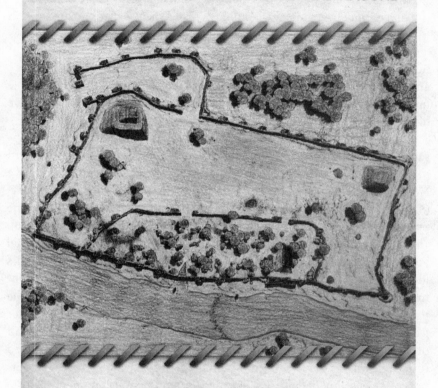

FIGURE 25. Cover of *The Book of Big Dog Town: Poems and Stories from Aztalan and Around* by Jim Stevens (2013).

That first night, while camping out (in those days this was still permitted) and talking until late with some others in the next camper, I went back to my small tent. Suddenly the world changed for me. A door in the world opened, or the heavens opened, and I sensed other imposing presences, other Spirits. This took place for what seemed like some period of time, and there was nothing in my life before that prepared me for this, and the moment is still with me. (2–3)

Returning to Wisconsin, Stevens "continued in my sojourns to Aztalan," and expanded his knowledge about this "spiritual place" through multiple modes of research: reading in the paper archives, walking the living archive of the land, remaining open to the archive of powerful dreams (3, 4).

As already noted, Stevens describes the distinctive shape of the palisade that once surrounded and subdivided the village as having "the form of a horse." "This was the small indigenous horse called big-dog by the Ho-chunk people," he writes, "and celebrated in legend as a dream-helper" (6). He speculates: "At Aztalan, which I have come to call Big Dog Town, the people resided within the body of their own special dreaming power" (6). The central village formed by the palisade encoded the people's communal stature in relation to larger forces of the universe. Stevens develops this idea in some detail, arguing for an understanding of Aztalan's placement in the landscape of southern Wisconsin as a particular alignment with the prominent set of three bright stars we know as the Belt of Orion. In other words, similar to other earthworks complexes sited across the eastern half of the continent, one understanding of Aztalan is that it was constructed to actively mirror the sky-world. Far from an isolated village, a remote outpost of Mississippian culture, the site forms an integral component within a vast "star-map" written into—and literally through—the medium of the earth itself (6). A meeting of worlds.

In April 2017, I had the opportunity to walk this star-map and dreaming site with colleagues from the University of Wisconsin–Milwaukee. I had been invited to campus to give a talk about my work-in-progress and to meet with faculty and graduate students. Despite their close proximity to the state park, none of the Native faculty and none of their students,

I learned, had ever been to Aztalan. I proposed we remedy that situation with the occasion of my visit, to which they readily agreed. Among my hosts was Margaret Noodin, an accomplished Anishinaabe poet and scholar and a renowned specialist in Anishinaabe language, and she was among my companions for our walk among the mounds.[9]

Although I eagerly anticipated the morning of our visit, during the drive west from Milwaukee, as we sipped take-away coffees and made casual conversation, my thoughts turned inward and I became conscious of my ongoing role as a student *of* and *with* the mounds—not an expert *on* or *about* them. I thought, too, of how dependent I had been in following the lead of my research collaborators who are also my primary teachers in this work, especially Monique Mojica and LeAnne Howe, who had guided our embodied research together at earthworks in Ohio. Not only had none of my Wisconsin companions visited Aztalan, but for some of the students this would be a first encounter with any configuration of Indigenous mounds. They would look to me to lead them through this experience and, given my talk the previous afternoon, perhaps to guide them into specifically Indigenous research practices. I admit I felt uncomfortable in this role. I took a deep breath and another sip of coffee. I thought of Mojica and Howe and what I had learned from them thus far. Before leaving the parking lot, we would do our best to prepare mentally, emotionally, and spiritually. We would take our time to walk the land slowly and fully. We would remain mostly quiet but occasionally make space for focused conversation. We would open ourselves to forces seen and unseen. We would engage our embodied senses, including our embodied imaginations. If so called, we would allow ourselves to improvise, and we would endeavor both to make some kind of record of our improvisations, whether in memory, a notebook, a camera, an audio recording, or our physical bodies, and to keep them distinct from other kinds of observations. Our perceptions would be both individual and communal—and they would form within the tensions that move between experiences of the individual and communal. Whatever was meant to happen during our necessarily brief visit would happen as it was supposed to. There was no prearranged script and no expected outcome.

We arrived via the state highway and small access road, and we parked

in one of the appointed lots, which were mostly empty, not far from the 1991 official marker I had encountered online. It stands near additional markers that commemorate the site's 1964 designation as a Registered National Historic Landmark and that acknowledge key moments in the site's preservation up to the late 1920s. (As I suspected from my online research, no evidence remains of the pre-1991 official marker.) The series of conical mounds is visible there, as is a segment of the reconstructed palisade that stands near the crest of the ridge and the northwest platform, before the land begins to fall off to the east toward the river and the stand of forest that dominates its far bank. It was midmorning in early spring, the air cool, the sky a dull blue overlaid in layers of wispy clouds.

In the past, I thought, when Aztalan was active with life, welcomed visitors would not have approached the palisaded village either on foot or from this raised position to the west, the location of the contemporary highway and access road. Instead, visitors would have arrived by water, landing canoes on the banks of the river, entering the village through one of the several gates in the eastern wall—beneath the belly and feet of the big dog—then walking up the slope into the various precincts, through the central plaza and on toward the large platforms. From that vantage, because of the land's natural rise from the valley, visitors would experience noticeable shifts in the line of horizon. I suggested we make our way along the northern edge, past the upright posts of the reconstructed palisade, alongside the big dog's raised hindquarters, down to the bank of the river. Once there, we would begin again. We would imagine ourselves arriving by water, a sign of both our good intentions and our relations to the lower world.

> To reorient, we walk south along the riverbank, mimicking the big dog we cannot see but must imagine into being. Instinctively we match pace with the current, the slow, deliberate movement of water. We watch obscured light play on rocky shallows and deeper pools, and we watch our own shadows, oddly truncated and pale, enter the shade cast by small stands of trees—willow thin and still bare of leaves—then quickly depart. *Furtive*, I think, but say nothing to my companions. We pause to note the remains of the fish dam I had seen marked on nineteenth-century site maps, ghost of an ancient engineering,

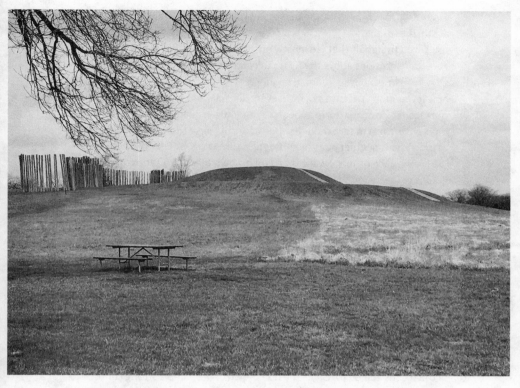

FIGURE 26. View of the southwest platform mound and section of the reconstructed palisade at Aztalan State Park. Photograph by Chadwick Allen.

the alignment of carefully chosen stones so subtle now the structure is easily missed. Only then do we turn back toward the west.

The heavy atmosphere of the sky, dull blue behind misty white, dominates our perception, although browns and greens and straw yellows are all around. Occasionally, a breeze gusts from behind, bracing and chill, the river reminding us that winter has lived in this place. We try to become aware of both our bodies and our minds in relation to the lay of the land, to notice how the physical terrain intrigues and challenges as we leave the bank to ascend the slope. It moves up through what was once the central plaza toward the southwest platform— the raised chest of the big dog (Figure 26). My thoughts turn to the Alligator

Mound in Ohio, how my companions and I perceived the effigy's earthen body as still breathing.

Through signals that are mostly unspoken, our present group gathers at certain locations above the riverbank and along the edges of the plaza to engage in brief conversation. As changed as we know the site must be from how it was in the past, we say, from every distance and from nearly every angle the reconstructed platform appears to mark the very edge of the world. For a moment we rest in that thought, then again disperse to continue our walking as individuals or quiet pairs (Figure 27).

Leaving the others, I walk ahead on my own to make a series of photographs of the reconstructed platform from various distances—starting back at the riverbank and then every twenty feet or so as I approach the two-tiered mound and the broad wooden steps set into its eastern, river-facing slope. I try to capture how the platform appears to be but a continuation of the upward rise of the land, the drift of the ancient glacier, how the mound, too, forms a horizon and thus creates the sense of a complete world (Figure 28). Once I reach the platform's summit, I turn back toward the river to take photographs of my companions as they make their own approach, first at some distance, then closer, then closer still. As if summoned, we are all standing on the mound together on cue, remarking on the view of the slope and the river, the colors of the vibrant grasses and bare trees, when someone spots a distinctive presence overhead.

The eagle circles above the line of upright posts that form another segment of the reconstructed palisade, the dull brown of the wood a strong contrast to the yellows and greens of the winter and spring grasses and to the dull blue and white of the sky. Gliding wide arcs, the dark shapes of our relative's outspread wings cut sharp against the cloudscape. A sudden flash of bright white reminds us that the site marks relations among the three worlds: cycles of movement among water, earth, and sky. And we are reminded, as well, that we human visitors are not the only beings who look, watch, and try to make sense. We, too, are seen and contemplated.

After walking along the ridge, imagining ourselves as viewed from the sky, we visit the series of conical mounds near the state highway, beyond the segments of reconstructed palisade and above the horizon lines of the village. We try to express in photographs the graceful curves of the mounds' serialized slopes, how they form swells in a sea of grass. But with so much of the immediate context transformed by highway and access road and parking lots, by

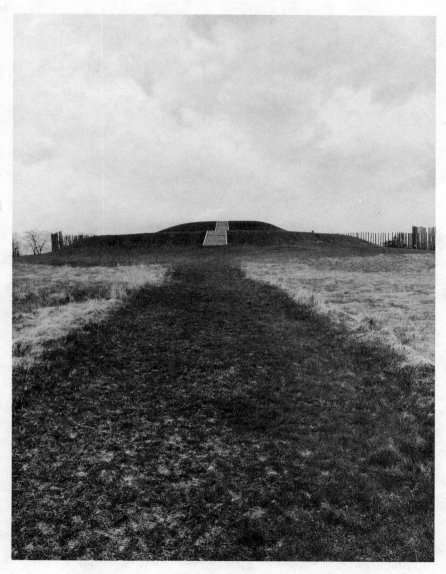

FIGURE 27. Approaching the southwest platform mound from the Crawfish River, Aztalan State Park. Photograph by Chadwick Allen.

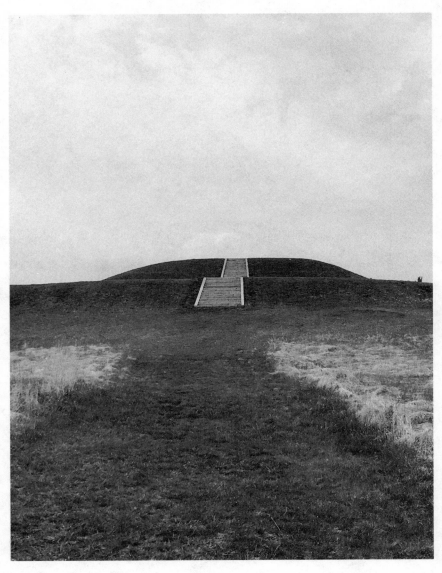

FIGURE 28. Horizon line created by the southwest platform mound, Aztalan State Park. Photograph by Chadwick Allen.

scattered houses and outbuildings and surrounding farms, by so much scraping and leveling and covering over, only the images we make in closeup suggest the possibility of transport to other worlds.

A week or so following our visit, when I am no longer in Wisconsin, Noodin sends me the poem she has composed in response to our walk among the mounds at Aztalan. The remarkable gift is not a single poem, however, but two. And although intimately related, the components of this twinned text are neither identical nor exactly fraternal. The first is an original composition in Anishinaabemowin (Anishinaabe language), the second an approximation of the first glossed in idiomatic English. Noodin often employs this kind of dual-language practice in her poetic work. It is part of her contribution to keeping Anishinaabemowin active as a living language among speakers and learners at all levels of proficiency, part of her contribution to maintaining Anishinaabemowin as a medium not only for carrying the past forward into the present but also for creating new Anishinaabe thought and expression for the future. As she explains in the preface to her 2015 collection *Weweni: Poems in Anishinaabemowin and English:*

> The poems here are an attempt to reflect the essence of Anishinaabemowin. They were written first in Anishinaabemowin and then in English, which is why the Anishinaabemowin versions are more complex and musical. In many cases, the sounds and juxtapositions of meaning add layers of action and imagery. Because Anishinaabemowin is the focus of the collection, the English version of each poem is not always a literal translation and serves primarily as a lyric explanation.[10]

Noodin remarks further that when Indigenous languages appear in contemporary poetry, they typically "serve as a semiotic accent to predominantly English writing," a minor gesture. In marked contrast, her purpose in composing first in Anishinaabemowin is to allow "the Anishinaabe language to fully define the poems," to place modes of Indigenous expression and thought at the vital center.[11]

How, I wondered, would Noodin reflect—and reflect upon—our walk

at Aztalan within the conventions and possibilities of Anishinaabemowin? The dual-language poem she first sent me reads like this:

Aazhawa'zhiwebag / Paths into the Past
— Margaret Noodin (inspired by a day with Chad Allen at Aztalan State Park)

Gimbabimosemin maazinibikwadinaang / We walk along the earth drawings
wegodogwen giisphin waabamiyangid / wondering if we are seen
ezhi-bimikaweyaang / leaving footprints
ezhi-ninjiishinyaang / leaving handprints
biiweiwebiyaang ikidowinan, enendamowinan / scattering words and ideas
aabitaa-biindaabia'maang ankenootamawinan / half-baked translations
gaye wanitawinina / and misunderstandings
gaa enji-zaagidiwaad ningizowaad gemaa / where lovers might have
 melted or
gebaawa'ondag aawiwaad awakaanag / prisoners became slaves.

Gaawiin igo gikendasiiman aaniin miniki / We don't know how many
gii o'o giizhenindaanaawaa / created this
aazhawa'ezhiwebag / path into the past
gii wa'aw giizhenimaad / created this
wiiyawakiing biitoosing / earth body of layers
ani-asinikaag ani-bingwikaag ani-nibikaag / soil turning to sand turning
 to water
bangitoowaad memeshkwad miigaadiwaad / vacillation between quiet
 and uprising
waanadinaag ezhi-nisidotaadiyaang / a lacuna of understanding
mizhishawising anaami-giizhigong. / left wide open to the sky.

My initial response was delight that my visit to Wisconsin had inspired not only a communal engagement with the platforms and conical mounds at Aztalan but also a subtly affective response and a boldly intellectual contemplation of that experience within the epistemology and specific idiom of a living Indigenous language. In our contemporary era, more often than not we simply lack access to creative expression within Indigenous languages—

whether our own or others'. My next response was a feeling of mild dread: despite my lack of facility with Anishinaabemowin, I would be expected to produce an educated response, a nuanced interpretation. Again I was made to feel inadequate to my assigned role. But I took another deep breath and again sought the medicinal properties of strong coffee. I would engage the dual-language poem to the best of my ability and see what happened.

What I noticed first is that Noodin begins by juxtaposing the communal act of "walking" the land at Aztalan with the idea that the mounds are a form of "earth drawing," what I am typically inclined to name a form of earth *writing*. Noodin then raises the question of our potential role not only as the ones who see and perceive, who interpret the earth drawing (or read the earth writing), but also as the ones who might be seen and perceived— and thus how we ourselves might be interpreted or read. (I interpreted Noodin's question as a coded gesture to the gifted presence of the eagle, her own gift to the small group of readers who would remember that experience and know.) I appreciated how, toward the end of the poem, the early image of "earth drawing" becomes one of "earth body of layers," and how, in the line that immediately follows, in an extension of the image, sequencing and repetition create a dynamic sense of *movement* among these layers, that is, "*soil* turning to *sand* turning to *water*": "ani-*asini*kaag ani-*bingwi*kaag ani-*nibi*kaag" (emphasis added). Moreover, I appreciated the honesty and lack of pretense in the several lines that describe the flawed nature of our individual and communal attempts to make sense of these complex ancient structures and their larger environment—how from our contemporary vantage we might form, at best, only partial understandings.

As I worked through my initial thoughts about each part of the poem, trying to pay close attention to the original but knowing I relied heavily on the secondary gloss, it occurred to me to ask Noodin if she could provide a literal translation of the Anishinaabemowin. So I wrote a quick message of praise, telling Noodin how honored I felt by the creation of the dual-language poem, and tacked on a polite inquiry about the possibility of a third version that might exist at some position *between*—and in some form of productive tension *with*—the two versions Noodin had already sent. What might the "text between" the Anishinaabemowin original and the gloss

in idiomatic English look like? And how might it contribute to my own and others' understanding of the poem's primary components?[12]

Noodin's response was positive—and remarkably swift. She clearly found the linguistic challenge of interest. She wrote back:

> I'm glad you like [the poem]! Below is a version with the literal translation added between the Anishinaabemowin and English. The only thing to note is that the line "it is created" ["created this"] is repeated with two different types of demonstratives and verbs to account for the fact that what is created could be animate or inanimate, which is why I gave you "it" ["this" in the gloss] versus "he/she" in the literal translation.
>
> I was definitely trying to account for the fact that the mounds always feel so powerful and intimate and yet we really can't be sure whether good, evil or banal events took place in a curve or a corner and it is likely that over time all three may have occurred as places were built, abandoned, lost and/or reclaimed and "discovered."

With access to Noodin's literal translation of the Anishinaabemowin and to a more complex version of the dual-language poem, I was able to push my understanding further. For interpretive purposes, I have used italics to mark the literal translation, what I am calling the "text between" the Anishinaabemowin original and the idiomatic gloss in English:

Aazhawa'zhiwebag
Return to what happened
Paths into the Past

Gimbabimosemin maazinibikwadinaang
We are strolling around writing on the hills
We walk along the earth drawings

wegodogwen giisphin waabamiyangid
wondering if he/she sees us
wondering if we are seen

ezhi-bimikaweyaang
the way we make a trail
leaving footprints

ezhi-ninjiishinaang
the way we make handprints
leaving handprints

biiwewebidooyaang ikidowinan, enendamowinan
we scatter them, the words, the thoughts
scattering words and ideas

aabitaa-biindaabia'maang ankenootaagewinan
half-we bake them the translations
half-baked translations

gaye wanendaagwag
and what is not understood
and misunderstandings

gaa izhi-zaagidiwaad ningizowaad gemaa
(past) the way they love each other the melt possibly
where lovers might have melted or

gebaawa'ondag aawiwaad awakaanag
the ones locked up are tamed/controlled
prisoners became slaves.

Gaawiin igo ingikendaasiimin mii minik
Not really I know so many
We don't know how many

gii o'o giizhenindamowaad
(past) this thing they created
created this

aazhawa'zhiwebag
a return to what happened
path into the past

gii wa'aw giizhenimaad
(past) this he/she they created
created this

wiiyawakiing biitoosing
body of earth between
earth body of layers

ani-asinikaag ani-bingwikaag ani-nibikaag
becoming dirt/stones becoming sand becoming water
soil turning to sand turning to water

bangitoowaad memeshkwad miigaadiwaad
they are quite back and forth they are at war
vacillation between quiet and uprising

waanadinaag ezhi-nisidotaadiyaang
a space in the earth as they understand each other
a lacuna of understanding

mizhishawaang anaami-giizhigong.
it is left out in the open under the sky.
left wide open to the sky.

Reading among the versions, pivoting above and below the lines of lit-
eral translation, I was struck that my sense of the close relationship be-
tween earth *drawing* and earth *writing* is built into Noodin's original jux-
taposition of Anishinaabemowin and English. And I was struck that the
transformation of the early image "writing on the hills" into "earth body of
layers" later in the poem is linked to a central conception of the mounds as
bodies of "earth between," that is, a conception of the mounds as markers
on the surface world situated between worlds above and below. The three
lines that precede the line "body of earth between," as Noodin remarks in
her explanatory note, indicate that within an Anishinaabe epistemology
the mounds can be either inanimate ("this thing they created") or animate
("this he/she they created"). The inanimate possibility is developed in the

abstract image "a return to what happened" (which Noodin glosses "path into the past"), while the animate possibility is developed in the concrete image "body of earth between" (which Noodin glosses "earth body of layers"). The sense of "between" is then expanded in the line that immediately follows by an active sense of "becoming." The literal translation makes clear that it is not the sequence of nouns—whether inanimate "things" or animate "persons"—that is most prominent in the tripartite repetition of the Anishinaabe original, that is, "*soil* turning to *sand* turning to *water*," important as these elements are. Rather, what is emphasized is the ongoing *movement*, the continuous *action* of transformation: "*ani*-asinikaag *ani*-bingwikaag *ani*-nibikaag": "*becoming* dirt/stones *becoming* sand *becoming* water." The original line is not a sequence of three nouns with verbal forms positioned as connectors or conduits in between, but a tripartite repetition of a striking verbal form that literally *surrounds* and in that sense *controls* the sequence of nouns.

Finally, the idea of partial interpretation, what is rendered in the gloss as a "lacuna" in our understanding, links to this sense of "between" in the literal translation's image of "a space in the earth." (And this phrasing reminds us that the English word *lacuna* has its roots in the idea of a *lake* or *pool*, a depression filled with *water*, rather than in some kind of cosmic void or arid plain.) But this line, in the literal translation, performs additional work, too. The abstract image "a lacuna of understanding," easy to pass over in the idiomatic gloss, is revealed to be not an abstraction at all but rather a literal sense of "space" between beings in the act of perceiving and thinking: "a space in the earth *as they understand each other*" (emphasis added). This was our experience walking the mounds at Aztalan: we moved among multiple spatial configurations of both embodied experience and intellectual, emotional, and spiritual perception. We moved together and apart among different locations in the landscape, but also in different relations to the landscape, other-than-human beings, and our interpretations as individuals, pairs, and cohesive group.

In my reading of the first version Noodin sent me, I paid little attention to the poem's final line. The phrasing in the gloss, "left wide open to

the sky," did not seem especially provocative as closure to either the idea or the image of "a lacuna of understanding." But the subtle difference in the literal translation, "it is left out in the open under the sky," especially as a closure to the idea and the image of "a space in the earth as they understand each other," strikes me as more arresting and complex. The line of literal translation evokes a sense of *availability*: the mounds as vehicles for becoming are still here for us to experience and interpret. At the same time, the line evokes a sense of *vulnerability*: the mounds as vehicles for becoming have been "left out in the open" on their own, outside a community of understanding, exposed to physical and ideological forces that are potentially destructive. (And we know too well that, historically, settler forces have performed extreme acts of violence toward these and other mounds.) This evocation of vulnerability and potential danger, obscure in the idiomatic gloss, imbues the end of the poem with a heightened sense of urgency.

Noodin's process of composing across Anishinaabe and English languages is not only highly productive of a complex poetics; it also points to possibilities for conceiving how multiple and distinct Indigenous peoples might have gathered at sites like Aztalan to engage "earth drawing" and "earth writing"—both separately and together. Against the grain of dominant discourses, how might we imagine such sites outside assumptions of an exclusively hostile world, outside stereotypes of savage exotics in conflict with primitive locals? How might we imagine Indigenous pasts within the difficulties and rich possibilities of interactions among multiple peoples, cultures, and languages? How might we imagine the spaces archaeologists designate "interaction spheres" more fully as productive nodes within networked systems?

The literal translation of Noodin's Anishinaabe title, "Return to what happened," which repeats in the poem as "this thing they created / a return to what happened," evokes the idea put forward by Choctaw intellectual LeAnne Howe that, for descendants of mound-building peoples, the generative perspective for research and contemplation is not an orientation to the past as fixed object of interpretation—with the archaeological emphasis on controlling the narrative through a discourse of "mysteries," whether

perpetuated or resolved. No, the generative orientation for research and contemplation is to the future, to a focus on how sites and peoples continue by changing over time. Within a future orientation, Howe contends, earthworks and earthworks complexes are understood neither as sites of loss nor as sites of mere survival, but as sites of productive return. "Paths into the past," *aazhawa'zhiwebag,* become paths into the future. We "return to what happened" so that we might begin again.

Burials

Gathering Generations

Center

Wombed Hollows, Sacred Trees

I've learned a lot about my cultural legacy from the collage process itself and the way it tends to release my imagination through the making of connections. Originally, the use of the turtle in my art derived from the burial mound motif. . . . As I made connections over time, I realized the mound was like a womb.

— Alyssa Hinton, "Awakening Series," from
Earth Consciousness and Cultural Revelations (2017)

Without my womb, they but dust.
— Allison Hedge Coke, "Burial Mound," from *Blood Run* (2006)

For a time during my research process, when I am living in Ohio and able to regularly visit mounds and the remains of mounds, sometimes on my own but often in the company of fellow researchers, burials seem to propel my dreams. (To be clear, it is the site-specific research that is often conducted collaboratively, not the resulting dreams . . . although I do find it useful to discuss with colleagues these visions and, more typically, revisions of experiences . . . and I do occasionally wonder about the possibilities of co-creation.) I don't mean that my dreams are propelled by a sense of foreboding, by anticipation of my own or others' passing to the next world. And I don't mean that my dreams manifest anxieties; I recall no nightmares. I mean, instead, that for a time my dreams function as a form of remote sensing: a lens for seeing beyond waking attempts at careful physical observation of earthworks and their environments, a tool for thinking beyond efforts at rational analysis of what I've observed and tried to record in memory and body, in photographs made with a camera or

smartphone, in writing in a notebook or on a computer. This form of re-
mote sensing feels akin to the type of heuristic Tanana Athabaskan theorist
and poet Dian Million names an *intense dreaming:* productive acts of imagi-
nation that draw from both felt knowledges and critical thinking to work
toward conceptions of Indigenous futures.[1] My intense dreaming in Ohio
manifests in contrasting archetypes of Indigenous interment, each scene of
encountered burial idealized but also deceptive in its own way. The juxta-
position reminds me to consider the deep complexities—often, the painful
ironies—of earthworks' duration. It reminds me to consider how earthen
mounds and the human and other-than-human remains they were meant
to shepherd through transitions manage to endure despite all manner of
desecrations, historical and ongoing, despite all manner of neglect and
damage. Their endurance is often physical, in remnants and traces, and
often against remarkable odds. But it is also metaphysical and metaphori-
cal, manifest in ideas and concepts and particular ways of knowing, and
these forms of endurance, too, are often achieved against remarkable odds.

In one intense dream:

> Companions and I carry braids of sweetgrass as we approach the stunningly
> uniform shape, the impossibly smooth sides of the large interment known as
> Seip Mound. A bright midday sky illuminated by an even brighter midday sun
> irradiates the mound's perfectly manicured surface. We can smell the fresh cut
> of the grass, its moist promise of growth and seed; the blades shimmer with
> an intensity that feels more Amazon than Ohio, dense and fecund. Small birds
> chitter, large insects buzz, hum, and click all around in a pulsing chorus. We
> know the elliptical structure measures an astounding 240 feet long by 130 feet
> wide by 30 feet high, but we are surprised nonetheless by the multiple lines of
> horizon that form and re-form as we slowly process toward the massive mound
> of precisely packed earth enveloped in a luminous, aromatic, symphonic green
> (Figure 29).
>
> Continuing our slow procession, we walk the circumference of the mound's
> elongated structure—once, twice, a third, and then a fourth circumambulation.
> Instinctively we walk counterclockwise, following the way of wind and water
> but noting in each revolution how the high position of the sun causes shadows
> to subtly shift across the planes of cut grass. From every angle, the mound is a

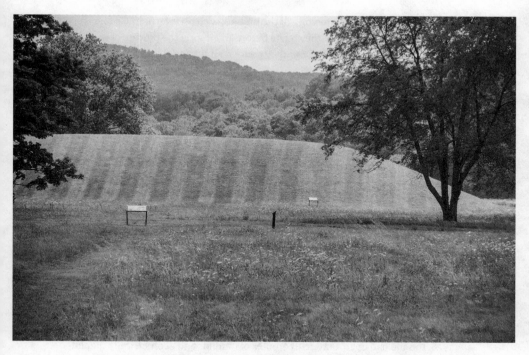

FIGURE 29. Image of the reconstructed elliptical burial known as the Seip-Pricer Mound at Seip Earthworks, near what is now Paxton Township, Ohio. Photograph by National Park Service/T. Engberg.

marvel of geometric symmetry. After completing our ritual walk of the perimeter, we offer the braids of sweetgrass along with words of gratitude and grief to the ancestors whose remains we know have been made absent from this place meant to endure. Only then do we make physical contact.

Lying with our backs against the mound's broad, angled sides, warmed by the sun, we close our eyes and open our minds to imagine through the cut grass into the layers of dark soils and porous clays of the site's deep history. What were they like, those ancestors who built the original form of this mound and set it within an elaborate complex of geometric enclosures? What past events, which remembered ancestors of their own motivated their actions? What visions or forces inspired their designs? Did they follow established procedures, or did they

experiment with the engineering of the mound, with their techniques for con-
struction? What chants did they recite before and during the process of making,
and what songs did they sing? Did they dance counterclockwise to press energy
across and into soil?

In the distance, through the pulsing buzz and chitter and hum, we hear
Woodpecker's staccato knocking in the trees, although we do not actually see him.

Later, after the sun has shifted from zenith and we have moved our human
bodies off the mound's now cooling earthen body, we once again walk past
the official signage on our way to the small square of gravel that serves as the
site's parking lot. We wonder aloud why the remnant of this once exquisite
complex bears the name Seip. The name holds no relation to the builders or
subsequent caretakers of the original mounds and enclosures; but neither
does it recognize the non-Native settlers who first homesteaded the land and
whose farming first began to damage the embankments in the mid-nineteenth
century. Rather, the name recognizes the non-Native family that purchased the
property decades later. Why does the remnant—this last mound standing—
commemorate Charles Seip, an immigrant from Germany who became a
prominent businessman in nearby Chillicothe, the seat of Ross County? Neither
Seip nor his descendants protected the site that bears their family name. Before
the Ohio Historical Society sent archaeologists to excavate between 1925 and
1928, the site had been a 121-acre complex of mounds and geometrically shaped
embankment walls arranged within a sharp elbow of Paint Creek. The archae-
ologists evacuated the complex of its more than one hundred human remains,
and they carted away both its extensive inventory of finely crafted funerary
objects and its cache of "exotic" materials linking the ancestors who built these
mounds to quarries and sites of gathering located across a broad expanse of the
continent. The principal burial was then reconstructed, its newly leveled and
symmetrical surfaces planted with a protective envelope, an introduced species
of short grass easily cultivated and mowed. The once hallowed elliptical form,
its multiple layers of soils full of potential for life, survives as a beautiful but
hollow memorial. An empty tomb. It stands alone, bereft of its former contents
and companions. It serves as a brief stop for local children on school field trips, a
photo opportunity for occasional tourists who travel the back roads of rural Ohio.

For us, however, despite knowledge of the destruction and subsequent cover-
up, despite knowledge that the contemporary mound is but a hologram—but a
three-dimensional illusion—Seip remains a glowing and green primary destina-
tion.[2] It remains a place to prompt memory and imagination and hope.

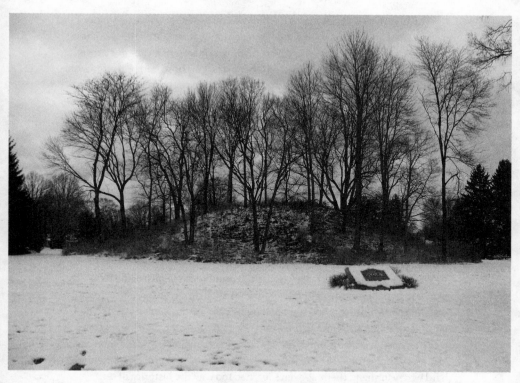

FIGURE 30. Image of the conical burial known as Jeffers Mound during winter in what is now the Columbus suburb of Worthington, Ohio. Photograph courtesy of Wikimedia Commons.

In the other intense dream:

My companions and I place tobacco around the base of the unevenly sloped cone of a twenty-foot-high interment known as Jeffers Mound. We are in Worthington, Ohio, once an independent settler town but now a near-suburb of the capital city, Columbus. In contrast to the manicured green of Seip, the surface of Jeffers bristles with both native and introduced grasses, some blond, some brown and russet, all grown long and seemingly wild. The mound's surface bristles, too, with low tufts of spiky brush and with a stand of thin trees, their branches already bare of leaves (Figure 30).

The burial is all that remains of what was once an eight-acre complex of mounds and enclosures sited above the Olentangy River along the dramatic ledge of a sixty-foot bluff. With trees and brush cleared, the site must have offered strategic views. But what is left today is largely obscured by overgrowth of various kinds. In addition to grasses, brush, and trees, the central mound is practically encircled by the asphalt of a residential street, around which stands an imposing half-circle of middle-class houses. None of the owners appears to be home; doors have been shut, curtains drawn, blinds closed to gray skies bearing low clouds and a misting rain. No one gawks at our presence before the mound, but no one approaches in greeting, either. Several of the houses, we cannot help but notice, prominently display U.S. flags. The bright colors and straight-edged shapes telegraph coded messages, and they make a stark contrast to the more natural blonds, browns, and russets of the overgrown burial in autumn. We make photographs of ourselves standing between the dominant signals and the ancestral mound, as though we form a human shield. As though protection might be achieved so easily.

Despite the asphalt, the glaring circle of middle-class houses, the flags brazenly signaling in the light rain, here it is easy to imagine burials secreted and intact, the ancestors and their belongings and companions protected by untamed grasses, by prickling brush and the high-grasping branches of trees. Here it is easy to imagine undisturbed claims to ground. At least for a time. Such ideas won't hold, though, no matter how hard we cling to them. No matter how hard we try to shield them. We have learned too well the histories of settler colonialisms, recited too many times the drives toward destruction made under the banners of inquiry and industry, or of religious and political freedoms, or, especially, of economic opportunity. And we have read the specific accounts, the details of so-called first encounters, details of which settler then purchased which divided parcel of land when, why, and how, details of subsequent settler inheritances followed by losses and further divisions, stark details repeated over and over in old paper archives and now on site after site on the internet. So many small-town governments, so many county historical societies sharing the same stories of their founding. The accumulating details amass in settler chants of discovery, in settler chants of platting, in settler chants of owning. We've read enough to know the chants run together in overlapping rounds to become indistinguishable.

Similar to the elliptical Seip Mound to the south, this conical burial bears the family name of a late arrival, the non-Native settler Herman Plesenton

Jeffers, who purchased the land beneath and surrounding the mound in 1921. The site had been homesteaded by an earlier non-Native settler, William Vining, who arrived from Connecticut in 1804; decades of farming by Vining and his descendants had already eroded the embankments long before Jeffers negotiated his purchase. The Vining descendants claimed the family protected the burial for many years, for as long as they could. Nonetheless, in 1866 they apparently did nothing to prevent an amateur excavation: William Heath dug a vertical shaft from the top of the cone down to its base, then dug an intersecting tunnel from the eastern side. The idea was to reveal the mound's hidden interior—and hopefully to discover its treasured contents—while maintaining its layers and overall form. This measured approach had become something of a standard method for the more civic- and preservation-minded among nineteenth-century amateur archaeologists and professional looters.[3] Although reports of the dig were written and filed, no record remains of the two ancestors Heath removed from the mound.

Were the bodies divided and dispersed as individual heirlooms passed down the Heath or perhaps the Vining generations? Might some dark attic, some musty toolshed still hold a yellowed femur patiently waiting its return? (I realize that may sound overly dramatic, but one hears stories. And some of us were present the time a retired custodian from a rural school district showed up at an Ohio powwow gingerly carrying a basket . . . that itself cradled a human skull. The custodian, a self-identified mixed-blood originally from Canada, said the skull had been tucked away in a school closet for decades, perhaps longer. He assumed it belonged to a Native ancestor and wanted to help the skull find its way home.) Were the bones instead sold, in the name of some science, to an acquiring university or museum? Displayed in a sideshow? Simply abused and discarded? There are many possibilities.

In 1954, when descendants of Jeffers had the land platted for subdivision, they made a point of protecting what was left of the already evacuated burial, cloaking the mound's nineteenth-century looting within a twentieth-century illusion of an overgrown remnant, a tragic ruin. In its obvious state of decline— cone diminished, sides uneven and slumping, surface overgrown in weeds and trees—surrounded by asphalt and houses and flags, the mound seems oddly familiar, an icon of Romance or the Gothic or both. We feel sure we have seen its likeness, felt its haunting presence before. It fulfills an expectation that an evocative trace of the past will erupt into an unsuspecting present, filled with irrepressible truth, and thus the mound's history appears legible and clear. But

Jeffers, too, is a hologram, a reverse illusion to Seip cast in three-dimensional blonds, russets, and browns instead of radiant green.

Standing near the small but substantial bronze marker that commemorates the site in the Jeffers name, our backs turned to the drawn curtains and closed doors of the glaring houses, sifting more tobacco between fingers and thumb, we wonder why it is that we find it so much easier to sustain feelings of uplift when in view of Seip. The pristine form of the rural elliptical mound is equally an ideological and political captive as is the degraded form of suburban Jeffers, and it is equally if not more completely desecrated and destroyed. Our ability to sustain feelings of uplift in the presence of Seip, we think, has something to do not only with its bucolic setting but also with its reconstructed surface, with the even smoothness that accentuates its geometric symmetry, something to do with the luminous green of its cut grass that seems to promise renewal. And it has something to do with the absence of trees rooted deeply beneath the surface of the leveled soil. At Jeffers, we want desperately to imagine the trees as protectors of the mound and of the ancestors the mound was built to shelter and carry. But we cannot help but also see the bare trunks rising out of the long grasses and the bare branches reaching toward the overcast sky as evidence of an invasion. Like Vining and Heath and Jeffers and so many others before and after them, the trees seem invasive. They seem to assert the grasping authority of the settler's presence from above while working the settler's slow, destructive uprooting from below.

Dreaming, I began to understand the need to contemplate our relationships not only to the extant mounds and the remnants of mounds but also to the trees that so often grow out of them, obscuring their forms. Where such contemplation might lead, though, I was at first unsure.

BEYOND STERILE CHAMBERS

For many who either seek or stumble upon them, burial mounds signal loss, herald doom: dead Indians, dead savage civilizations, dead pagan pasts ground to dust and now overgrown in brush, obscured by weeds and trees. And yet for others burial mounds announce regeneration, the possibilities of reclamation and renewal; they continue to connect and bloom. Native individuals, families, communities, and nations rise up against the

narratives of loss and doom to reclaim and repatriate, restore and reactivate. Interpretation depends on the perspectives of viewers and interlocutors—on their epistemologies, histories, and politics. On their lived experiences and felt knowledges. On their abilities to dream intensely. But there are no easy divisions, no clear-cut binaries of Indigenous and settler in the twenty-first century (if there ever were), and there are no easy escape routes out of dominant ideologies and worldviews. As Million states succinctly: "The struggle in our generation has been to honor our own paradigms, concepts that arise from our lives, our histories, and our cultures while knowing that these are often inextricably mixed with concepts growing from our subjugation."[4] Too often, descendants of the builders resemble the remains of the mounds: those that miraculously survive find themselves enclosed, confined within the fences of state memorials or the cul-de-sacs of private properties. They find themselves excavated and reconstructed or excavated and overgrown.

In pursuit of honoring Indigenous paradigms, concepts, and models for understanding the complex operations of burial mounds—in the past, yes, but also in our present moment and in possible futures—this chapter juxtaposes the poetry of Allison Hedge Coke, a writer, intellectual, and activist of Cherokee, Huron, and Creek descent whose work is discussed at some length in previous chapters, with the visual and sculptural art of Alyssa Hinton, a mixed media artist and intellectual of Tuscarora and Osage descent. I place Hedge Coke's and Hinton's diverse productions in focused conversation in order to explore some of the ways in which contemporary writers and artists conceive ancient burials not as sites of loss and death and absence—as they have so often been depicted in European and European-American representations since the eighteenth century—but rather as sites of regeneration and renewal and, importantly, as sites for Indigenous returnings. Although Hinton began her series of vibrant photo-collages and assemblages depicting burial mounds in the 1990s, a decade before Hedge Coke published her sequence of interrelated earthworks poems in 2006, I encountered Hedge Coke's work first, and thus my itinerary begins with Hedge Coke and her provocative engagements with burials in *Blood Run*.

Previous chapters describe how Hedge Coke's sequence animates an extensive earthworks site located along the Big Sioux River on what is now the border between Iowa and South Dakota. As at other earthworks complexes and cities, the mounds at Blood Run were built to serve multiple civic, intellectual, and sacred functions. They were designed to align with natural features in the landscape, with each other, and with discernible patterns in the sky, and both designs and alignments were based not only in precise observations of the natural world and cosmos but in complex symbolic languages and systems of abstract notation, including sophisticated mathematics. Hedge Coke simulates these multiple relations in her precise positioning of *Blood Run*'s two narrative and sixty-four persona poems within numbered sections and within the sequence as a whole, and she simulates the mounds' multiple physical and symbolic alignments by manipulating a set of standard units of measurement—the natural numbers *four, three, seven*, and their multiples—as well as the sequence of the first twenty-four *primes*—those natural numbers that can be divided only by themselves and the number one. These embedded numerical alignments manifest in Hedge Coke's precise numbering of lines, in her precise patterning of stanzas per poem, lines per stanza, words per line, even syllables per word—and, crucially, in how these multiple numerical configurations align, further, with specific content, with wordplay, allusion, and imagery, with building themes. One such theme is the gendered and productive nature of burial mounds.

In the series of sixty-four persona poems that comprise the main body of the sequence, Hedge Coke enables thirty-seven distinct elements associated with the Blood Run site to "speak." In this way, the poems function as a script for embodied or imagined performance. Some personas speak only once in the sequence, often in direct conversation with the persona situated on the facing page, while other personas speak multiple times. The personas that speak more than once include the collective voice of The Mounds, which speaks seven times across the sequence, as well as the individual voice of Burial Mound, which speaks three times. Both personas emphasize the mounds' gendered potential for creation. In her first appearance, for example—positioned as the seventh poem in section II ("Origin")—Burial

Mound describes her body of layered soils and packed earth as a "venter," a word derived through Anglo-French from the Latin that can indicate the swell of a muscle, suggesting the mound's inherent strength.[5] But "venter" also indicates a swollen belly or uterus, suggesting the burial mound is in a state of pregnancy and, through the word's multiple meanings, linking the mound's pregnancy to physical strength rather than vulnerability. More directly, "venter" can mean "womb" or "mother." In her third appearance—the fourteenth poem in section III ("Intrusions")—Burial Mound then describes her outer surface as a "seed coat," "hull," and "tremendous testa," that is, a seed's protective covering. In the poem's final line, she describes herself explicitly as a productive "womb" (58). I offer a more expansive reading of this "Burial Mound" poem in a previous publication.[6] Here I will note that the poem's macrostructure of seventeen lines (the seventh prime) arranged into six stanzas is echoed in this final line, composed of seven syllables (the fourth prime) arranged into six words. Moreover, just as the center of the poem is marked at line 9—the line is set off as its own stanza and as a complete statement, and it is composed of seven syllables arranged into four words, divided evenly by the pause of a central comma, which effects the line's productive juxtaposition ("So lamentable, what was!")—the center of the final line is also marked by the dramatic pause of a central comma. This positioning creates a caesura, signaling an intake of life-giving breath and effecting the line's epitomizing juxtaposition: "Without my womb, *[pause and breath]* they but dust."

The seventh and final appearance of the collective persona The Mounds is positioned as the seventh poem in section IV ("Portend"), emphasizing an alignment of two of the sequence's basic units of measurement, the sacred numbers seven and four (seven is the fourth prime). The poem consists of twenty-seven lines divided into nine stanzas, emphasizing the sequence's other basic unit of measurement, three, through cubing and squaring.[7] The poem is further divided into thirteen statements; thirteen is the sixth prime. These mathematical encodings create meaning at the structural level of the poem, and they create multiple alignments with other poems in the sequence. As the final articulation of the collective voice of the mounds, the poem summarizes the earthworks' primary functions:

"Civic, ceremonial, elegant effigy—Snake— / our purposes funerary, fundamental, immaculate" (82). In its suggestion of purity of purpose, "immaculate" responds to the dominant culture's damning of Indigenous imagery—especially of snake imagery—as pagan and unholy. Moreover, "immaculate" carries the specific connotation of the Christian concept of the Immaculate Conception, linking to the assertion made throughout *Blood Run* that the burial mounds function as "earthly wombs" for the honored dead, portals for the shepherding of energy across worlds above and below (17). Significantly, this role is emphasized at line 14 in the fifth stanza, the poem's precise fulcrum, where thirteen lines and four stanzas balance above and below. Here, at the poem's effective navel, in seven words The Mounds assert as one of their primary functions the literal rebirth of their Indigenous makers: "all will know our great wombed hollows" (82). The specific idea of burial mounds functioning as "wombs" and "seeds," and the broad theme of ancient earthworks spurring Indigenous regeneration in the present and future, are developed across the *Blood Run* sequence, so that this final voicing of The Mounds serves as a culmination, a movement toward the beginning of a new cycle of creation. Hedge Coke then further aligns the poem so that it is in immediate conversation with the fourth and final voicing of Memory, positioned on the facing page. The abstract persona offers a concrete vision of renewal and return: "Yet just as our children's children have little ones / seeking us again from the places they do dwell nearby, / they, too, are returning to proximity for sacred sustenance" (83). Memory rearticulates Burial Mound's assertion of "knowing" as a future marked by Indigenous generations.

It was during the time I was arriving at these conclusions about the gendered functions of burial mounds in *Blood Run* that I learned about Hinton's evocative works that also center burials. Hinton describes these collages and assemblages as "mixed media composite." Although the collages, in particular, are created with photographic, digital, and other visual media rather than spoken language or alphabetic writing, Hinton's creative process has much in common with Hedge Coke's. As Hinton explains in the catalog for her 2017 exhibit *Earth Consciousness and Cultural Revelations*: "The process involves the piecing together of photographic elements, with origi-

nal hand rendered art and digital editing, to create a hybrid art form."[8] She continues:

> The digital collage method is a slow "trial and error" process of mixing and matching image fragments. I spend a lot of time positioning and repositioning within Photoshop. It's like an elaborate refinement process where layers of meaning filter through to convey a story. This approach allows me to explore my design and color options in a fluid way.

Hinton's layering of image fragments to create narrative meaning resembles Hedge Coke's aligning and realigning of multiple poetic elements to animate Blood Run, to enable the site to "speak" its own story—rather than be spoken *about* or *for*.

It was Hinton's 1998 photo-collage *Ancestral Plane*, part of her Spiritual Ground series, that first drew my attention. Assembled from thirty-three image fragments, *Ancestral Plane* depicts a burial mound constructed in the deep past and now overgrown with grass and trees not as a site of death or colonial nostalgia, but rather as a site of Indigenous rebirth and regeneration (Plate 5). I was immediately drawn to the vibrancy of Hinton's palette, to the purple, blues, and orange. But I was also drawn to Hinton's bold reclamation of the dominant culture's convention of representing burial mounds in cross sections. Archaeologists, anthropologists, and historians create these cutaway perspectives in photographs of excavations-in-progress, as well as in drawings, diagrams, and other illustrations, and sometimes in 3D scale models, in order to expose the "hidden" interiors of mounds, to display what lies beneath their surfaces. These depictions typically reveal multiple distinct layers of rocks and soils. Some also reveal multiple layers of distinct mound structures, that is, smaller mounds constructed at earlier periods and now set within larger mounds built over them. As expected, most include one or more distinct layers of funerary objects, other cached objects and materials, and human interments.

The 3D scale model on display in the small interpretive center at the Serpent Mound State Memorial located in Ohio, a site discussed in detail in chapters 1 and 2, provides a dramatic example. Fabricated in the 1960s,

FIGURE 31. Image of the 3D scale model of a large and complex burial mound, presented in cross section, on display in the interpretive center at the Serpent Mound State Memorial. Courtesy of the Ohio History Connection. Photograph: Bill Kennedy.

this cutaway, cross section diorama of a conical burial mound is presented in a limited palette of dull browns, pinks, and grays, and it is set behind glass within an otherwise bare display case that creates a stark foreground and background (Figure 31). The setting can be characterized as "clinical," perhaps "sterile." Presented in complete isolation, the burial is depicted as devoid of relations with any aspect of its surrounding environment. This feature is an obvious contrast to Hedge Coke's elaborately situated and elaborately aligned burials in *Blood Run*.

The cross section exposes multiple layers of interments arranged beneath the mound's surface, and thus the model makes available to viewers a complex but discernible narrative of original burials and constructions followed by successive burials and constructions and at least one "intrusive" burial. At the base of the model lie two "primary" interments, represented as two bare skeletons laid flat on their backs and arranged perpendicular to each other in the shallowly dug subsurface of the earth and covered by

two separate but adjacent low earthen mounds. A third "primary" inter-ment is situated directly above the first two, represented as another bare skeleton laid flat on its back atop a layer of soil infill between the two origi-nal adjacent low mounds; this third skeleton is covered by a larger mound that encompasses the original two. A fourth "primary" interment is situ-ated as attached to the third, represented as a bundled—or jumbled—bare skeleton in a semi-seated or fetal position, set within a small partial fourth earthen mound built to the right of the third, similar to an addition on a house or other structure. A fifth "primary" interment is then situated di-rectly above the third, represented as a still-clothed and still-decomposing deceased human body laid flat on its back on the surface of the third mound; this fifth burial is covered by the large conical mound, which en-compasses the earlier interments and mound formations beneath its structure. Finally, the cutaway model exposes a subsequent "secondary" or "intrusive" interment—which brings the total burials to six—represented as a still-dressed and still-composed deceased human body laid in a prone fetal position within a still-open rectangular grave dug into the surface of the left side of the large conical mound. Through the depiction of multiple layers of mound structures, and through the use of scale models of realistic skeletons and human bodies in multiple stages of decomposition, the 3D model offers attentive viewers a sense of mastery over the burial mound's elaborate history. Although it is illustrative and potentially instructive, this kind of "revelatory" representation of mound building and this kind of clinical display of the dead can make some Native viewers (and perhaps some non-Native viewers) uncomfortable. In addition to oversimplifying Indigenous histories, the model can be seen as dehumanizing and debas-ing Indigenous ancestors.

Similar to Hedge Coke's *Blood Run,* Hinton's *Ancestral Plane* offers a strik-ing contrast. Unlike the dull diorama, removed from its surroundings and situated within a sterile environment, Hinton positions her vibrant mound within an equally vibrant setting. The middle ground depicts a radiant field of grasses in vivid tones of golden yellow and pale orange immedi-ately adjacent to the mound, while the foreground depicts a radiant field of wildflowers in rich tones of pink and fuchsia; these luminous fields extend

behind the mound as well, where they meet the horizon. Above this line, the background depicts radiant clouds in misty white bleeding into higher clouds in a glowing red-purple; these clouds nearly fill a still-discernible blue-purple sky. Set within this dramatic sky-world, above and to the left of the central figure of the mound, is the kinetic figure of a dark bird, outlined in white—wings pulled back, legs extended, as it makes its descent. Similar to the vibrant fields in the foreground and radiant cloud-filled sky in the background, the mound itself emanates light and color from within. Although the mound's uneven surface is strikingly dull—a mossy brown or drab olive—and although this surface is depicted as overgrown with low tufts of weeds and three small trees in leaf, a cutaway exposes the mound's brilliant interior. Unlike the crisply cut cross sections of typical archaeological models and diagrams, which are often rendered with a draftsman's precision, the edges of Hinton's opening are jagged and organic, reminiscent of the edges of puzzle pieces—or perhaps the edges of continents. The interior of the mound is only partially revealed, and the opening's irregular edges suggest movement: like continental plates, the surface of the mound appears to be in motion, slowly breaking apart to reveal its contents. What viewers see exposed by this jagged cutaway is a cross section of funerary objects, other buried materials, and human interments set within vivid layers of soils, as well as dark roots outlined in white extending into the layers from the three trees growing on the surface.

The mound's base is a deep red soil with yellow and orange highlights, and this layer is nearly filled with mostly indistinct remains rendered in blacks, blues, reds, and whites—there may be human interments, but if so, they can no longer be recognized; they blend into the shapes and colors of funerary objects and other materials. The image is reminiscent of Hedge Coke's first Burial Mound poem, which states in her closing lines: "Wise men, blessed children, mothers of stars / slumber in perpetuum, the seat of my mass" (19). Above this dark base, Hinton's photo-collage depicts a middle layer of soil that glows in pixilated golden yellows. Two distinctly human interments glow as well, but they are neither the bare skeletons nor the realist decompositions depicted in the diorama on display in the Serpent Mound interpretive center. Rather, the interred bodies glow in pixilated multicolor,

shadings of whites, oranges, yellows, and blues that form organic shapes. Together, these shapes and color gradations suggest the shaded contours of digitized maps: geographic area maps and topographic contour maps, but especially evocative heat maps (Plate 6). Lying within layers of packed soils, the interred bodies are themselves depicted as *animate* landscapes and *active* sources of heat—hidden reservoirs of *life* and *energy*. Above this middle layer of interment, between the radiant landscape-bodies and the dull surface of the mound, centered within reddish soil among additional funerary objects and the living roots of the trees, Hinton has placed the figure of a human embryo. In contrast to the interred landscape-bodies, which lie on their sides in repose—the lower body on its left side, the upper body on its right—the embryo is depicted in an upright fetal position, its head facing left toward the descending dark bird. And where the ancestors produce light and heat in multicolor, the embryo glows a dark electric blue, outlined in black and haloed in pixilated white. It too is a vibrant source of energy. Situated in the layer of soil above that of the radiant, heat-generating landscape-bodies of interred ancestors, the electric-blue embryo is a vital sign of the mound's function as a womb, a productive source of new life (Plate 7).

In her artist's statement, Hinton describes *Ancestral Plane* as "the cross section of a burial mound, breaking open to reveal remnants and remains of cultural relics and people. Trees draw upon these vestiges for sustenance while the embryo also is fed to support its new life (re-awakening/re-birth). The hawk, able to see the 'unseeable,' is the messenger of change landing, reminding us of our potential."[9] In this gendered and Indigenous account, similar to Hedge Coke's poetic accounts, the burial mound is more seed than sepulcher. When conditions are appropriate, the surface breaks open seemingly of its own volition—like the shell of a bird's egg that first cracks then slowly breaks apart as new life emerges from within—rather than be broken into from the outside by desecrating looters or archaeologists. Through this revelatory movement, the mound reunites upper and lower worlds. It becomes a portal linking generations, including the living and the dead. And it appears that it is the sheltered seed, represented in the figure of the electric-blue embryo—which seems to float within nutrient-rich,

amniotic soil—that offers contemporary Indigenous communities the power to rebuild their worlds and thus the potential to rebuild their lives anew.[10]

In the vibrancy of her composite image, Hinton not only reclaims the practice of archaeological cross sections; she reconceives that dominant "scientific" practice in distinctly Indigenous terms that serve distinctly Indigenous purposes. The dull-colored 3D model on display at the Serpent Mound interpretive center freezes the body of a burial at a particular stage of invasive excavation and freezes the interments within the mound at particular stages of decomposition—all of which is depicted as located firmly in the past and isolated from ongoing natural, human, or other-than-human processes and forces. In marked contrast, through the precise use of radiant color and multiple suggestions of movement, Hinton's photo-collage depicts both the body of the mound and the bodies of interred ancestors as active and changing. These vibrant bodies are connected to multiple worlds, including natural and spiritual worlds, and distinctly Indigenous futures.

From the beginning, I noted Hinton's explicit reference in her artist's statement to the trees growing out of the burial mound depicted in her photo-collage. Although Hinton describes the trees as alive and as drawing on the contents of the mound for their "sustenance," I initially ignored this aspect of *Ancestral Plane*. Similar to the trees growing out of Jeffers Mound in a near-suburb of Columbus, Ohio, the trees in Hinton's image registered primarily as intrusions and invasions, as signs of the loss of Indigenous control over the mounds and their signification. Rather than grapple with the potential meaning or meanings of these trees, I focused instead on the figure of the electric-blue embryo positioned above the mound's heat-generating and topographic ancestral remains. Why, I wondered, does Hinton color this symbol for new life *blue*? Can a blue child—or a blue embryo—signify something other than distress?

My first thought was that the coding of the figure as blue suggests a "code blue" medical emergency, that is, when a patient in distress requires resuscitation because of respiratory or cardiac arrest. The most obvious interpretation seemed to be that the embryo signals the ways in which Indigenous cultures and technologies are in need of revitalization. But as I studied the image I came to realize that the blue coding may also link

Hinton's arresting depiction to the provocative work of Anishinaabe writer and intellectual Gerald Vizenor, who, as noted in chapter 2, evokes the idea of an Indigenous "blue radiance" or "blue power" of "creation." In his 1991 novel *The Heirs of Columbus* and in other works produced across multiple genres, Vizenor codes Native "survivance"—survival understood as active, creative presence—as "blue" or, even more suggestively, as "blue transmotion," that is, creative movement that crosses realms, including between the material and the spiritual, the living and the dead.[11] As Hinton suggests in the overall vibrancy of *Ancestral Plane*, earthworks are a category of creation through which humans actively relate to each other, to nonhuman animals and other aspects of the environment, to the spirit world. The electric radiance of the blue embryo appears directly connected to the glowing topographic and heat maps of the interred ancestors lying within the earthen mound in productive repose. What the dominant culture so often codes as "red" and "dead," Hinton, similar to Vizenor, codes as blue and as multiply alive and creative.

Hinton's choice to position the blue embryo in an upright fetal position, facing left—the direction from which the all-seeing hawk descends—reminded me of a well-known image from the nineteenth century that depicts a large burial mound in the process of elaborate excavation. My memory was that I had seen the image reproduced as illustration in several print publications about earthworks—including, I quickly confirmed, on the cover and as the frontispiece for the paperback edition of Robert Silverberg's popular 1970 account *The Mound Builders*—and that I had also seen multiple versions of the image circulating on the internet, some displaying the scene of excavation in full, but many cropped to display only the cross section of the mound.[12] As I searched for information about the image and its provenance so I could place it in conversation with *Ancestral Plane,* I learned that this nineteenth-century depiction of excavation has been discussed in a range of Americanist scholarship in art history, history, and literary and cultural studies produced since the 1970s.[13] And I learned that, although the image of excavation is often displayed or discussed on its own, it is actually part of a much larger set of painted scenes—twenty-five in total—that depict the Mississippi Valley at multiple points in history.

Moreover, I learned something that is not readily apparent when these scenes are viewed as book illustrations or digitized image files: the originals are enormous in size, more on the scale of scenic backdrops painted for a theater stage than landscape paintings produced for the walls of a gallery, and they are literally connected, part of a single canvas. Indeed, the twenty-five images comprise a massive panorama that measures 7 1/2 feet tall by 348 feet long, painted in tempera on a continuous roll of cotton muslin.

Titled *Panorama of the Monumental Grandeur of the Mississippi Valley* and produced by the Philadelphia-based Irish American artist John J. Egan in or around 1850, the elaborate series of painted scenes was commissioned by Montroville Wilson Dickeson, a physician and amateur archaeologist from Philadelphia who had excavated a number of Mississippian mounds between 1837 and 1844.[14] Dickeson's excavations were thus completed before the 1848 publication of Squier and Davis's seminal *Ancient Monuments of the Mississippi Valley*, with its evocative hand-drawn "maps" and black-and-white aerial diagrams of earthworks. Based on Dickeson's notes and sketches from the field, Egan created images that were not only more varied and more colorful than those produced by Squier and Davis but also more spectacular. His 348-foot painting was not simply a "continuous portrait" of the Mississippi River and its environs, but rather a series of juxtaposed vignettes "depicting dramatic, idealized river views and quasi-historical events," including idealized events of exploration and discovery.[15] Once completed, the massive panorama served as a backdrop for Dr. Dickeson's traveling lecture about his explorations of Mississippian landscapes. For its time, the huge muslin scroll, which was wound and unwound on rollers, represented the latest in educational technology; we might think of it as an early form of a slide show or PowerPoint presentation projected on a massive screen. By all accounts, Egan's painted panorama and Dr. Dickeson's live lecture—which were augmented by a "cabinet of Indian Curiosities" purported to include "forty thousand relics collected from one thousand mounds"—were extremely popular with their nineteenth-century (presumably non-Native) audiences.[16]

Positioned as scene twenty, the image of an excavated burial mound in cross section is probably the best-known vignette from the *Panorama*.[17]

Typically referred to as *Huge Mound and the Manner of Opening Them*, this scene, similar to Hinton's *Ancestral Plane*, depicts an ancient burial overgrown with trees (Plate 8). The cutaway perspective of Egan's image—the opening of which, also similar to Hinton's photo-collage, features distinctly jagged, organic-looking edges—reveals multiple layers of rocks and soils as well as multiple layers of funeral objects and human interments. As already noted, the central detail of the cutaway mound is often cropped when it is repurposed as illustration, and it is this version I most remembered having seen and was looking for when I began my research (Plate 9). Egan's original, more complex vignette, however, warrants detailed description.

In the center foreground, literally in front of the cross section of the large mound, a well-dressed Dr. Dickeson is depicted in the act of writing notes about the excavation-in-progress. He stands beside another well-dressed white man, presumably in conversation. Toward the left edge of the mound, Dr. Dickeson is depicted a second time, now in the act of sketching the excavation.[18] Beyond the edge of the mound to the right, two other well-dressed white men and a small group of well-dressed white women observe the scene of "discovery" from a short distance; some of these figures direct their gazes toward the surrounding rustic scenery of river, mountains, and forest—and additional mounds.[19] Most striking, however, are the figures of eight African American men spread across the central foreground. In contrast to the well-dressed white men and women, the African Americans are dressed in work clothes—their shirt sleeves rolled to expose muscular forearms—and they are depicted in neither intellectual nor leisure pursuits but as wielding shovels and pickaxes in the hard labor of the actual excavation. As previous scholars have noted, Egan's muslin canvas exposes a racialized division of labor (Plate 10). Americanist scholar Melissa Gniadek describes the scene in these terms: "The racial division within the image is clear. African American men work to unearth Indian bones at the direction of white 'scientists' like Dickeson, shown at the center of the mound's base. Wielding paper and pencil, Dickeson and two colleagues record and diagram their findings, seeking to make the human past of the landscape known."[20] Anthropologist Richard Veit, who has written extensively about

Dickeson and his archaeological work, describes the scene's racial dynamics in even greater detail. He notes that the scene depicts not a generic or composite excavation, as Gniadek's account can suggest, but the specific event of Dickeson's 1843 excavation of a burial mound located in Concordia Parish, Louisiana, on the plantation owned by William Feriday. One of the well-dressed white men depicted in the scene likely represents Feriday, Veit argues, and the laborers are not simply African Americans but "presumably slaves."[21]

Stated plainly, in scene twenty, enslaved Black bodies marked as muscular perform manual labor in the service of free white bodies marked as intellectual and refined in order to "unearth" Indigenous bodies marked as ancient, skeletal, and dead. This account of the scene's racial dynamics is complicated, however, by what is depicted in the extreme right-hand corner of the vignette's foreground. Here, under a canopy of tall trees and before a set of pitched tents, a small group of American Indians is depicted in separate conversation: two men dressed in feather bonnets and blanket robes flank two women who recline on the ground, one holding a swaddled infant (Plate 11). None of the Indians directs his or her gaze toward the excavation. Positioned at the far edge of the scene, the Indians are typically omitted when the image is cropped, even when the excerpt includes Dickeson, Feriday, and the Black slaves.[22] Nonetheless, the group of Indians, their tranquil and disinterested presence located literally at the edge of "scientific" modernity, would appear to authorize and perhaps to legitimate the scene's violent act of exposing Indigenous ancestors for non-Native purposes. Gniadek reads the presence of "living Indians" adjacent to the exposure of ancestral remains as a "temporal multiplicity" within the scene, and she reads the pitched tents behind the Indians as "tepees" that "reproduce the shape of the mound in miniature": "The arches of the dark tent openings in particular evoke the cross-section interior of the barrow, linking the spaces of the living and the departed, or suggesting that the living will soon be departed" (47). I am not fully persuaded that the tents are distinctly "tepees"—they appear to be something of a hybrid between a Plains-style conical tipi constructed around a circular array of upright lodge poles and a military-style A-frame pup tent constructed around

a rectangular base—and in my analysis the smooth sides of the pitched, triangular-shaped tents do not echo but contrast the rounded shape of the large mound covered in trees. As art historian Angela Miller remarks more generally about the depiction of living American Indians in multiple scenes of earthworks included within the larger *Panorama*: "Yet if there is no distinct separation of the two cultures [mound builders and contemporary Indians] by race in Dickeson's account, there is a sharp historical division between a monumental past and a present whose achievements appear distinctly minor. It is this element that most marks Dickeson's archaeological fantasy as a product of his time."[23] We might note further that, within the larger vignette, the small configuration of contemporary Indians depicted at the extreme right of the foreground is counterbalanced at the extreme left of the foreground not by a similar configuration of either white directors or Black laborers but rather by an expanse of unoccupied "wilderness." It is unclear if viewers are meant to equate the contemporary Indians with this portrayal of untamed land, or if viewers are meant to read the vignette chronologically from left to right, that is, from a state of "wild" nature (nothing to see here but swamp and trees) to an example of a "lost" civilization (the cutaway mound and its revealed skeletons and clay urns) to the Indians' contemporary state (exotic in feathers and robes, but self-contained and marginalized, cut off from an American modernity defined in terms of "scientific" inquiry and the white oversight of Black labor). In either account, "living" Indians are of little consequence to the central triad of directing and observing white bodies, laboring Black bodies, and dead Indigenous bodies rendered as intact skeletons and scattered bones.

A visual empathy between Egan's *Huge Mound* and Hinton's *Ancestral Plane* becomes most apparent in each work's central figure of a cutaway burial presented in cross section. Set side by side, the photo-collage echoes the 7 1/2-foot-tall vignette painted almost 150 years earlier (Figure 32). The digital image removes the African American agents of excavation as well as the white directors of that enslaved labor, the white spectators who observe the mound's destruction, and even the group of living Indians sequestered at the extreme margin, replacing these elements with fields of vibrant grasses and colorful wildflowers. But the stratigraphy, the order

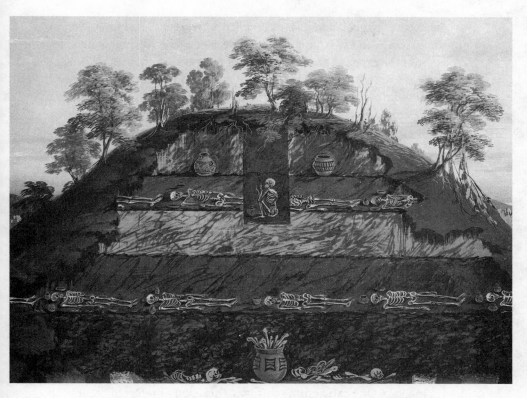

FIGURE 32. Set side by side, a visual empathy is revealed between Alyssa Hinton's *Ancestral Plane* (copyright 1998) and the detail from John J. Egan's *Huge Mound and the Manner of Opening Them* (ca. 1850).

and positioning of layers, revealed in Hinton's cross section echoes the stratigraphy revealed in Egan's—and either updates or repurposes the layers and their sequencing in significant ways.

Dickeson took detailed notes on the stratigraphy of the mounds he excavated, and no fewer than five distinct interior layers comprise the elaborate, large-scale cross section depicted in Egan's painting.[24] Starting from the bottom, at the base of the cross section is a thick layer of dark soil and rock, in front of which sits a large red-orange clay urn, its surface decorated

with "primitive" symbols and its interior filled with protruding human bones; additional bones and what appear to be oversize projectile points lie scattered across the exposed ground in front of the cutaway mound.[25] The second layer of the cross section is a similar thickness of reddish-orange soil filled with multiple human interments and small clay pots; four full and two partial skeletons are visible, all laid flat on their backs, their heads oriented to the left. The third layer, positioned midway up the height of the mound and slightly less thick than the previous layers, is a more vibrant, golden-yellow soil with no interments. The fourth layer, noticeably less thick than the others, repeats the reddish-orange soil and is again filled with multiple human interments and small pots; four partial skeletons are visible, again laid flat on their backs with their heads oriented to the left. The top, fifth layer of the cross section, of similar thickness as the bottom layers, repeats the golden-yellow soil and is filled with two large and decorated clay urns; in contrast to the single urn set before the bottom layer, these appear empty. The mound's surface, as already described, is overgrown with grass and trees; grasping roots visibly extend into the top layer.

In addition to the five distinct layers of soils, the cross section exposes a vertical shaft dug from the mound's summit through the top two layers and into the third. Although the shaft does not extend to the base, Egan's depiction evokes the process of amateur excavation described for Jeffers Mound in Ohio. One can assume this was Dickeson's preferred technique as well. As art historian Lisa Lyons notes in her caption for Egan's image: "Exploration of a mound was initiated by cutting a vertical shaft through the various layers of earth. In this way a time sequence was revealed that indicated the kind of materials contained within the mound."[26] The vertical shaft is cut between the two exposed urns in the top golden-yellow layer of soil, and it partially obscures two of the exposed skeletons in the reddish-orange layer of soil below. Within the shaft, a small pot rests next to a single human skeleton arranged in an upright fetal position. Its head, like those of the skeletons laid flat on their backs beside and below it, is oriented to the left.[27]

The prominent elements of Egan's painted cross section are echoed but reimagined in Hinton's photo-collage, including the five distinct layers

of soils and the multiple layers and multiple kinds of human interments. Where Egan's layers remain perfectly level despite their age, Hinton's have settled and shifted. Similarly, where Egan depicts large clay urns, upright and unbroken, in the mound's base and top layers, Hinton depicts what appears to be a jumble of human remains and funerary objects in the base of her cross section, and a golden-colored figure of a human head—a funeral mask, perhaps, or a clay figure—lying on its side near the blue embryo in the layer or layers of soil above the interred ancestors. Most striking is how *Ancestral Plane* reimagines Egan's cut vertical shaft and exposed skeleton arranged in an upright fetal position. The photo-collage includes a thin black outline that suggests the embryo also sits—or perhaps floats—within a vertical shaft. In keeping with Hinton's overall aesthetic, and in contrast to the rigidly straight lines of Egan's shaft walls and floor, this black outline is wavy. The line's suggestion of *sinuous movement* is again suggestive of a more organic composition. This wavy line appears to form a protective container around the central figure of the electric-blue embryo, which replaces the ivory-colored bones of Egan's adult skeleton. This substitution, especially, signals how, in contrast to Egan's static image, Hinton's mound functions as an active portal between worlds. Hinton's substitution of the blue embryo, positioned above the substitution of the glowing landscape-bodies of interred ancestors, signals the mound's function as a womb for generating new (Indigenous) life.[28]

MORE THAN INVASIVE SPECIES

Even after I connected Hinton's electric-blue embryo to Vizenor's "blue radiance" of "creation," and even after I began to understand Hinton's ancestral mound, which opens of its own volition, as a response to Egan's depiction of intrusive and violent "scientific" excavation, I still felt ambivalent about the presence of the trees in *Ancestral Plane*. Growing out of the radiant burial, the trees continued to signify primarily as invasive. And no matter how beautifully rendered they might be, the fact that the roots of the trees reach toward the blue embryo and the remains of ancestors buried within the mound struck me as more menacing than generative. I had to admit

that when I conjured positive images of ancient interments, I imagined the desecrated-but-reconstructed Seip Mound, with its smooth grass surface accentuating its symmetrical geometric form, rather than the desecrated but partially intact Jeffers Mound, with its sunken sides and its overgrowth of bristling grasses, brush, and trees. But eventually I had to admit, as well, that the burial depicted in *Ancestral Plane* is more similar to the natural cycle of the obviously declining Jeffers Mound haphazardly overgrown with living trees than it is to the reconstructed Seip Mound with its artificially pristine surface frozen in stasis. And as I became more familiar with Hinton's larger body of work, I had to notice that vibrant, living trees are not exclusive to *Ancestral Plane* but are prominent figures across many of her photo-collages and other works that depict burial mounds. I began to wonder if I was missing something important about the presence of these trees.[29]

In the artist's statement for her 1996 photo-collage *Slumber,* for instance, which is also part of her Spiritual Ground series, Hinton states: "From the sedimentary silence of a burial mound, normally unseen energy forms vibrate and emanate as death brings forth new life and the spirit of the old ones rises" (Plate 12).[30] Assembled from twenty-four image fragments, this collage epitomizes arguments increasingly put forward by Native writers, artists, intellectuals, and nations: like other Indigenous systems for writing, and like many Indigenous languages, earthworks and their encoded knowledge have been "asleep" rather than "dead." Dormant but alive, they have waited to be awakened by descendants of their makers finally free to re-approach and even to remake them, finally free of the psychological fetters of an internalized colonialism that has undervalued Indigenous practices, technologies, and ways of knowing. Earthworks and earthworks principles have been waiting, these Native individuals and communities assert, to be reactivated. Here, too, my initial instinct was to focus attention on the lower half of Hinton's striking image: the burial mound itself, with its two layers of ancestral remains outlined in a radiant blue—again evoking Vizenor's "blue radiance" of "creation." But Hinton gives equal prominence to the upper half of the image: the vibrant tall tree crowned in yellow leaf thriving on the mound's ancestral energy. Indeed, within the composition

of *Slumber* the mound and the tree are balanced, suggesting their equal importance for signification.

It was when I studied Hinton's 1997 photo-collage *Spiritual Archaeology* that I began to better understand the messages encoded in these images (Plate 13). In the artist's statement for this evocative piece constructed from forty image fragments, Hinton writes: "A burial site exposes what was hidden underneath but can no longer be contained." This statement resonates with the message of *Ancestral Plane,* in which the mound is depicted as slowly opening of its own accord. Hinton adds, however, that "the descendants and the ancestors are here in various forms," explicitly linking the ancestors buried within the mound to their contemporary descendants.[31] In Hinton's mixed media work, as in Hedge Coke's poetic sequence, ancestors and descendants are linked through the vehicle of the burial mounds. Hedge Coke makes this connection explicit, for instance, in the third Burial Mound poem in *Blood Run:* "Their heritage seed below at Macy, in Omaha— / . . . / Each needing antithesis to fare well through me" (58). The Burial Mound names the location of the contemporary Omaha Reservation as the location of the "heritage seed" of the interred ancestors; that is, these Omaha descendants represent an enduring link to the ancestors who built the mounds—and thus they represent part of the mounds' potential for renewal. But ancestors and descendants are also linked, I began to realize, through the trees that grow out of and are sustained by the ancestors within the burial mounds. The trees, as living and growing other-than-human beings, seem to be a key for understanding the larger messages of Hinton's work. Similar to how she reclaims the dominant archaeological practice of representing mounds in cross sections, Hinton reclaims the trees that grow on and out of mounds—signs that the mounds have been neglected, evidence of how they have been denied necessary upkeep—and to not only reframe but also revalue these animate beings as serving distinctly Indigenous purposes. Or perhaps more accurately: Hinton reacknowledges the sacred role of trees within the larger and long-term environmental cycles of Indigenous earthworks. Sites were never meant to remain cleared and pristine forever; the overgrowth of trees is a natural stage in the processes of birth leading to death leading to birth.

Building upon and expanding the message of *Slumber,* Hinton created a number of photo-collages that juxtapose burial mounds and living trees in a series titled Awakening. Consider, for example, *Awaken 7* from 2005, which Hinton describes as "mixed media composite using photos, original acrylic paintings, found papers, relief print and digital editing" (Plate 14). In the artist's statement for this piece, Hinton writes: "A child's face is shown as the centerpiece for a burial mound/tree composition, denoting the reawakening of the seventh generation."[32] Here Hinton makes explicit her intention to combine the motifs of ancient burial mound and living tree in order to evoke continuance and regeneration. If we consider *Awaken 7* and *Slumber* side by side, one of the things that becomes immediately apparent is the way that, in *Slumber,* the cutaway burial is balanced by the tree in leaf; moreover, in the upper half of the image, it is the bright crown of leaves that is emphasized rather than the tree's dark trunk. In contrast, in *Awaken 7,* Hinton uses layering and superimposition so that the green-hued trunk of the tree is emphasized rather than the crown of leaves; in fact, no leaves are visible in the image. In addition, the shape of the burial mound depicted at the base of the image is echoed by the shape of the sky dome above. It is as though the tree grows *between* burial mounds, one below and one above. This emphasis on the trunk stretching between mounds suggests that the green-hued tree in *Awaken 7* can be considered a sacred pole and *axis mundi*—a "world axis," "cosmic axis," or "world tree"—that functions as a vital center here on the surface world and that serves as a vital *conduit* between worlds above and below. This sacred pole and *axis mundi* simultaneously functions as a vital conduit between Indigenous generations, between the living and the dead, ancestors and descendants.[33] In *Awaken 7* there is a strong association of the ancient burial mound or mounds with the future rather than the past, represented in the superimposed face of an Indigenous child. This imagery and emphasis link back to the substitution in *Ancestral Plane* of the electric-blue embryo for the adult skeleton arranged in a fetal position that is prominent in Egan's nineteenth-century *Huge Mound.* Both images emphasize the future through the depiction of coming generations.

These and other analyses of Hinton's mixed media works that combine

burial mounds and living trees brought me back to Hedge Coke's *Blood Run*, particularly to aspects of the sequence of interrelated earthworks poems I had avoided researching or analyzing in any depth. I had avoided asking, for instance, why Hedge Coke gives prominence to the image of a tree growing out of a low mound on *Blood Run*'s provocative cover. The image is from a photograph Hedge Coke made herself (she is a skilled photographer as well as an award-winning writer), and she chose the specific image as the cover art, as is clearly announced in the design credits. Why did she choose this photograph over others? And what should we make of the two persona poems within *Blood Run* that appear to directly relate to this image, both titled "The Tree at Eminija Mounds"?

Eminija Mounds names a group of burials located slightly to the north of the central Blood Run site along the Big Sioux River. The large, suggestively sculptural tree Hedge Coke depicts in her cover image is prominent at the site, and it is often photographed by tourists and other visitors. Similar to Hinton's photo-collages, Hedge Coke's photograph is striking not only in its careful composition but also in its color palette and tone (Plate 15). A low mound fills the bottom quarter of the landscape-oriented image, the grass tinted a distinctly mossy green accented with shades of orange and strewn with dark branches that have fallen from the tree. The background of the upper three-quarters of the image is filled with a cloudless sky the color of green turquoise, reminiscent (at least to this Oklahoman) of the sky that often precedes a tornado; the deep blue-green color evokes a certain ominous stillness. But this is not the color of menace or destruction. Rather, the sky effuses a stillness that portends the blue-green (sky-land-water) potential for new life as growth and positive change. My phrasing here is a subtle reference to the Choctaw word *okchamali*, which can refer to both the colors blue and green, and which Choctaw writer and intellectual LeAnne Howe associates with the period of creation and emergence in Southeastern traditions.[34] In Hedge Coke's arresting photograph, the tree emerges out of mossy green earth to intersect the vitality of this blue-green potential. The tree's dark trunk rises from the summit of the low mound just to the right of center, then quickly cleaves into two primary branches, which arc left and right, first up toward the sky and then back down to the

mound, like two living arches, or perhaps like two elongated arms. These primary branches, in turn, diverge into multiple medium-size branches that then diverge into multiple smaller branches; the smaller branches are covered by leaves tinted red. The tree as a whole fills the middle two quarters of the image, with the mound below and clear sky above. Moreover, Hedge Coke's photograph wraps around the front and back covers of the published book, the central trunk just off the spine on the front cover, making the tree's centrality and prominence more obvious, and perhaps beginning an argument for the importance of The Tree at Eminija Mounds to Hedge Coke's central project in *Blood Run*.

Once I allowed myself to fully take account of the cover image, I could not avoid the fact that Hedge Coke gives prominence to the persona of The Tree at Eminija Mounds: she positions its first appearance as the first poem in section III ("Intrusions") and its second appearance as the first poem in section IV ("Portend"). This primary positioning within the larger sequence links The Tree to *Blood Run*'s two shape-shifting personas: River, which is positioned as the first poem in section II ("Origin"), and Clan Sister, which is positioned as the first poem in the epilogue. As noted in chapter 2, Hedge Coke aligns the sinuous shape of River not only with that of living snakes but also with the sly ability of snakes to remake themselves in the regular shedding of their skins. She similarly emphasizes River's sinuous movements across the land and thus River's creative, world-making (or -remaking) power. In her description of the persona Clan Sister, Hedge Coke emphasizes her ability to assume multiple human and other-than-human forms, including that of deer. In her second appearance, for instance, Clan Sister refers to deer as "sisters of mine" (35). In her third appearance, she again refers to the deer as her "Sister" but now explicitly describes her own ability to appear in multiple forms: "When you see me / in the distance / you believe me / speckled brown / wide-eyed, / pawing earth / for fresh shoot. / When I have foot / not hoof / am upright, / bipedal, / since my early days" (50). But in addition to shape-shifting, Hedge Coke's primary positioning of The Tree at Eminija Mounds' two poems links the persona to significant periods of transition.

The first transition moves readers from section II ("Origin") to section III ("Intrusions"), and thus from the more distant past when Blood Run was a thriving center for trade to the more recent past when the site was overtaken by outside "intruders," its diverse populations dispersed, its structures purposely damaged and largely destroyed. The poems that immediately precede and immediately follow "The Tree at Eminija Mounds" in this first major transition all evoke aspects of Indigenous *memory*. Preceding the first appearance of The Tree at Eminija Mounds, the final three poems in section II are titled "Memory," "Cupped Boulder," and "Pipestone Tablets." While the persona of Memory animates an abstract concept, the singular persona Cupped Boulder and the collective persona Pipestone Tablets refer to Indigenous technologies for marking people and events *by means of* durable materials (sacred dust harvested from the ancient boulder and worn as adornment) and for recording the memories of those people and events *through the medium of* similarly durable materials (patterns marked on tablets of pipestone). This is the second voicing of Memory within the larger sequence. She refers directly to technologies for "marking" on people and stone, and she links these to other, related Indigenous technologies for recording memory in multiple media, including painting on tanned hides for the seasonal calendars often described in English as "winter counts":

> Wearing white mourning paint
> powdered from pink granite
> weathered light as crusted snow.
> For prayer, song, story—life.
> .
> Marking our bird-print presence.
> Buffalo marks on Pipestone Tablets,
> on boulder stone,
> on the belly of the earth,
> on every raised ridge,
> seasonal hide, come winter. (40)

Cupped Boulder similarly emphasizes its role in marking people and events and recording them as remembered history: "From me lives were earmarked / blazed, blessed, eternized" (41). Pipestone Tablets then emphasize their role in carrying knowledge forward into the future for the specific purpose of Indigenous renewal:

> Buffalo markings trace comings, goings upon these slabs
> a language according to symbolic design, by man
> reveals written accounts of the time before Next Dawning,
> reveals our presence, patterning, purpose—
> .
> We record balance, restore, give grace, prove tenure— (42)

The final line voiced by Pipestone Tablets, set off as its own stanza, reads: "We will replenish" (42).

Immediately following the first appearance of The Tree at Eminija Mounds, the next three poems in section III complete the transition: "Burial Mound," "Ghosts," and "Skeletons." Together, the personas represent three integral components of interment: the constructed vehicle of burial, the released human spirit, and the carried human remains. This second voicing of Burial Mound asserts "Memory thrives here" and emphasizes that the ancestors the mound shelters are neither inanimate nor inert. Occasionally, in remembering the vibrancy of their former lives, these animate remains "shift" and, sometimes, like a new shoot from a dormant plant, reach a "finger" out from the mound to "test the temperature" (46). The collective Ghosts, positioned across the open book in immediate conversation with Burial Mound, emphasize these spirits' ongoing presence at the site. That living presence is visible in the "swirl" and "swing" of tall prairie grasses, and it is audible in the "familiar rustle" of the wind (47). The collective Skeletons then emphasize that, even though "silence overcame this sanctuary," Blood Run still emits "sounds" for those who can hear:

> She who hears, come know us.
> With stillness, walk among us.

Without malice, note our presence.
Glad-hearted remember us, our glory. (48)

Across the six poems that immediately precede and follow the first appear-
ance of The Tree at Eminija Mounds, Indigenous *memory* asserts its endur-
ance in multiple forms and aspects. And it displays its enduring presence
across multiple human senses: visual, tactile, aural.

The Tree's own persona poem, placed between these six personas focused
on forms and aspects of Indigenous memory, emphasizes many of the ideas
prominent in Hinton's mixed media artworks that juxtapose burial mounds
with living trees. In particular, across twenty lines arranged into ten two-line
stanzas, The Tree voices similar ideas of Indigenous *awakening* and *return*:

The Tree at Eminija Mounds [1]

My limbs outstretched
once again as in my human life.

I stand before you
naked and without shame

without contempt
or hate.

Without need for explanation
nor compromise.

Here, in this life,
I am free to stand upon this earth.

Holding memory from a thousand years ago
of a People once flourishing

on this same ground
once sustaining life,

a holy innocent, cut quick,
whose greatest wish was to return

without frail flesh
of common man.

Here, I stand before you.
Here, I stand. (45)

One way to interpret this persona poem is that it gives voice to an In-
digenous ancestor who has been returned—reincarnated or in some way
resurrected—to new life in an other-than-human form, namely, as a tree
growing out of the burial mound. Notably, the persona repeats and thus
emphasizes versions of the verb *to stand*. Harnessing the multiple valences
of the verb and its common uses, The Tree juxtaposes this sense of new
creation and an Edenic innocence of the knowledge of good and evil—"I
stand before you / naked and without shame"—with a sense of Indigenous
people's long tenure and thus long knowledge *in* the land—"I am free to
stand upon this earth. // Holding memory from a thousand years ago / of a
People once flourishing." The persona ends his first voicing with an empha-
sis on place in its repetition of the verb *to stand* juxtaposed with the common
adverb *here*, the juxtaposition emphasized by the use of the comma: "Here
[in this place], I stand before you. / Here [in this place], I stand." But this
use of the adverb can also suggest an emphasis on time, as in: "Here [at this
time], I stand before you. / Here [at this time], I stand." The persona's time-
traveling return, the ancestor's reincarnation or resurrection from the past
into the present as an evocative tree, is effected through this emphasis on
sacred geography, this standing at the center of the world simultaneously
within and outside ordinary time. Similar to the trees in Hinton's vibrant
photo-collages, Hedge Coke's The Tree at Eminija Mounds functions as a
sacred pole and *axis mundi* connecting worlds and generations, the living
and the dead.

Another subtle but striking aspect of this first voicing is how it func-
tions not simply as soliloquy, The Tree speaking aloud to himself, but ap-
pears to address a proximate audience and potential interlocutor: "I stand
before *you*" (emphasis added). This "you" can be interpreted in multiple
ways. While The Tree may address a generalized "you," and thus no one in

particular, it may address the implied or real author of *Blood Run* (we may recall here that Hedge Coke has described her process as composing on-site), generations of visitors to the Eminija Mounds, or, more specifically, contemporary descendants of the mounds' builders. A number of personas in Hedge Coke's sequence address a "you" that is similarly multivalent. The first Clan Sister poem, for instance, positioned as the second poem in section II ("Origin"), addresses a "you" five times across its thirty lines divided into seven stanzas. As noted in earlier chapters, the shape-shifting Clan Sister speaks a total of seven times across the *Blood Run* sequence and serves as a spiritual guide to the site. In this first appearance, she first addresses a "you" early in the poem, in lines 3 and 4, the end of the first stanza and beginning of the second; here, the "you" seems to refer to the mounds and perhaps to ancestors buried within the mounds rather than to any contemporary human: "I have come to pray / I have come to sing / to dance before *you* // Call *you* to rise / again, to enormity" (14, emphasis added). Late in the poem, Clan Sister again addresses a "you," in lines 25, 28, and 29, across the sixth and seventh stanzas. In contrast to the earlier use, this "you" seems to refer to a contemporary human visitor to the site, perhaps to the implied or real author of the poem: "Guide *you* here / as do the stars / each crossing. // Though I lead *you* here, / allow *you* privy, / dare not exploit entry" (14, emphasis added). A similar "you" appears to be addressed late in the sequence in the seventh and final appearance of The Mounds, which is positioned as the seventh poem within section IV ("Portend") (seven is the fourth prime), and with a similar sense of invitation balanced with caution: "We allowed *you* entry to gain / *your* sentiment, consideration. // When *you* leave here take with *you*, / only what with *you* came" and "For *you*, learning has begun. / Let *your* mind be mindful" (82, emphasis added). In his role as returned ancestor reincarnated or resurrected and literally rooted in the Blood Run site, The Tree embodies the function of an *axis mundi,* connecting worlds and generations, including the living generation of the "you" before whom it now stands as witness.

The second transition in *Blood Run* marked by the appearance of The Tree at Eminija Mounds moves from section III ("Intrusions") to section IV

("Portend")—from the recent past to the ongoing present and possible futures. The three poems at the end of section III immediately preceding the second appearance of The Tree are "Skeletons," "Horizon," and "The Mounds." This third voicing of the collective persona Skeletons emphasizes the loss of human care at the site, and thus the loss of assistance in transitioning across worlds and in making a return. The Skeletons ask: "Who will leave us / offerings to tide us over?" (69). The pun on "tide" suggests both material assistance and regular movement. The abstract persona Horizon, in its fourth voicing, emphasizes its role as "witness" to hundreds of years of history and reveals its knowledge that "descendants" of the builders of the mounds "do survive" (70). The idea of witnessing, "marking," and "bearing" memory is then echoed in the sixth voicing of the collective persona The Mounds: "In this posture / we've seen the rise, / and leaving of nations" and "We've seen / passages—livelihoods—/ scattering doe, bird, larger herds." The poem and the section ends by linking back to the concepts of the previous transition: "Here, in this wintering of our old world, this harboring—time—/ we've become another marker, one who must bear mortal memory" (71). The three poems in section IV that immediately follow the second appearance of The Tree at Eminija Mounds are titled "Ghosts," "Prairie Horizons," and "Skeleton." In their second voicing, the collective persona Ghosts emphasize their power to render the invisible visible and assert that, eventually, all will be *revealed* (76). The collective persona Prairie Horizons, in its first and only voicing, emphasizes that, eventually, all will be *returned* (77). And the singular persona Skeleton, held captive in the colonizer's "collections"—and distinct from the collective Skeletons voiced earlier—emphasizes the need for eventual *release* (79). Together, the six personas articulate aspects of witnessing and returning.

In the second voicing of The Tree, this emphasis is articulated through the lens of a spatial positioning that is three-dimensional. The living Tree, understood as the return of an Indigenous ancestor, locates himself between above and below worlds, within the cardinal directions, and as a central conduit—an *axis mundi*—between worlds material and spiritual. In this way, the second voicing proceeds from the first, picking up from the emphasis on the multivalent adverb *here* repeated to great effect in the ear-

lier poem. But the second voicing also reveals a more nuanced argument about place and, specifically, about what it might mean to be deeply *rooted* in place:

The Tree at Eminija Mounds [2]

My reaches long, lift,
stretch above in prayer,
below extend
 to touch earth *in prayer.*

On right,
 dipping lightly, waving fringe westward.
On left,
 glad spirit returns to me, running.

In this form,
upriver from focal dwelling,
freed to open myself amply.

In this fashion
 rooted, liberated,
 acumen leafed.

In this shape,
 prolific.

Sheathed now, fervent, burly,
Shielded, fixed, ingrained in terra firma,
Rooted below, outstretched above—open—

What in last life failed me,
In this life liberates. (75)

This second voicing is composed of twenty-one lines arranged into six stanzas of variable lengths: four, four, three, five, three, two. In the first half, The Tree locates himself within a seven-point spatial system common to many

Indigenous traditions: standing at the emblematic center of the world, he articulates relations to positions above and below, then to the four cardinal directions.[35] Having established this precise positioning, at line 11 at the end of the third stanza—the poem's midpoint or fulcrum—the returned ancestor builds from the first poem to assert that in his new "form" as The Tree he has been "freed" to "open" himself "amply." At the beginning of the poem's second half, The Tree makes a second assertion about the effects of this new "form": "In this fashion / rooted, liberated, / acumen leafed." The central juxtaposition—"rooted, liberated"—set off as its own line and indented toward center, feels like an oxymoron; the unlikely proximity of these terms works against typical (Western) binary oppositions. The seeming contradiction directs attention back to The Tree's repeated declaration in his first voicing: "Here, I stand." I say seeming contradiction because, together, the two poems demonstrate that it is the returned ancestor's reincarnation or resurrection as a vibrant, living tree rooted in the land and standing at the emblematic center of material and spiritual worlds—standing, that is, as a conduit for communication and communion through *prayer*—that gives the returned ancestor this sense of liberation. It is an arresting sense of *rooted liberation* that the exhumed Skeleton, still captive to a museum far from the mounds at Blood Run, can only long for.

Moreover, in the second poem's final stanzas The Tree describes himself in terms that evoke the protection of the burial mounds for which the Skeleton longs. Indeed, much of the language in the penultimate stanza echoes the language of protection evoked in the third voicing of the Burial Mound: The Tree's use of "sheathed" and "shielded," even "burly," refers back to and extends Burial Mound's language of "seed coat," "sheltering," "shield," and "testa" (58). The lines of the final stanza, "What in last life failed me, / In this life liberates," refer back to lines in The Tree's first voicing—it is the "frail flesh / of common man" that failed the ancestor in his previous life—and end on the repetition of the idea that return represents a positive liberation. Taken together, the two sets of transitions built around and through the persona of The Tree at Eminija Mounds create a complex matrix of *memory* and *future possibility*, of resurrection and return.

ROOTED *AND* LIBERATED

The seeming contradiction evoked by and through the figure of Hedge Coke's Tree sent me back to Hinton's vibrant works that juxtapose ancestral burial mounds and living trees. In several of Hinton's photo-collages, the sacred tree or *axis mundi* is positioned in the background and is less easily discernible, although it remains central to how the image produces meaning. A striking example that resonates with Hedge Coke's returned Tree—and one that contains a photographic image some viewers may find disturbing—is Hinton's 2002 work titled *See No Evil: Resurrection of Chief Big Foot.* Hinton describes this piece as "mixed media composite using photos, feathers, original acrylic paintings, pencil drawings, relief prints & digital editing" (Plate 16).[36] The composite image can be divided vertically into three zones that align with the three worlds of Southeastern and other mound-building traditions: the watery below world, the land-based surface world, and the sky-world above. Hinton's depiction of the below world links the shape of the turtle's shell, which evokes the well-known story of the Earth Diver and the creation of North America on Turtle's back, to the shape of a burial mound; Hinton alludes to this connection in the first epigraph at the beginning of the chapter. Her surface world emphasizes the tragic figure of Lakota Chief Big Foot (also known as Spotted Elk) as captured in an infamous photograph made a few days after the massacre at Wounded Knee Creek, South Dakota, not far from the Pine Ridge Reservation, where Big Foot and three hundred or more of his band were killed by the U.S. Cavalry on December 29, 1890. Encountering the disturbing photograph, I am reminded of the first voicing of Hedge Coke's Tree: "a holy innocent, cut quick." As noted in chapter 1, in the discussion of similar photographs evoked in Alice Walker's 1976 novel *Meridian*, this genre of tragic image—the elder Big Foot shot dead by the cavalry, his contorted body lying frozen in the snow—is typically associated not only with the defeat of the Lakota and other Plains Indians but also with Native American "death" writ large and with the expansive trope of the "vanishing" Indian. Within dominant discourses, especially, but also within other discourses, the image is often deployed to signify the end of vibrant, independent, and free Native

nations. And, finally, Hinton's depiction of the above world links the dome of heaven toward which the image of Chief Big Foot ascends to the dome shape of a conical burial mound, mirroring the turtle's back below.

Hinton removes the iconic image of Chief Big Foot from its original contexts of trauma, tragedy, and obscene photographic exploitation. In the mixed media composite, the image is encased—or more precisely, *cradled*—within figures of burial mounds that are simultaneously figures of creation. The image of the murdered chief, warrior, and elder, frozen in the snow, is made a sheltered seed, an embryo protected by the strength of mounds. Less discernible but still present, the faint figure of the sacred tree is positioned directly behind the figure of Chief Big Foot, in effect creating the vertical path upon which he ascends in his "resurrection," along with a blue flame that is again suggestive of Vizenor's "blue radiance" of "creation." In the artist's statement for this piece, Hinton writes: "Rising from the turtle's back, the famous photo of Lakota Chief Big Foot in death at Wounded Knee signifies the defeat and subsequent resurrection of the last free Indian Nations. The upper half shows the Sky Dome, the realm of the spirits. The seven stars represent the past seven generations of ancestors. . . . The lower half shows the globe with the turtle as the symbol for the land. Also shown are the tree of peace and the blue flame of purpose (halfway up the tree)."[37] There is much more to say about this complex image. Following the analysis of Hedge Coke's Tree, my immediate response was to focus attention on the way Hinton depicts Chief Big Foot as crossing worlds by means of the combined vehicle of burial mounds and the sacred tree stretching between them. I also focused attention on the way Hinton combines an iconic image of the 1890 massacre at Wounded Knee—which has come to possess national and international significance as a symbol of tragedy—with what seems like more localized and less well known imagery of ancient Southeastern burial mounds.

What I did not realize at first, however, is that the iconic image of Chief Big Foot was made on January 3, 1891, a full five days after the massacre; a subsequent blizzard had impeded outside access to the site. Moreover, I had always assumed the photograph's broad circulation was something of an accident, that the image had been produced by a military or govern-

ment photographer for official purposes, perhaps to be used as evidence in an inquiry. But my assumptions were wrong. The image was produced by a commercial photographer, most likely George Trager or Clarence Morledge, who had endured the difficult travel to the scene of massacre in a large company of "entrepreneurial photographers" and newspaper reporters, all of whom were eager to capitalize on the atrocity they would solemnly misname in print as a "battle" between U.S. "civilization" and Indian "savagery."[38] These agents of the popular press and popular media knew there was money to be made in the creation of particular images and in the telling of particular stories. The photographers did not document the scene of dead bodies they encountered strewn across the snow in an "objective" manner; rather, they deliberately composed the bodies of the dead to conform to dominant narratives of innate Indian violence (the corpses of elderly Lakota "warriors" are made to look grim and menacing, posed with weapons they did not bear) and similarly dominant narratives of settler innocence (there are no photographs of the Lakota women and children who comprise a full half if not more of the cavalry's victims). A few days after the photographs were made, one of the reporters on the scene at Wounded Knee described for readers of a Chicago newspaper how the photograph of Chief Big Foot was composed:

> Big Foot lay in a sort of solitary dignity. . . . He was dressed in fairly good civilian clothing, his head being tied up in a scarf. He had underwear of wool and his general appearance was that of a fairly prosperous personage. He was shot through and through, and if he ever knew what hurt him, appearances dissembled very much. A wandering photographer propped the old man up, and as he lay there defenseless his portrait was taken. . . . He was however spared the customary adjuration to look pleasant.[39]

In addition to staging this and other photographs created at the massacre site to conform to dominant narratives, the "wandering" commercial photographers immediately produced a large number of affordable prints to sell as collectable postcards and highly prized frontier mementos. As

historian Mick Gidley recounts: "The Northwestern Photographic Company marketed a sequence of such images as a cardboard-mounted boxed set with the legend: 'Everything of interest in the late Pine Ridge War is held by us for sale. Agents wishing to make $10 to $15 per day wanted.' An article in the company's hometown paper informed readers that 'There are a number of beauties among them, and are just the thing to send to your friends back east.'"[40] The photographs were never intended to serve as official records, never intended to be carefully stored away from public view in government files. In fact, Gidley reports that "no photographs at all were submitted as evidence to the various official inquiries" into the massacre (26). The photographs were always intended to function as commercial products to be circulated widely among triumphant white settlers. Linking these commercial photographs of American Indian massacre to similarly obscene photographs of African American lynching, which also circulated widely, political scientist J. Marshall Beier argues, "Far from provoking offense, the Wounded Knee photographs merged unproblematically with a wider popular culture and Euro-American sense of self whence they could be celebrated and fetishized."[41] He continues: "The intelligibility of this [acceptance and celebration of the horrific images] inheres in imaginaries certain of moral righteousness." The highly staged photographs simply confirmed dominant narratives of Manifest Destiny and white supremacy.

Part of the work of Hinton's remarkable mixed media composite, then, is to effect an Indigenous reclamation of the contexts within which the historical photograph can produce meaning. In this way, Hinton joins a wide range of Native American artists who have worked to reclaim and recontextualize the dominant settler culture's fantastical and often obscene imagery of Indigenous peoples. One such Native artist is the highly regarded Seminole, Muscogee, and Navajo photographer Hulleah Tsinhnahjinnie, whose own work incorporates, reframes, and repurposes historical photographs of American Indians. In 2003, Tsinhnahjinnie published the essay "When Is a Photograph Worth a Thousand Words?" as part of the edited collection *Photography's Other Histories;* the essay was likely written about the time Hinton was assembling her 2002 composite. In this highly personal and moving meditation on the power of photography in the lives of

Native peoples, Tsinhnahjinnie describes how she "first encountered photographic sovereignty" and "decided [she] would take responsibility to reinterpret images of Native peoples" from "an indigenous perspective."[42] Rather than comply with the standard narrative that photographs of Native peoples produced from dominant perspectives capture "a vanishing race," she found she could detect "perseverance" in these images (42). She then describes her relationships with examples of both familial and historical photographs, including the famous photograph of Chief Big Foot "frozen in death" at Wounded Knee.

Tsinhnahjinnie's account of her complex affiliation with the 1891 commercial photograph intersects Hinton's *Resurrection of Chief Big Foot* in multiple ways, offering another lens through which to interpret the arresting image of the mixed media composite. Tsinhnahjinnie writes:

> I had a vivid dream of this photograph. In my dream I was an observer floating—I saw Big Foot as he is in the photograph, and my heart ached. I was about to mourn uncontrollably when into the scene walked a small child, about six years old. She walked about the carnage, looking into the faces of those lying dead in the snow. She was searching for someone. Her small moccasin footprints imprinted the snow as she walked over to Big Foot, looking into his face. She shakes his shoulders, takes his frozen hand into her small, warm hand, and helps him to his feet. He then brushes the snow off of his clothes. She waits patiently with her hand extended, he then takes her hand and they walk out of the photograph. This is the dream I recall when I look upon this image of supposed hopelessness. (45–46)[43]

With the imagined intervention of the Native child, Tsinhnahjinnie's vivid dream transforms the photograph's fixed image of Indian tragedy and death into an active *narrative* of Indigenous hope. The photograph emphasizes Big Foot's grim facial expression and his left arm frozen in a raised position, his hand seeming to grasp at air. In Gidley's account: "Big Foot lies half-upraised, as if trying to get up, locked in rigor mortis" (34). Tsinhnahjinnie's dream literally revivifies Big Foot through the active seeking and then

active care of the future generation, when the vibrant Lakota child takes the elder's frozen hand into her own. Note how, at the crucial juncture, Tsinhnahjinnie's account emphasizes the act of revivification and its significance by abruptly switching from past tense to present. Tsinhnahjinnie describes how the small child "walked" about the carnage and how the child's moccasins "imprinted" the snow, using verbs in the past tense. But when Tsinhnahjinnie witnesses the child locate Big Foot among the victims, the verb tense shifts: the child "shakes" the elder's shoulders and "takes" his frozen hand. Revived by this physical encounter with the power of Indigenous youth, Big Foot "brushes" off the snow, "takes" the child's warm hand, and together "they walk out of the photograph"—that is, out of the dominant culture's static discourses of tragic victimry—all in the present tense. Tsinhnahjinnie's account feels closely aligned with Monique Mojica's descriptions of "embodied Indigenous research" and "embodied improvisation," discussed in earlier chapters, as well as with Dian Million's concept of "intense dreaming," discussed at the beginning of this chapter. At a later point in her essay, Tsinhnahjinnie describes such dreaming as "receiving information," a powerful process that can both augment and balance "Western" academic practices of "research." In addition to the orthodox practices of "scrutinizing, investigating, collating assembled notes from museums, [and] ethnological reports," she receives information "via the aboriginal internal world—information by dreams, ethereal coincidences, and the very important oral tradition of the aboriginal people around the world." These latter methods offer hope, she contends, because they signify "the reemergence of aboriginal traditions, the wave of rebirth, people surviving, harvest dances being danced and songs returning in dreams . . . information resurfacing" (51).[44]

 Tsinhnahjinnie's dynamic focus on acts of "resurfacing" helps further elucidate Hinton's remarkable composite. Similar to Tsinhnahjinnie's powerful dreamwork, Hinton's careful artistic manipulation of the historical photograph of Chief Big Foot "frozen in death" is highly evocative of *movement*. Not only does Hinton set the figure of Big Foot between lower and upper worlds, rising along the vertical path of the sacred tree. In Hinton's repurposing, the horrific details of the black-and-white pho-

tograph are muted, shifting attention away from the photograph's original emphasis on the Lakota leader's grim facial expression to the overall shape of his prone body—knees bent, head slightly raised, and one arm raised, all of which can suggest *motion*—which Hinton further emphasizes by outlining the body's dark contours in stark white. This outline is then reproduced at least twice in vivid red and offset to the left and right. These offset contour lines suggest flickers of movement, the presence of life force, the beginnings of new life. The shape of the blue flame rising behind the outlined body similarly mimics the shape of Big Foot's dark torso, so that the flame, too, suggests flickering movement—the spirit rising from the prone body. The reclamation and repurposing of the emblematic colors red, white, and blue is a subtle but important element of the image's composition as well.

In *Resurrection of Chief Big Foot*, Hinton not only responds to the obscene commercial photograph of massacre from 1891 but also amplifies her response to Egan's 1850 painting of violent and exploitative excavation. She externalizes what is typically "hidden" within burial mounds—the revered dead—but substitutes the representation of a more recent American Indian ancestor, the martyred Chief Big Foot frozen in the snow, for the expected bare skeletons and other "ancient" remains. Moreover, she externalizes what is typically an interior process within the mounds by placing the entire scene of reclamation and reactivation along the vertical path of the sacred tree rising from Turtle's back and standing at the center of the world. As with Hedge Coke's The Tree at Eminija Mounds, this is a resurrection that signifies beyond the specific ancestor depicted as making a return. Big Foot's resurrection signifies as hope for all Indigenous Americans— perhaps for all Indigenous peoples.

In additional works, Hinton brings the sacred tree forward to emphasize more explicitly its role as *axis mundi*, its role as vital conduit between worlds and generations. In the artist's statement for her mixed media sculptural assemblage from 2013 titled *Burning Tree*, Hinton writes: "The sacred 'Tree of Life' is one of the oldest and most basic shamanistic . . . concepts. This iconic burning tree is growing from a mound filled with buried prayer ties, a southeastern Indian tradition. This is a statement about . . . a wish for healing" (Plate 17).[45]

SENSING THE DYNAMIC MOMENT OF MEANING

I began this chapter by invoking Dian Million's concept of intense dreaming and suggesting that these focused acts of critical imagination can function as a form of remote sensing. As I bring the chapter to closure, I will admit that I described examples of my own acts of intense dreaming about burial mounds in Ohio with some trepidation. Within the dominant conventions of scholarship on literature, other arts, and material culture it can be difficult to evoke methodologies and concepts rooted in Indigenous epistemologies and Indigenous ways of knowing without being accused of lacking intellectual rigor. The forms of remote sensing that are typically engaged for contemporary archaeological research on mounds—multiple techniques for aerial photography and satellite imaging, for instance, including the LiDAR discussed in earlier chapters, as well as multiple techniques for geophysical surveying, including magnetometry and ground spectroscopy—assist researchers in locating physical remains and traces of remains; they also assist researchers in describing these remains and traces, along with their changing environments, in more precise detail. Intense dreaming, in contrast, is more likely to assist with locating—and seeing and experiencing—something other than or something in addition to physical remains and traces of the past. Similar to Mojica's description of "embodied improvisation" discussed in chapter 1 and similar to Tsinhnahjinnie's description of "receiving information" discussed in the present chapter, intense dreaming can assist with locating, seeing, and experiencing *intangible* aspects of the past, including aspects of performance that would have animated mounds and other physical objects located at and within earthworks sites in these Indigenous communities.

Accessing intangible aspects of the Indigenous past is a particular challenge, but it represents a great need if we are to increase our understanding in ways that will be responsible to Indigenous individuals and communities of the past and meaningful to Indigenous individuals and communities of the present and future. Writing in the context of research conducted on finely crafted pieces of regalia and other art objects from the Pacific Northwest Coast that function within traditions of dance, song, storytelling, and other forms of embodied performance, art historian and curator

Kathryn Bunn-Marcuse argues: "When objects are removed from their performative contexts, as is often the case in museum displays and text-based art-historical inquiries, their cultural meanings are deactivated, and they become [but] artifacts of the dynamic moment of meaning."[46] Hedge Coke's and Hinton's contemporary productions, which evoke experiences of dynamic and multidimensional *movement*, whether performed on the voice, page, canvas, or screen, have the potential to help listeners, readers, and viewers experience some of the ways burial mounds must have functioned within Indigenous communities in the past—as components within networked systems, as portals between worlds, as conduits linking generations. These works may help listeners, readers, and viewers better conceptualize, in other words, the complex relationships enacted *among* mounds, interments, and human experiences of genealogically based resurrections and returns.

In a broad sense, of course, these functions represent exactly what literary and artistic works are supposed to *do* for their audiences: bring aspects of culture to life and into contemplation. The particularity of Hedge Coke's and Hinton's earthworks-based productions, however, lies in the specific enactment of Indigenous ontological relationships to land in and across time through the dynamic vehicle of burial mounds combined with living trees. The noted Indigenous Australian intellectual Aileen Moreton-Robinson (Goenpul) wrestles with the nature of this pivotal ontological relationship in a provocative essay published in 2003, the same year Tsinhnahjinnie published "When Is a Photograph Worth a Thousand Words?" "Our ontological relationship to land is a condition of our embodied subjectivity," Moreton-Robinson writes. "The Indigenous body signifies our title to land and our death reintegrates our body with that of our mother the earth. However, the [settler] state's legal regime privileges other practices and signs over our bodies."[47] Hedge Coke and Hinton confront a similar U.S. history of settler dispossession of Native lands and bodies and a similar history of settler impositions of non-Native interpretive frames for the understanding of those dispossessions, their multiple consequences, their ongoing legacies. Similar to Moreton-Robinson, and in defiance of dominant narratives—legal, political, popular, literary, artistic—Hedge Coke and Hinton reassert

the dynamic and productive nature of Indigenous death. Through diverse works in multiple media they demonstrate how Indigenous death leads not to the "vanishing" oblivion forecast and foreordained in dominant discourses, but rather to new forms of creation and return. These artists perform in their works an Indigenous subjectivity Moreton-Robinson describes as "processual," in the sense that Indigenous subjectivity "represents a dialectical unity between humans and the earth" (37). Moreton-Robinson notes that this processual Indigenous subjectivity "is a state of embodiment that continues to unsettle white Australia" (37). As Hedge Coke and Hinton demonstrate in their powerful poetic and artistic productions based in the juxtaposition of ancestral mounds and living trees, processual Indigenous subjectivity is a state of embodiment that continues to unsettle, as well, the dominant narratives of non-Native America.

Secured Vaults

> It was an old lesson, never touch what evil has touched. They took a vote
> and agreed to bury the money with McAlester. Delores laughs aloud. In
> a hundred years or so, when archaeologists stumble upon McAlester's
> skeletal remains, they'll find gifts from Xerox and Microsoft, along with
> millions of dollars buried next to him. His gravesite will confirm the long-
> held theory that Indians so deeply revere their leaders that they bury them
> with precious gifts.
>
> — LeAnne Howe, *Shell Shaker* (2001)

What if, instead of a protective seed or generative womb, the community
needed a burial to function as a quiet locus of stasis, a place and a period
of suspended animation? What if, instead of movement between worlds
or contact across generations—some kind of strategic resurrection or
return—the need was for holding and containment, an equipoise of com-
peting forces, an equilibrium maintained over the long term? What if, in-
stead of preparing to make a transition or transformation, the interred
were meant to remain under carefully monitored control?

These are not ideas typically encountered in archaeological reporting or
theory, either in past centuries or recent decades. In accounts both ama-
teur and professional, speculation about the intended purposes of burial
mounds usually begins with the careful measure of exterior dimensions: a
mound's height, length, and width, its circumference, area, and volume, the
calculation of the number of cubic feet of rocks and soils borrowed, heaped,
and sculpted. The greater the physical dimensions, the more impressive the
assumed power and reputation of the interred dead. How else would those
ancients left behind have been able to motivate so much planning and hard
labor, all that digging deep in order to pile high? Speculation usually turns
next to the measure of the human remains and other materials discovered

within the mounds. First, the careful sorting and counting of other-world companions interred alongside the primary burial or burials, the male and female, elderly and youthful human bodies willingly (or perhaps, runs the typical speculation, less-than-willingly) sacrificed. If applicable, the sorting and counting of other-than-human other-world companions and how they have been arranged in relation to the human burial or burials. And then, second, the careful sorting and counting of finely crafted regalia and funerary objects—beaten copper bracelets and breastplates, multiple strands of beads fashioned from wood, bone, shell, or sheathed in bright metal, incised shell gorgets, intricately carved stone pipes and beautifully decorated clay vessels, occasional fragments of elaborately woven textiles that have somehow survived their long tenure beneath soil—followed by the careful sorting and counting of cached durable materials assembled from near and far—masses of bear's teeth and freshwater pearls, shiny black shards of obsidian, blood-red tablets of pipestone, pink-and-cream marine shells miraculously still whole, fragile sheets of mica that catch light like glittering stars. Here, too, the greater the number and aesthetic grandeur of the materials gathered, worked, and then elaborately disposed under soil, the more impressive the assumed power of the interred dead. *So much physical labor. So much thought, intention, and craftsmanship. So much careful arranging.* So much wealth amassed only to be removed from circulation, hidden literally beneath ground—imagine the glorious *waste* of it all. The ancient persons buried in the mounds must have held extremely high rank within their societies, must have been the equivalents of "chiefs" and "nobles," "princesses" and "god-kings." Moreover, they must not only have been held in high esteem; they must also have been universally revered. Why else, asserts the typical reasoning, would the mounds have been built on such a grand scale and filled with so much *treasure*?

Within orthodox discourses, the idea that burial mounds populated with other-world companions and amassed with inestimable treasure might serve not (only) as monuments to the venerated dead but (also) as secured vaults to placate problematic spirits is truly radical. I first encountered the idea in print in Choctaw writer LeAnne Howe's 2001 debut novel *Shell Shaker*. But although the idea that at least some burial mounds may have served

as technologies for the containment of difficult or violent spirits is central to the time-traveling plot of Howe's remarkable novel—which moves back and forth between Choctaw ancestors negotiating rapidly changing political, economic, and social landscapes in the Southeastern homeland in the 1730s and 1740s and contemporary Choctaw negotiating similarly changing political, economic, and social landscapes in southeastern Oklahoma in the 1990s—it took years of reading and teaching *Shell Shaker* before Howe's argument and its ramifications really sank in. The idea of elaborate interment figured as necessary containment rather than as aggrandizing celebration runs so profoundly counter to prevailing archaeological and popular narratives about burial mounds and stands so profoundly at odds with dominant settler assumptions about Indigenous peoples that it is difficult to fully comprehend. I have reserved its explication and discussion for this final chapter because the idea of burial mounds serving as secured vaults offers such a compelling check on dominant discourses and their assured assumptions about the irrelevance of Indigenous peoples, cultures, and knowledges to the present and to possible futures.

UNSPEAKABLE HORRORS ON (AND IN) THE MOUNDS

The four previous chapters have focused almost exclusively on *positive* and *generative* aspects of Indigenous earthworks and earthworks principles: mounds as forms for encoding knowledge through the medium of the land itself; mounds as powerful nodes within networked systems; mounds as portals between worlds and conduits between generations; mounds as sites of return. But there are theories and stories and ongoing experiences of mounds that signal in ways that are less consistently positive and less clearly generative. Most obvious, as briefly discussed in the introduction, are the dark theories of predominantly non-Native archaeologists, anthropologists, and historians who speculate why specific mounds, complexes, and cities were abandoned by their makers and first users at specific moments in (pre)history. These researchers typically posit that something terrible must have occurred at or near these sites and on a grand scale. Some cataclysmic event must have driven the builders of the mounds away from

their elaborate creations. It might have been an event induced by natural forces: a dramatic change in climate, for instance, such as persistent cycles of extreme weather or dangerously high temperatures followed by periods of crop-destroying drought. Or it might have been an event induced by dramatic forces more human in nature: an extreme avarice at a societal level, resulting in the overconsumption of resources and the destruction of fragile habitat, or worse, an individual or class-based lust for power, resulting in the formation of decadent social hierarchies that fomented unnecessary wars and enacted brutal enslavements, that created massive wealth for the few, abject poverty for the majority, that compelled rituals of human sacrifice at the whim of corrupt political leaders or delusional priests. (As detailed in the coda to Part II, such accounts occasionally include rumors of outright cannibalism.) Perhaps the devastation resulted from a combination of these forces: when the crops failed season after season, ordinary folks began to panic, and the elites feared a rebellion; in response, they sacrificed more and more enslaved bodies to their hungry gods, creating a culture of violence and fear until the people finally had enough and either rebelled or simply drifted away.

The possibilities for this kind of speculation are seemingly endless, as is evidenced by a steady stream of similarly dark "histories" of mound culture failure produced not only in academic theories but across a wide range of popular genres and media. In these narratives, speculation about sites marked as Indian burial have been—and continue to be—especially fruitful. Typically, these stories are less focused on the fates of the builders of the mounds per se and more concerned with the capacity—and the desire—of the spirits of long-dead mound-building Indians to haunt, curse, or actively terrorize non-Native settlers and their descendants. Many readers will be familiar with the trope of the disturbed Indian cemetery, which has long been a staple of non-Native genres of campfire stories, pulp and paperback fictions, and both high- and low-budget horror on screens large and small. Jay Anson's popular 1977 novel *The Amityville Horror*, first adapted into a feature film in 1979 and then followed by numerous sequels, and Stephen King's popular 1983 novel *Pet Sematary*, first adapted into a feature film in 1989 and then again in 2019, are but two of the better-known ex-

amples. Disturb the graves of the Indian dead, these narratives warn their (presumably) non-Native audiences, and you will surely release all manner of violent mayhem and deep psychological torment. You may even lose a child or two. In some of these popular texts the haunted, cursed, or terrorizing site of Indian burial is specifically designated as an ancient mound.

A surprisingly complex version of these formulaic narratives appears in "The Horror from the Mound," originally published in the May 1932 issue of *Weird Tales: The Unique Magazine.* This creepy and sensationalist story is notable, in part, because of the minor celebrity of its author, the prolific pulp and fantasy writer Robert E. Howard, who is best known for creating the "sword and sorcery" world of Conan the Barbarian and also for creating other preternaturally violent "lost" worlds—including lost worlds situated within the Americas. The aptly titled "Horror" draws interest, as well, as an early example of the "weird" or "undead" Western, since Howard's story is set neither in the contemporary backwoods of Stephen King's rural Maine nor in the mound-filled rural Midwest, but rather in the wilds of the author's own desolate homeland of West Texas and in that region's "Anglo frontier" of the mid-nineteenth century.[1] Howard's protagonist is Steve Brill, "browned by the sun and strong as a long-horned steer," a prototypical white, "Anglo-Saxon" American cowboy unsuccessfully trying his hand at farming (303). Frustrated by severe weather and by cycles of crop failures on the land he leases, Brill dreams of moving farther west, but not before attempting to unearth the substantial treasure that is rumored to have been hidden somewhere in the land by sixteenth-century Spanish explorers. "Of all the continent of North America," the narrator opines early in the story, "there is no section so haunted by tales of lost or hidden treasure as is the Southwest" (306). When Brill's closest neighbor, a "taciturn old Mexican" named Juan Lopez, ominously warns that the odd "knoll" prominent on Brill's leased property is an "accursed mound" and that under no circumstances should he disturb it, Brill is convinced he knows precisely where he should dig to find his "golden cache" (304, 306). The Spaniards must have buried their treasure of "virgin ore from forgotten mines" within an actual Indian burial, he reasons, or they must have disguised their cache of silver and gold to *look* like a mound, knowing that irrational fears of disturbing

the dead would keep treasure seekers at bay (307). In either scenario, the hidden riches should be easy to locate for the young and hearty "Anglo-Saxon" cowpuncher free of such superstitions—and easy for him to liberate.

Despite his appearance within the pages of *Weird Tales*, Brill seems unaware of basic conventions of the horror genre. He does not appear to know that one should open suspected ancient graves only during the brightest hours of daylight and preferably in the company of well-armed companions. Any other timing—and certainly any circumstance of opening an ancient grave *alone*—is likely to invite disaster. Nonetheless, acting on a sudden "impulse," Brill chooses to swing his lone pickax and work his lone shovel through the early evening into twilight and on into the dense shadows of night. In the process of this increasingly "dark" excavation, Brill's digging exposes not only the expected stone tomb of an ancient Indian grave but also something the cowboy has not anticipated. The unexpected find is, however—at least within the pages of *Weird Tales*—appropriately ghastly. Instead of a cold cache of Spanish silver and gold, or even the cold "relics of a past and forgotten age, containing the moldering bones of chiefs and warriors of a lost race"—that is, Indian remains—the white cowpuncher turned farmer now turned "treasure-hunter" uncovers the cold body of the living-dead. Indeed, in his impulsive quest for easy Spanish treasure, he unwittingly releases a voracious Spanish *vampire* that the sixteenth-century caballeros had secured in the mound's evacuated Indigenous "death-chamber" of "roughly hewn" stone (305, 308).

Beyond its adherence to formulas of the horror genre, Howard's story draws interest for how it follows other familiar conventions: how it literally displaces Indigenous bones from an Indian burial mound in order to replace them with an embodiment of the "black legend" of Spanish colonialism. This is a colonialism marked as so alien that, even after three centuries locked within American stone and soil, it remains indelibly foreign and insatiably violent. Howard actively conflates the well-worn "black legend" of Spanish colonialism's extreme violence with the "black legends" of vampires, namely, that "human weapons were powerless" to stop these "already dead" creatures (318). The story's multi-step substitution of the voracious "undead Spaniard" for the "moldering bones" of the displaced

Indian remains provides an elaborate setup for the story's climactic reckoning, a Texas-style frontier showdown between Spain's markedly ancient and ghastly pale *extractive*—literally, blood-sucking—colonialism from the sixteenth century and an emphatically robust, sun-browned "Anglo-Saxon" settler colonialism from the nineteenth. Once released from the Indian burial mound, the undead Spaniard, Don Santiago de Valdez, immediately locates and drains the life from Brill's Mexican neighbor Lopez, thereby silencing the only carrier of the vampire's name and story. The "nightmare" then continues as the undead murderer seeks out and attempts to steal the life of the white cowboy as well. Although the ensuing battle is fierce, its eventual outcome will surprise few readers. In this way, Brill's drawn-out battle with the foreign "fiend" and inhuman "monster" effects a final erasure of historical and contemporary Indigenous peoples from American soil, and, at the same time, a less-than-subtle assertion of white settler innocence.

One of the compelling aspects of Howard's "weird tale," for my purposes, is the inclusion of the "taciturn" Mexican neighbor. Lopez is no recent immigrant, but rather a direct descendant of one of the sixteenth-century explorers who survives the vampire's insatiable hunger. The original Spanish company of "some forty-odd soldiers, servants, and masters," accompanied by a "priest" and by a "mysterious nobleman" rescued from a "helplessly floating ship in the Caribbean Sea" (who will turn out to be vampire), are all *men*. The subtle implication, therefore, is that Lopez descends from a union between one of the surviving "armored pikemen" and an unnamed Indigenous woman (315). Lopez's supposedly reticent body actually speaks volumes about local histories. Moreover, as he details in an account of the "curse of the mound" he writes out for Brill in a "crude laborious script"—since he has sworn never to "speak" of it—Lopez descends from a long line of mixed-blood "Mexican" guardians charged with watching over the tomb of the undead Spanish nobleman who has become a living-dead Texas squatter (315). Back in 1545, Lopez recounts, while the vampire lay in a deep sleep after feeding on one of his unfortunate comrades, the surviving Spaniards carried the engorged body "to an old Indian mound nearby. This they opened, *taking forth the bones they*

found there, and they placed the vampire within and sealed up the mound"
(316, emphasis added). It is Lopez's long-dead Spanish ancestors, rather
than the robust white American settler cowboys, who are presented as re-
sponsible for the literal displacement of Indian remains and thus for the
displacement of Indigenous claims to the land. Although Lopez cautions
against opening the burial mound on the land Brill *leases* but does not own,
the Mexican's story opens the way for Brill and other white men to eventu-
ally stake their claims to an American West they have (re)coded as "empty."
The mixed-blood Lopez is made to confirm a white settler assertion: no
matter how ancient its past history, the land has been evacuated of its
Indigenous presence.

But even within Howard's pulp story-world, these claims to white set-
tler legitimacy ring false, or at least less than fully actualized. Early in the
narrative, Brill asks Lopez why he avoids walking close to "the low rounded
hillock which jutted above the level of the pasture." Does the Mexican think
"that mound's ha'nted or somethin'?" Lopez replies: "Let hidden things
rest" and "Best not to disturb what is hidden in the earth" (304, 305). Brill
misinterprets Lopez's secretive but practical warning about the violent
contents within the mound as an irrational expression of a "superstitious"
fear of the dead. Brill then reveals that this is not, in fact, his first rodeo:
the white cowpuncher has opened other burial mounds. He tells Lopez:
"Me and some boys busted into one of them mounds over in the Palo Pinto
country and dug up pieces of a skeleton with some beads and flint arrow-
heads and the like. I kept some of the teeth a long time till I lost 'em, and I
ain't never been ha'nted" (305). The taking of the teeth alludes to practices
of mutilating victims of war and massacre and then collecting severed
body parts as trophies. The long-"kept" but subsequently "lost" teeth serve
as Brill's souvenirs of past Indian conquest, but they also function as his
talisman for an asserted white settler dominance against both ongoing
Indigenous claims and "Mexican"—that is, mixed-blood—"superstition."
And at the story's climax, when Lopez already lies dead and Brill is poised
to battle the vampire, Howard's language connects the undead Spaniard to
the "savagery" of both the Indians Brill has helped to absent from mounds
and the natural world he finds so inhospitable. The narrator describes the

scene: "Framed in the black doorway crouched that abhorrent shape out of the past, and Brill's brain reeled. A savage cold radiated from the figure— the scent of moldering clay and charnel-house refuse. And then the undead came at the living like a swooping vulture" (317–18). At other moments of the battle, in addition to a menacing "vulture," the narrator likens the vampire to a sharp-clawed "panther" and a venomous "snake" (318, 319). In case readers have missed the thrust of Howard's allusions, the narrator adds: "As his pioneer ancestors fought hand to hand against brain-shattering odds, Steve Brill fought the cold dead crawling thing that sought his life and soul" (318). Ostensibly an existential battle between the living and the undead, this contest is actually an extension of the frontier struggle over rights to soil and settlement. The "life and soul" being fought over are less those belonging to an individual cowboy and more those belonging to an expansive land still in the process of becoming America.

Also of interest is the way the battle between the New World cowboy and the Old World vampire works ultimately to cleanse this disputed territory of the "curses" of both Indian savagery and the savage history of Spanish colonialism, rendering Texas and the Southwest more generally available for (innocent) white American settlers. During his initial late-night excavation, Brill's sign that the mound is an authentic Indian burial is the presence of charcoal: "He began to be convinced that the mound was a genuine Indian tomb, as he found traces of charcoal in the soil. The ancient people which reared these sepulchers had kept fires burning upon them for days, at some point in the building. All the mounds Steve had ever opened had contained a solid stratum of charcoal a short distance below the surface" (308). The details chosen here, as well as the narrator's precise vocabulary, suggest Howard was aware of the most up-to-date archaeology available at the time, such as Henry Shetrone's 1930 study *The Mound-Builders* discussed in the Introduction. Howard describes evidence of the kind of "charnel houses" Shetrone and others associate with so-called Hopewell burials, although these are typically located not in West Texas but across the Ohio Valley. And Brill's first sign that something is terribly amiss in the mound he excavates is that the expected layer of charcoal has been disturbed: "But the charcoal traces he found now were scattered about through the soil"

(308). The detail of charcoal becomes significant again near the end of the story, when the "coal oil lamp" Brill uses to light his cabin is overturned during his battle with the vampire and the cabin is suddenly consumed by fire. "Through darting jets and licking tongues of flames they reeled and rolled like a demon and a mortal warring on the fire lanced floors of hell," the narrator relates. "And in the growing tumult of the flames, Brill gathered himself for one last volcanic burst of frenzied strength" (318). Notice how, as the story draws toward conclusion, Howard aligns the unsuccessful white tenant farmer with the productive depths of the very soil that has thwarted his efforts. The final "burst" of "strength" that allows Brill to overcome the embodiment of Spanish colonialism is nothing less than "volcanic." As he rallies this subterranean strength, Brill's cabin burns to the ground, becoming a contemporary charnel house for the undead Spaniard. The final lines of the story read: "And as a man runs from the portals of hell, [Brill] ran stumblingly through the mesquite and chaparral until he fell from utter exhaustion. Looking back he saw the flames of the burning house and thanked God that it would burn until the very bones of Don Santiago de Valdez were utterly consumed and destroyed from the knowledge of men" (319). The "black legend" of violent Spanish colonialism is destroyed once and for all—as is, almost incidentally, the power of the Indigenous dead to in any way haunt or otherwise occupy their own lands. In his conquest of the ghastly vampire, the sun-browned settler cowboy is shown to be the ultimate American hero. Interestingly, however, he is also shown to be an exemplar of an always *endangered* white American innocence.

Howard's "The Horror from the Mound" represents an extreme example of a non-Native writer deploying scenes of disturbed Indian burial in order to make broad assertions about Indigenous erasure, settler rights to American soil, and both individual and collective white American moral innocence. More typical, perhaps, are stories in which Brill's combined roles as a "rational" excavator of Indian mounds and a "capitalist" developer of American lands are disaggregated into distinct individuals, groups, or forces. Such separations are strategic. They allow authors to portray archaeologists, along with the "academic" institutions or the "scientific" enterprises they front, as working in opposition to, rather than in concert with, settler-

invaders who would violate Indigenous burials for reasons clearly material-
istic rather than cerebral. Authors can thus more easily portray non-Native
archaeologists as morally neutral—they are "just doing their jobs" to ad-
vance a disinterested science—or as morally virtuous—they are "rescuing"
endangered data, "saving" important knowledge of a universal "human" past
for posterity. In chapter 3 we saw how Timothy Pauketat's popular nonfic-
tion account *Cahokia: Ancient America's Great City on the Mississippi* narrates a
"mesmerizing" story of remarkable discoveries that were made by a series of
twentieth-century archaeologists, whom Pauketat portrays as nothing less
than heroic. The vital work these researchers undertake is consistently set
against, rather than simply alongside, a backdrop of sometimes unwitting,
sometimes uninformed, but always voracious urban and suburban capitalist
development that threatens to destroy—and therefore threatens to waste—
the hidden potential of the "mysterious" mounds before their significance
can be properly—and profitably—examined, cataloged, and recorded.

Fictional texts that perform similar ideological work include non-Native
playwright Lanford Wilson's Obie Award–winning *The Mound Builders*. De-
veloped and first performed off-off-Broadway in February 1975, the two-
act play was adapted for public television's *Theater in America* series and
broadcast in February 1976, then immediately published as an inexpensive
Mermaid Dramabook, also in 1976. *The Mound Builders* has enjoyed regular re-
vivals at major playhouses and small community theaters and on the stages
of high schools, colleges, and universities ever since. The positive review
published in the *New York Times*, written in response to the premiere, cap-
tures much of the play's appeal as a nuanced study of interpersonal rela-
tionships set against the backdrop and, to some extent, explored within the
methodologies of archaeological discovery:

> Lanford Wilson's multi-layered new play, "The Mound Builders," which
> opened last night at the Circle Repertory Company, is about civilizations—
> people, singular and plural. The subject is archeology, the uses of the
> past, ours and others—to what purpose? Is archeology a search for life
> or meaningless gravedigging? What will archeologists of the future say
> about our present?

> Mr. Wilson's past work . . . has not prepared us for the complexity
> and metaphorical suggestiveness of "The Mound Builders." It is an epic
> in the guise of a family drama.[2]

The play's "family" consists of two university scientists, their wives, and additional dependent relatives and hangers-on. Over three successive summer breaks the archaeologists have run a field school, supervising a group of (mostly offstage) students who help them dig at a Mississippian site in Blue Shoals, Illinois, known as Jasker's Field. They hope to uncover a find equal to or greater than that of nearby Cahokia.[3] In addition to the expected emotional, psychological, and interpersonal baggage the members of this family carry with them to the old farmhouse they share each season, the present is marked by additional pressures. The land being excavated by the senior professor, August Howe, and the junior professor, Dan Loggins, is privately owned, and thus potentially insecure as a site for research; moreover, destructive development is already under way. A new interstate highway will be built along one of the site's edges, while its central precinct, the location of a Mississippian village, is slated for flooding. The Blue Shoals Dam is nearly complete, and soon a large lake will cover the central precinct, cutting off access to the ancient mounds, plazas, and other structures beneath the soil in order to accommodate tourist ventures that will be made viable by the interstate highway, such as a motel and restaurants adjacent to the man-made lake. In other words, the play evokes a classic scene of "salvage" archaeology set against the ticking clock of capitalist "progress." The rural landowner's uneducated but darkly charismatic adult son, Chad Jasker, lurks around the edges of both the excavation and the archaeological "family," placing additional pressure on the married couples' strained relationships and repeatedly expressing his impatience for the academic work to end so that his new life of tourist-driven wealth can begin. Whatever scientific specimens lie beneath the dampening soil must be uncovered quickly, or they will be forever lost to water and commerce.

Subsequent reviews, such as the positive response to a 1987 revival published in the *Washington Post*, have continued to emphasize how Wilson's script deploys the offstage scene of communal excavation in order to pro-

voke multiple levels of personal discovery onstage. The characters "are not just digging down into the distant past," the reviewer notes. "At the same time, they're probing their own relationships, uncovering buried emotions and letting skeletons out of the closet. Both a family drama and a meditation on the evanescence of human culture, 'The Mound Builders' is a dense and brooding work."[4] The few scholars who have written about Wilson's play tend to follow the lead of the positive reviewers, emphasizing the dynamics of the "family drama" as well as the play's meditations on psychology and its interest in how individuals come to know—or come to think they know—their own and others' pasts. These scholars read the script's evocation of the "empirical science" of archaeology primarily as a "metaphor" for "the human condition." Just as the academic field attempts to grapple with "man's limited knowledge" of past civilizations in order to better understand its own, individuals attempt to retrieve their "personal" pasts in order to "possess" themselves more fully. Both attempts, these scholars point out, are repeatedly shown as "futile."[5]

My own reading is less interested in the dynamics of interpersonal relations or the philosophical complexities of "universal" questions about our individual and communal relations to the past. Instead, my attention is drawn to how *The Mound Builders* evokes its offstage backdrop of archaeological excavation. Wilson cleverly frames his story as the melancholic recollections of the senior professor, August Howe, as he reviews "the wreckage of last summer's expedition," which, the audience slowly learns, resulted not only in the submersion of the excavation site and the loss of its unexpected major find, but also in the death of August's younger academic colleague, Dan, and the breakup of August's marriage to Cynthia.[6] Sitting alone in his dark study, August examines this ruinous recent past through a series of slides he projects on a back wall while speaking notes into a tape recorder. As in my analysis of Howard's "Horror," I am particularly interested in how Wilson's play evokes not only the scenes of physical excavation but also the grave consequences—pun intended—that befall those who disturb the Indigenous dead.

It likely goes without saying that Wilson's characters are non-Native and that the play makes no attempt either to include or to evoke Native

perspectives—ancient, historical, or contemporary—either about the Mississippian site and the culture or cultures that flourished in what is now southern Illinois or about the contemporary practices of salvage archaeology (4). Every speculation presented about the mounds and their builders is unquestionably non-Native. Early in act 1, the play suggests that the impetus behind the building of the mounds must be universal, crossing time, geographies, and human cultures. The impetus to build, therefore, whether imagined as grand or mundane, is necessarily legible to contemporary non-Native "scientists":

> DAN: "Why did they build the mounds?"! They built the mounds for the same reason I'd build the mounds. Because I wanted to make myself conspicuous; to sacrifice to the gods; to protect me from floods, or animals; because my grandfather built mounds; because I was sick of digging holes; because I didn't have the technology to build pyramids and a person isn't happy unless he's building something. . . . Every society reaches a point where they build mounds. As the society becomes more sophisticated, the rationalization for building them becomes more sophisticated. (22)

Through Dan's self-reflexive explanation, Wilson is able to quickly list a range of theories about mound building that were prevalent at the time, giving the implication that, although the details of an excavation may still be of interest, the larger sociological and psychological questions have been settled. The builders of the mounds represent not a radically distinct cultural formation but an earlier version of "our" own familiar psyches and motivations.

Although we can only speculate that Howard consulted archaeological texts when he was writing in the early 1930s, we know that Wilson actively sought the advice of archaeologists and other researchers in the early 1970s. In the acknowledgments to the published script, Wilson thanks various individuals for assisting him with relevant research, but especially "Dr. Howard Winters of the Department of Anthropology, New York University, who kindly helped with the archaeological data, spoke with

the cast and production crew of *The Mound Builders*, and generously gave us a hint at the archaeologist's dream." Born and raised in Ohio, Winters (1923–94) was a prominent archaeologist of eastern North America, devoting most of his career to studying sites in southern Illinois. Before joining the faculty at NYU in 1966, during the years of his graduate training at the University of Chicago he held archaeological and curatorial appointments at Southern Illinois University and at the Illinois State Museum.[7] Winters's unwavering confidence that the region held evidence of archaeological insights as important as those of anywhere else in the Americas, along with his focused interest in the significance of long-range trade routes to the civilizations that flourished there, can be felt throughout the dialogue Wilson created for his archaeologist characters.[8] Later in act 1, Dan explains to the women in the house—and thus to the listening audience—prevailing archaeological theories involving multiple waves of increasingly sophisticated mound-building cultures:

> DAN: There's been at least three different cultures who built mounds in the area—the Adena, back around 600 B.C. . . . Then the Hopewell Culture. They both built burial mounds. Then along about A.D. 700 a whole new people moved into the area, and instead of building burial mounds, they built a mound and on top of the mound built a temple. Two mounds. One for their temple and one for their God-King. (47)[9]

The specific detail of the "God-King," with its oblique echo of the Latin etymology of the senior archaeologist's name, August, becomes increasingly significant as the play moves toward its climax centered around an unexpected discovery quickly followed by an unexpected disaster.

Act 2 opens with the unearthing of an unusual interment—what the archaeologists will eventually describe as the burial of a Mississippian "God-King." In the frame narrative, sitting alone in his study and reflecting on the events at Jasker's Field from the previous summer, August offers the following soliloquy about the significance of the find—and, seemingly incidentally, about the significance of the archaeologist's role in saving the find from developers:

AUGUST: The dig at Jasker's Field was unfinished. A salvage operation from which we salvaged nothing. . . . A great amount of work has been done on the early cultures of North America and we have found only the periphery of the culture. Three hundred mounds, numberless graves have been opened, usually seconds before the bulldozers plowed them under. And of the Mississippian Culture—never before had the grave of a god-king been discovered. The most important find in forty years of work. (113)

The scene of reporting the discovery is then immediately embodied onstage when Dan runs into the farmhouse exclaiming about the burial. The archaeologists' original surmise that they had uncovered nothing more than a mundane grave of low-caste individuals, whom they refer to as "Stinkards," is wrong. They now realize that what they had stumbled upon were the sacrificed bodies of *retainers* to an exalted God-King:

DAN: He isn't a Stinkard, he's a retainer, dozens of them—all over the place—and in the center the ground is dark—a big black square where there has been a log tomb. It's all rotted away, but the ground is dark. August said, Oh, my God. Oh, my God. It's the tomb of a god-king. Nobody's ever found—(*Breathes deeply.*) You have never seen anything like it. Never. We didn't know if they had gold—but a gold thing on his face—and copper—Beautiful copper breastplates—everywhere—pearls like—obsidian axes, beads, thousands of tons of—come on. . . . I swear to you, two more days and the lake would have flooded it. (114)

The detail of the "gold thing" placed over the face of the God-King is unprecedented within the archaeologists' vocabulary of interment, and it becomes the play's primary symbol for the wealth and prestige of Mississippian culture, as well as for the scientific importance of the unexpected find. The discovery, naming, and then physical handling of this extraordinary object also functions as a foreshadowing of the play's impending tragedy. Once the "gold thing" and other artifacts have been brought back to the farm-

house, Dan speculates: "It's a death mask—we guess. It might have had feathers around it here. We have to guess. We've never seen anything like it before." Wilson's stage directions indicate that Dan "holds [the death mask] up to his face, and almost inadvertently it stays in place." Notice the suggestion in Wilson's use of the adverbial phrase "almost inadvertently" that the mask possesses its own agency. Dan then says: "Is that incredible? Tell me I look like a god-king" (121). The young researcher, representing the future of "science," literally becomes one with his ancient—and dead—object of study.

As the play moves toward its tragic conclusion, an impatient and increasingly frustrated Chad Jasker accuses the archaeologists of "grave robbing" (129) and declares that the site and everything on it belongs to him and to his vision of material progress—not to the long-dead Mississippians, and not to the scientists who want to study their remains. "My land, baby!" Jasker screams, "MY LAND! MY LAND! It don't belong to your Indian god. It don't belong to you. It's my land and there is an Interstate coming through" (131). Where Howard's "Horror" places bald assertions of "Anglo-Saxon" superiority and legitimacy in the mouth of its cowboy hero, who plays the roles of both archaeologist and land developer, Wilson's *The Mound Builders* displaces such sentiments onto the play's ostensible villain, the untutored materialist. In the play's final moments of onstage action, Dan will awaken from sleep to noises he hears in the dead of night. When he enters the living room to investigate, he will discover Jasker stealing the excavation's precious artifacts, including the rare "thing" of gold. Mimicking Dan's earlier gestures, Jasker too has placed the "death mask" over his face, where it holds of its own accord, extending the foreshadowing. Wilson's stage directions read: "The beam [of Dan's flashlight] catches Chad full in the face. He is wearing the God-King's mask, and has the knapsack in his arms" (137). His bag and his arms loaded with the stolen artifacts, Jasker lures a confused Dan out of the house and toward his demise: "There's something outside I want to show you" (138). When the sun rises and the others awaken, not only the artifacts but both Jasker and Dan are missing. A bulldozer has been run over the excavation site; abandoned, the heavy machine

sits stuck in the mud of the rising lake. In the ensuing scene, the few pho-
tographs August's wife, Cynthia, had made of the artifacts are destroyed,
leaving no physical evidence of the find (143). Neither Dan's nor Jasker's
body is ever located. Like the Mississippian God-King and his remarkable
burial, including the "thing" of gold, the young archaeologist and the young
land developer simply vanish "without a trace."

Although they work within the conventions of distinct genres, Howard's
"The Horror from the Mound" and Wilson's *The Mound Builders* develop
similar plots of loss and destruction out of the same basic archaeological
theory, namely, that the mounds were heaped high and filled with im-
mense treasure in order to honor revered leaders. Each evokes but then
quickly dispenses with the idea that the mounds might be "haunted" by
the active spirits of these Indigenous dead. Early in act 1 of Wilson's play,
when Dan's pregnant wife, Jean, first arrives at the farmhouse, she asks
August's wife, Cynthia, "Is it haunted?" Cynthia responds in deadpan:
"Not that we've noticed" (13). Later that night, however, Dan suddenly
awakens because he hears "weird" sounds in the house (14). August and
Cynthia's adolescent daughter Kristen also awakens that night, telling her
father she has heard voices: "They were talking." August comforts her by
saying, "They're only shadows" (15).[10] Then, late in act 1, Jean expresses a
related sense that there is something "weird" about the site: "The place has
changed since last year. . . . But something odd is happening now—or not
happening. There's something . . . I don't think it's the pregnancy, I think
it's *here*" (58). Similar to the way Howard resolves the Mexican "supersti-
tion" of Indian ghosts with the revelation of a voracious Spanish vampire,
Wilson resolves the suspicion of Indigenous haunting with the revelation
of a rapacious (and oversexed) local yokel. The audience comes to realize
that it is Jasker, who has conducted illicit affairs with both Cynthia and
Jean (and made homoerotic overtures toward Dan as well), who has been
lurking around the farmhouse and making "weird" sounds. In both sce-
narios, the Indigenous dead are effectively contained and silenced, their
presence literally evacuated or covered over, relegated to the distant and
all-but-forgotten past.

ACKNOWLEDGING THE HORROR OF THE MOUND BUILDER WITHIN

Much less obvious—and much less expected among non-Native readers—
are the cautionary stories about the mound builders that still circulate
among Indigenous peoples. Here, too, assumptions about the builders of
the ancient mounds are often based in the idea that something terrible
must have occurred in the past. These stories circulate primarily orally
and within specific Indigenous communities. Several have made their way
into print, however, including the evocative examples that make up part of
the 2012 composite text *Cherokee Stories of the Turtle Island Liars' Club*, which
Cherokee scholar Christopher Teuton wrote in collaboration with master
storytellers Hastings Shade and Woody Hansen, citizens of the Cherokee
Nation, and Sammy Still and Sequoyah Guess, citizens of the United
Keetoowah Band of Cherokee Indians, all of whom resided in the Cherokee's
relocated territory in northeastern Oklahoma. In the book's transcribed
records and descriptions of contemporary storytelling, mound-building
peoples are incorporated into several versions of the expansive narrative of
Cherokee migration. In the version related by Sequoyah Guess, along the
way to the Cherokee homeland located in the Smoky Mountains in what is
now the U.S. Southeast, the ancestors encounter "people who were mound
builders."[11] The Cherokee's own "architects" exchange knowledge with these
builders of mounds, and for a time the two peoples get along amicably and
intermarry. "But then one day," Guess recounts, "something happened":

> A prominent person,
> > of our people
> was found dead.
> And . . .
> they noticed she had no
> > blood.
> And the people started wondering what happened.
> And then they realized that these mound builders
> > were cannibals.
> And they sacrificed humans. (74)

The details are fascinating—and significant. That the person found dead is identified as a prominent woman of the Nation links the story of migration to the importance of matrilineal descent and the conferring of personal and tribal identities within Cherokee society through matrilineal clans. The prominent woman—a clan mother, perhaps—is found not simply dead, however, but literally drained of her blood.

The detail of vampiric cannibalism is riveting, of course, but it signifies somewhat differently in Guess's oral telling than it does in Howard's published "weird tale," discussed above, or in the old signage at the Aztalan site in Wisconsin, discussed in the coda to Part II. Later in this section of *Cherokee Stories*, Teuton remarks that "Cherokee tradition attaches great meaning to blood" in the sense of genealogical descent and affiliation (78). How should the Cherokee ancestors, who were *relative* newcomers to the land of the mound builders (pun intended), respond to this unexpected development? Guess continues:

> And with this prominent person being found dead,
> and everything pointed to these mound builders
> being the ones that killed her,
> our people had a great war with them.
> And they, well, you might say they wiped 'em out,
> but there were still some that were left
> and they had married into our people.
> But most of the others were killed. (74)

The story of an ancient Cherokee "war" with mound-builder "cannibals" is simultaneously a story of the incorporation of mound-builder "blood"—and thus the story of the incorporation of mound-builder technologies and practices—into Cherokee society. While not explicitly gendered within Guess's account, marrying "into" a matrilineal system suggests it was mound-builder men who married into the families of Cherokee women; the children who resulted from these unions were fully incorporated into Cherokee society through the inheritance of matrilineal clans.

In a related version of the migration story, the highly respected elder

Cherokee storyteller Hastings Shade offered Teuton the theory, similar to Howe's theory developed in *Shell Shaker*, that burial mounds were sometimes created to contain the spirits of the difficult dead. In line with the version Guess tells, Shade describes how, during the long journey, the Cherokee's ancestors encountered already-established mound-building peoples, exchanged knowledge with them, and intermarried:

> And they said *nadehidwa*, that's where they found the mound builders. They were already there, you know? Cherokees found them. They encountered the mound builders. They stayed there for a long time till they became one—*saqwu unastvne*—that's what that means: "they became one" with the mound builders. And that's how come the Cherokees now are associated with mound builders. They weren't mound builders at the time, but they were associated. And that was when the priest clan and all them came in. (58)

In Shade's and the other storytellers' versions of the migration story, the encounter with the mound builders—whom, Teuton notes, "the Cherokee know as the Dinikani, the Red Eye People, or the Aninayegi, the Fierce People" (61)—is associated with the creation of a problematic clan of powerful priests. In addition to their association with mound builders, these ruling priests are described as "not of this world" (59). Over time, the priests became "more and more power hungry and abusive." As in Guess's account, Shade relates that "these were the ones that sacrificed people and were cannibals" (61). Because the priests abused their status within the Cherokee hierarchy and created so much violence, even the Earth herself rejected them. Shade offers this theory behind the creation of at least some of the burial mounds:

> These people were so mean that when they buried dead into Mother Earth she would reject them. The elders say when they would bury the mean ones into the ground as we do our people that have died, the next day they would be lying on top of the ground. So in order to bury their dead they built mounds. This is how they became known as the mound

builders. This way they would be buried above the ground and not into Mother Earth. (62)

In the account, in at least some instances mounds are built as a substitution for more typical burials *below* the surface of the earth. The point is not to honor those interred, as non-Native archaeologists, anthropologists, and historians assume, but to contain their violence and difficult spirits. Teuton completes the section by stating: "Hastings believed that when the mounds were excavated and tampered with by archaeologists, the spirits of those Red Eye people were let loose in the world" (62). This is an idea Howe also explores in her work—and, as noted above, it is an idea that many non-Native writers and filmmakers have entertained as well, sometimes explicitly and sometimes not, in their own stories of what happens when "we" disturb the Indigenous dead.

Similar to Guess's account of the Cherokee migration, Shade's includes the detail that, eventually, the hierarchical and abusive priest clan had to be destroyed (61). The Cherokee, however, retained knowledge about the construction of mounds. Shade states: "And as we continued on to North Carolina, that's where we built some of the mounds. We didn't build a whole lot of the mounds. A lot of the mounds was already there when we got there" (59). And similar to the lessons relayed in Guess's version, Shade's story emphasizes multiple aspects of this incorporation. The elder recounts: "Most of the priest clan was killed, but some of the blood survived" because of intermarriage (59). Put another way: "The priest clan were killed out, but the blood remains" (62). Some of the descendants of these unions, Shade suggests, produce contemporary "medicine people" (60).

These less positive accounts of mound-building peoples and of how mound-building traditions moved across cultures and generations in the deep past link to similarly negative representations of despotic rulers at Cahokia in Phillip Morgan's 2014 novel *Anompolichi*, discussed in chapter 3. Morgan grounds his story in Chickasaw, Choctaw, and other Southeastern traditions that view the impressive accomplishments developed at Cahokia with admiration but also with wary suspicion. And he includes as a major plot device how the "evil," power-hungry leader of the Allahashi, Yoshoba,

designs hollow vaults beneath some of the central mounds at Cahokia, which he uses first to conceal his army of warriors and then to imprison his unsuspecting visitors from the rival Yukpan Confederacy. The scene of imprisonment within the mounds draws attention, in part, for the way it allows Morgan to embed a version of the Yukpan creation story within this climactic scene. Before she is imprisoned within one of the structures:

> Taloa noticed unusual openings underneath the mounds—entrances with heavy beamed frames and large, double wooden doors. She imagined they must have to do with the unusual burial customs of the Allahashi. She had heard of bizarre Allahashian ceremonies and customs, but thought it all only gossip generated by skeptics like Iskifa to discredit this clearly advanced civilization.[12]

Once Taloa is taken prisoner and placed "into the chamber under the royal mound," the narrator relates:

> The darkness inside was complete. . . . She managed to move to the earthen wall of the vile cave, illuminated only by a tiny shaft of light peeping through a crack in the door. Taloa pressed her back against the wall and slid down to sit on the cool, moist dirt. She fought past the throbbing in her head and remembered the story of creation told to her by her Chahta father—of wet clay people emerging from the earth of *Nanih Waiya* cave into the light. "*Yaaknaat ittihoobataa*—is this the same earth?" she puzzled, bewildered.[13]

The scene of Taloa's subterranean contemplation is poignant in its evocation of her sense of bewildered anguish. The level of Allahashi deception and the extent of their violence raise questions about the very basis of her Yukpan worldview.

The subterranean scene is also of interest for its invocation of the Nanih Waiya, generally considered the Choctaw Mother Mound, located in what is now Winston County, Mississippi.[14] The Nanih Waiya is often described as the site of Choctaw creation and emergence, although there is debate

over whether it is this man-made mound or a cave beneath a natural hill located not far from the mound that is the actual site. And although there is consistent agreement that the noun *nanih* in Nanih Waiya can refer to *either* a man-made mound *or* a natural hill, there is disagreement over whether the adjective that follows should be *waiya* or *waya*. In *The Early Chickasaw Homeland*, discussed in chapter 3, the historical linguist John Dyson states:

> The better known *nanih*, a man-made Middle-Woodland mound, has been consistently confounded in time, name, legend, and language with another *nanih* a short distance away. The second of those features is a natural, swollen, belly-like hill at whose base a cave entrance is visible to all who approach it.
>
> The artificial *Nanih Waiya* is said by many to mean the "Leaning Mound," but it does not lean now and there is no reason to believe that it ever did. The geographic proximity and the resulting confusion of that man-made mound with the natural hillock nearby are reflected in the pronunciation of the Choctaw language's near-homophones *waiya* and *waya*, "leaning" and "fruitful," respectively. Although neither mound "leans," only one of them can logically or metaphorically have been considered fruitful or productive, and that is the one that resembles a distended earthen womb with its associated cave as symbolic birth canal. There is every reason to assume therefore that the spelling *Nanih Waiya* represents an enduring but mistaken folk etymology and that only *Nanih Waya* makes any semantic or mythological sense.[15]

I first became aware of the *waiya/waya* distinction when I was analyzing the short animated film *Crazy Ind'n* by award-winning Choctaw filmmaker Ian Skorodin and his Barcid Productions team. Released in 2007, *Crazy Ind'n* is a twenty-minute stop-motion feature starring plastic action figures who populate an alternative reality set in 2007's near-future of 2008.[16] Within this alternative reality, Skorodin imagines that a multi-front, global Indigenous uprising is under way to reclaim large portions of the Earth, led in what is left of the United States by the Indigenous lawyer-turned-guerrilla leader known as Crazy Ind'n. In addition to the film itself, an

elaborate website was built to support the Crazy Ind'n project. The website provided relevant backstory for the film as well as a world map detailing where events of the uprising were described as happening in real time. Clicking various icons revealed synopses of actions and on-the-spot news reports. One of the key icons within the map of North America was "Fort Nanih Waya."[17]

The icon's positioning on the map confirmed that it was a reference to the Choctaw Mother Mound. When clicked, the icon popped up as a tripartite image: a central text box with two smaller images positioned to its left and right. On the left was the detail of a map showing Winston County, Mississippi, and thus indicating the precise location of the mound within contemporary U.S. geography. On the right was a small black-and-white historical photograph of the Nanih Waya. The distinctive sloped shape of the Mother Mound looms large within the photograph's background, the mound's surface visible but overgrown with thin trees. The sky behind the mound glows a hazy, overexposed white. In the middle ground, at roughly the center of the photograph, a single individual stands before the mound to provide a sense of its twenty-five-foot height and overall scale. Details about the individual are difficult to discern. Finally, the furrowed foreground shows that the land surrounding the mound has been repeatedly plowed and sown. Although Skorodin provides no caption, the photograph may have been recognized by some viewers. An internet search reveals that the photograph was taken by B. N. Powell of Columbus, Mississippi, in 1914, nearly eight decades after Choctaw removal.[18] Situated between the detail map and the black-and-white historical photograph, the text box describes "Fort Nanih Waya" as captive to embattled U.S. forces, who have made the Choctaw site not only into a military stronghold but also into a symbol of the ongoing U.S. colonial struggle for legitimacy. In bright yellow lettering against a black background, the text box reads:

> One of the last bastions of United
> States hegemony, Fort Nanih Waya
> secures the most sacred site to
> the Choctaw people.

Founded over a million years ago,
Nanih Waya is the birthplace of
the Choctaw people. This is Crazy
Ind'n's most important campaign.

In my original analysis of the short film and supporting website, I assumed that "Nanih Waya" was simply a misspelling for Nanih Waiya. I now think the website's repeated use of *waya* may open to more complex possibilities. In addition to the colonial occupation of the large mound, an icon of Choctaw ingenuity and creativity, Fort Nanih Waya may refer, as well, to the colonial occupation of the Choctaw emergence site, the literal birthplace of Choctaw and other Southeastern peoples.[19] It is the site of generative wet earth that Morgan's fourteenth-century character Taloa imagines in her time of distress at the climax of *Anompolichi*. In the twenty-first century, Crazy Ind'n's campaign to release the site from a different version of captivity is a campaign to reclaim control over the Indigenous past, including not only the height of Choctaw independence before removal but also the deep past of creation, when the ancestors of the Choctaw and other Southeastern peoples emerged from within the Earth. Nothing less than access to the power of creation is needed in order for the Choctaw and other Southeastern peoples to move forward into a renewed Indigenous future, a future that resonates on a scale that is not only local but also global.

BREAD BOWLS OF MUD

This chapter's itinerary through "The Horror from the Mound," *The Mound Builders, Cherokee Stories of the Turtle Island Liars' Club, Anompolichi,* and the *Crazy Ind'n* website brings me at last to LeAnne Howe's award-winning *Shell Shaker.* Burial mounds and other earthworks are not the central concern of Howe's first novel, either for characters within the story-world or for most readers and critics.[20] Rather, issues of contemporary Choctaw politics in the 1990s and their relationship to unfinished Choctaw business from the 1730s and 1740s are the novel's more obvious focus, as is the importance of women to Choctaw history in both the past and the present.

Earthworks, however, provide the essential ground upon which the main plot and its several subplots are constructed, and the mounds play a key role in the novel's climax and conclusion, which resolves with the creation of a secured vault for the difficult spirit of a troubled and dangerous chief, Red McAlester, and with the willing sacrifice of other-world human companions who vow to look after his spirit into the future.

As already noted, Howe's narrative moves back and forth between the complexities of eighteenth-century Choctaw history in the southeastern homeland centered in what is now Mississippi and the complexities of Choctaw life in the 1990s in what is now southeastern Oklahoma, where the Choctaw were removed in the 1830s. Both temporal frames are set against a backdrop of even older Indigenous histories centered on earthworks, which are themselves centered around the generative Nanih Waiya (and/or Nanih Waya), the Choctaw Mother Mound and place of emergence discussed above. Howe's story of political corruption, difficult love, and necessary murder crosses multiple centuries, from the deep past to the contemporary era, and it asserts continuity across changing cultures and technologies rather than conform to an archaeological teleology of developmental "stages." In Howe's narrative, earthworks remain relevant in the post-removal, post–Allotment Act, post–Oklahoma statehood, post–Indian casino present. In fact, they are essential to enabling contemporary Choctaw to take care of old business, to reunite their Mississippi and Oklahoma communities divided by colonial dislocations, and to build their Indigenous world anew.

In a remarkable scene, generative wet mud from the Mother Mound and emergence site in Mississippi literally bubbles up from a bowl of rising bread dough in a kitchen in Durant, Oklahoma, the contemporary seat of government for the Choctaw Nation. The sudden appearance of the mud is a "sign from [the] ancestors" to the women gathered in the Billy family kitchen that the time has come to once again call their community to action, to rewrite the colonial scripts of Indigenous history, and, more importantly, to make right problems within the specifically Choctaw past barely understood or completely unknown to the colonizers. "The whole Nanih Waiya area represents the cradle of the Choctawan civilization," explains

Aunt Delores, a contemporary elder and a "modern *foni miko*, bone picker," a singer of traditional funeral songs for the Choctaw dead.[21] "A long time ago people came from all directions to settle there. It takes a sacred space like that to heal a troubled spirit" (161). Similar to Skorodin's suggestive text box on the *Crazy Ind'n* website, in this understanding both the ancient Earth and the ancient earthworks remain productive, generative, alive in the present, actively building Indigenous futures.

Howe situates the scene where bread dough transubstantiates into earth bubbling up from the Mother Mound within chapter 10 of the seventeen-chapter novel, that is, within the chapter immediately following the novel's *hinge* or *fulcrum* at chapter 9, where eight chapters are balanced before and eight chapters balanced after. Chapter 10, the first chapter of the novel's second half, is set in the present of September 24, 1991, two days past the autumnal equinox, the novel's central marker of seasonal time. Howe translates the phenomenon and the significance of the autumnal equinox from the Choctaw term *Itilauichi*, that is, as the time to "make things even" (2). As she explains in a note appended to the end of the narrative:

> Some liberties have been taken with the Choctaw language in the novel. I use the verb *Itilauichi*, meaning "to even," as a noun for "Autumnal Equinox." After studying the historical Choctaw calendar names in Byington's dictionary and in his papers at the Smithsonian, as well as Henry S. Halbert's articles on the Choctaw language and culture, I reasoned that there may have been phrases used by early eighteenth-century Choctaws for the equinoxes that have fallen out of use. Important events for Choctawan people seem to have taken place around the autumnal and vernal equinoxes, and the summer and winter solstices. (225)

As the time "to even," the equinox is the appropriate time to restore balance; moving past the equinox means moving into the next seasonal cycle. Space breaks divide chapter 10 into twelve sections, which help demarcate the chapter's movements among the present conflicts of 1991, Aunt Delores's multiple memories of moments in the historical past, and her vision of multiple points in the more distant past.

Aunt Delores stands in an Oklahoma kitchen kneading bread dough in a bowl: like the Mother Mound and its broader area, including the emergence cave, the round bowl can be read as a microcosm, a "center" place, a symbolic Earth navel, a womb. Aunt Delores's "kneading" of the dough reminds readers that the Choctaw are in *need* not only of renewal but also of spiritual and cultural sustenance. And like the dough animated by living yeast that Aunt Delores works with her hands, the Choctaw, too, will "rise" only if their nurturing work is successful. As she makes conversation with her sister and nieces, Aunt Delores, whose name evokes the Spanish word for "sorrows," remembers herself as a young woman choosing to become a traditional singer for the dead when her own Choctaw mother passes; remembers herself as a young woman struggling with complicated and ultimately unrequited love with Isaac Billy, her nieces' maternal uncle; remembers herself as a young girl captive to the horrors of Indian boarding school.[22] Her vision of the distant Choctaw past occurs in the seventh section: situated just past the chapter's center, just past its own hinge or fulcrum, its own marker of "even," the beginning of the next cycle, moving toward the next seasonal milestone, echoing the positioning of chapter 10 within the larger novel.

The process of Aunt Delores's central vision of earthworks and the distant past begins when she has finished kneading and it is time to shape her dough into rolls. To knead dough, of course, is to mix together its essential ingredients with the hands, more precisely, to mix flour enriched with a leavening agent, such as yeast, with water. But kneading is more than simple mixing. Kneading helps proteins in the flour expand, warms and stretches the resulting strands of gluten, creates tiny pockets of carbon dioxide, adding texture and elasticity, strengthening the dough so that it will rise or "prove." Once this process is complete, a spirit voice speaks to Aunt Delores in Choctaw, telling her that it is time to return to her homeland to bury the recently murdered chief of the contemporary Choctaw Nation, Redford McAlester (157).

Part of what the spirit voice tells Aunt Delores represents a significant revision of dominant archaeological understandings of the deep past:

The gravediggers are wrong. Not all ancient burial mounds were stuffed with beloved leaders. Some contain bad people who were given everything in death that they had coveted in life. Shell beads, copper, axes, knives, pottery bowls, baskets, animal skins, blankets. There were times when good people followed the bad ones into the spirit world to care for them. Like a parent of a spoiled child, they were there to give things to the bad ones. Make them comfortable so that they would not want to leave their resting place and harass the living. (158)

The Choctaw spirit relates two key ideas. First, that elaborate mound interment can represent a methodology of containment for problematic spirits. And second, that a cache of material goods is not always adequate to this task. Sometimes, the willing spirits of "good people" are required to fully secure the vault of the burial mound—that is, to ensure the necessary containment of a spirit that is problematic or violent. Moreover, similar to Hasting Shade's Cherokee account, Howe's Choctaw spirit relates how "gravediggers" and archaeologists have unwittingly disturbed these problematic spirits:

But when the mounds were opened by gravediggers, these flawed spirits escaped like flesh-eating flies. They passed through many changes. Always becoming predatory. Put your dead chief in a mound so he will be protected from escaping again. Give him everything in death he wanted in life. That way he will never leave it again. (158)

Note that a flawed spirit is buried in a secured mound not only for the protection of the community but also for the protection of the flawed spirit itself. The interment is thus an act of care meant to promote personal as well as communal healing.

As Aunt Delores receives this knowledge and instruction, the bowl of dough becomes hot in her hands, glows "red like the coals of a fire," evoking the central sacred fire around which Southeastern peoples designed their towns and built their communities (158). Aunt Delores then sees herself when she was thirteen years old. In this part of the vision she watches herself at home from boarding school, polishing her mother's iconic Queen

Anne table, a point of pride, since it represents the Choctaw family's "first attempt at buying colonial" (158). As she works to clean the ornate and highly prized piece of furniture, dust turns first to "layers of dirt," then "handfuls of Earth," until the thirteen-year-old Delores "begins filling basket after basket and still the Earth grows higher and spreads like a lake of mud," covering— *consuming*—the table and all it stands for (159). At this point "relatives" appear to help the thirteen-year-old girl in this "earth" work. These relatives are figured not in terms of conventional kinship markers, however, but rather as "memories," "thoughts," "voices," and "arguments," which are further delineated by their distinctive clothing and technologies—"Memories dressed in thick bear skins with ice in their hair. Thoughts with gorgets made of mastodon toes around their necks"—which suggest they represent distant and ancient generations. Next, "the grandparents of tribes" arrive to offer their help, too, and their generations move through a series of additional technologies, from "blow guns" to "a giant yellow Caterpillar [tractor] with four wheels the size of houses" (159). "Together with a thousand hands," these multiple Choctaw generations from the distant past to the present "open Mother Earth's beautiful body." In response, "Mother Earth turns herself inside out and a gigantic platform mound emerges out of the ground" (159). Aunt Delores thus witnesses the conversion of a colonial construction, her mother's finely wrought but delicate Queen Anne table, into the building materials for an Indigenous civilization. Moreover, she witnesses the creation of the Nanih Waiya as a collaborative project, the multigenerational human community and the Earth working together to produce a "sacred ovulation," a "gift" for the future (159). When Aunt Delores returns from her vision to the contemporary kitchen, the dough rising in her bowl has literally "turned to mud," physically linking the generations of Choctaw women gathered in Durant, Oklahoma, to the Mother Mound and its environs in Mississippi (160). The risen dough become mud continues to bubble from the bowl, from the microcosm and center place, from the symbolic navel and womb—a generative source of the Earth's and the people's collective power.

Within the larger plot of the novel the scene is significant for how it propels the characters toward multiple resolutions, which involve burying

the murdered body of discredited Choctaw chief Redford McAlester in a mound near the Nanih Waiya in Mississippi and, in the process, reuniting a divided Choctaw Nation. Moreover, Aunt Delores and her nieces' Uncle Isaac, the object of her long unrequited love, are finally brought together in order to perform the important role of accompanying the chief's spirit so that he will stay at rest in the mound. In chapter 16, within another vision—this time experienced by Delores's niece Auda Billy, the former assistant chief and former romantic partner of McAlester who has been accused of the chief's murder—Isaac says of his and Delores's own murders at the hands of McAlester's criminal associates: "This is what was meant to happen. . . . Someone must remain with the chief and help him to stay put" (212–13). But the scene of mud bubbling from a bread bowl is significant, as well, for how it articulates Indigenous understandings of the complex technological, spiritual, and symbolic power of earthworks and how it makes of these understandings not dead artifacts to be discussed in archaeological textbooks and displayed in museums to the past, but rather living, active entities for the present and future.

NARRATING PAST TIME

At the head of each of *Shell Shaker*'s seventeen chapters, below its evocative title, Howe indicates a primary location and a date or dates for the chapter's primary action. When relevant, she indicates as well that the action occurs on the autumnal equinox (chapters 1 and 2) or on the winter solstice (chapter 8).[23] If we map this macrostructure we can create a table that, like an architectural schematic, reveals the multiple structural patterns and sets of structural relations Howe develops across the chapters. In Figure 33, the columns indicate each chapter's title, the year in which the primary action is set, the specific date or dates of the action (if designated), and the specific location or locations of the action (again, if designated). The final column records my own accounting of where each chapter fits within the three broad periods of *time* into which Howe divides her story: the historical "past" of the 1730s and 1740s, the historical "present" of September 22–26, 1991, and what I am calling the "no time," which exists *outside* the

Chapter	Title	Year	Date(s)	Location(s)	Time
1	Blood Sacrifice	1738	9/22 Autumnal Equinox	Yanabi	past #1
2	The Will to Power	1991	9/22 Autumnal Equinox	Durant	present #1
3	Intek Aliha, The Sisterhood	1991	9/22–23	Dallas/New Orleans	present #2
4	Choctough	1991	9/23	Durant	present #3
5	Prayers for the Mother	1991	9/24	Durant	present #4
6	Koi Chitto, The Bone Picker	1738	December	Gulf Coast	past #2
7	Penance	1991	9/24	Durant	**present #5**
8	A Road of Stars	1738	Winter Solstice	Yanabi	past #3
9	Borrowed Time	1991	9/24	Durant	present #6
10	Funerals by Delores	1991	9/24	Durant	present #7
11	Black Time	1747	6/21	Panther	past #4
12	Suspended Animation	none	none	Talihina	no time #1
13	The Nanih Waiya	1991	9/26	Mississippi	present #8
14	Road of Darkness	none	none	Talihina	no time #2
15	Heart of the Panther	1991	9/26	none/ Durant	present #9
16	Absolution	none	none	Talihina	no time #3
17	The Shell Shaker	none	none	none	no time #4

FIGURE 33. The macrostructure for *Shell Shaker*, indicating chapter number; chapter title; year, dates, and locations of the primary action; and sense of "time." Boldface marks two of the novel's obvious structural *hinges* or *fulcrums*.

linear designations of a chronological "history." In addition, I have added spacing to further demarcate the novel's shifts among these broad temporal periods, and I have added boldface to indicate the novel's two obvious *hinges* or *fulcrums*. As I explain below, one of these occurs at chapter 9, the center of the novel's seventeen numbered chapters, while another occurs at chapter 7, which is simultaneously the fifth or center chapter within the novel's sequence of nine chapters set in the historical "present."

Within this macrostructure, four of the novel's seventeen chapters are set in the historical "past" (1, 6, 8, and 11), nine are set in the historical "present" (2, 3, 4, 5, 7, 9, 10, 13, and 15), and four are set in the "no time" that exists outside chronology's strict linearity, allowing aspects of the "past" and "present" to intersect, overlap, or superimpose within a single plane (12, 14, 16, and 17). Written as a simple equation, the macrostructure can be expressed as $17 = 4 + 9 + 4$, *seventeen chapters equals four "pasts" plus nine "presents" plus four "no times,"* which highlights the novel's structural balance as well as its highly constructed symmetries along a complex axis of "time." As readers will recall from discussions in previous chapters about the mathematical relationships significant to Hedge Coke's highly encoded poetic sequence *Blood Run*, 17 is the seventh prime, 4 is the square of the first and only even prime (2×2), and 9 is the square of the second prime (3×3).[24] And as noted in the discussion of Delores's vision, nine is significant as the central *hinge* or *fulcrum* for the seventeen chapters. A second central hinge or fulcrum occurs in the fifth chapter within the sequence of the nine chapters set during the historical "present" of 1991 (2, 3, 4, 5, 7, 9, 10, 13, and 15), chapter 7, where four "present" chapters are balanced before and four after. In other words, the novel's complex center itself has a significant center. The macrostructure's simple equation can thus be expanded, by means of the associative property of addition, as the more elaborate equation $17 = 4 + (4 + 1 + 4) + 4$, *seventeen chapters equals four "pasts" plus four-plus-one-plus-four "presents" plus four "no times,"* further highlighting the complexity of the novel's structural balance and its multiple symmetries developed around the axis designated "time."

The two fulcrums within the novel's macrostructure, 9 (the midpoint of the 17 total chapters) and 5 (the midpoint of the 9 chapters set in the

"present"), may appear incidental, but they map onto the novel's primary temporal intersection of the years 1738 in the historical "past" and 1991 in the historical "present" through the *seasonal* time marker of the autumnal equinox. Although the novel names the equinox *Itilauichi* and declares that it is the appropriate time to make things "even," the significant dates are separated by 253 years, an odd number that is also a semiprime, that is, the product of two prime numbers. The number 253 factors as 23 x 11—the *ninth* prime multiplied by the *fifth*—again emphasizing a structural convergence through the numbers 9 and 5. These structural alignments are admittedly subtle—perhaps extremely so—but they contribute to the novel's overall project of demonstrating Indigenous connections and continuities *within Indigenous epistemologies* and *within Indigenous systems of encoding* and thus *on Indigenous terms* across both space *and* time.

As the above discussion should make clear, the table helps highlight the novel's complex structural patterning, especially, around the axis we call "time." The novel begins with a chapter set in the historical "past" but then moves into the historical "present" for four chapters, allowing Howe to establish the novel's central characters and primary plot elements before returning to the significant "past"; the novel then alternates between the "past" and the "present" with some (although not complete) regularity. The fourth (and final) chapter set in the historical "past" is chapter 11 (the fifth prime), structurally aligning it with the center of the chapters set in the historical "present" (i.e., chapter 7, the *fourth* prime). The remaining six chapters then alternate—irregularly—among two chapters set in the "present" (13 and 15) and four chapters set in the "no time" where the "past" and "present" intersect, overlap, and superimpose (12, 14, 16, and 17). As already suggested, the complex equation $17 = 4 + (4 + 1 + 4) + 4$ indicates that chapter 7, "Penance" can be read as one of the novel's multiple structural "centers." Thematically, this is the chapter in which Howe argues for drawing a crucial distinction between the concepts of "making even" and "getting even," between restoring necessary balance and exacting problematic revenge (see, especially, 112–13). The chapter's oblique alignment with chapter 11, "Black Time," set in the historical "past," can also be understood through the lens of this crucial distinction. The eighteenth-century character Anoleta, who

aligns with the twentieth-century character Auda as a first-born Choctaw daughter, desires nothing less than a "blood revenge" on the eighteenth-century corrupt warrior Red Shoes, who aligns with the twentieth-century corrupt chief Red McAlester (188).

As other scholars have noted in some detail, Howe's novel is structured as an elaborate set of parallels and alignments across space and time: characters and actions from the significant "past" of the 1730s and 1740s in the Southeast recur in similar but altered forms in the "present" of the 1990s in southeastern Oklahoma. The eighteenth-century Choctaw matriarch Shakbatina, her brother Nitakechi, her husband, Koi Chitto, and their three daughters, Anoleta, Neshoba, and Haya, recur in the twentieth century as the Choctaw matriarch Susan Billy, her brother Isaac Billy, her (deceased) husband, Presley War Maker, and their three daughters, Auda, Adair, and Tema. The divisive eighteenth-century Choctaw warrior Red Shoes recurs as the divisive and corrupt twentieth-century Choctaw chief Red McAlester. And so on. Across the novel's seventeen chapters, earthworks make significant appearances in chapter 10, "Funerals by Delores" (set in the historical "present" but detailing Delores's vision of both historical and distant "pasts"), and chapter 13, "The Nanih Waiya" (again set in the historical "present" but evoking the significant Choctaw "past").

It is in chapter 13 that Howe brings a central part of her narrative to closure. The body of the murdered chief and the bubbling mud from the bread bowl have been driven from Oklahoma to Mississippi, led by a newly married Aunt Delores and Uncle Isaac—finally united "after a fifty-year courtship"—who lead a seven-vehicle caravan to the Southeastern homeland, to the Choctaw Mother Mound and place of emergence. There, they meet for the first time their Southeastern Choctaw relatives, including Earl Billy, a distant cousin, who have gathered at the center place of the Nanih Waiya to assist the Oklahoma Choctaw in their important endeavor:

> "We're going into a swampy area," [Earl Billy] says. "We had to use a backhoe to dig such a large hole. We're going to put your chief and his things in the ground, cover it up with the mud you're hauling, then let

Mother Nature take it from there. We'll hold the ceremony back here.
Maybe McAlester will stay put that way." (195)

McAlester's murder in Oklahoma and burial in Mississippi reunite the long-divided Choctaw Nation. The discredited chief's body and all his coveted, prized possessions—"clothes, ties, shoes, golf clubs, magazines, a computer, and an office copier," plus "a large nylon bag" filled with ill-gotten money stolen from the mob (194)—are buried deep in wet earth, "a swampy area," and then covered by the wet "mud" hauled to Mississippi from Oklahoma. As the divided Choctaw reunite through McAlester's death and burial, so too does the Earth herself. "The black earth of the mound is soft and open from recent rains," the narrator relates, "like the pores of skin" (193). The detail of wet soils—the Nanih Waiya soaked with rain, the "swampy area" close by where they will bury McAlester's body and possessions, the "mud" hauled from Oklahoma—is significant. The burial is not simply in dirt, but in the generative, supersaturated soils brought up from beneath water. As discussed in previous chapters, these soils evoke the story of the Earth Diver and the original creation of the land. In this way, the mud from Mississippi bubbling up in a bread bowl in Oklahoma signifies new creation alongside enduring vision. Delores has seen into the past, but she has also helped her community to imagine its possible future. The mud from Mississippi collapses these distinctions. The scene and the chapter end with the significant performance of reunion: "Delores slows down her breathing as she's done a hundred times before in preparation for singing the songs for the dead. But her gaze shifts and she sees the afternoon sunlight dancing around them, as if birthing new life. She exhales, pushing all herself out of her body and, in this moment, she feels a miraculous beginning as she and the other Chahta women of the Southeast join hands and sing" (197).

EARTHWORKS AS INTERFACE

Within Indigenous contexts, how might we understand the work of *representation* as correlated to but also distinct from the work of *relation*? Mounds

produce meaning both as material objects in the physical world and as significant ideas and principal concepts within multiple intellectual and spiritual systems. But mounds also function as highly structured environments, highly encoded spaces, elaborate sets of relationships—spatial *and* temporal—places where worlds and generations can intersect, overlap, superimpose. I think again of Alyssa Hinton's photo-collage *Ancestral Plane*, the electric-blue embryo suspended in pixilated amniotic soils above the bodies of interred ancestors that radiate like topographic heat maps. And I think again of Allison Hedge Coke's sequence of interrelated poems *Blood Run*, how the book's multiple structures and alignments emphasize the *theatricality*, the quality of performance, inherent in earthworks sites, complexes, and cities. Earthworks sites are inherently spheres for multiple kinds of interaction, arenas for the performance of multiple kinds of relations. More than sites of simple replication, they are sites of potential regeneration.

Over time I have come to the idea that, among their many functions, mounds operate as a type of *interface*, not unlike the interface on a computer screen. In other words, mounds serve not only as nodes within networked systems, but also as points where multiple systems meet and interact. Moreover, in their role as structures for making connections across worlds and generations, mounds operate similarly to a computer interface in the sense that they enable communication between disparate structures. In her fascinating essay "Reading Interface," Johanna Drucker, a non-Native scholar of information studies and digital aesthetics, describes our attempts to understand and thus to "read" the interface on a computer screen in these terms:

> Our task is to understand how they [interfaces] organize our relation to complex systems (rather than how they represent them) and, maybe more important but less tangible, to understand how an interface works as a boundary space (though it masquerades as a reified image or menu of options). As the double entendre of my title suggests, we face the challenge of reading interface as an object and of understanding it as a space that constitutes reading as an activity.[25]

Following discussions in chapters 4 and 5, focused around burials, and building from the discussion in chapter 3, built around living earthworks vocabularies, we might say that burial mounds do not *represent* the possibility of Indigenous rebirth so much as help organize the human community's *relation* to a complex system involving birth, death, and the potential for rebirth or other forms of return. Similarly, we might say that burial mounds do not *represent* portals or conduits between worlds so much as help organize the human community's *relation* to the possibilities and potential of such connections and intersections. This is perhaps another way of stating that the social, artistic, and spiritual functions of mounds are not simply metaphorical, not simply figurative or tropic, at least not in the typical ways we understand the functions of literary metaphors, figures, and tropes.

In her analysis of our human relationships to the computer's interface, Drucker states:

> We manipulate hidden circuits, chips, and processors by using icons that serve as *metaphors once removed*, logical analogues to behaviors whose cues we can follow by inference. I know that if I see a file folder on-screen I can place something in it. That folder is a behavioral cue, *not a representation either poetic or literal.* Icons do not show the processes that make them functional. (216, emphasis added)

Indigenous mounds may also function in this way, as "metaphors once removed"—as metaphors *from other generations*, from other degrees of abstraction, from other epistemologies—as behavioral cues rather than as either poetic or literal representations. As noted from the very beginning of *Earthworks Rising*, Howe has been arguing that earthworks function primarily as sites of *return*. The physical presences of mounds have always served as cues for significant human behavior that crosses and re-crosses space and time, seasons and generations, the living and the dead.

CODA 3

Trans-worlds Performance

> History is present. Time is a variable. While the Indian past seems long ago to other Americans, it is a constant in the daily minds of our own people. . . . We know this land is a living being and we walk on the blood of our histories.
>
> – Linda Hogan, "New Trees, New Medicines, New Wars: The Chickasaw Removal" (2015)

Over the years of our collaboration, LeAnne Howe has regularly reminded the artistic team supporting *Sideshow Freaks and Circus Injuns* that it is important for us to travel. Hundreds and thousands of years ago, Indigenous peoples moved from mound to mound, from one earthworks complex to another. The ancestors traveled for annual visits and special occasions, for important social and political events, for astronomical observations, for economic, artistic, and intellectual exchange. Especially relevant for our project, they appear to have traveled from community to community to analyze other examples of earthen structures and to conduct research among other builders—to swap innovations with designers, architects, and engineers, to talk shop with materials experts and construction managers, to learn techniques from laborers. It was their version of what we know as professional conferencing. Our inquiry, too, Howe emphasized, should be grounded in purposeful movement.

It was in that spirit of inquisitive travel that, in May 2013, my Ohio State colleague Marti Chaatsmith and I took Howe and fellow researcher Monique Mojica to visit the celebrated (if misnamed) Alligator effigy crouched on a bluff above Granville, Ohio, and to visit the celebrated Great Circle and its companion geometrical figures arranged in the valley that contains Newark, Ohio. After these evocative trips that followed well-worn paths northeast of Ohio's capital, Columbus, we then drove Howe

and Mojica northwest of the city to conduct additional research among a group of relatively obscure burial mounds and geometric enclosures sited near the banks of the Scioto River. These structures had only recently reentered public discourse and become more accessible to visitors; Chaatsmith had already seen them, but only once; like Howe and Mojica, I had not yet had the opportunity. This detail is not insignificant: as noted throughout *Earthworks Rising,* Native peoples have been cut off from their ancient and historic sites for generations—physically removed from their presence, denied access to their encoded knowledge, excluded from their upkeep and care. In too many instances, access of any kind is only being regained now.

Since the nineteenth century, when they were first mapped, this particular group of mounds has been known as Holder-Wright, although, subsequent to our visit, the site was slated to be renamed Ferris-Wright Park and Hopewell Earthworks.[1] (All of these names, as is typical, acknowledge the settler families who dug, plowed, looted, or bulldozed the mounds toward partial destruction or full erasure, not their builders, original users, or subsequent caretakers.) And although the site's location must have seemed remote to early non-Native explorers and settlers, today Holder-Wright sits adjacent to the northwest arc of Interstate 270—Columbus's bustling, multi-lane outer belt constructed at great expense between 1962 and 1975, which forms a loop around the city and helps demarcate the core of its metropolitan area—about a mile outside the historical center of Dublin, one of the several small towns the interstate has transformed into Columbus suburbs. What remain of the five burial mounds and three geometric enclosures at Holder-Wright are available for viewing only because they happen to stand within some of the area's last intact farmland. Homesteaded by Joseph Ferris in 1818, the approximately forty-seven acres straddle a picturesque creek known as Wright's Run, notable for small waterfalls, limestone cliffs, and a system of caves. The creek flows west to join the nearby Scioto River just south of a wide expanse of level shoreline that has been a canoe access point for centuries if not millennia. Fortunately, this natural launch has been preserved as part of Scioto Park, where it now sits under the watchful gaze of a twelve-foot-high, massive limestone monument, erected in 1990, depicting the silhouette of the storied eighteenth- and nineteenth-

century chief of the Wyandot known to settlers as Leatherlips (1732–1810).[2] The Scioto flows south through what is now downtown Columbus to eventually join the Ohio; Holder-Wright was no lonely outpost, no cut-off backwater, but rather an accessible node within a larger network.

Despite their preservation, as at other sites in the region the remnants of mounds and enclosures at Holder-Wright are literally surrounded by non-Native civilization. Neighboring farms, also homesteaded in the nineteenth century, were sold off one by one as the descendants of the original Irish and other settlers abandoned small-scale agriculture and moved on. Over time, the farms were amalgamated by new owners, then, with the planning and building of the interstate, subdivided once again into tracts for suburban housing. Although Ferris's Holder and Wright descendants had deeded this last section of "undeveloped" land to the city of Dublin with the stipulation that it be made into a public park, and thus had protected the site from the asphalt and concrete of yet another subdivision, their contemporary act could not undo nearly two centuries of active farming. Some of the mounds had been plowed, sown, and harvested for generations; others had been completely or partially destroyed in the building of a frame house and other structures. Moreover, local history reports how the mounds were repeatedly "explored" by curious settlers in the early and mid-nineteenth century; already disturbed, they were then subject to more systematic excavations by professional archaeologists, first in 1890, then in the 1920s, again in the 1960s, and more recently during archaeological field schools led by Ohio State faculty in 2013, 2014, and 2016. At the time of our visit in May 2013, the earthwork that remained most physically conspicuous was a crescent-shaped embankment from what had once been a large circular enclosure; damaged and diminished, the earthen arc nonetheless stood defiantly extant near the farmhouse. In an adjacent field, fallow and brown, darker outlines of what had once been a similarly large square embankment and the conical burial mound it enclosed were still visible on the turned soil, although only as faint traces.[3]

Our visit to Holder-Wright was facilitated by a well-informed Dublin city park ranger, who led us on a pleasant walking tour around the old house, silo, and outbuildings, through the fallow fields, and along accessible

parts of the creek bank. He described what he knew of the site's history—including a tantalizing story of the discovery, in one of the larger limestone caves, of six complete skeletons of canines, the dogs apparently arranged as guardians—and what were then early plans for converting the defunct farm into an earthworks-themed historical park and interpretive center. Once the formal tour was complete, the ranger allowed us to spend additional time at the site; Howe and Mojica were now able to engage in embodied research and improvisation. They walked the land again on their own, individually and together, without the ranger's directions or running commentary. After a time, each described feeling a distinctly female energy emanating from what remained of the square enclosure and its conical mound. And remarkably, while Chaatsmith and I made polite conversation with the ranger, the researchers were able to gather a song from this part of the site that they will incorporate into their evolving performance. I photographed Howe and Mojica crouched low on what appeared to be barren ground as they recorded themselves singing the ancient song into a smartphone. The song, they later explained, had risen from the razed but still encoded earth to ride the wind skyward, traversing and thus linking the three worlds. They were certain the high-pitched song had been sung by a young girl. Howe subsequently began referring to the razed square and the trace of its enclosed burial as the Little Girl's Mound.[4]

As at other sites where they have received song, Howe and Mojica's experience at Holder-Wright confirmed a central Indigenous understanding about the ongoing vitality of ancient earthworks. It was not only selected rocks and soils that were carefully layered in the building of these structures; words were spoken and chanted, songs were sung, dances were danced *into* earth during the preparation of carefully chosen sites for construction, during the preparation of soils carefully selected and then carefully gathered as materials for building. Words were spoken and chanted, songs were sung, and dances were danced into earth once again during actual mound construction, during subsequent ceremony, during regular upkeep, maintenance, and renewal. In these ways, layers of packed rocks and soils were imbued with the power of sacred discourse, the energy of rhyth-

mic movement. It is this communal power and energy that prepared the earth and helped build the mounds. It is this communal power and energy that continues to sustain their extant remains, their remnants and traces.[5]

The image I made of Howe and Mojica singing upon the trace of the Little Girl's Mound is difficult to translate into words. Simultaneously, the image describes an event of embodied research *about* performance, an event of embodied research *and* performance, an event of embodied research *as* performance. Neither the photograph I took nor the audio recording the researchers themselves produced, however, conveys the full complexity of this scene of embodied improvisation. Howe and Mojica crouched upon the repeatedly plowed earth, sang into the rising wind, and recorded their voices on a smartphone only a few yards in front of me, slightly to my left. But just behind me, to my right, stood the park ranger who had guided our formal tour of the homestead and farm, only recently acquired by the city of Dublin, and he was now explaining in more detail how the site could become a public park, with walking trails and children's playground equipment, with rain gardens of indigenous plants and restored or perhaps newly constructed earthworks, with the 1820 farmhouse converted into a state-of-the-art interpretive center. The Native women's impromptu performance made the ranger obviously uncomfortable. Although he did not comment explicitly on the women's unexpected actions unfolding before us, he continued to speak directly into my ear when first one and then the other caught the ancient rhythm, sought ground, and began to sing. As the women's separate voices united into one, the ranger's volume increased; his voice grew louder and then louder still as he continued to enumerate park regulations and possibilities, to describe the difficulties of managing sites at remote locations.

Desecrated and nearly destroyed, the earthworks refused to remain silent. The Little Girl's Mound offered her voice to those who would hear, but the ranger seemed unable to stop talking, even to lower his volume. I don't think he meant disrespect. His actions embodied the experience of a cognitive dissonance, of a physical disconnect from earth that only moments before had seemed so familiar and under rational control. An asset to be

managed. As the women crouched and sang, the sterile metes and bounds of the Dublin plat map were receding before him, and new maps, layered from moist and fecund earth, were rising. For my part, in that moment of trying to remain polite without succumbing to the ranger's volume or vision, in that moment of trying to listen and see and remember, to record Howe's and Mojica's presence and actions in their fullness, I was caught in an embodied experience of my own. I stood literally between competing discourses and performances. It was a situation, I would realize only later, that is not unlike that of the mounds and enclosures at Holder-Wright—or of the myriad earthworks located along the waterways of central and southern Ohio, or spread across the eastern half of the North American continent. In all these places, what remain of ancient mounds stand caught between communal, gendered, and multidimensional Indigenous performances, on the one hand, and, on the other, a patriarchal, non-Native insistence, an authoritative settler monologue, that seeks to overpower all other voices, all other visions and understandings. But cannot—at least not fully.

Efforts to perceive, engage, research, appreciate, understand, and explain earthworks and both their original and ongoing significance *from Indigenous perspectives* continue to be similarly spoken over, similarly sidelined and devalued, often in similar terms, even—or perhaps especially—within the discourses of the dominant academy. Standard archaeological, anthropological, and historical narratives, produced almost exclusively by non-Native (and predominantly male) scholars, continue to dominate authoritative discourses and continue to direct major funding for research and preservation. But despite these persistent impediments, we find ourselves in an extraordinary period of possibility. Earthworks seem suddenly to be on every (Indigenous) body's mind: not only trained archaeologists, anthropologists, and historians, park rangers and museum curators, but artists, writers, and performers, public intellectuals and activists, communities and nations and their keepers of knowledge, story, and ceremony. In diverse works of art, in texts and performances, in built environments, knowledge encoded in Indigenous pasts is being reactivated in the present in order to rewrite Indigenous futures. These contemporary produc-

tions respond to dominant discourses—which typically code earthworks as silent, static, and dead, cut off from living Indigenous communities—by recoding earthworks as vital and alive, as articulate, generative, and in motion. They encode earthworks as sites not of stasis and death but of ancient and ongoing energy.

Earthworks Uprising

Decolonization is not an "and." It is an elsewhere.

> — Eve Tuck and K. Wayne Yang, "Decolonization Is Not
> a Metaphor" (2012)

It is not a remythologizing of space that is occurring, such as is often performed by nationalist groups, but a (re)mapping that addresses the violent atrocities while defining Native futures.

> — Mishuana Goeman, *Mark My Words: Native Women
> Mapping Our Nations* (2013)

My people are out on the land, even if we are criminalized, even if we have to ask settlers for false permission, even though the land is not pristine, even though, even though. This is in part because within Nishnaabeg thought, the opposite of dispossession is not possession, it is deep, reciprocal, consensual attachment.

> — Leanne Betasamosake Simpson, *As We Have Always
> Done: Indigenous Freedom through Radical Resistance* (2017)

The Southeast was covered with Mississippian mound builder cities and communities a century before the Spanish arrived in the Southeast. The Southeast is still covered with the remains of mounds. . . . These mounds might be leveled by shovels, tractors or hate, but they will show up on any energetic geophysical map. They continue to exist in memory, in memory maps.

> — Joy Harjo, *An American Sunrise* (2019)

This is what return looks like and how it feels: an autumn day of rain and low cloud in central Oklahoma *(people red earth)*, nations gathering along the banks of the river highway, relations meeting at the crossing places of roads traveled for generations, preparing themselves and the land for the reclamation that is not simply promised but already begun. This is Indigenous

world-building on a grand scale: sky intersecting earth intersecting water. This is reactivation of our mound-building cultures.

In October 2019, I make a quick visit home to south-central Oklahoma to see family and meet with research colleagues and work toward a full draft of my manuscript. My time for writing is interrupted, however, by the opportunity to tour the American Indian Cultural Center and Museum (AICCM) under construction in Oklahoma City, scheduled to open in 2021 under the guidance of director James Pepper Henry (Kaw and Muscogee Creek) and his extraordinary team of Native curators. The complex has since been renamed the First Americans Museum (FAM). Despite the intermittently heavy rain, the opportunity is more than worth the extra drive each direction. I have been hearing about the new museum for several years— the exciting conception and early building, the loss of promised federal and state funding and the stalling out of the work, the raising of new funds and the renewal of activity—but somehow I have not actually seen the site or its structures.[1] It wasn't time. Now that I am moving my book toward conclusion, this behind-the-scenes tour is both a surprise and a gift.

Rising along an urban stretch of the Canadian River marked by an honorific as the Oklahoma River, the massive facility that will commemorate the thirty-nine federally recognized tribes in what is now Oklahoma, formerly the Indian Territory, is aligned to the cardinal directions, its front doors opening east to sunrise. And appropriately, given the complexities of Indigenous migrations and forced removals, the museum is situated at the major transportation junction where Interstate 35 (running north and south between Texas and Minnesota) crosses Interstate 40 (running east and west between California and North Carolina). Not that long ago, this auspicious interchange was marked by grimy oil fields and processing plants, dumping grounds for old tires and toxic waste, multiple areas designated as Superfund sites. Reclaimed, the riverbank and floodplain are slowly restoring to productive bottomland, slowly inviting fish and insects, reptiles and birds and other animals, slowly coming back to life.

The design for the museum's three-hundred-acre campus is a version of a life-evoking spiral, a series of interlocking arcs and partial circles of in-

door and outdoor spaces. There will be exhibit halls and art galleries, high-tech theaters for live and recorded performances, areas specially designed for children to play and learn, gift shops to promote the work of Native artists, cafés to nourish bodies, spirits, and memories with updated versions of traditional foods. There will be spaces for social, political, and intellectual exchange, for ceremony and celebration. The most striking feature, visible from the bustling crossroads of the highways, is an enormous "promontory mound" that forms one of the open circles (Plate 18). This 1,780-foot embankment of packed earth curves around a thousand-foot diameter of grass, creating a plaza and festival grounds. A centering place. Opening north to the river, the spiraling mound gradually ascends to a height of ninety feet at the promontory, and it is aligned to the seasonal time of the winter and summer solstices. At sunset on the shortest day of the Northern Hemisphere's solar year, about December 21, beams of evening's last light shoot through a tunnel constructed precisely at the right location along the embankment's arc (Plate 19). At sunset on the longest day of the Northern Hemisphere's solar year, about June 21, the ball of the evening sun sets precisely behind the high point of the promontory's ninety-foot concluding ledge.

When Jim Pepper Henry explains the alignments to me, shows me photos on his phone of the sunset in action at the previous winter solstice, I immediately think of Linda Hogan's poem "The Maps," which I had read literally the day before. The poem is included in the handsome catalog for *Visual Voices: Contemporary Chickasaw Art*, a joint venture by the Chickasaw Nation and the (then) AICCM.[2] Although I missed the exhibit's 2018 run at the Fred Jones Jr. Museum of Art in Norman, I had picked up the catalog at the Chickasaw Nation Welcome Center, a rest stop on I-35 near Davis, as I drove south to my parents' home from the airport in Oklahoma City.[3] Hogan's poem details an event of ancestral return to the mounds:

> When I went to the return of our ancestors
> to the dozed open earthen mounds
> the bones were wrapped in white, all clean

as if held in dry caves on a ledge.
Near this same place they were found
they are returned.

Toward the end of the poem, after imagining what our world might look like now if the old traditions had been allowed to continue, renew, and flourish, after imagining what "the map" might look like now "if the beaver had been left alone / to make the meadows and the river / all with their own ways of coursing through the land, / changing it to their will not ours," Hogan imagines a mound strikingly similar to the new museum's spiraling promontory:

mounds shaped to eagles, turtles, water spider,
or the place light still enters on one side
and walks toward a great bowl of water,
and the sky watchers know what stars tell others
and where the milky way takes us back
to the fold of the galaxy, a spiral trail souls follow
when they walk away from the rise of body rib.

In Oklahoma City, now, there is once again a "place light still enters on one side / and walks toward . . . water." Fittingly, this place is part of an earth-spiral that mirrors the great sky-spiral of the Milky Way.

On the day of my autumn visit, clouds and mist hang low over the site and the distant outline of the city. The three worlds—sky, earth, and water—feel very close. Walking through the grounds and structures still in their becoming, and especially walking the sloped arc of the promontory mound, is exhilarating. Native artists have been commissioned to design the museum's exhibits and interactive spaces. As part of my tour, Henry and I briefly join a small group who take notes and make measurements as the master Caddo potter Jereldine Redcorn walks through the still-bare, still-open space of the main hall, gesturing and speaking into reality her vision for how the future pottery exhibit should look and feel.[4] This is Indigenous design and construction in the twenty-first century, I reflect. This is the ac-

tive extension of ancient traditions, old stories told through new materials and contemporary building techniques, old stories expanded through the incorporation of new ideas—new *Indigenous* ideas. This is an earthworks complex built for the twenty-first century and beyond. As LeAnne Howe and Jim Wilson wrote in 2015 during an earlier phase of construction, "new cultural complexes in Oklahoma like the Chickasaw Cultural Center [CCC] in Sulphur or the American Indian Cultural Center and Museum in Oklahoma City, foster Native return and renewal. . . . Mound cities, whether in the ancient past or the 21st century, affirm Native peoples as ever alive and ever present."[5] First the CCC, now the FAM, and soon, Howe tells me, a new "community mound" being built in Atoka by the Choctaw Nation—and, undoubtedly, more to come.[6]

Rising within warm autumnal mists and light rain, the promontory mound feels like something out of a sci-fi movie, like something out of a work of speculative fiction. Seamlessly incorporated into the arc of the primary museum building's outdoor veranda, an extension of its graceful incline and curve, the promontory makes me think of an earthworks-cyborg (Plate 20). The living earth of the spiraling mound and the high-tech building alive with Indigenous ideas are co-constitutive. Both conceptually and structurally, the entirety of the complex is undeniably future-oriented. Indeed, the FAM's hybrid material structure embodies the idea that all Indigenous earthworks, built across thousands of North American miles and across thousands of North American years, have always been oriented to the future. Always.

NOTES

INTRODUCTION

1. Upper Mississippian, also known as Oneota, is an archaeological designation. I discuss the Blood Run site and Hedge Coke's work in more detail in chapters 1, 2, and 4.

2. Abenaki scholar Lisa Brooks demonstrates Indigenous networks connected by trails, rivers, and streams in *The Common Pot*.

3. Shetrone was an Ohio-based reporter with no formal training in archaeology who apprenticed under William C. Mills (1860–1928), an amateur archaeologist formally trained as a pharmacist. Mills, who had become the Ohio Historical Society's curator of archaeology in 1898, hired Shetrone as an assistant in 1913; Mills then appointed Shetrone curator of archaeology when he became the society's inaugural director in 1921. Shetrone succeeded Mills as director upon the elder man's death in 1928; Shetrone then served in the position until his retirement in 1947. See Lynott, *Hopewell Ceremonial Landscapes of Ohio*, 9.

4. Shetrone, *The Mound-Builders*, 471. Hereafter cited parenthetically in the text.

5. Another useful account is Kolodny, "Fictions of American Prehistory."

6. Stuart, "A Southeast Village in 1491," 54.

7. Wallace, foreword, 11.

8. This kind of building is not limited to the Americas, and evidence of ancient earthworks is found across the planet, including in Europe and Asia. A 2015 article in the *New York Times*, for example, details the "revelation" of "colossal earthworks" in Kazakhstan. See Ralph Blumenthal, "NASA Adds to Evidence of Mysterious Ancient Earthworks," *New York Times*, October 30, 2015.

9. Here and throughout the book, I follow Tewa scholar Gregory Cajete's definition for Native science: "a metaphor for a wide range of tribal processes of perceiving, thinking, acting, and 'coming to know' that have evolved through human experience with the natural world. Native science is born of a lived and storied participation with the natural landscape. To gain a sense of Native science one must *participate* with the natural world" (*Native Science*, 2).

10. Elsewhere I write about the irony of the country club's beginnings at precisely the same time as the formation of the Society of American Indians, the first national Native American rights organization led by American Indians, which held its first

meetings on the campus of Ohio State and visited earthworks in central Ohio in 1911. See Allen, "Introduction"; also see Chaatsmith, "Singing at a Center."

11. Additional mounds in Ohio are also typically referred to as effigies, although archaeologists have been unable to verify their status. A much larger number of effigy mounds are located in what are now the states of Wisconsin and Iowa.

12. The name *Cahokia* was ascribed to the site in the eighteenth century, a reference to the then local Cahokia Indians, who were related to the Illini.

13. See Toner, "City of the Moon."

14. See, for instance, Hively and Horn, "Geometry and Astronomy," and Lepper, *The Newark Earthworks*.

15. See Hively and Horn, "The Newark Earthworks."

16. For an early account of the research establishing the so-called Great Hopewell Road, see Lepper, "Tracking Ohio's Great Hopewell Road"; for a subsequent account see Lepper, "The Great Hopewell Road." Also see Lynott, *Hopewell Ceremonial Landscapes of Ohio*, 86–88. In 2009, as part of a project to bring greater attention to the Road, the Newark Earthworks Center at Ohio State University Newark engaged Native cartographer Margaret Wickens Pearce (Citizen Band Potawatomi) to create a series of maps under the heading "Walk with the Ancients." Over part of that summer, a group of faculty, staff, students, and community members would walk a route between the sites at Newark and Chillicothe, using contemporary roads, that would follow the Great Hopewell Road as closely as possible. Pearce was tasked with creating a series of maps that included not only the detailed route of the contemporary walk but also a larger conceptual map of the Great Hopewell Road in its entirety, which, as already noted, aligns at certain times of the year beneath the visible stars of the Milky Way. To convey the drama of the larger conceptual piece, Pearce devised a narrow but long map, with accordion folds like an elaborate brochure, that seamlessly joined an evocative image of the path-like Milky Way to a topographic map of the land between Newark and Chillicothe stretching beneath, with the Great Hopewell Road and the contemporary walking route superimposed as white and yellow lines, respectively. When the map was unfolded and extended to its full length, the stars of the Milky Way and the Great Hopewell Road written on the earth beneath it were joined in a continuous image, demonstrating in the map's single plane how the Road mirrors the sky-world here on the surface world. The detail maps for the walking route were printed on the reverse side, joining the practical itinerary and the breathtaking conceptual image into one document.

17. P. C. Smith, "The Ground beneath Our Feet," 62, 61.

18. P. C. Smith, 60.

19. Dalan et al., *Envisioning Cahokia*, 27.

20. Computer-based interactive exhibits have been developed by the Center for the Electronic Reconstruction of Historical and Archaeological Sites (CERHAS) at the University of Cincinnati; see the EarthWorks website at www.cerhas.uc.edu. Also see the website for the Ancient Ohio Trail, a collaborative site geared toward earthworks tourism created by the Ohio Historical Society, the U.S. National Park Service, the Newark Earthworks Center, and CERHAS at www.ancientohiotrail.org.

21. Drawing on the work of Tewa scholar Gregory Cajete, Maori scholar Linda Tuhiwai Smith, and Pasqua First Nation scholar Margaret Kovach, among others, social science researchers Eve Tuck and Marcia McKenzie point out in *Place in Research: Theory, Methodology, and Methods* that "Indigenous methodologies both are enacted by and seek to study relationships, rather than object-based studies that typify Western sciences. Among the most primary relationships, upon which all other relationships are configured, are relationships to land and place, or what sometimes gets called the natural world" (94). I am borrowing the language of "geometric regularity" and "geometrical harmony" from Hively and Horn ("Geometry and Astronomy," 58).

22. Archaeologist Sarah Baires draws similar conclusions about the role of mounds as forms of citation. See *Land of Water, City of the Dead*, 3, 6, 154, 159.

23. See, for example, Bernardini, "Hopewell Geometric Earthworks." An example of an attempt to broaden our understanding of the experiential meaning of a particular earthworks site is Dalan et al.'s 2003 study *Envisioning Cahokia: A Landscape Perspective*, written collaboratively by a research collective of anthropologists, geographers, earth scientists, and landscape architects. Jay Miller discusses contemporary, small-scale mound building in the context of annual ceremonies in his 2015 study *Ancestral Mounds*. Knight discusses similar practices of contemporary ceremonial mound building among Muscogee and Oklahoma Seminole in his 2006 essay "Symbolism of Mississippian Mounds." Cherokee scholar Christopher Teuton described similar contemporary, small-scale mound building within the context of annual Cherokee Green Corn ceremonies in several personal communications.

24. Jay Miller makes a similar point in *Ancestral Mounds*.

25. Anthropologist H. Martin Wobst examines a number of these issues in his useful overview "Power to the (Indigenous) Past and Present!"

26. For a fuller discussion of these distinctions and an argument for employing an expansive definition of writing in the Indigenous Americas, see Brooks, *The Common Pot*; Boone and Mignolo, *Writing without Words*; and Boone and Urton, *Their Way of Writing*. For examples of engaging expansive definitions of writing in contemporary literary analysis, see Allen, *Trans-Indigenous*; and Garcia, *Signs of the Americas*.

27. The idea that mounds and other earthworks need to be understood not in isolation but within broader conceptions of built environments, including the creation of borrow pits and the construction of level plazas and raised causeways, is detailed in works such as Dalan et al.'s *Envisioning Cahokia* and Baires's *Land of Water, City of the Dead*.

28. Geographers Jay Johnson and Soren Larsen make a similar point about the centrality of "embodied and performative" research methodologies, including walking, in the introduction to their coedited collection *A Deeper Sense of Place* (15).

29. Tuck and McKenzie, *Place in Research*, 15.

30. Horton and Berlo, "Beyond the Mirror," 17.

31. Horton and Berlo, 18.

32. Tallbear, "An Indigenous Reflection," 234. In a 2017 essay Tallbear states: "I am struck again and again, reading the new materialisms, by their lack of acknowledging indigenous people" ("Beyond the Life/Not-Life Binary," 197).

33. Momaday, "The Man Made of Words," 52. It is unfortunate that Momaday's language from 1970 feels less than fully inclusive. One hopes that if he delivered the address today, he would replace "man" with "person."

34. Ortiz, "Some Concerns," 18. The highly influential Dakota scholar Vine Deloria Jr. makes a similar point in relation to Native American religions, namely, that they are oriented toward a "spatial" rather than a "temporal" framework; see *God Is Red*. More recently, Abenaki scholar Lisa Brooks points to the possibilities of reorienting our study of American literatures away from a focus on a strictly linear chronology in our understanding of literary "periodization" and toward a "primacy of place" in our scholarship; see "The Primacy of the Present."

35. Howe, "The Story of America," 31.

36. Howe, "Embodied Tribalography—First Installment," 173. I focus on the work of Howe because of her centrality across the chapters of *Earthworks Rising*. Howe's work is part of a larger movement within American Indian and Indigenous studies to actively engage the "reciprocal embodiment between people and land," often from perspectives that are marked as feminist. See, for instance, the generative theoretical insights of Abenaki scholar Lisa Brooks's *The Common Pot*, Yup'ik scholar Shari Huhndorf's *Mapping the Americas*, and Seneca scholar Mishuana Goeman's *Mark My Words*, as well as the innovative work of Anishinaabe archaeologist Sonya Atalay and Potawatomi cartographer Margaret Wickens Pearce.

37. Weismantel, "Seeing Like an Archaeologist," 141.

38. Weismantel, "Encounters with Dragons," 37.

39. In addition to assisting Mojica with research at Ohio earthworks in 2011 and

assisting Mojica and Howe with research at Ohio earthworks in 2013, I participated in production workshops for *Sideshow Freaks and Circus Injuns* at the Centre for Indigenous Theatre in Toronto in August 2014 and at Chickasaw Nation facilities in Sulphur, Oklahoma, in December 2014, and I served as a dramaturge for a workshop performance at the Centre for Indigenous Theatre in Toronto in August 2017.

1. SERPENT SUBLIME, SERPENT SUBLIMINAL

1. Randall, *The Serpent Mound*, 4, 3. Hereafter cited parenthetically in the text. In his "Preface to Second Edition," Randall writes: "The first edition of this little volume, consisting of one thousand copies, having been exhausted and the demand for its circulation continuing unabated, the issuing of a second edition seems justifiable" (3).

2. Greenman, *Guide to Serpent Mound*, 1.

3. Glotzhober and Lepper, *Serpent Mound*, 3.

4. *Serpent Mound*, Ohio History Central online, www.ohiohistory.org/w/Serpent _Mound.

5. For additional examples, see Milner, *The Moundbuilders*; Potter, *Ohio's Prehistoric Peoples*; and Glotzhober and Lepper, *Serpent Mound*. For the theory that the oval-shaped disk represents the sun, see Romain, *Mysteries of the Hopewell*, 253.

6. Milner, for example, writes: "This long, low embankment snakes its way down a narrow ridge. The tail forms a *tight spiral*, and the other end widens to join an oval embankment, commonly interpreted as the head, although some have thought the snake is swallowing an egg" (*The Moundbuilders*, 79, emphasis added).

7. See, for example, Milner, 58.

8. See DeMallie, *The Sixth Grandfather*, especially 52 and 55.

9. Hedge Coke, *Blood Run*, 31. Hereafter cited parenthetically in the text.

10. Although Snake Mound speaks only once in the sequence, the persona does appear again, in an altered form, as Stone Snake Effigy; see Allen, "Serpentine Figures, Sinuous Relations."

11. For an analysis of the theme of repatriation, see Kelsey and Carpenter, "'In the End, Our Message Weighs.'" For an analysis of Hedge Coke's poetic sequence as a form of Indigenous activism, see Melamed's chapter "Difference as Strategy in International Indigenous Peoples' Movements" in *Represent and Destroy*.

12. As early as 1982, Hively and Horn argued that the earthworks at Newark demonstrate "a remarkable degree of symmetry, precision, and geometrical harmony, apparently based on a single length [of measurement]" ("Geometry and Astronomy," 57). In *Mysteries of the Hopewell*, Romain confirms Hively and Horn's finding that this basic unit of measurement is 321 meters, or 1,053 feet (68).

13. Romain and his colleague Jarrod Burks published several online essays about the preliminary findings of their LiDAR research in Ohio, from which my information is taken. See "LiDAR Assessment of the Newark Earthworks" and "LiDAR Analyses of Prehistoric Earthworks in Ross County, Ohio."

14. Elsewhere I offer extended analyses of the sequence produced from this "aerial" perspective; see "Siting Earthworks, Navigating Waka" and "Serpentine Figures, Sinuous Relations."

15. Cajete, *Native Science*, 65, 234. Hereafter cited parenthetically in the text.

16. I employ the concept of a fourth dimension metaphorically to highlight the activist politics of Hedge Coke's inclusion of explicitly Indigenous perspectives in *Blood Run*. Within Western mathematics and philosophy, however, the concept of a fourth dimension generally refers to time. Hedge Coke's poetic structures also suggest this kind of fourth dimensional aspect in their potential to link the present to the past and to project into the future.

17. Part of the Blood Run site located in what is now South Dakota was officially renamed and dedicated as Good Earth State Park in 2017. See https://gfp.sd.gov/parks/detail/good-earth-state-park/.

18. Allen, "Serpentine Figures, Sinuous Relations."

19. Romain, *Mysteries of the Hopewell*, 253. Hereafter cited parenthetically in the text.

20. Romain demonstrates true astronomical north in a line running from the tip of the Serpent Mound's coiled tail through the base of its head; the summer solstice sunset point from this line through the center of the serpent's head and the oval disk; and the six lunar rise and set points running through six of the serpent's seven body convolutions. Moving from the head toward the tail, these six alignments are ordered (1) moon maximum southern set point, (2) moon minimum northern rise point, (3) moon mid-point set point, (4) moon mid-point rise point, (5) moon minimum northern set point, and (6) moon maximum southern rise point.

21. The number 19's position as the eighth prime aligns Snake Mound not only with the factoring 2 x 4, emphasizing its relationship to the sacred number 4, but also with the factoring 2 x 2 x 2, or the cube of 2, the first (and only even) prime, that is, the first prime made three-dimensional.

22. It is tempting to point to what seems an overdetermined pun in the Snake Mound's final line: that *sinuous* can suggest *sin-you-us*, or *Sin you [against] us*.

23. Hedge Coke has worked with a number of Indigenous communities to stage performances of *Blood Run* as a methodology of healing for historical trauma (personal communication).

24. Mojica, "In Plain Sight," 219. Hereafter cited parenthetically in the text.

25. Hedge Coke describes her methodology for writing *Blood Run* in her introduction to the 2011 anthology *Sing: Poetry from the Indigenous Americas*. She has also discussed her methodology in a number of public presentations, including "Writing Presence: Earth, Rivers—A Workshop in Witness," which she offered during the Western Literature Association conference in Spearfish, South Dakota, on October 2, 2009.

26. Hedge Coke, introduction, 4–5.

27. See Wilson's *Research Is Ceremony: Indigenous Research Methods*.

28. See also the work of Anishinaabe archaeologist Sonya Atalay. For an account of some of the controversies stirred by the concept of an Indigenous archaeology for orthodox archaeologists, see Colwell-Chanthaphonh et al., "The Premise and Promise of Indigenous Archaeology."

29. T. Million, "Developing an Aboriginal Archaeology," 39–40.

30. See, for example, James A. Brown, "The Shamanic Element of Hopewellian Period Ritual."

31. Howe, "Embodied Tribalography: Mound Building," 80. Hereafter cited parenthetically in the text.

32. Another snake mound, badly damaged, is located in High Park in Toronto, Ontario, Canada, which Mojica and Howe also visited during their research.

33. Here and below, with her permission I quote from Mojica's unpublished manuscript of the scene "Inside-Outside." Ric Knowles served as dramaturge for the improvisation.

34. In Glotzhober and Lepper's *Serpent Mound*, the authors suggest that the Serpent Mound cryptoexplosion site was created either by an explosive eruption from deep underground or by a meteor or asteroid impact (15–17). More recent investigations confirm the site was struck by a meteor. Evidence for the impact was reported on the website for the Ohio Department of Natural Resources Division of Geological Survey (http://geosurvey.ohiodnr.gov). In contrast to Mojica and other Indigenous researchers, the non-Native archaeologists Glotzhober and Lepper are confident that "little evidence exists for any relationship between effigy and geology. . . . The fame of the Serpent Mound cryptoexplosion structure is probably because of the coincidence of its association with the well known effigy mound" (18).

35. In Hedge Coke's "The Mounds," this listening descendant "you" is acknowledged at line 14: "our holy graceful place upon which you now stand, dignified" (30). Other poems in *Blood Run* also acknowledge this listening descendant "you."

36. See Downey, "'A Broken and Bloody Hoop,'" and Tucker, "Walking the Red Road."

37. See Riley, "Wrapped in the Serpent's Tail," and Vigil and Miles, "At the Crossroads."

These intersections are also an interest of Stecopoulos in the epilogue to *Reconstructing the World*.

38. DeMallie, *The Sixth Grandfather*, 83.

39. Walker, *Meridian*, 54, 56.

40. In his epilogue to *Reconstructing the World*, in a brief aside Stecopoulos attempts to link the deep pit of the Sacred Serpent's tail to the "deep central pit" at the base of some Southeastern burial mounds (165). The comparison does not hold, given the differences in construction of burial mounds and effigies.

41. Lame Deer and Erdoes, *Lame Deer*, 11.

42. Power, *The Grass Dancer*, 205. Hereafter cited parenthetically in the text.

43. The use of "snuff" in Walker's description of the creek that runs near the Sacred Serpent seems tellingly ambiguous. On the one hand, snuff evokes tobacco, sacred to many Indigenous North American traditions, as well as life-giving breath, since snuff tobacco is inhaled; on the other hand, snuff also evokes death and, more specifically, murder, as in the genre of the "snuff film."

44. The name *Longknife* is an interesting choice. Some readers will associate the name with the term *Long Knives*, used by the Iroquois and other Native Americans to refer to British soldiers.

45. Silverberg, *The Mound Builders*, 191–94. This is an abridged edition of Silverberg's 1968 *Moundbuilders of Ancient America*. Both are regularly cited, although Silverberg is neither a trained archaeologist nor an academic historian. Best known as an award-winning writer of science fiction, Silverberg is also a prolific writer of nonfiction on a wide range of topics, including many titles about "worlds of the past" targeted at juvenile and young adult audiences. Prior to writing *Moundbuilders*, Silverberg wrote a broader account of precontact Native American history, *Home of the Red Man*, published in 1963 for a target audience aged "12 to 16," which includes a chapter titled "The Mound Builders" (86–101). Glotzhober and Lepper also overview the history of how the Serpent Mound became part of a state park in *Serpent Mound* (12–14).

46. The list of Indians who are named as having photographs in Mr. Hill's white room is striking, and we might ask how the young Meridian knows these names, which include not only the famous nineteenth-century leaders Sitting Bull, Crazy Horse (although there is no known photograph of Crazy Horse), and Geronimo but also the lesser-known Little Bear and Yellow Flower. Questions might be asked as well about the brief description of Mr. Hill's books on Indians, and about the ordering of Walker's sequence "their land rights, reservations, and their wars," which moves in a reverse chronological order to emphasize, again, death.

47. It is interesting to note that, besides the new preface, the excerpt from Long-

fellow's *Hiawatha* is the only significant addition to the second edition of *The Serpent Mound*.

48. For a detailed history of Reverend West and his theory see Wilensky-Landord, "The Serpent Lesson."

49. Randall appears to take his cue from an essay by F. W. Putnam, "The Serpent Mound of Ohio," published in *The Century Illustrated Monthly Magazine* in April 1890, which gives an account of the snake mound in Scotland and quotes part of Blackie's poem.

50. Blackie writes: "And west, far west, beyond the seas, / Beyond Tezcuco's lake, / In lands where gold grows thick as peas, / Was known this holy snake" (124–25). Blackie refers to the Aztec city-state Tezcuco on the shores of Lake Tezcuco in the Valley of Mexico; Tezcuco (Texcoco) was an important Aztec site located to the northeast of the capital city, Tenochtitlan. An article on "The Ancient Worship of Serpents" published in an 1833 edition of the *Asiatic Journal and Monthly Register* mentions Tezcuco by name: "But not only in the ancient world was serpent-worship heretofore very prevalent; the Spaniards found it likewise established in America. In Mexico, the great rattle-snake has evidently been an object of very general adoration, and this reptile was every where found in some connexion with the other idols of the country. Figures of this serpent, rudely sculptured in stone, are very common in the native villages of Mexico: there is one in perfect preservation at Tezcuco" (34–35). A key text in this genre is Ephraim Squier's *The Serpent Symbol, and the Worship of the Reciprocal Principles of Nature in America* (1851).

51. Bradley, "Serpent Mound," 14.

52. Oliphant, *Lines & Mounds*, 20, 22. Hereafter cited parenthetically in the text.

53. Napora worked for many years as a professor of English at Ashland Community and Technical College in northern Kentucky. The broadside for "The Adena Serpent Mound" was produced by the master printer Walter Tisdale on handmade paper by Kathy Kuehn (Napora, personal communication).

54. *Scighte* was published by Pooté Press. The limited-edition art book is composed of twelve leaves of double-couched pulp paintings by Lingen, with Napora's letter-pressed poem and magnesium linecuts by Ely. Twenty-one copies were produced in a special edition that included extra hand coloring on the book and an additional broadside poem, both of which fit into a specially made compartmented box that (purportedly) incorporated soil from the Serpent Mound in Ohio. Another sixty-four copies were printed without the broadside or special box, for a total of eighty-five copies. My analysis is based on access to number forty-five, without the broadside or box, held in Special Collections at the University of Washington libraries. I have

been unable to confirm that the boxed editions actually contain soil from the Serpent Mound; regardless of the intention, I read the gesture of removing soil from the effigy as both destructive and colonial, and in line with many similarly destructive and colonizing incursions at the site by members of various New Age movements.

55. Prior to reading Napora, I had made a similar play on the homophones *siting*, *sighting*, and *citing* in my 2010 article on Hedge Coke's *Blood Run*, although toward somewhat different and more explicit ends.

56. In 2014, Wuwu and Bender shared with me the unpublished manuscript for the collection, which includes two versions of each poem, one in Chinese characters and one in English translation. In addition, Bender shared his character-by-character translation of "Indian Serpent Mound" into English so that, as a reader with no access to Chinese, I could have a better sense of how the translation works.

2. RIVER REVERE

1. *Jimmie Durham: At the Center of the World* was curated by Anne Ellegood of the Hammer Museum at UCLA. Following its Los Angeles run, the retrospective was staged at the Walker Art Center in Minneapolis, June 22–October 8, 2017; the Whitney Museum of American Art in New York, November 3, 2017–January 8, 2018; and the Remai Modern in Saskatoon, Canada, March 25–August 12, 2018.

2. See, for example, Meredith, "Why It Matters." Increasingly comprehensive overviews of the controversy and its ongoing implications were published after submission of this manuscript to the press; see, for example, the well-researched account "Decentering Durham" by Chiricahua Apache curator and art historian Nancy Mithlo (2020).

3. P. C. Smith, "Radio Free Europe," 137.

4. See Watts, Meredith, et al., "Dear Unsuspecting Public." Part of the context for the Minneapolis response to Durham was the unrelated controversy over the gallows-inspired *Scaffold* installation created for the Walker Art Center by the non-Native artist Sam Durant, also in the summer of 2017, which evoked the history of the mass hanging of thirty-two Dakota men in 1862. Durant failed to consult with Dakota tribal officials prior to creating the piece, or to consider the installation's potential effects on Dakota and other Indigenous community members.

5. P. C. Smith, "The Most American Thing," 7. Hereafter cited parenthetically in the text.

6. In anticipation of the retrospective opening at the Remai Modern in Saskatoon in March 2018, the executive director, Gregory Burke, posted a statement on the museum's website, dated February 22, 2018, that addresses the controversy over Durham's identity. The statement reads, in part: "Durham self-identifies as Cherokee, but

has been clear that his own identity is not the subject of his work. He does not, and has not sought to, belong to any of the federally recognized and historical Cherokee tribes in the United States, which as sovereign nations determine their own citizenship. Self-determination and cultural authority are imperative for nations striving to regain control over their own narratives. Many artists and scholars have expressed concerns that Durham's identity—at times overtly emphasized by museums, galleries and critics—has been tokenized in a field where Indigenous artists and voices are often marginalized and misrepresented. These are valid contentions, and pose important questions about institutional frameworks and responsibilities." See https://remaimodern.org/field/read/directors-statement-jimmie-durham-gregory-burke.

7. See, for example, Watts, Meredith, et al., "Dear Unsuspecting Public," and Mithlo, "Decentering Durham."

8. Brooks, *The Common Pot*, 124–25.

9. Hedge Coke, *Blood Run*, 80. Hereafter cited parenthetically in the text.

10. Durham's work was also included, for instance, in the 1992 *Land, Spirit, Power: First Nations at the National Gallery of Canada* exhibit in Ottawa.

11. Among the many quincentenary events staged in Columbus, Ohio—the world's largest city bearing the name of the Admiral of the Ocean Sea—was the anchoring of a full-scale replica of Columbus's flagship for the first voyage, the *Santa Maria*, to the banks of the Scioto River downtown. The replica has served has a settler museum and as a site of perennial Indigenous protest ever since.

12. In addition to Heap of Birds and Durham, *Will/Power* included work by Papo Colo, David Hammons, Adrian Piper, and Aminah Brenda Lynn Robinson. Beyond the exhibition itself, the Wexner organized wide-ranging educational programming around both the exhibit and the quincentenary—including relevant films, lectures, artist talks, workshops, and other events—in partnership with OSU's Hale Black Cultural Center, Office of Hispanic Student Services, Office of Minority Affairs, and American Indian Council, and with the city of Columbus's Martin Luther King, Jr. Cultural Complex, Native American Indian Center, and Museum of Art.

13. Based in London, Phaidon is a premier global publisher of high-quality books on art, architecture, photography, design, performing arts, decorative arts, fashion, film, travel, and contemporary culture.

14. Mulvey, "Changing Objects, Preserving Time," 72. Hereafter cited parenthetically in the text.

15. Siebert, *Indians Playing Indians*, 148. Hereafter cited parenthetically in the text.

16. Numerous recorded versions of the murder ballad can be found on internet sites such as YouTube.

17. Multiple versions of the lyrics for "The Banks of the Ohio" are posted on the internet; here, I quote the version available at www.bluegrasslyrics.com.

18. Horton, *Art for an Undivided Earth*, 54.

19. Durham, "Against Architecture," 108.

20. Lippard, "Jimmie Durham," 64. Hereafter cited parenthetically in the text.

21. Gonzalez, "Categorical Refusal," 197.

22. Rogers, "Introduction: Poetry and Politics," 11. Hereafter cited parenthetically in the text. Similar language is used in the *Will/Power* exhibit program: "Images of serpents are common to many Native American traditions, including those of both the Moundbuilders of the Ohio River valley and the Cherokee culture that is Jimmie Durham's heritage. The horned serpent of the Cherokees is a symbol of the evening star and so of passage from day to night, of transition. For Durham, the serpent is thus also an apt metaphor for the history of this region and this country in general, which he sees as a succession of transitions and contradictions—not isolated 'great events' such as 'discoveries.' Durham uses materials such as mud, glue, and PVC pipe, found in industrial and domestic plumbing, to disrupt assumptions about the preciousness of art and define his own anti-aesthetic approach."

23. The horned serpent is a common symbol among Southeastern and other Native peoples. For an overview see Lankford, "The Great Serpent." Cherokee traditions describe a great horned serpent known as the Uktena. In *Myths of the Cherokee*, first published in 1900, early non-Native anthropologist James Mooney writes: "Those who know say that the Uktena is a great snake, as large around as a tree trunk, with horns on its head, and a bright, blazing crest like a diamond upon its forehead, and scales glittering like sparks of fire. It has rings or spots of color along the whole length, and can not be wounded except by shooting in the seventh spot from the head, because under this spot are its heart and its life" (297).

24. Durham, "A Central Margin," 163.

25. Lankford argues that, within Eastern Woodlands systems, "the Great Serpent was located not only in the water world, but also in the celestial realm" ("The Great Serpent," 109). He argues, further, that the celestial form of the Great Serpent was identified with the constellation known in the West as Scorpio, and that, "conceptually, the appearance of the Great Serpent in the sky is of great importance, because it constitutes a change in cosmological levels, from the Beneath World to the Above World" (132).

26. In Gerald Vizenor's terminology, this is evidence of *transmotion*, vital movement *across* and *through* distinct realms. See note 43 below, as well as the discussion in chapter 4.

27. Wallis, review of *Will/Power*, 117. Attentive readers will have noticed that different writers locate the Serpent Mound near different towns in southern Ohio. Chillicothe is one of the larger towns in the region, sited along the Scioto River about forty-five miles south of Columbus.

28. Durham was also unaware the Wexner retained these works in its archives. When I presented an early version of this chapter at UCLA, Anne Ellegood, the curator of the retrospective, informed me Durham thought the works on paper had been destroyed after the *Will/Power* exhibit was taken down; Durham then confirmed that this had been his understanding when he granted permission to publish digital images of the works here.

29. I was employed at The Ohio State University between 1997 and 2015, when I took a position at the University of Washington. As luck would have it, I began my research on *The Banks of the Ohio* after I left OSU and no longer had easy access to the Wexner.

30. This detail suggests the mud head was built upon a base form constructed from papier-mâché.

31. In the photograph, the PVC pipe serpent appears complete, and the west and east gallery walls have been marked with mud. Set between the tail end of the serpent and the opening to the alcove space are several items that suggest the installation was either just completed or nearly complete when the photo was taken: a large plastic bin full of waste materials, a white bucket, a tire mounted on an axle with which some of the mud "tracks" were rolled onto the white walls, and a low cart loaded with additional equipment. Approximately three-quarters of the first "drawing" is visible in the photo, pinned to the west wall of the alcove space at the north end of Gallery B.

32. Durham, "A Central Margin," 163.

33. Like other scholars, art historian Jessica Horton comments on the prevalence of snakeskin and references to snakes across Durham's body of work in all media. She states: "The skin of the sinuous figure is a metonym for live snakes of the sort that Durham encountered growing up in Arkansas. They appear throughout his poetry as eloquent beings modeling confident speech and action" (*Art for an Undivided Earth*, 58). Also see Durham's 1993 collection *Columbus Day* (8).

34. For a detailed account of Indian removal in Ohio, see Stockwell, *The Other Trail of Tears: The Removal of the Ohio Indians*.

35. Versions of Glass's AP article appeared in various U.S. newspapers on April 3, 4, and 5, 1991, under titles such as "Archaeologists Near Pin-Pointing Columbus Vessels" (*Anniston (Ala.) Star*), "Columbus Ship Discovery Near?" (*Greenfield (Ind.) Daily Reporter*), "Remains of 2 of Columbus' Ships Might Soon Be Found in Jamaica" (*Asbury Park (N.J.) Press*), "Search Narrows for Missing Columbus Ships" (*Indiana (Pa.) Gazette*),

"Archaeologists Expect to Find Columbus Ships" (*Elwood (Ind.) Call-Leader*), and "Columbus Ships Could Be Recovered" (*Billings (Mont.) Gazette*). Most versions include language identical to that of the texts Durham affixes to his collages. I have yet to discover the actual article, however, with the exact word placement and lineation, from which Durham cut his fragments.

36. Earlier editions, published under the auspices of earlier state auditors of Ohio at least since the 1950s, were titled *A Short History of Ohio Land Grants*. The most recent edition, available from the State Auditor's website, is titled *The Official Ohio Lands Book* and is attributed to Dr. George Knepper, professor of history emeritus from the University of Akron and author of numerous books on Ohio history; in addition, the auditor currently offers a version for younger readers titled *Along the Ohio Trail: A Short History of Ohio Lands*. www.ohioauditor.gov.

37. Shiff, "Necessity," 75.

38. Durham, "Probably This Will Not Work," 20.

39. I am borrowing this representative language from Josephy, *America in 1492*, 7.

40. According to the Library of Congress website, the woodcut depicts "Columbus landing in the West Indies during his first voyage (1492)." It adds: "This woodcut is taken from the Basel edition of Columbus's Letter of Columbus, on the islands of India beyond the Ganges recently discovered, published in 1494. The image shows Columbus landing in Hispaniola, where some natives flee and others trade." www.sciencephoto.com.

41. Durham writes in *Columbus Day*: "I grew up with coral snakes, and they are special to my people because their colors are three of our important colors and because of their poison" (9).

42. Major references to this "blue radiance" and "blue power" of "creation" appear in Vizenor, *The Heirs of Columbus*, 16, 18, 28, 38, 40, 140.

43. See, for instance, Vizenor, *Fugitive Poses*, 183.

44. *Progressive Architecture*, October 1989; Paul Goldberger, "The Museum That Theory Built," *New York Times*, November 5, 1989.

45. In *Culture and Truth*, anthropologist Renato Rosaldo defines "imperialist nostalgia" as "a mourning for what one has destroyed" (69).

46. Goldberger, "The Museum That Theory Built."

47. *Progressive Architecture*, October 1989, 69.

48. Taylor, *Disfiguring*, 264. Taylor makes the same point in briefer form in his contribution to the October 1989 special issue of *Progressive Architecture* ("Eisenman's Coup," 89).

49. Taylor, "Eisenman's Coup," 89.

50. Durham, "A Central Margin," 163–64. Durham makes a similar argument in his often-quoted essay "The Ground Has Been Covered," originally published in 1988: "Nothing could be more central to American reality than the relationships between Americans and American Indians, yet those relationships are of course the most invisible and the most lied about. The lies are not simply a denial; they constitute a new world, the world in which American culture is located" (138). In his 1990 essay "Cowboys and . . . ," Durham states: "America's narrative about itself centres, has as its operational centre, a hidden text concerning its relationship with 'American Indians.' That central text *must* be hidden, and sublimated, and acted out" (173).

51. This reading would appear to be confirmed in the October 1989 special issue of *Progressive Architecture*, which notes in its description of the Wexner complex's extensive landscaping: "Contrasting with the crisply cut walls of the plinths, their tops are mounded up and planted with wildflowers and grasses—wise choices in terms of maintenance, but also, reports Eisenman, an allusion to the Indian mounds scattered across Ohio" (Dixon, "Wexner Center," 74–76).

52. Not surprisingly, Adams County, established in 1797, was named for John Adams, the second U.S. president, who was in office at the time; Franklin County, established in 1803, was named for U.S. founding father Benjamin Franklin (Knepper, *Along the Ohio Trail*, 82).

53. Ferguson, *Ohio Lands*, 3, 4.

54. LiDAR stands for light detection and ranging; see my discussion in chapter 1.

55. Weismantel, "Inhuman Eyes," 25. Hereafter cited parenthetically in the text.

56. I develop these ideas further in chapter 3.

57. In "Water and Mud and the Recreation of the World," anthropologist Ted Sunderhaus and Fort Ancient State Memorial site manager Jack Blosser argue that "water is quite commonly associated with the three-tiered Eastern Woodland world, with water typically associated with the lower or underworld" (141). Describing the "multistage construction sequence for the earthworks walls" at the Fort Ancient hilltop enclosure site in south-central Ohio, they argue that water-laden soils were used in specific ways within the walls' architectural structure (143). They state: "It is suggested here that these water-laden gleyed soils were sought specifically because they were obtained from under the surface of a body of water, thus playing a symbolic role in reenacting the Mud Diver myth, or the creation of dry land" (145).

Coda 1

1. Howe, "Embodied Tribalography: Mound Building," 82.

2. I discuss *Sideshow Freaks and Circus Injuns* in more detail in chapter 1.

3. Other researchers have made similar inferences.

4. Hogan, "Turning Earth, Circling Sky," 77.

5. For an overview of theories about Alligator Mound, see Lepper and Frolking, "Alligator Mound."

6. Personal communication, February 1, 2019.

7. Hedge Coke, *Blood Run*, 10.

8. Howe tells a version of the Southeastern story of the Animals' Ball Game, in which Bat plays a starring role because of his in-between status, in "Embodied Tribalography: Mound Building."

9. Settler impositions at the Great Circle are well documented, including the site's use as fairgrounds, an amusement park, and a racetrack. See Pickard, "A View within the Circle."

3. WALKING THE MOUNDS

1. Allen, "Solstice at the Mounds," 19. Hereafter cited parenthetically in the text.

2. Archaeologists have determined that, over a period of roughly three hundred years, a series of five "woodhenge" circles were constructed at Cahokia, each comprising a different number of upright posts but always a multiple of twelve, ranging between twenty-four and seventy-two. The reconstructed woodhenge of forty-eight posts is described as the third circle in the series.

3. In his 2016 article "Designing Indian Country," Washington University professor of landscape architecture Rod Barnett makes a similar point about the "role of rhetoric in landscape curation" at Cahokia. "The simulacrum is all," he writes. "The reality of marginalized communities is obscured rather than clarified by landscape representations in [the] museum ([at] Cahokia) . . . because their marginalization is institutionalized and naturalized" (12).

4. Crump (1887–1979) continued the series with *Og of the Cave People* (1935) and *Og, Son of Og* (1965). Og had his own radio drama series in 1934 and 1935.

5. Crump, *Mog*, ix–x.

6. Morgan, *Anompolichi*, Hereafter cited parenthetically in the text.

7. In his review for *Southeastern Geographer*, University of Kansas archaeologist William Woods writes: "I accepted this assignment with a sense of foreboding. Unfortunately, my instincts proved to be correct. The book has been described as 'Mesmerizing' and indeed it is, but for the wrong reasons." He continues: "The author of this volume . . . will start a story that everyone would agree with and spin it into the most implausible and merely fanciful or patently false conclusions. I found this unbeliev-

able for a scholar who has spent his entire career working in the American Bottom region (this too is a problem) and surely should know better" (review of *Cahokia*, 236).

8. Pauketat, *Cahokia*, 25. Hereafter cited parenthetically in the text.

9. LeAnne Howe explores these kinds of complex burial practices from an Indigenous perspective in *Shell Shaker*, discussed in chapter 5. For an analysis of Howe's representation of scaffold burials and bone-picking ceremonies, see Siebert, "Repugnant Aboriginality."

10. Weismantel, "Inhuman Eyes," 25, 27.

11. Weismantel, 28. See also Weismantel, "Encounters with Dragons," 40.

12. Loren, review of *Cahokia*.

13. "Review of Cahokia, Ancient America's Great City on the Mississippi, by Timothy Pauketat," *The Historians Manifesto* blog site, August 21, 2014. https://thehistoriansmanifesto.wordpress.com/2014/08/.

14. Anderson, "North America's 'Big Bang.'"

15. The 2018 exhibit *Visual Voices: Contemporary Chickasaw Art* uses a stylized version of an eighteen-century Chickasaw deerskin map as its logo. The catalog describes the original map in these terms: "In 1723, the Chickasaw leader Squirrel King *(Fani' Minko')* presented a deerskin map of the Southern continent to the governor of South Carolina. It was a rendering of the world as Chickasaws knew it, a placement of tribes and waterways, the British, the French, and others across more than seven hundred thousand square miles" (Clark, *Visual Voices*, 126). A version of this map is displayed at the Chickasaw Cultural Center.

16. Here I am thinking of works such as William Steele's *Talking Bones: Secrets of Indian Burial Mounds* (1978); Mildred Payne and Harry Kroll's *Mounds in the Mist* (1969); Robert Myron's *Shadow of the Hawk: Saga of the Mound Builders* (1964); William Scheele's *The Mound Builders* (1960); and Blanche Busey King's *Under Your Feet: The Story of the American Mound Builders* (1939). Thelma Bounds's *Children of Nanih Waiya* (1964) includes a brief discussion of mound building but focuses on the postcontact history of the Choctaw.

17. In addition to the YA mound-builder novels, there are a wide range of (ostensibly) adult versions. A few of the more colorful titles from the nineteenth and early twentieth centuries include *Behemoth: A Legend; or, The Mound-Builders*, by Cornelius Mathews (1839); *The Book of Algoonah, Being a Concise Account of the History of the Early People of the Continent of America, Known as Mound Builders*, by Cyrus Flint Newcomb (1884); and *The Vanished Empire: A Tale of the Mound Builders*, by Waldo Hilary Dunn (1904). There are many others.

18. William Webb, foreword to Bunce, *Chula*, 9.

19. Another YA novel to place in conversation with *Anompolichi* is Mary Austin's *The Trail Book*, originally published in 1918. A precursor to the 2006 film *Night at the Museum*, in which a night watchman discovers that exhibits in New York City's Museum of Natural History come to life, *The Trail Book* follows the adventures of two non-Native children who similarly discover that the museum's displays become animated at night. In Austin's version, the adventures include encounters with mound builders.

20. Pratt, *Imperial Eyes*, 7.

21. My analysis follows from the work of the Indigenous Australian scholar Aileen Moreton-Robinson (Goenpul): "In postcolonizing settler societies Indigenous people cannot forget the nature of migrancy and we position all non-Indigenous people as migrants and diasporic. Our ontological relationship to land, the ways that country is constitutive of us, and therefore the inalienable nature of our relation to land, marks a radical, indeed incommensurable, difference between us and the non-Indigenous. This ontological relation to land constitutes a subject position we do not share, and which cannot be shared, with the postcolonial subject whose sense of belonging in this place is tied to migrancy" ("I Still Call Australia Home," 31).

22. The unpublished essay Morgan shared with me in late 2018 is titled "The Origins of *Anompolichi the Wordmaster* (first draft)." Hereafter cited parenthetically in the text.

23. This type of flat-topped earthwork is also known as a "temple mound" or "minko [chief's] mound." In addition to the earthwork at the Chickasaw Cultural Center near Sulphur, an earthwork has been constructed at the new First Americans Museum in Oklahoma City, which I discuss in the conclusion.

24. For a broader study of Chickasaw museum spaces, see Gorman, *Building a Nation*. The Chickasaw Press was founded in 2006; visit www.chickasawpress.com. For an account of its creation, see Rule, "The Chickasaw Press." Find Chickasaw TV at www.chickasaw.tv.

25. As noted in the introduction, Lisa Brooks makes similar claims about other forms of Indigenous writing, such as belts of wampum and birchbark scrolls, in *The Common Pot* (12, 220).

26. I am indebted to Amanda Cobb-Greetham (Chickasaw), former administrator for the Chickasaw Nation's Division of History and Culture and currently professor and chair of Native American Studies at the University of Oklahoma, for giving me a behind-the-scenes tour of the Chickasaw Cultural Center in 2013 and for engaging in extended conversation about the center's conception, ongoing activities, and plans for the future. All interpretations of the center and its earthwork presented in this chapter, however, are my own.

27. The earthworks vocabularies discussed below represent only a partial list of extant Chickasaw words for mounds. The term *shintok*, for instance, is not used in the signage at the Chickasaw Cultural Center but is commonly used in contemporary Chickasaw discourse. See, for example, the use of *shintok* in Travis, "Halbina' Chikashsha, A Summer Journey."

28. Titled *Anompolichi, the Riverines*, Morgan's sequel is complete, although publication by White Dog Press has been delayed by Covid-19. Ironically, the author tells me, the plot of this second novel "begins with a pandemic" (personal communication).

29. Dyson, *Early Chickasaw Homeland*, 28. Hereafter cited parenthetically in the text.

30. In support of this possibility, Dyson enlists the work of another researcher of Southeastern traditions, adding, "Indeed, in his previously cited essay on mound symbolism, Vernon J. Knight Jr. has commented on those earthen 'navels' as loci of both birth and death, of emergence as well as burial" (*Early Chickasaw Homeland*, 28). In the cited essay, Knight, a professor of anthropology at the University of Alabama, explores a wide range of Southeastern terms for Mississippian-period mounds—including terms from the Muskogee, Yuchi, Chickasaw and Choctaw, Cherokee, and Seminole languages—as a basis for his arguments about the mounds' potential symbolism.

31. In English, pottery is typically divided into the categories *earthenware* (fired at low temperatures and more porous), *stoneware* (fired at high temperatures and less porous), and *porcelain* (fired at even higher temperatures, nonporous and glasslike, and especially strong).

32. I am grateful to Phil Morgan for helping me arrive at the translation "sublime earthenware vessel."

33. Dalan et al., *Envisioning Cahokia*, 11. Hereafter cited parenthetically in the text.

34. I write briefly about the destruction of mounds in Saint Louis in "Earthworks as Indigenous Performance."

35. Howe writes about this hymn and its possible meanings in "Embodied Tribalography: Mound Building." She performed a version of the hymn arranged by the Native singer and musician Pura Fe.

36. A version of this Choctaw song or chant first appeared in print in Howe's 2001 novel *Shell Shaker* (see, for instance, pages 5–6).

Coda 2

1. Azure, *Games of Transformation*, ix. Hereafter cited parenthetically in the text.

2. See, for instance, the Aztalan State Park website (www.orgsites.com/wi/aztalan); Tom Heinen, "Preserving a Civilization: Aztalan State Park Could Develop into Major

Visitor Site," *Milwaukee Journal Sentinel*, June 10, 2006; Richards, "Viewing the Ruins"; and Kassulke, "Who Were They and Why Did They Leave?"

3. Birmingham and Goldstein, *Aztalan*, 79–83.

4. Online photographs indicate reconstruction of segments of the palisade began in the 1950s.

5. See, for instance, https://commons.wikimedia.org/wiki/File:Aztalan_State_Park _Entrance_Sign.jpg.

6. I first found an undated photograph of the earlier version of the historical marker posted on Pinterest (see https://nl.pinterest.com/pin/349310514823085324/), then located a photograph that had been published in the *Wisconsin State Journal* on July 23, 1967 (see https://www.wisconsinhistory.org/Records/Image/IM123213). Examples of book-length scholarship with a focus on Aztalan include Birmingham and Eisenberg's *Indian Mounds of Wisconsin* and, more directly, Birmingham and Goldstein's *Aztalan*. Birmingham and Goldstein note: "Over the years, archaeological research at Aztalan has turned our understanding of the site from a fortress built by a mysterious race to an ancient Indian ceremonial town with origins in the mighty Mississippian civilization that once flourished in the Midwest and across the southeastern United States" (19). Their final chapter details the history of the park's creation. They write: "The name Aztalan poignantly reminds us of a time when Euro Americans refused to acknowledge that the native population was capable of such wonders or even that North American Indians had a deep history that connected them to the land. The name also now symbolizes a fascinating and important time in Native American history that molded much of what was to come later" (107). Fascinating, indeed. The chapter includes a photograph of the 1991 marker but no discussion of the earlier version.

7. The image on the cover is "based on a painting at Wisconsin's Aztalan State Park," which is itself based on historical maps and surveys of the site, along with aerial photographs. Archaeologists typically divide the village into a residential precinct near the river, a central plaza, an elite precinct (which contains both the southwest and northwest platform mounds), and a southwest enclosure, which sits behind the southwest platform, forming the head of the big dog.

8. Stevens, *Book of Big Dog Town*, 1. Hereafter cited parenthetically in the text.

9. Noodin was among the Native artists and scholars who attended the SAI Centennial Symposium I organized at Ohio State University in 2011, which concluded with a group visit to the Newark Earthworks. As recounted in my introduction to and several pieces within *The Society of American Indians and Its Legacies*, the combined special issue of the journals *SAIL* and *AIQ* published in 2013 as a follow-up to the symposium,

Noodin was one of the Native participants who sang or chanted in an Indigenous language that October morning at the Octagon Earthworks. In addition to the previously cited essays by Chaatsmith and Noodin, see also Robert Warrior's moving account.

10. Noodin, *Weweni*, ix. Noodin explains that "Anishinaabemowin is the language of a group who refer to themselves as 'the People of the Three Fires'—the Odawa, Potawatomi, and Ojibwe—who migrated from the eastern Atlantic area to the Great Lakes watershed thousands of years ago" (ix).

11. Noodin, xi.

12. In *Blood Narrative* I use the phrase "the text between," along with its Maori-language equivalent, "te korero i waenganui," to describe the possibility of a third text produced by bilingual and bicultural readers when they read *across* versions of dual-language texts (see 64–65).

4. WOMBED HOLLOWS, SACRED TREES

1. See Million's "Intense Dreaming" and "There Is a River in Me."

2. At the conclusion of his brief account of Seip's 1920s excavation and reconstruction in *The Mound Builders* (1970), Silverberg writes: "Nonetheless, the mound as seen today was assembled by archaeologists, not by prehistoric Indians, and this is a touchy point. Excavation means destruction. In order to find out what is in a mound, archaeologists must open it and, if they are to do their work properly, they must level it to its base. Even if they use the same soil afterward to build a mound of the original size and shape, is it truly the same mound?" (211–12). Silverberg does not discuss, however, exactly for whom "this is a touchy point."

3. Silverberg notes that in 1847 "Squier and Davis had excavated many of these mounds [in Ohio] by driving shafts through them from their summits" (91).

4. D. Million, "There Is a River in Me," 34.

5. Hedge Coke, *Blood Run*, 19. Hereafter cited parenthetically in the text.

6. Allen, *Trans-Indigenous*, 215–21.

7. I give a more elaborate description of the mathematical alignments in *Blood Run* in chapter 1.

8. Hinton, *Earth Consciousness and Cultural Revelations*, 47.

9. This is Hinton's statement available on her website between 2011 and 2015 (alyssahintonart.com). A slightly altered version appears in *Earth Consciousness and Cultural Revelations* (12). Hinton has continued to update her online artist's statements, for this and other pieces, in the years since.

10. Chickasaw curator Heather Ahtone draws a similar "seed" analogy in her foreword to the catalog for the 2018 exhibit *Visual Voices: Contemporary Chickasaw Art*:

"Chickasaw people have learned, over centuries of duress, to protect our culture and our philosophy in the same way that some seeds have evolved the capacity to require fire or smoke to emerge. It is not that those seeds started out so hardened, rather that they evolved a protective genetic code that keeps their delicate seeds protected until the conditions are ripe to fully bloom in a healthy environment. As the Chickasaw people have necessarily protected our culture through centuries of assault, the circumstances have ripened for the arts to emerge and bloom" (11).

11. See Vizenor, *The Heirs of Columbus*, 16, 28, 140, and *Fugitive Poses*, 183.

12. As noted in chapter 1, *The Mound Builders* (1970) is an abridged version of Silverberg's *Moundbuilders of Ancient America: The Archaeology of a Myth* (1968).

13. See, for example, Lyons, "Panorama"; Angela Miller, "'The Soil of an Unknown America'"; and Gniadek, "Seriality and Settlement."

14. For biographical information on Dickeson, see Veit, "A Case of Archaeological Amnesia."

15. Lyons, "Panorama," 32.

16. Angela Miller, "'The Soil of an Unknown America,'" 11. The restored *Panorama* is currently on display in the main hall of the Saint Louis Art Museum. Because of the work's size, the museum can show only one scene at a time. When I visited in October 2018, the image was "Scene 15: Chamberlain's Gigantic Mounds and Walls—Natchez above the Hill." The signage read, in part: "Nestled between jagged ravines, monumental earthen mounds rise atop bluffs along the Mississippi River. In 1844, Dr. Charles Chamberlain (1815–1871) invited self-taught archaeologist Montroville W. Dickeson (1810–1882) to excavate these structures on his property about six miles north of Natchez, Mississippi. Using Dickeson's field sketches, John J. Egan painted this scene containing over a dozen mounds of different sizes and shapes. At the center stands a large, flat-topped mound crowned by trees. Smaller rounded domes and earthen ridges dot the surrounding landscape."

17. Gniadek, "Security and Settlement," 45.

18. Veit, "Mastadons," caption to Figure 5.

19. Additional groups can be seen gathered near two of the other mounds; these are presumably white men and women, although the figures are too indistinct to clearly identify.

20. Gniadek, "Security and Settlement," 48 (hereafter cited parenthetically in the text). Gniadek appears unaware that Dickeson is depicted in the scene not once but twice.

21. Veit, "A Case of Archaeological Amnesia," 110.

22. Art historian Angela Miller's article about the *Panorama* uses an image of scene twenty that omits the living Indian figures ("'The Soil of an Unknown America,'" 15). Anthropologist Richard Veit uses similarly cropped images in his 1997 and 1999 articles about Dickeson. The images used on the cover and as the frontispiece for Silverberg's *The Mound Builders* also omit the living Indians.

23. Angela Miller, "'The Soil of an Unknown America,'" 19.

24. Veit, "Mastadons."

25. Several scholars have noted the image's multiple sense of perspective; the ground immediately in front of the opened mound is depicted as if it is simultaneously seen from both a frontal and an aerial perspective. In chapter 3, I briefly note the use of clay urns in (some) Southeastern interments in my discussion of living earthworks vocabularies.

26. Lyons, "Panorama," 34.

27. Veit describes this shaft and skeleton in a fetal position as an "intrusive burial," similar to the intrusive or "secondary" burial depicted in the 3D model on display at the Serpent Mound interpretive center ("A Case of Archaeological Amnesia," 110).

28. After completing a draft of this chapter, I asked Hinton if she would check whether I describe the technical aspects of her works accurately and appropriately. I also told her I welcomed any additional comments she might like to provide. In a subsequent email, Hinton affirmed she had seen Egan's (cropped) image published in a book, and she confirmed my surmise that she had responded to Egan in the making of her photo-collage.

29. Vernon Knight offers the fascinating possibility—although it is based in an early non-Native source that some researchers consider less than reliable—that in Choctaw mortuary mound traditions, "As a symbolic manifestation of world renewal, the mound surfaces are replanted with trees after the mound is completed" ("Symbolism of Mississippian Mounds," 424). If this possibility is based in fact rather than fancy, it suggests the need to rethink dominant understandings of the relationship of trees to the durability of burial mounds.

30. Hinton, *Earth Consciousness and Cultural Revelations*, 14.

31. Hinton, 8.

32. Hinton, 36.

33. The concept of the *axis mundi* is often associated with the generative scholarship of the Romanian historian of religion and celebrated University of Chicago professor Mircea Eliade (1907–86); see, for instance, *The Sacred and the Profane* (1957).

34. See, for example, Howe, *Miko Kings*, 38–39, and *Choctalking on Other Realities*, 172.

35. Hedge Coke's structuring of these "transitions" as comprising seven parts—the central Tree preceded and then followed by three interrelated personas—appears to align with this seven-part spatial system. It may also align with the significance of the number seven in Cherokee traditions.

36. Hinton, *Earth Consciousness and Cultural Revelations*, 50.

37. Hinton, 50. In a different artist's statement about *Resurrection of Chief Big Foot* available online, Hinton has written: "I came up with this image by mixing and matching motifs that are repeated in other works. In this case, the turtle motif acting as the foundation for the Bigfoot motif begets a third meaning. It so happens that the turtle is a female icon and correlates to the water element, which relates to birth and regeneration. The Wounded Knee military campaign marked the defeat of the Lakota, the last free Indians. The way I combined the symbols here talks about the eminent regeneration of Native Americans seven generations later. Originally, the use of the turtle in my art derived from the burial mound motif as I developed my themes. As I made connections over time, I realized the mound was like a womb. From that arched shape, a turtle took form organically. Recently, I read that the triune of stars making up Orion is referred to as a turtle, and is the cosmic birthplace of the Solar/Corn God during the summer solstice. But the original turtle information came to me as a by-product of the creative process!" (https://alyssahinton.com/mixed-media-artwork /resurrection-of-chief-big-foot/).

38. For scholarly accounts of the commercial photographs, see Carter, "Making Pictures"; Beier, "Grave Misgivings"; and Gidley, "Visible and Invisible Scars." Carter suggests the photograph of Big Foot was made by Trager, whereas Gidley ascribes it to Morledge. The phrase "entrepreneurial photographers" is from Gidley (25).

39. Carl Smith, *Chicago Inter-Ocean*, January 7, 1891, quoted in Jensen et al., *Eyewitness at Wounded Knee*, 113.

40. Gidley, "Visible and Invisible Scars," 31. Hereafter cited parenthetically in the text.

41. Beier, "Grave Misgivings," 255.

42. Tsinhnahjinnie, "When Is a Photograph Worth a Thousand Words?," 41 (hereafter cited parenthetically in the text). Other Indigenous scholars who theorize visual sovereignty include Jolene Rickard (Tuscarora) and Michelle Raheja (Seneca).

43. Beier quotes part of this account ("Grave Misgivings," 259).

44. Tsinhnahjinnie's descriptions align with the research experiences of Monique Mojica and LeAnne Howe, which I describe in the codas to Parts I and III.

45. Hinton, *Earth Consciousness and Cultural Revelations*, 60.

46. Bunn-Marcuse, "Textualizing Intangible Cultural Heritage."

47. Moreton-Robinson, "I Still Call Australia Home," 36. Hereafter cited parenthetically in the text.

5. SECURED VAULTS

1. Quotations are taken from *The Black Stranger and Other American Tales*, a collection of Howard's magazine stories with "New World settings" edited by Steven Tompkins (hereafter cited parenthetically in the text). Tompkins provides a useful introduction to Howard's career and an overview of his particular interests in "the prehistory and history of North America" (vii). In "Make Settler Fantasy Strange Again," Franks offers a persuasive analysis of "The Horror from the Mound" focused on Howard's investments in tropes of Indigenous absence, the inevitability of white settler colonialism, and a possessive white masculinity.

2. Mel Gussow, "Theater: Wilson's 'Mound Builders,'" *New York Times*, February 3, 1975, 29.

3. The 1976 public television version was filmed on location in southern Illinois. See Edwin Wilson, "A Tribe in Search of Serenity," *Wall Street Journal*, February 11, 1976, 12.

4. David Richards, "Theater: Muddy 'Mound,'" *Washington Post*, June 11, 1987, C9. Less positive reviews chastise the playwright for burying his themes under too much high-strung dialogue. Frank Rich's *New York Times* review of a 1986 revival complains that "'The Mound Builders' is nearly all philosophical speechifying and highfalutin metaphor." Moreover, "Never explored as deeply as the archeological sites nearby, Mr. Wilson's people are usually mouthpieces for authorial sermons or pawns in symbolic conflicts pitting builders against spoilers, the haves against the have-nots, the idealists against the cynics." Rich, "Theater: Wilson's 'Mound Builders,'" *New York Times*, February 1, 1986, 17.

5. Callens, "When 'the Center Cannot Hold,'" 212.

6. Lanford Wilson, *The Mound Builders*, 7. Hereafter cited parenthetically in the text.

7. For a more detailed account of Winters's career and research, see Cantwell, Conrad, and Reyman, *Aboriginal Ritual and Economy*.

8. When Dan's wife, Jean, suggests that the Mississippian culture was perhaps more "rural" than the truly "spectacular cultures . . . like the Aztec Empire," August replies, "It was quite spectacular," and Dan insists, "If Cortes had landed here in 1250, you wouldn't be talking about Aztecs at all; you'd be talking about the glory that was Jasker's Field. They had longer trade routes—they just didn't leave anyone around to translate their poetry" (51).

9. Dan also relates the theory that the Mississippians are related to the Toltecs: "I think everyone would like to agree that they were runaways from the Toltecs, but haven't found substantial correlation; . . . but it's all looking like a mud version of the Toltecs—so when they came up they fought off whoever was here. And built the first fortifications and all that. Probably kept the first slaves" (53).

10. Wilson appears to have removed the minor character of the daughter from later versions of the play; see, for example, Mel Gussow's review from 1986. Gussow, "Lanford Wilson's Latest Revival Plumbs Levels beneath Levels," *New York Times*, February 9, 1986, H5.

11. Teuton, *Cherokee Stories*, 74. Hereafter cited parenthetically in the text.

12. Morgan, *Anompolichi*, 163.

13. Morgan, 180.

14. Knight relates that "the motif of a great mound with a hollow chamber in its center appears again in Choctaw origin and migration mythology. In accounts collected by Henry Halbert, the large platform mound at Nanih Waiya in Winston County, Mississippi, was considered the *ishki chito*, the 'great mother,' of the Choctaw tribe" (423). Another well-known version was recorded by the eminent Choctaw historian Muriel Hazel Wright (1889–1975); in the undated "Legend of Nanih Wayah," included in the 1995 anthology *Native American Writing in the Southeast*, Wright uses the phrase "Inholitopa Ishki (Beloved Mother)" rather than *ishki chito*, although the relationship is clear (220). (Byington records in his Choctaw dictionary that holitopa = beloved, dear, valuable, and so forth [164, 393] and inholitopa = dear, revered [164].)

15. Dyson, *Early Chickasaw Homeland*, 27.

16. I first wrote about *Crazy Ind'n*'s reference to "Fort Nanih Waya" in "Re-scripting Indigenous America."

17. At the time of drafting this chapter in late 2019 and early 2020, www.crazyindn .com was no longer active. Fortunately, I had taken a screenshot of the world map with the expanded Fort Nanih Waya icon sometime between 2008 and 2010.

18. The photograph is featured on the National Park Service website "Indian Mounds of Mississippi," for example, where it is attributed to Powell but is also acknowledged as provided courtesy of Ken Carleton, tribal archeologist, Mississippi Band of Choctaw (https://www.nps.gov/nr/travel/mounds/nan.htm.).

19. There are multiple versions of the emergence story, including those in which not only the Choctaw but other Southeastern peoples, such as the Chickasaw and the Creek and sometimes the Cherokee, also emerge from this site.

20. Much of the scholarship about *Shell Shaker* has focused on its depictions of Na-

tive women's power and its engagements with history and politics. See, for example, Hollrah, "Decolonizing the Choctaws"; Squint, "Burying the (Un)Dead"; and Trefzer, "The Indigenous Uncanny."

21. Howe, *Shell Shaker*, 146. Hereafter cited parenthetically in the text.

22. Aunt Delores is an "aunt" to the Billy women in the "Indian way" rather than in a strict "blood relation" way. She is not closely related to her love interest, Uncle Isaac, by blood.

23. Chapter 11, "Black Time," is set on June 21, 1747, the summer solstice, although Howe does not indicate it as such.

24. Another version of the equation for the macrostructure is $17 = 2^2 + 3^2 + 2^2$, *seventeen chapters equals the square of two "pasts" plus the square of three "presents" plus the square of two "no times,"* or $p_7 = p_1^2 + p_2^2 + p_1^2$, *the seventh prime equals the square of the first prime plus the square of the second prime plus the square of the first prime.*

25. Drucker, "Reading Interface," 213. Hereafter cited parenthetically in the text.

Coda 3

1. See McQuaide, "Dublin's Ties."

2. From the internet site Atlas Obscura: "This limestone monument in the shape of Chief Leatherlips' silhouette, erected in 1990, overlooks Scioto Park. Visitors can stand on the head of the ill-fated chief to look out on the very land that he signed over to the settlers." See www.atlasobscura.com/places/chief-leatherlips-monument. For more information on the city of Dublin's relationship to Chief Leatherlips, see "Leatherlips Story Lives on through Local Legend," *Columbus Neighborhoods*, at columbusneighborhoods.org, and "Chief Leatherlips," Dublin Historical Society, at dublinohiohistory.org.

3. The square enclosure is more clearly visible in aerial photographs made in the 1930s and 1950s. See https://www.researchgate.net/figure/Old-aerial-photographs -of-the-Holder-Wright-farm-souce-USDA_fig3_314033681.

4. Howe, personal communication, May 2013; Howe, "Mounds and Earthworks as Performance Sites," presentation with Chadwick Allen, Native American and Indigenous Studies Association conference, Vancouver, Canada, June 23, 2017; Howe, plenary performance "A Reading for the Mound Builders," with Chadwick Allen, Allison Hedge Coke, and Phillip Carroll Morgan, Western Literature Association conference, St. Louis, Missouri, October 26, 2018.

5. In part II ("Origin") of *Blood Run*, Hedge Coke evokes the idea that earthworks are imbued with sacred discourse primarily through the persona The Mounds. In

their first appearance, The Mounds state: "Here, the earth is sanctified, sacrament caressed" (17); in their second appearance: "With each layer, came credence; reverence" (30). In part III ("Intrusions"), the persona Skeletons directly equates earthen burial mounds to sacred discourse: "Our people labored for this honoring / no human should dismantle prayer" (56). In *The Book of Big Dog Town*, Jim Stevens makes a similar point about the Aztalan site in Wisconsin: "Their spiritual presence [that of three destroyed mounds] still remains because of the nature of mound-building, for this is a spiritual art which entails their being embedded within the earth. In other words, once the prayer has been set in the soil, it remains there" (6). Jay Miller makes a similar point about contemporary, ritual mound building, use, and upkeep among Southeastern peoples relocated to Oklahoma in *Ancestral Mounds*: "As air sustains life, so song sustains the land. Singing sets the rhythms of the Feather, Ribbon, and Buffalo dances, while the distinctive stomp step pumps these into the ground, where some bubble up into mounds. Song is the vehicle for *powha* [power], strengthened in these instances by their sacred, communal expression" (122).

CONCLUSION

1. In their beautifully illustrated coffee-table book *New Architecture on Indigenous Lands*, architectural historians Joy Malnar and Frank Vodvarka write about the (then) AICCM with an emphasis on the role of its innovative design and on the specific roles played by the team of architects and engineers. In their essay "Life in a 21st Century Mound City," Choctaw writer LeAnne Howe and her husband, Jim Wilson, a non-Native archaeologist, write about the AICCM with an emphasis on the roles played by contemporary Native peoples and nations.

2. Hogan, "The Maps," 30. The poem also appears in Hogan's 2020 collection *A History of Kindness* (28–29).

3. I was able to visit *Visual Voices* at the IAIA Museum of Contemporary Native American Arts in Santa Fe, New Mexico, in January 2020. One of the most striking pieces is Dustin Mater's mixed-media painting *Dreaming Perched upon the Mounds* (2013).

4. For information on Redcorn's work see www.redcornpottery.com.

5. Howe and Wilson, "Life in a 21st Century Mound City," 3.

6. A story about the mound being built by the Choctaw Nation is available on the Nation's YouTube channel, ChoctawNationOK, "Choctaw Nation Community Mound in Atoka," posted July 28, 2016. The accompanying story by Tina Firquain reads, in part: "Councilman Anthony Dillard used leftover resources to create a mound honoring the culture and heritage that mounds share with the Choctaw people. The idea of

creating mounds and items of cultural significance in each district has been talked about by the Tribal Council and the Tourism Department for several years, but the funds have never been available. The Atoka mound was possible due to the construction of the Choctaw Nation's Atoka Head Start. To build the head start, dirt had to be removed from the site and Councilman Dillard saw this as an opportunity to start the mound project."

BIBLIOGRAPHY

Ahtone, Heather. "Foreword: In the Summer We Dance: Aesthetic Renewal and Gratitude." In *Visual Voices: Contemporary Chickasaw Art*, edited by Laura Marshall Clark, 11–13. Ada, Okla.: Chickasaw Press, 2018.

Allen, Chadwick. *Blood Narrative: Indigenous Identity in American Indian and Maori Literary and Activist Texts*. Durham: Duke University Press, 2002.

Allen, Chadwick. "Earthworks as Indigenous Performance." In *In the Balance: Indigeneity, Performance, Globalization*, edited by Helen Gilbert, J. D. Phillipson, and Michelle Raheja, 291–308. Liverpool: University of Liverpool Press, 2017.

Allen, Chadwick. "Introduction: Locating the Society of American Indians." *Studies in American Indian Literatures* 25, no. 2 (Summer 2013): 3–22.

Allen, Chadwick. "Performing Serpent Mound: A Trans-Indigenous Meditation." *Theatre Journal* 67, no. 3 (October 2015): 391–411.

Allen, Chadwick. "Re-scripting Indigenous America: Earthworks in Native Art, Literature, Community." In *Twenty-First Century Perspectives on Indigenous Studies: Native North America in (Trans)Motion*, edited by Birgit Daewes, Karsten Fitz, and Sabine N. Meyer, 127–47. New York and London: Routledge, 2015.

Allen, Chadwick. "Serpentine Figures, Sinuous Relations: Thematic Geometry in Allison Hedge Coke's *Blood Run*." *American Literature* 82, no. 4 (December 2010): 807–34.

Allen, Chadwick. "Siting Earthworks, Navigating Waka: Patterns of Indigenous Settlement in Allison Hedge Coke's *Blood Run* and Robert Sullivan's *Star Waka*." In *Trans-Indigenous: Methodologies for Global Native Literary Studies*, 193–247. Minneapolis: University of Minnesota Press, 2012.

Allen, Chadwick. "Solstice at the Mounds." *Nine* 6, no. 6 (June 1990): 18–21, 46.

Allen, Chadwick. *Trans-Indigenous: Methodologies for Global Native Literary Studies*. Minneapolis: University of Minnesota Press, 2012.

Allen, Chadwick. "Vital Earth / Vibrant Earthworks / Living Earthworks Vocabularies." In *Routledge Handbook of Critical Indigenous Studies*, edited by Brendan Hokowhitu, Aileen Moreton-Robinson, Linda Tuhiwai Smith, Chris Andersen, and Steve Larkin, 215–28. London: Routledge, 2020.

Allen, Chadwick, and LeAnne Howe. "Indigenous Methodologies: A Conversation." Western Literature Association Conference. Reno, Nevada, October 16, 2015.

"The Ancient Worship of Serpents." *Asiatic Journal and Monthly Register* 10, no. 37 (January–April 1833): 32–35.

Anderson, Chad. "North America's 'Big Bang.'" Review of *Cahokia: Ancient America's Great City on the Mississippi*, by Timothy Pauketat. *Common-Place* 12, no. 2.5 (February 2012). www.common-place.org.

Atalay, Sonya. "Indigenous Archaeology as Decolonizing Practice." *American Indian Quarterly* 30, nos. 3–4 (Summer–Autumn 2006): 280–310.

Atalay, Sonya. "Multivocality and Indigenous Archaeologies." In *Evaluating Multiple Narratives: Beyond Nationalist, Colonialist, Imperialist Archaeologies*, edited by Junko Habu, Clare Fawcett, and John M. Matsunaga, 29–44. New York: Springer, 2008.

Austin, Mary. *The Trail Book*. 1918. Reno: University of Nevada Press, 2004.

Azure, Alice M. *Games of Transformation*. Chicago: Albatross Press, 2011.

Baires, Sarah E. *Land of Water, City of the Dead: Religion and Cahokia's Emergence*. Tuscaloosa: University of Alabama Press, 2017.

Barnett, Rod. "Designing Indian Country." *Places Journal*, October 2016. placesjournal .org.

Beier, J. Marshall. "Grave Misgivings: Allegory, Catharsis, Composition." *Security Dialogue* 38, no. 2 (June 2007): 251–69.

Bernardini, Wesley. "Hopewell Geometric Earthworks: A Case Study in the Referential and Experiential Meaning of Monuments." *Journal of Anthropological Archaeology* 23 (2004): 331–56.

Birmingham, Robert A., and Leslie E. Eisenberg. *Indian Mounds of Wisconsin*. Madison: University of Wisconsin Press, 2000.

Birmingham, Robert A., and Lynne G. Goldstein. *Aztalan: Mysteries of an Ancient Indian Town*. Madison: Wisconsin Historical Society Press, 2005.

Boone, Elizabeth Hill. "The Cultural Category of Scripts, Signs, and Pictographies." In *Their Way of Writing: Scripts, Signs, and Pictographies in Pre-Columbian America*, edited by Elizabeth Hill Boone and Gary Urton, 379–90. Washington, D.C: Dumbarton Oaks, 2011.

Boone, Elizabeth Hill, and Walter D. Mignolo, eds. *Writing without Words: Alternative Literacies in Mesoamerica and the Andes*. Durham: Duke University Press, 1994.

Boone, Elizabeth Hill, and Gary Urton, eds. *Their Way of Writing: Scripts, Signs, and Pictographies in Pre-Columbian America*. Washington, D.C: Dumbarton Oaks, 2011.

Bounds, Thelma V. *Children of Nanih Waiya*. San Antonio: Naylor, 1964.

Bradley, Sam. "Serpent Mound *(Serpent Mound State Park, southern Ohio)*." *Poetry* 115, no.1 (October 1969): 14.

Brooks, Lisa. *The Common Pot: The Recovery of Native Space in the Northeast.* Minneapolis: University of Minnesota Press, 2008.

Brooks, Lisa. "The Primacy of the Present, the Primacy of Place: Navigating the Spiral of History in the Digital World." *PMLA* 127, no. 2 (March 2012): 308–14.

Brown, Dee. *Bury My Heart at Wounded Knee: An Indian History of the American West.* New York: Henry Holt, 1970.

Brown, James A. "The Shamanic Element of Hopewellian Period Ritual." In *Recreating Hopewell*, edited by Douglas K. Charles and Jane E. Buikstra, 475–88. Gainesville: University Press of Florida, 2006.

Brown, Virginia Pounds. *The Gold Disc of Coosa: A Boy of the Mound Builders Meets DeSoto.* Montgomery, Ala.: Junebug Books, 2007.

Bryce, George. *The Mound Builders.* Winnipeg: Manitoba Free Press, 1884–85. Project Gutenberg eBook #17987, 2006.

Bunce, William H. *Chula, Son of the Mound Builders.* New York: Dutton, 1942.

Bunn-Marcuse, Kathryn. "Textualizing Intangible Cultural Heritage: Querying the Methods of Art History." *Panorama* 4, no. 2 (Fall 2018). https://editions.lib.umn.edu/panorama/.

Byington, Cyrus. *A Dictionary of the Choctaw Language.* Ed. John R. Swanton and Henry S. Halbert. Bureau of American Ethnology Bulletin 46. Washington, D.C.: Government Printing Office, 1915.

Byrd, Jodi. "A Return to the South." *American Quarterly* 66, no. 3 (September 2014): 609–20.

Cajete, Gregory. *Native Science: Natural Laws of Interdependence.* Santa Fe: Clear Light, 2000.

Callens, Johan. "When 'the Center Cannot Hold' or the Problem of Mediation in Lanford Wilson's *The Mound Builders*." In *New Essays on American Drama*, edited by Gilbert Debusscher and Henry I. Schvey, 201–26. Amsterdam: Rodopi, 1989.

Cantwell, Anne-Marie, Lawrence A. Conrad, and Jonathan E. Reyman, eds. *Aboriginal Ritual and Economy in the Eastern Woodlands: Essays in Memory of Howard Dalton Winters.* Springfield: Illinois State Museum Scientific Papers, vol. 30. 2004.

Carter, John E. "Making Pictures for a News-Hungry Nation." In *Eyewitness at Wounded Knee* by Richard E. Jensen, R. Eli Paul, and John E. Carter, 39–60. Lincoln: University of Nebraska Press, 1991.

Chaatsmith, Marti L. "Native (Re)Investments in Ohio: Evictions, Earthworks Preservation, and Tribal Stewardship." In *The Newark Earthworks: Enduring*

Monuments, Contested Meanings, edited by Lindsay Jones and Richard D. Shiels, 215–29. Charlottesville: University of Virginia Press, 2016.

Chaatsmith, Marti L. "Singing at a Center of the Indian World: The SAI and Ohio Earthworks." *Studies in American Indian Literatures* 25, no. 2 (Summer 2013): 181–98.

Charles, Douglas K., and Jane E. Buikstra, eds. *Recreating Hopewell*. Gainesville: University Press of Florida, 2006.

Clark, Laura Marshall, ed. *Visual Voices: Contemporary Chickasaw Art*. Ada, Okla.: Chickasaw Press, 2018.

Colwell-Chanthaphonh, Chip, T. J. Ferguson, Dorothy Lippert, Randall H. McGuire, George P. Nicholas, Joe E. Watkins, and Larry J. Zimmerman. "The Premise and Promise of Indigenous Archaeology." *American Antiquity* 75, no. 2 (2010): 228–38.

Crump, Irving. *Mog, the Mound Builder*. Introduction by H. C. Shetrone. New York: Grosset and Dunlap, 1931.

Dalan, Rinita A., George R. Holley, William I. Woods, Harold W. Watters Jr., and John A. Koepke. *Envisioning Cahokia: A Landscape Perspective*. Dekalb: Northern Illinois University Press, 2003.

Deloria, Vine, Jr. *God Is Red*. New York: Grosset, 1973.

DeMallie, Raymond J., ed. *The Sixth Grandfather: Black Elk's Teachings Given to John G. Neihardt*. Lincoln: University of Nebraska Press, 1984.

Dixon, John Morris. "Wexner Center for the Visual Arts." *Progressive Architecture*, October 1989, 70–83.

Downey, Anne M. "'A Broken and Bloody Hoop': The Intertextuality of *Black Elk Speaks* and Alice Walker's *Meridian*." *MELUS* 19, no. 3 (1994): 37–45.

Drucker, Johanna. "Reading Interface." *PMLA* 128, no. 1 (January 2013): 213–20.

Durham, Jimmie. "Against Architecture." In *Waiting to Be Interrupted: Selected Writings, 1993–2012*, edited by Jean Fisher, 103–9. Milan: Mousse Publishing, 2013.

Durham, Jimmie. "A Central Margin." In *The Decade Show: Frameworks of Identity in the 1980s*, 162–75. New York: Museum of Contemporary Hispanic Art, New Museum of Contemporary Art, and Studio Museum of Harlem, 1990.

Durham, Jimmie. "A Certain Lack of Coherence." In *A Certain Lack of Coherence: Writings on Art and Cultural Politics*, edited by Jean Fisher, 143–47. London: Kala Press, 1993.

Durham, Jimmie. *Columbus Day: Poems, Drawings and Stories about American Indian Life and Death in the Nineteen-Seventies*. Albuquerque: West End Press, 1983.

Durham, Jimmie. "Cowboys and . . ." In *A Certain Lack of Coherence: Writings on Art and Cultural Politics*, edited by Jean Fisher, 170–86. London: Kala Press, 1993.

Durham, Jimmie. "Probably This Will Not Work." In *Waiting to Be Interrupted: Selected Writings, 1993–2012*, edited by Jean Fisher, 13–22. Milan: Mousse Publishing, 2013.

Dyson, John P. *The Early Chickasaw Homeland: Origins, Boundaries, and Society*. Ada, Okla.: Chickasaw Press, 2014.

Eisenman Builds. Special issue, *Progressive Architecture*, October 1989.

Eliade, Mircea. *The Sacred and the Profane: The Nature of Religion*. 1957. New York: Harcourt, Brace & World, 1959.

Ellegood, Anne, ed. *Jimmie Durham: At the Center of the World*. Los Angeles: Hammer Museum, 2017.

Ferguson, Thomas E. *Ohio Lands: A Short History*. Researched and written by Thomas Aquinas Burke. 3rd ed. Columbus: Ohio Auditor of State, 1991.

Fisher, Thomas. "Wexner Center for the Visual Arts: Intro/duction." *Progressive Architecture*, October 1989, 68.

Fitzgerald, Pitt L. *The Black Spearman: A Story of the Builders of the Great Mounds*. New York: Books, Inc., 1934, 1939.

Franks, Travis. "Make Settler Fantasy Strange Again: Unsettling Normative White Masculinity in Robert E. Howard's Weird West." *Western American Literature* 54, no. 3 (Fall 2019): 295–322.

Garcia, Edgar. *Signs of the Americas: A Poetics of Pictography, Hieroglyphs, and Khipu*. Chicago: University of Chicago Press, 2020.

Gehlbach, D. R. "The Builders of the Jeffers Mound—Were They the Adena or Hopewell People?" *Ohio Archaeologist* 61, no. 3 (Summer 2011): 40–43.

Gidley, Mick. "Visible and Invisible Scars of Wounded Knee." In *Picturing Atrocity: Photography in Crisis*, edited by Geoffrey Batchen, Mick Gidley, Nancy K. Miller, and Jay Prosser, 25–38. London: Reaktion Books, 2012.

Glancy, Diane. "The Mound Builders." In *The Dream of a Broken Field*, 178–84. Lincoln: University of Nebraska Press, 2011.

Glotzhober, Robert C., and Bradley T. Lepper. *Serpent Mound: Ohio's Enigmatic Effigy Mound*. Columbus: Ohio Historical Society, 1994.

Gniadek, Melissa. "Seriality and Settlement: Southworth, Lippard, and *The Panorama of the Monumental Grandeur of the Mississippi Valley*." *American Literature* 86, no. 1 (March 2014): 31–59.

Goeman, Mishuana. *Mark My Words: Native Women Mapping Our Nations*. Minneapolis: University of Minnesota Press, 2013.

Gonzalez, Jennifer A. "Categorical Refusal: Unwinding the Wound." In *Jimmie Durham: At the Center of the World*, edited by Anne Ellegood, 192–97. Los Angeles: Hammer Museum, 2017.

Gorman, Joshua M. *Building a Nation: Chickasaw Museums and the Construction of History and Heritage.* Tuscaloosa: University of Alabama Press, 2011.

Greenman, Emerson F. *Guide to Serpent Mound.* Columbus: Ohio State Archaeological and Historical Society, n.d. [1935?]. Revised editions: Columbus: Ohio Historical Society, 1939, 1957, 1964.

Grosvenor, Abbie Johnston. *Winged Moccasins: A Tale of the Adventurous Mound-Builders.* New York: D. Appleton, 1933.

Harjo, Joy. "The Southeast was covered." In *An American Sunrise: Poems,* 65. New York: Norton, 2019.

Hedge Coke, Allison Adelle. *Blood Run: Free Verse Play.* Cambridge, UK: Salt Publishing, 2006.

Hedge Coke, Allison Adelle. Introduction. *Sing: Poetry from the Indigenous Americas,* edited by Allison Adelle Hedge Coke, 1–19. Tucson: University of Arizona Press, 2011.

Hinton, Alyssa. *Earth Consciousness and Cultural Revelations.* Ed. Adam Silver. Brattleboro, Vt.: C. X. Silver Gallery, 2017.

Hively, Ray, and Robert Horn. "Geometry and Astronomy in Prehistoric Ohio." 1982. In *Foundations of New World Cultural Astronomy: A Reader with Commentary,* edited by Anthony Aveni, 39–60. Boulder: University Press of Colorado, 2008.

Hively, Ray, and Robert Horn. "The Newark Earthworks: A Grand Unification of Earth, Sky, and Mind." In *The Newark Earthworks: Enduring Monuments, Contested Meanings,* edited by Lindsay Jones and Richard D. Shiels, 62–93. Charlottesville: University of Virginia Press, 2016.

Hobson, Geary. *The Last of the Ofos.* Tucson: University of Arizona Press, 2000.

Hogan, Linda. *A History of Kindness: Poems.* Salt Lake City: Torrey House Press, 2020.

Hogan, Linda. "The Maps." In *Visual Voices: Contemporary Chickasaw Art,* edited by Laura Marshall Clark, 30. Ada, Okla.: Chickasaw Press, 2018. Reprinted in Hogan, *A History of Kindness: Poems,* 28–29. Salt Lake City: Torrey House Press, 2020.

Hogan, Linda. "New Trees, New Medicines, New Wars: The Chickasaw Removal." *Canadian Review of Comparative Literature* 42, no. 1 (March 2015): 121–29.

Hogan, Linda. "Turning Earth, Circling Sky." In *Visual Voices: Contemporary Chickasaw Art,* edited by Laura Marshall Clark, 76–78. Ada, Okla.: Chickasaw Press, 2018.

Hogan, Linda. "Walking." In *In Short: A Collection of Brief Creative Nonfiction,* edited by Judith Kitchen and Mary Paumier Jones, 229–32. New York: Norton, 1996.

Hollrah, Patrice. "Decolonizing the Choctaws: Teaching LeAnne Howe's 'Shell Shaker.'" *American Indian Quarterly* 28, nos. 1/2 (Winter–Spring 2004): 73–85.

Horton, Jessica L. *Art for an Undivided Earth: The American Indian Movement Generation.* Durham: Duke University Press, 2017.

Horton, Jessica L. "Jimmie Durham's Stones and Bones." In *Jimmie Durham: At the Center of the World,* edited by Anne Ellegood, 76–83. Los Angeles: Hammer Museum, 2017.

Horton, Jessica L., and Janet Catherine Berlo. "Beyond the Mirror: Indigenous Ecologies and 'New Materialisms' in Contemporary Art." *Third Text* 27, no. 1 (January 2013): 17–28.

Howard, Robert E. "The Horror from the Mound." *Weird Tales,* May 1932. In *The Black Stranger and Other American Tales,* edited and introduced by Steven Tompkins, 303–19. Lincoln: University of Nebraska Press, 2005.

Howe, LeAnne. *Choctalking on Other Realities.* San Francisco: Aunt Lute Books, 2013.

Howe, LeAnne. "Embodied Tribalography—First Installment." In *Choctalking on Other Realities,* 173–93. San Francisco: Aunt Lute Books, 2013.

Howe, LeAnne. "Embodied Tribalography: Mound Building, Ball Games, and Native Endurance in the Southeast." *Studies in American Indian Literatures* 26, no. 2 (Summer 2014): 75–93.

Howe, LeAnne. *Miko Kings: An Indian Baseball Story.* San Francisco: Aunt Lute Books, 2007.

Howe, LeAnne. *Shell Shaker.* San Francisco: Aunt Lute Books, 2001.

Howe, LeAnne. "The Story of America: A Tribalography." In *Choctalking on Other Realities,* 13–40. San Francisco: Aunt Lute Books, 2013.

Howe, LeAnne, and Jim Wilson. "Life in a 21st Century Mound City." In *The World of Indigenous North America,* edited by Robert Warrior, 3–26. New York: Routledge, 2015.

Huhndorf, Shari M. *Mapping the Americas: The Transnational Politics of Contemporary Native Culture.* Ithaca: Cornell University Press, 2009.

"Jeffers Mound: Worthington's Oldest Manmade Structure." Worthington Historical Society, Worthington, Ohio. www.worthingtonhistory.org.

Jensen, Richard E., R. Eli Paul, and John E. Carter. *Eyewitness at Wounded Knee.* Lincoln: University of Nebraska Press, 1991.

Johnson, Jay T., and Soren C. Larsen, eds. *A Deeper Sense of Place: Stories and Journeys of Collaboration in Indigenous Research.* Corvallis: Oregon State University Press, 2013.

Josephy, Alvin M., Jr., ed. *America in 1492: The World of the Indian Peoples before the Arrival of Columbus.* 1991. New York: Vintage, 1993.

Kassulke, Natasha. "Who Were They and Why Did They Leave?" *Wisconsin Natural Resources Magazine,* October 2009.

Kelsey, Penelope, and Cari M. Carpenter. "'In the End, Our Message Weighs': *Blood*

Run, NAGPRA, and American Indian Identity." *American Indian Quarterly* 35, no. 1 (Winter 2011): 56–74.

King, Blanche Busey. *Under Your Feet: The Story of the American Mound Builders.* New York: Dodd, Mead, 1939.

King, Kathleen. *Cricket Sings: A Novel of Pre-Columbian Cahokia.* Athens: Ohio University Press, 1983.

Knepper, George W., ed. *Along the Ohio Trail: A Short History of Ohio Lands.* 4th ed. Ohio Auditor of State, 2003.

Knepper, George W., ed. *The Official Ohio Lands Book.* Ohio Auditor of State, 2002.

Knight, Vernon James, Jr. "Symbolism of Mississippian Mounds." In *Powhatan's Mantle: Indians in the Colonial Southeast,* edited by Gregory A. Waselkov, Peter H. Wood, and Tom Hatley, 421–34. Rev. ed. Lincoln: University of Nebraska Press, 2006.

Knowles, Ric. "Mounds, Earthworks, Side Show Freaks and Circus Injuns." In *Enacting Nature: Ecocritical Perspectives on Indigenous Performance,* edited by Birgit Dawes and Marc Maufort, 47–58. Brussels: Peter Lang, 2014.

Kolodny, Annette. "Fictions of American Prehistory: Indians, Archeology, and National Origin Myths." *American Literature* 75, no. 4 (December 2003): 693–721.

Lame Deer, John (Fire), and Richard Erdoes. *Lame Deer: Seeker of Visions.* New York: Simon and Schuster, 1972.

Lankford, George E. "The Great Serpent in Eastern North America." In *Ancient Objects and Sacred Realms: Interpretations of Mississippian Iconography,* edited by F. Kent Reilly III and James F. Garber, 107–35. Austin: University of Texas Press, 2007.

Lepper, Bradley T. "The Great Hopewell Road and the Role of Pilgrimage in the Hopewell Interaction Sphere." In *Recreating Hopewell,* edited by Douglas K. Charles and Jane E. Buikstra, 122–33. Gainesville: University Press of Florida, 2006.

Lepper, Bradley T. *The Newark Earthworks: A Wonder of the Ancient World.* Columbus: Ohio Historical Society, 2002.

Lepper, Bradley T. "Tracking Ohio's Great Hopewell Road." *Archaeology,* November/December 1995, 32–56.

Lepper, Bradley T., and Tod A. Frolking. "Alligator Mound: Geoarchaeological and Iconographical Interpretations of a Late Prehistoric Effigy Mound in Central Ohio, USA." *Cambridge Archaeological Journal* 13, no. 2 (2003): 147–67.

Lippard, Lucy R. "Jimmie Durham: Postmodernist 'Savage.'" *Art in America* 81, no. 2 (February 1993): 62–68, 55.

Loren, Diana DiPaolo. Review of *Cahokia: Ancient America's Great City on the Mississippi,* by Timothy Pauketat. *Urban History* 39, no. 2 (2012): 379–80.

Lynott. Mark J. *Hopewell Ceremonial Landscapes of Ohio: More than Mounds and Geometric Earthworks*. Havertown, Pa.: Oxbow Books, 2014.

Lyons, Lisa. "Panorama of the Monumental Grandeur of the Mississippi Valley." *Design Quarterly* 101/102 (1976): 32–34.

Malnar, Joy Monice, and Frank Vodvarka. *New Architecture on Indigenous Lands*. Minneapolis: University of Minnesota Press, 2013.

McNickle, D'Arcy. *They Came Here First: The Epic of the American Indian*. Philadelphia: J. B. Lippincott, 1949.

McQuaide, Sarah. "Dublin's Ties to Ancient Peoples Will Soon Be Showcased." *Dublin Life Magazine*, July 29, 2018. www.cityscenecolumbus.com.

Melamed, Jodi. *Represent and Destroy: Rationalizing Violence in the New Racial Capitalism*. Minneapolis: University of Minnesota Press, 2011.

Meredith, America. "Why It Matters That Jimmie Durham Is Not a Cherokee." *artnet News*, July 7, 2017. www.news.artnet.com.

Miller, Angela. "'The Soil of an Unknown America': New World Lost Empires and the Debate over Cultural Origins." *American Art* 8, nos. 3/4 (Summer–Autumn 1994): 8–27.

Miller, Jay. *Ancestral Mounds: Vitality and Volatility of Native America*. Lincoln: University of Nebraska Press, 2015.

Million, Dian. "Intense Dreaming: Theories, Narratives, and Our Search for Home." *American Indian Quarterly* 35, no. 3 (Summer 2011): 313–33.

Million, Dian. "There Is a River in Me: Theory from Life." In *Theorizing Native Studies*, edited by Audra Simpson and Andrea Smith, 31–42. Durham: Duke University Press, 2014.

Million, Tara. "Developing an Aboriginal Archaeology: Receiving Gifts from White Buffalo Calf Woman." In *Indigenous Archaeologies: Decolonizing Theory and Practice*, edited by Claire Smith and H. Martin Wobst, 39–51. London: Routledge, 2005.

Milner, George R. *The Moundbuilders: Ancient Peoples of Eastern North America*. London: Thames and Hudson, 2004.

Mink, Claudia Gellman. *Cahokia: City of the Sun*. 1992. Rev. ed. Collinsville, IL: Cahokia Mounds Museum Society, 1999.

Mithlo, Nancy Marie. "Decentering Durham." In *Knowing Native Arts*, 181–209. Lincoln: University of Nebraska Press, 2020.

Mojica, Monique. "In Plain Sight: Inscripted Earth and Invisible Realities." In *New Canadian Realisms: New Essays on Canadian Theatre*, vol. 2, edited by Roberta Barker and Kim Solga, 218–42. Toronto: Playwrights Canada Press, 2012.

Mojica, Monique, and LeAnne Howe. *Sideshow Freaks and Circus Injuns.* Unpublished
 script. 2017.
Momaday, N. Scott. "The Man Made of Words." In *Indian Voices: The First Convocation of
 American Indian Scholars,* 49–84. San Francisco: Indian Historian Press, 1970.
Mooney, James. *Myths of the Cherokee.* 1900. St. Clair Shores, Mich.: Scholarly Press,
 1970.
Moreton-Robinson, Aileen. "I Still Call Australia Home: Indigenous Belonging and
 Place in a White Postcolonizing Society." In *Uprootings/Regroundings: Questions
 of Home and Migration,* edited by Sara Ahmed, Claudia Castaneda, Anne-Marie
 Fortier, and Mimi Sheller, 23–40. Oxford: Berg, 2003.
Morgan, Phillip Carroll. *Anompolichi: The Wordmaster.* Ada, Okla.: White Dog Press,
 2014.
Morgan, Phillip Carroll. "Mississippian Ideological Interaction Sphere." Unpublished
 annotated map. 2018.
Morgan, Phillip Carroll. "The Origins of *Anompolichi the Wordmaster* (first draft)."
 Unpublished essay. 2018.
Morgan, Phillip Carroll. "Postcards from Moundville." 2018. In *Famine Pots: The
 Choctaw-Irish Gift Exchange, 1847–Present,* edited by LeAnne Howe and Padraig
 Kirwin, 207. East Lansing: Michigan State University Press, 2020.
The Mound Builders. Directed by Ken Campbell and Marshall W. Mason. Produced by
 Ken Campbell. Circle Repertory Company, New York, N.Y. Public Broadcasting
 Service. New Jersey Public Television, New Jersey. WNET Channel 13, New York,
 N.Y. Broadway Theatre Archive, 1976. Alexander Street video. www.alexanderstreet
 .com/watch/the-mound-builders.
Mulvey, Laura. "Changing Objects, Preserving Time." In *Jimmie Durham,* by Laura
 Mulvey, Dirk Snauwaert, Mark Alice Durant, and Jimmie Durham, 32–75.
 London: Phaidon, 1995.
Myron, Robert. *Shadow of the Hawk: Saga of the Mound Builders.* New York: Putnam,
 1964.
Napora, Joe. "The Adena Serpent Mound: Adams County, Ohio." Broadside. N.p., 1983.
Napora, Joe. *Scighte.* Art and binding by Timothy Ely. Paper by Ruth Lingen. New
 York: Pooté Press, 1987.
Neihardt, John G. *Black Elk Speaks: Being the Life of a Holy Man of the Oglala Sioux.* 1932.
 Lincoln: University of Nebraska Press, 1961.
Noodin, Margaret. "Aazhawa'zhiwebag / Paths into the Past." Unpublished poem.
 2017.

Noodin, Margaret. "Bundling the Day and Unraveling the Night." *Studies in American Indian Literatures* 25, no. 2 (Summer 2013): 237–40.

Noodin, Margaret. *Weweni: Poems in Anishinaabemowin and English*. Detroit: Wayne State University Press, 2015.

Oliphant, Dave. *Lines & Mounds*. Berkeley: Thorp Springs Press, 1976.

Oliver, Louis Littlecoon. "The Mound." In *Chasers of the Sun: Creek Indian Thoughts*, 85. Greenfield Center, N.Y.: Greenfield Review Press, 1990.

Ortiz, Alfonso. "Some Concerns Central to the Writing of 'Indian' History." *Indian Historian* 10, no. 1 (Winter 1977): 17–22.

Pauketat, Timothy R. *Cahokia: Ancient America's Great City on the Mississippi*. New York: Penguin, 2009.

Payne, Mildred Y., and Harry Harrison Kroll. *Mounds in the Mist*. South Brunswick, N.Y.: A. S. Barnes, 1969.

Pearce, Margaret Wickens. "The Cartographic Legacy of the Newark Earthworks." In *The Newark Earthworks: Enduring Monuments, Contested Meanings*, edited by Lindsay Jones and Richard D. Shiels, 180–97. Charlottesville: University of Virginia Press, 2016.

Pfeiffer, John. *Indian City on the Mississippi*. Time-Life Nature/Science Annual 1974. Excerpt. Collinsville, IL: Cahokia Mounds Museum Society, n.d.

Pickard, Bill. "A View within the Circle, Part II: Inside Looking Out." Ohio History Connection's Archaeology Blog, October 20, 2009. apps.ohiohistory.org /ohioarchaeology/2009/10/.

Pidgeon, William. *Traditions of De-coo-dah and Antiquarian Researches: Extensive Explorations, Surveys, and Excavations of the Wonderful and Mysterious Earthen Remains of the Mound-builders in America; the Traditions of the Last Prophet of the Elk Nation Relative to their Origin and Use; and the Evidences of an Ancient Population More Numerous than the Present Aborigines*. New York: Horace Thayer, 1858.

Potter, Martha A. *Ohio's Prehistoric Peoples*. Columbus: Ohio Historical Society, 1968.

Power, Susan. *The Grass Dancer*. New York: Putnam, 1994.

Pratt, Mary Louise. *Imperial Eyes: Travel Writing and Transculturation*. London: Routledge, 1992.

Putnam, F. W. "The Serpent Mound of Ohio." *The Century Illustrated Monthly Magazine* 39, no. 6 (April 1890): 871–87.

Raheja, Michelle. *Reservation Reelism: Redfacing, Visual Sovereignty, and Representations of Native Americans in Film*. Lincoln: University of Nebraska Press, 2010.

Randall, E. O. *The Serpent Mound, Adams County, Ohio: Mystery of the Mound and History*

of the Serpent. Various Theories of the Effigy Mounds and the Mound Builders. 2nd ed. Columbus: Ohio State Archaeological and Historical Society, 1907.

Richards, John D. "Viewing the Ruins: The Early Documentary History of the Aztalan Site." *Wisconsin Magazine of History* 9, no. 2 (Winter 2007/2008): 28–39.

Rickard, Jolene. "Sovereignty: A Line in the Sand." In *Strong Hearts: Native American Visions and Voices,* edited by Peggy Roalf, 51–61. New York: Aperture, 1996.

Riley, Patricia. "Wrapped in the Serpent's Tail: Alice Walker's African–Native American Subjectivity." In *When Brer Rabbit Meets Coyote: African-Native American Literature,* edited by Jonathan Brennan, 241–56. Champaign: University of Illinois Press, 2003.

Rogers, Sarah J., curator. "Introduction: Poetry and Politics." In *Will/Power: New Works by Papo Colo, Jimmie Durham, David Hammons, Hachivi Edgar Heap of Birds, Adrian Piper, Aminah Brenda Lynn Robinson,* 8–16. Columbus, Ohio: Wexner Center for the Arts, 1993.

Rogers, Sarah J., curator. *Will/Power: New Works by Papo Colo, Jimmie Durham, David Hammons, Hachivi Edgar Heap of Birds, Adrian Piper, Aminah Brenda Lynn Robinson.* Columbus, Ohio: Wexner Center for the Arts, 1993.

Romain, William F. *Mysteries of the Hopewell: Astronomers, Geometers, and Magicians of the Eastern Woodlands.* Akron: University of Akron Press, 2000.

Romain, William F. "New Radiocarbon Dates Suggest Serpent Mound Is More than 2,000 Years Old." The Ancient Earthworks Project. July 26, 2014. www .ancientearthworksproject.org.

Romain, William F., and Jarrod Burks. "LiDAR Analyses of Prehistoric Earthworks in Ross County, Ohio." Ohio Archaeological Council website. Last modified March 3, 2008. https://www.ohioarchaeology.org.

Romain, William F., and Jarrod Burks. "LiDAR Assessment of the Newark Earthworks." Ohio Archaeological Council website. Last modified February 7, 2008. www .ohioarchaeology.org.

Rosaldo, Renato. *Culture and Truth: The Remaking of Social Analysis.* Boston: Beacon, 1989.

Rule, Elizabeth. "The Chickasaw Press: A Source of Power and Pride." *American Indian Culture and Research Journal* 42, no. 3 (2018): 183–202.

Scheele, William E. *The Mound Builders.* Cleveland: World Publishing Company, 1960.

Scully, Vincent. "Theory and Delight." *Progressive Architecture,* October 1989, 86–87.

Searcy, Margaret Zehmer. *Ikwa of the Mound-Builder Indians.* University of Alabama Press, 1974. Gretna, Ala.: Pelican, 2009.

Shetrone, Henry Clyde. *The Mound-Builders: A Reconstruction of the Life of a Prehistoric*

American Race, through Exploration and Interpretation of Their Earth Mounds, Their Burials, and Their Cultural Remains. New York: Appleton, 1930.

Shiff, Richard. "The Necessity of Jimmie Durham's Jokes." *Art Journal* 51, no. 3 (Autumn 1992): 74–80.

Siebert, Monika. *Indians Playing Indians: Multiculturalism and Contemporary Indigenous Art in North America.* Tuscaloosa: University of Alabama Press, 2015.

Siebert, Monika. "Repugnant Aboriginality: LeAnne Howe's *Shell Shaker* and Indigenous Representation in the Age of Multiculturalism." *American Literature* 83, no. 1 (2011): 93–119.

Silverberg, Robert. *Home of the Red Man: Indian North America before Columbus.* Greenwich, Conn.: New York Graphic Society, 1963.

Silverberg, Robert. *The Mound Builders.* Athens: Ohio University Press, 1970.

Silverberg, Robert. *Moundbuilders of Ancient America: The Archeology of a Myth.* Greenwich, Conn.: New York Graphic Society, 1968.

Simpson, Leanne Betasamosake. *As We Have Always Done: Indigenous Freedom through Radical Resistance.* Minneapolis: University of Minnesota Press, 2017.

Skorodin, Ian, dir. *Crazy Ind'n.* Barcid Productions, 2007. DVD.

Slenske, Michael. "Does It Matter If Jimmie Durham, Noted Cherokee Artist, Is Not Actually Cherokee?" *Vulture*, November 1, 2017. www.vulture.com.

Smith, Claire, and H. Martin Wobst, eds. *Indigenous Archaeologies: Decolonizing Theory and Practice.* London: Routledge, 2005.

Smith, Linda Tuhiwai. *Decolonizing Methodologies: Research and Indigenous Peoples.* New York: Zed Books, 1999.

Smith, Paul Chaat. "The Ground beneath Our Feet." In *Everything You Know about Indians Is Wrong*, 53–63. Minneapolis: University of Minnesota Press, 2009.

Smith, Paul Chaat. "The Most American Thing Ever Is in Fact American Indians: On Jimmie Durham, Native Identity, and *Americans*, the Forthcoming Smithsonian Exhibition." *Walker Art Magazine*, September 20, 2017, 1–31. www.walkerart.org /magazine.

Smith, Paul Chaat. "Radio Free Europe." In *Jimmie Durham: At the Center of the World*, edited by Anne Ellegood, 135–37. Los Angeles: Hammer Museum, 2017.

Somol, R. E. "O—O." *Progressive Architecture*, October 1989, 88.

Squier, Ephraim G. *The Serpent Symbol, and the Worship of the Reciprocal Principles of Nature in America.* 1851. Millwood, N.Y.: Kraus Reprint, 1975.

Squier, Ephraim G., and Edwin H. Davis. *Ancient Monuments of the Mississippi Valley.* 1848. Washington, D.C.: Smithsonian Books, 1998.

Squint, Kirstin L. "Burying the (Un)Dead and Healing the Living: Choctaw Women's

Power in LeAnne Howe's Novels." In *Undead Souths: The Gothic and Beyond in Southern Literature and Culture*, edited by Eric Gary Anderson, Taylor Hagood, and Daniel Cross Turner, 187–98. Baton Rouge: Louisiana State University Press, 2015.

Stecopoulos, Harilaos. *Reconstructing the World: Southern Fictions and U.S. Imperialisms, 1898–1976*. Ithaca: Cornell University Press, 2008.

Steele, Mary Q., and William O. Steele. *The Eye in the Forest*. New York: Dutton, 1975.

Steele, William O. *Talking Bones: Secrets of Indian Burial Mounds*. New York: Harper and Row, 1978.

Stevens, Jim. *The Book of Big Dog Town: Poems and Stories from Aztalan and Around*. Madison: Fireweed Press, 2013.

Stockwell, Mary. *The Other Trail of Tears: The Removal of the Ohio Indians*. Yardley, Penn.: Westholme, 2014.

Stuart, George E. "A Southeast Village in 1491: Etowah." *National Geographic* 180, no. 4 (October 1991): 54–67.

Sunderhaus, Ted S., and Jack K. Blosser. "Water and Mud and the Recreation of the World." In *Recreating Hopewell*, edited by Douglas K. Charles and Jane E. Buikstra, 134–45. Gainesville: University Press of Florida, 2006.

Tallbear, Kim. "Beyond the Life/Not-Life Binary: A Feminist-Indigenous Reading of Cryopreservation, Interspecies Thinking, and New Materialisms." In *Cryopolitics: Frozen Life in a Melting World*, edited by Joanna Radin and Emma Kowal, 179–202. Cambridge: MIT Press, 2017.

Tallbear, Kim. "An Indigenous Reflection on Working beyond the Human/Not Human." *GLQ* 21, nos. 2–3 (June 2015): 230–35.

Taylor, Mark C. *Disfiguring: Art, Architecture, Religion*. Chicago: University of Chicago Press, 1992.

Taylor, Mark C. "Eisenman's Coup." *Progressive Architecture*, October 1989, 89.

Teuton, Christopher B. *Cherokee Stories of the Turtle Island Liars' Club*. Chapel Hill: University of North Carolina Press, 2012.

Toner, Mike. "City of the Moon." *Archaeology*, March/April 2015, 40–45.

Travis, Rebecca Hatcher. "Halbina' Chikashsha, A Summer Journey." In *Visual Voices: Contemporary Chickasaw Art*, edited by Laura Marshall Clark, 44–46. Ada, Okla.: Chickasaw Press, 2018.

Trefzer, Annette. "The Indigenous Uncanny: Spectral Genealogies in LeAnne Howe's Fiction." In *Undead Souths: The Gothic and Beyond in Southern Literature and Culture*, edited by Eric Gary Anderson, Taylor Hagood, and Daniel Cross Turner, 199–210. Baton Rouge: Louisiana State University Press, 2015.

Tsinhnahjinnie, Hulleah J. "When Is a Photograph Worth a Thousand Words?" In

Photography's Other Histories, edited by Christopher Pinney and Nicolas Peterson, 40–52. Durham: Duke University Press, 2003.

Tuck, Eve, and Marcia McKenzie. *Place in Research: Theory, Methodology, and Methods.* New York: Routledge, 2015.

Tuck, Eve, and K. Wayne Yang. "Decolonization Is Not a Metaphor." *Decolonization: Indigeneity, Education & Society* 1, no. 1 (2012): 1–40.

Tucker, Lindsey. "Walking the Red Road: Mobility, Maternity, and Native American Myth in Alice Walker's *Meridian.*" *Women's Studies* 19 (1991): 1–17.

Urton, Gary. Introduction. In *Their Way of Writing: Scripts, Signs, and Pictographies in Pre-Columbian America,* edited by Elizabeth Hill Boone and Gary Urton, 1–7. Washington, D.C.: Dumbarton Oaks, 2011.

Veit, Richard. "A Case of Archaeological Amnesia: A Contextual Biography of Montroville Wilson Dickeson (1810–1882), Early American Archaeologist." *Archaeology of Eastern North America* 25 (1997): 97–123.

Veit, Richard. "Mastodons, Mound Builders, and Montroville Wilson Dickeson— Pioneering American Archaeologist." *Expedition* 41, no. 3 (1999): 20–31.

Vigil, Kiara M., and Tiya Miles. "At the Crossroads of Red/Black Literature." In *The Oxford Handbook of Indigenous American Literature,* edited by James H. Cox and Daniel Heath Justice, 31–49. Oxford: Oxford University Press, 2014.

Vizenor, Gerald. *Fugitive Poses: Native American Indian Scenes of Absence and Presence.* Lincoln: University of Nebraska Press, 1998.

Vizenor, Gerald. *The Heirs of Columbus.* Hanover: Wesleyan University Press, 1991.

Walker, Alice. *Horses Make a Landscape Look More Beautiful: Poems.* San Diego: Harcourt Brace Jovanovich, 1984.

Walker, Alice. *Meridian.* New York: Washington Square Press, 1976.

Wallace, Glenna J. Foreword. In *The Newark Earthworks: Enduring Monuments, Contested Meanings,* edited by Lindsay Jones and Richard D. Shiels, ix–xi. Charlottesville: University of Virginia Press, 2016.

Wallis, Brian. Review of *Will/Power. Art in America* 81, no. 2 (February 1993): 116–17.

Warrior, Robert. "The SAI and the End(s) of Intellectual History." *Studies in American Indian Literatures* 25, no. 2 (Summer 2013): 221–35.

Watkins, Joe. *Indigenous Archaeology: American Indian Values and Scientific Practice.* Walnut Creek, Calif.: Altamira Press, 2000.

Watts, Cara Cowan, America Meredith, et al. "Dear Unsuspecting Public, Jimmie Durham Is a Trickster." *Indian Country Today,* June 26, 2017. www .indiancountrytoday.com.

Weismantel, Mary. "Encounters with Dragons: The Stones of Chavin." *Res: Anthropology and Aesthetics* 65/66, no. 1 (March 2015): 37–53.

Weismantel, Mary. "Inhuman Eyes: Looking at Chavin de Huantar." In *Relational Archaeologies: Humans, Animals, Things,* edited by Christopher Watts, 21–41. London: Routledge, 2013.

Weismantel, Mary. "Seeing Like an Archaeologist: Viveiros de Castro at Chavin de Huantar." *Journal of Social Archaeology* 15, no. 2 (2015): 139–59.

Wesson, Cameron. Review of *Cahokia: Ancient America's Great City on the Mississippi,* by Timothy Pauketat. *Journal of American History* 98, no. 1 (June 2011): 176–77.

Wilensky-Landord, Brook. "The Serpent Lesson: Adam and Eve at Home in Ohio." February 3, 2017. www.thecommononline.org/the-serpent-lesson-adam-and -eve-at-home-in-ohio/.

Wilson, Lanford. *The Mound Builders.* New York: Farrar, Straus and Giroux, 1976.

Wilson, Shawn. *Research Is Ceremony: Indigenous Research Methods.* Halifax: Fernwood, 2008.

Wobst, H. Martin. "Power to the (Indigenous) Past and Present! Or: The Theory and Method Behind Archaeological Theory and Method." In *Indigenous Archaeologies: Decolonizing Theory and Practice,* edited by Claire Smith and H. Martin Wobst, 15–29. London: Routledge, 2005.

Woods, William J. Review of *Cahokia: Ancient America's Great City on the Mississippi,* by Timothy Pauketat. *Southeastern Geographer* 53, no. 2 (Summer 2013): 235–37.

Wright, Muriel Hazel. "Legend of Nanih Wayah." In *Native American Writing in the Southeast: An Anthology, 1875–1935,* edited by Daniel F. Littlefield and James W. Parins, 213–20. Jackson: University Press of Mississippi, 1995.

Wuwu, Aku. *Coyote Traces: Aku Wuwu's Poetic Sojourn in America.* Trans. Peihong Wen and Mark Bender. Columbus: National East Asian Languages Resource Center, Ohio State University, 2015.

INDEX

above world, 31, 106, 202–3, 228, 246, 264, 272, 276, 350n25. *See also* sky-world; upper world
activist poetics, 47
Adena, 31, 39, 81, 179, 299
aerial analysis, 49, 52, 344n14
aerial photography, 18, 137–38, 169, 175, 282
Ahtone, Heather, 359n10
Alligator Mound, 13, 16, 31, 144–45, 219–20, 325, 354n5
American Indian Cultural Center and Museum. *See* First Americans Museum
American Indian literary renaissance, 43
Ancestral Plane (Hinton), 247, 249–53, 255, 257–64, 322, 361n28
Ancient Monuments of the Mississippi Valley (Squier and Davis), 12, 39–40, 254
Ancient Ohio Trail, 341n20
animals' ballgame, 354n8
Anompolichi (Morgan), 33, 151, 161–68, 176–89, 195–96, 204, 306–7, 310, 356n22, 357n28
anti-conquest, 185–86
apparition, 130, 139
Archaic period, 31
astronomical alignments, 51–53, 65. *See also* lunar alignments; solar alignments
Atalay, Sonya, 342n36, 345n28

Austin, Mary, 356n19
axis mundi, 62, 264, 270–72, 275, 281, 361n33
Aztalan, 32, 207, 210–31, 304, 357n2, 358n4, 358nn6–7, 365n5
Azure, Alice, 207–11, 214

Baires, Sarah, 341n22, 342n27
Ballengee-Morris, Christine, 33
"Banks of the Ohio, The" (ballad), 102–4, 141, 349n16, 350n17
Banks of the Ohio, The (Durham), 85–141, 351nn30–31, 351n35
Barnett, Rod, 354n3
Basel edition, 126, 352n40
Beier, J. Marshall, 278
below world, 31, 106, 136, 202–3, 228, 246, 264, 272, 275, 350n25. *See also* lower world; underworld
Bender, Mark, 82, 348n56
Berlo, Janet, 26
biblical Serpent, 4, 42, 78. *See also* serpent worship
Bird Mound, 67, 143
Birmingham, Robert, 358n6
Black Elk Speaks (Neihardt), 42–44, 71, 73, 77
Blackie, John Stuart, 79, 347nn49–50
Blood Run, 2, 46, 50–51, 53, 56, 58, 94, 244, 247, 265, 267–68, 271, 274, 339n1, 344n17

Chadwick Allen is professor of English and adjunct professor of American Indian studies at the University of Washington. He is author of *Blood Narrative: Indigenous Identity in American Indian and Maori Literary and Activist Texts* and *Trans-Indigenous: Methodologies for Global Indigenous Literary Studies* (Minnesota, 2012).